THE BARNES FOUNDATION
MASTERWORKS

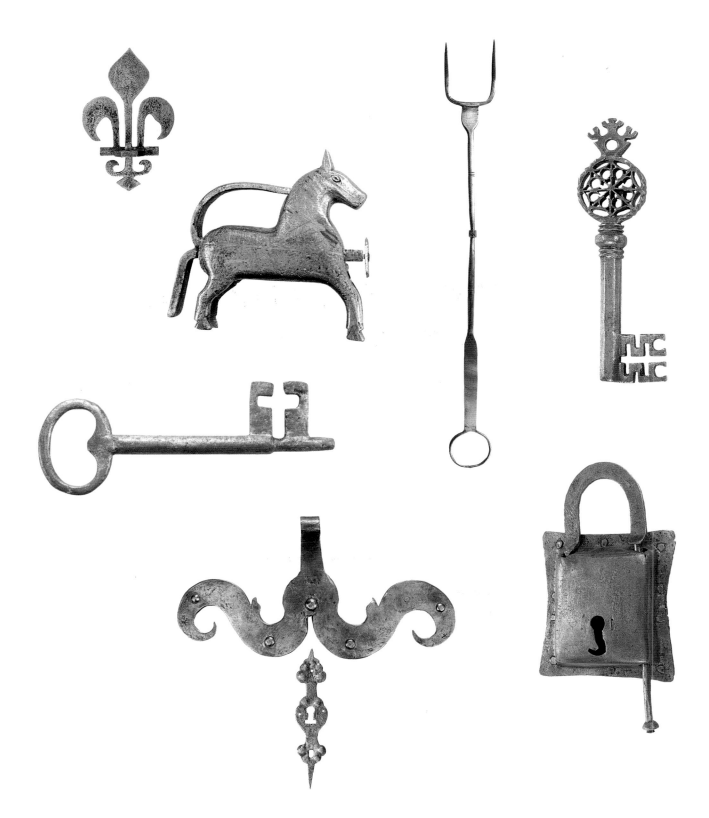

THE BARNES FOUNDATION
MASTERWORKS

JUDITH F. DOLKART AND MARTHA LUCY

with contributions by
DEREK GILLMAN

Skira_RIZZOLI_
NEW YORK

in association with The Barnes Foundation, Philadelphia

FOREWORD

The Board of Trustees of the Barnes Foundation is proud and honored to present this splendid volume, the first overview of the entire collection. Readers may be surprised to learn that it is not primarily a collection of impressionist painting, although that is the way it is frequently described. In fact, Dr. Albert C. Barnes's extraordinary post-impressionist and early modern paintings greatly outnumber his impressionist works, and his taste spanned not only millennia, but also cultures from across the world.

The Foundation houses exceptional examples of art and design from Africa, as well as Native American art, old master paintings, and Pennsylvania German ceramics, furniture, and ironwork, all of which were chosen by one of the most remarkable men of the last century. Barnes pioneered a commercially successful antiseptic medicine, established a factory in which labor practices were far ahead of their time, and was an early supporter of African American culture.

Barnes and American philosopher John Dewey used this unrivaled collection to extend educational and democratic opportunities to individuals who would otherwise have had few — establishing an institution intended to change American society. Ninety years later, the Barnes Foundation retains the same goals: to advance education through the appreciation of art from across the world. Visitors, and our own students who spend hours of intensive study in the Barnes galleries, will welcome this beautiful production, which is intended both to inspire and to educate.

Next to our curators Judith F. Dolkart and Martha Lucy, we owe a fond debt to our friend Joseph Rishel, Gisela and Dennis Alter Senior Curator of European Paintings and Sculpture before 1900, and Senior Curator of the John G. Johnson Collection and the Rodin Museum at the Philadelphia Museum of Art, for chairing the Barnes Foundation's Collections Assessment Project, which began in the late 1990s. Funded by the Andrew W. Mellon Foundation and championed by Angelica Zander Rudenstine, the project generated a wealth of scholarship on which this book draws. Other foundations that have generously supported research into, and care of, the collection include the Pew Charitable Trusts, the J. Paul Getty Trust, the Henry Luce Foundation, the Richard C. von Hess Foundation, the Dolfinger-McMahon Foundation, the Institute of Museum and Library Services, the National Endowment for the Arts, the National Endowment for the Humanities, and the Pennsylvania Historical and Museum Commission. The Barnes Board of Trustees offers particular thanks to President Alberto Ibargüen and the trustees of the John S. and James L. Knight Foundation, who have helped fund this publication. Wilmington Trust and M & T Bank have also provided generous support for this important achievement. The board extends its gratitude to Mark Graham for more than a decade of commitment to the Foundation, and to Donald E. Foley and Ira Brown for supporting a strong partnership with the Barnes.

BERNARD C. WATSON, *Chair, Board of Trustees*

PREFACE

This volume highlights the diversity of cultural forms assembled by Dr. Albert C. Barnes. The Foundation's board, staff, and faculty are delighted to make *The Barnes Foundation: Masterworks*, which accompanies the public opening of the Parkway campus, available to our visitors and students.

The introductory essay by Gund Family Chief Curator Judith F. Dolkart examines Barnes's collecting and display practices, and I am deeply grateful to her for overseeing the publication and for her illuminating entries. My sincere thanks extend also to Dr. Martha Lucy, associate curator, for her revelatory texts. Together they have included not only many post-impressionist and early modern works for which the Foundation is best known, but also, importantly, representative examples from our major holdings of African, Native American, and Pennsylvania German collections.

This book celebrates the brilliance and perspicacity of the collector. Paintings by Cézanne, Matisse, and Picasso are now admired across the world, but avant-garde collectors such as Barnes fought hard to achieve appreciation for the radical art they assembled, let alone the recognition that African sculptures and masks could be collected as works of art rather than as ethnographic specimens. Barnes's collection encourages us to reflect on what is held to be valuable and how value changes over time. Barnes argued that all good forms of art should be considered equal, and thus showed metal crafts alongside works by Renoir, African sculpture next to works by Modigliani. That belief underlies the unique display of the collection, the fascination of which is in both the arrangements and in the individual objects. I hope that this book will lead those who have not yet seen the collection to visit its new home in Philadelphia, and as the founder himself wished, to think further about the value of art and its relationship to our lives.

I offer my deep appreciation to Johanna Halford-MacLeod, publications manager, who has skillfully steered this publication from its conception, guiding all with a light but deft hand, and to Ulrike Mills for proficiently editing the manuscript. I thank Rick Echelmeyer and Tim Nighswander for their masterly photography; Deborah Lenert for her superb skills in managing the digital images; Brett Miller, Esq., for his authoritative counsel on visual rights; the conservation team, especially Head of Conservation Barbara Buckley, Margaret Little, and Tim Gierschick; instructor John Gatti for his thoughtful insights into the wall ensembles created by Barnes; and Diana Duncan and Shara Pollie of the External Affairs Department. We are most grateful to designer Abbott Miller and his team at Pentagram, and to the staff at Rizzoli for their professionalism and enthusiastic support, particularly Charles Miers, publisher, and Margaret Chace, associate publisher.

DEREK GILLMAN, *Executive Director and President*

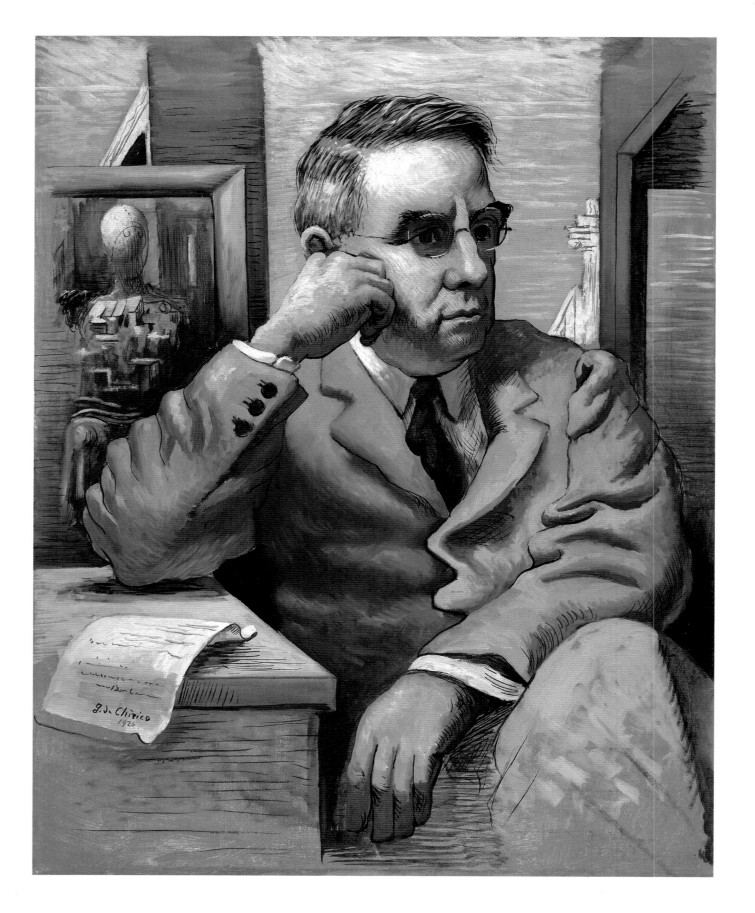

TO SEE AS THE ARTIST SEES
ALBERT C. BARNES
AND THE EXPERIMENT
IN EDUCATION

JUDITH F. DOLKART

Between 1912 and 1951, Dr. Albert C. Barnes (1872–1951) assembled one of the world's most important holdings of post-impressionist and early modern paintings. Acquiring works by avant-garde European and American artists—Paul Cézanne, Charles Demuth, Paul Gauguin, William Glackens, Vincent van Gogh, Henri Matisse, Amedeo Modigliani, Pablo Picasso, Maurice Prendergast, Pierre-Auguste Renoir, and Chaim Soutine, among others—Barnes demonstrated his audacity as a collector (fig. 1). With the establishment of his foundation in 1922, Barnes commissioned the Philadelphia-based French architect Paul Cret to build a gallery in Merion, just outside the city, for his growing collection and progressive educational program. In this space, dedicated in 1925, Barnes experimented with the display of his collection, arranging and rearranging the works in "ensembles," distinctive wall compositions organized according to the formal principles of light, line, color, and space, rather than by chronology, nationality, style, or genre.

The ensembles changed as Barnes made acquisitions and trades and developed new aesthetic connections between the collections, which diversified significantly over the decades with the addition of African sculpture; antiquities; Asian art; Native American ceramics, jewelry, and textiles; manuscripts; and old master paintings, as well as European and American decorative and industrial arts. Integrating art and craft, and objects spanning cultures and time periods, Barnes sought to demonstrate the continuity of artistic tradition and the universal impulse for creative expression.

Barnes the Collector: "How to Judge a Painting"
Barnes revealed little about his inspiration for his forty-year collecting adventure.[1] Before buying paintings, he had acquired horses. Argyrol, the silver compound that proved "bully stuff"[2] for treating ophthalmic infections, had

FIG. 1
Giorgio de Chirico
Dr. Albert C. Barnes, 1926
Oil on canvas, The Barnes
Foundation, BF805

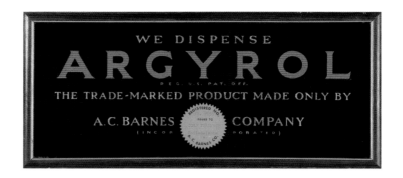

made him wealthy at a young age (fig. 2). Barnes and his wife, Brooklyn-born Laura Leggett (1875–1966), built their home, Lauraston, on Latch's Lane in Merion, on Philadelphia's tony Main Line, far removed from Kensington and The Neck, the impoverished, hardscrabble neighborhoods in which the physician-turned-pharmaceutical-entrepreneur grew up. Barnes joined the Rose Tree Fox Hunting Club in 1908 and endowed a Lauraston Cup two years later, purchasing mounts on approval, much as he later bought paintings.

Through his business, Barnes knew well the Philadelphia attorney John G. Johnson, a blacksmith's son, whose important holding of old master and Barbizon school paintings may have been idiosyncratically installed on doors, ceilings, and the footboards of beds.[3] Certainly, hunting proved short-lived for the restless and intellectually curious Barnes, who resigned from the hunt in April 1912, as his obsession with collecting began. Just months earlier, in 1911, he had revived his friendship with Glackens, whom he knew from Central High School. "Dear Butts," Barnes wrote in January 1912, "I want to buy some good modern paintings. Can I see you on Tuesday next in New York to talk to you about it?" (fig. 3).[4]

Acknowledged as a leader among American modernists—first for his urban realist fare and later for the sunny palette and impressionist touch exemplified by *Race Track* (p. 205)—Glackens led Barnes on tours of artists' studios.[5] Recognizing his debt to the artist, Barnes wrote later: "The most valuable single educational factor to me has been my frequent association with a life-long friend who combines greatness as an artist with a big man's mind."[6] Barnes reveled in the "pink cats, purple cows, cock-eyed houses, and a few other manifestations of artistic genius" that distinguished the vision of a painter such as Glackens.[7] Indeed, for the scientist the endeavor of both his collecting and his educational ambitions was to develop a rigorous method "to see as the artist sees."[8]

Quick to act, Barnes sent Glackens—the "best eyes in America,"[9] an opinion shared by the painter and critic Guy Pène du Bois—to Paris on a buying trip in February 1912, specifically designating works by Renoir and Alfred Sisley as

desirable.[10] With "spot cash"[11] — $20,000 — Glackens scoured Parisian galleries with Alfred Maurer, another American painter, whose fluency in French and friendship with the expatriate collector Leo Stein aided in the effort.[12] At the end of two weeks, Glackens had acquired thirty-three oils, prints, and watercolors, including *Toward Mont Sainte-Victoire* by Cézanne (fig. 4), *Young Woman Holding a Cigarette* by Picasso (p. 181), and *The Postman (Joseph-Étienne Roulin)* by Van Gogh (p. 89). Paintings by Cézanne, Maurice Denis, Camille Pissarro, Renoir, and Sisley found a home on the walls of Lauraston and later in the ensembles at the Foundation.[13] Barnes traded other works from the Glackens purchase in the teens, often through the dealer Paul Durand-Ruel, to whose New York branch he wrote in April 1915, "As you know it is my intention to have only important paintings in my collection."[14] Three years into collecting, Barnes imperiously dictated the terms of sale and exchange, demanding that Durand-Ruel take unwanted paintings, whether they had previously passed through his hands or not.

Although pleased by Glackens's selections, Barnes made all purchasing decisions thereafter. He traveled to Paris in June 1912, commencing a pattern of regular transatlantic voyages interrupted only by the two world wars. Paul Guillaume, the precocious, "up-on-his-toes"[15] dealer with whom Barnes worked in the 1920s, described a three-week buying trip to Paris by Barnes, the "Medici of the New World," noting that his "extraordinary, democratic, ardent, tireless, invincible, charming, impulsive, generous, unique" client had little time for leisure during these sojourns. Rather, "he bought, refused to buy, admired, critiqued; he pleased, displeased, made friends, made enemies."[16] Between trips to Europe, Barnes bought at auction and frequented the New York outposts of well-established purveyors of impressionism and post-impressionism such as Durand-Ruel.

Barnes continued to look to artistic currents at home, accumulating a significant trove of American modernism by Glackens and by Demuth (pp. 261, 308), Marsden Hartley (p. 340), Ernest Lawson, Maurer, and the Prendergast brothers (pp. 128, 151), some of whom became important correspondents, interlocutors, and visitors to his collection in Merion.[17] He also bought old master paintings by Frans Hals (p. 115), Peter Paul Rubens, Claude Lorrain, Lucas Cranach, Tintoretto, and El Greco (p. 90) from sources in New York and Europe, but at a more measured pace than his purchases of contemporary art — perhaps in emulation of the carefully calibrated holdings of Henry and Louisine Havemeyer, which he singled out as the "best and wisest collection in America."[18]

Barnes retained the Paris-based Maurer to promote the sale of Argyrol in France and to scout for paintings.[19] Maurer sent Barnes descriptions and occasionally drawings of possible acquisitions. The artist's account of an October 1912 visit with the dealer Ambroise Vollard further illuminates the vetting

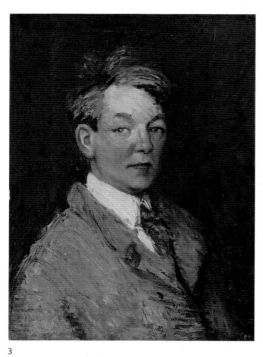

3

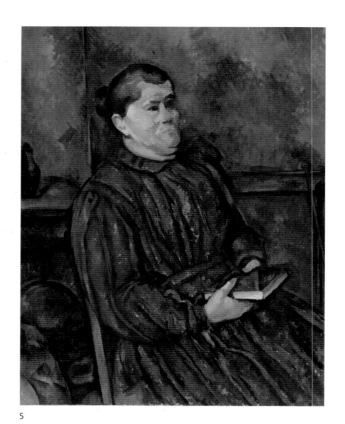

5

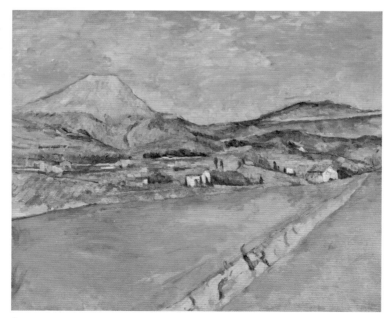

4

process: "Saw Vollard yesterday and he assures me he will send photos, I picked out the ones I wanted him to send . . . among them you will find the Cézanne woman in striped dress . . . you will find a small touch near the mouth which is not finished . . . don't let this bother you."[20] Barnes ultimately purchased the rugged *Portrait of a Woman* (fig. 5), which remains in the collection.

With an introduction from Maurer, Barnes visited the rue de Fleurus salon of Gertrude and Leo Stein at the end of 1912. Although Barnes and Gertrude never warmed to each other, he launched a decades-long aesthetic discourse and friendship with Leo (fig. 6), mainly by correspondence. Like Glackens, Stein occupied a critical role in the development of Barnes's collection and aesthetic theories, as Barnes later wrote: "It is safe to say that my talks with him in the early days were the most important factor in determining my activities in the art world."[21] Barnes purchased his first works by Matisse — including *Dishes and Melon* (p. 323) — from Stein during this 1912 trip. In all, the collection includes approximately thirty-five works that had belonged to Stein and his family members, including *Le Bonheur de vivre*, also called *The Joy of Life*, by Matisse (p. 272; fig. 7). Core artists for Stein — Cézanne, Matisse, Picasso, and Renoir — became linchpins for Barnes, who acquired enviable holdings of important works by each. With the world's largest single holding of paintings by Renoir, one hundred and eighty-one works, Barnes made good on his 1913 declaration to an equally Renoir-enamored Stein: "I am convinced I cannot get too many Renoirs."[22]

While Stein and Barnes debated aesthetics and psychology in their letters — and ceased their correspondence for a period — they also confided in each other. To Stein, Barnes declared the loneliness of their shared aesthetic convictions: "I am almost alone in this entire continent in collecting paintings such as mine." Barnes also acerbically noted the curiosity that his collection had already incited in 1914 among "prominent, successful men and women, therefore necessarily stupid." However, he found solace in the interest of artists who took inspiration from their encounters with the holdings.[23]

As Barnes acquired, he voraciously read the literature on art by authors such as Clive Bell, Bernard Berenson, Roger Fry, Julius Meier-Graefe, and Willard Huntington Wright, "in an effort to find out what is a good painting,"[24] as he wrote to Stein in 1914, when he had already accumulated two hundred works. He concluded "that no book on art ever written is worth a damn for the man who wants to find out for himself and use the qualities of mind that he has developed by education along personal lines."[25] Entering the critical fray with his essay "How to Judge a Painting," published in *Arts & Decoration* in April 1915, Barnes urged direct and repeated visual engagement with paintings. "Good paintings are more satisfying companions than the best of books and infinitely more so than most very nice people," he wrote.[26] This constant return to his pictures served to

FIG. 3
William James Glackens
Self-Portrait, 1908
Oil on canvas, The Barnes
Foundation, BF105

FIG. 4
Paul Cézanne
*Toward Mont Sainte-Victoire
(Vers Mont Sainte-Victoire)*,
1878–1879
Oil on canvas, The Barnes
Foundation, BF300

FIG. 5
Paul Cézanne
*Portrait of a Woman
(Portrait de femme)*, c. 1898
Oil on canvas, The Barnes
Foundation, BF164

refine the quality of his holdings. Form was what mattered to Barnes: a number of his old master works are to this day identified only by school, demonstrating his primary interest in "the essentials which link the expression of the spirit of our own times with the great creators of the past," which study had revealed to him.[27]

Barnes's strategy bore new revelations about the works and his own evolution as a collector, as he noted: "That is one of the joys of a collection, the elasticity with which paintings stretch to the beholder's personal vision which they progressively develop."[28] He condemned cubism as "academic, banal, repetitive, dead" in a 1916 article entitled "Cubism: Requiescat in Pace," but subsequently acknowledged that a work by Picasso in his collection—"a symphony in its bright yellow, blue, fawn, grey, white, and black"—prompted him to reconsider the idiom: "if a cubist picture moves me aesthetically by means of something more than mere pattern I shall accept their paintings even if I can't accept their theories."[29]

Barnes worked with a succession of primarily French dealers to build his collection of European modernism—most notably, the well-established impresario of the avant-garde, Durand-Ruel, and the ambitious up-and-comer Guillaume.[30] Buying from Durand-Ruel in the teens, Barnes quipped that "my collection is practically an annex to your business."[31] Invoices from Durand-Ruel in these early years record his insatiable buying, with ten or more works listed in a single sale—paintings by Honoré Daumier, Renoir, and Picasso, along with the occasional old master. Though the novice collector sometimes bullied Durand-Ruel over paintings, frames, and terms, and more than once threatened to withdraw his business, he also sent funds to support the care of wounded French soldiers during World War I.[32]

Durand-Ruel and Guillaume sold to Barnes from gallery stock—Barnes's bid to purchase Durand-Ruel's private collection in 1921 for $1 million was unsuccessful[33]—but they also served as agents for him, brokering sales while concealing his identity. "Do not tell Vollard it is for me,"[34] Barnes cautioned Durand-Ruel in 1913, beginning a series of surreptitious inquiries about works in the hands of Ambroise Vollard, whose prices and business practices often frustrated him. Later, urging Guillaume to "sneak under Vollard's crafty defenses,"[35] Barnes undertook a calm and unusually patient but subterfuge-filled five-year quest for *The Card Players* by Cézanne (p. 70), its successful conclusion in 1925 announced to the collector in a coded telegram from Guillaume.[36] Seeking manifesto paintings for his foundation, Barnes enlisted Guillaume to pursue the purchase of *Le Bonheur de vivre* by Matisse in 1922, despite a vow of austerity as he set up his new endeavor.

Fondly addressing him as "Your Excellency," Barnes named Guillaume foreign secretary to the Foundation, an honorary rank that underscored the French dealer's role as a spokesman-diplomat for the enterprise in Merion. Promoting

est environ dix fois plus importante
que celle qu'il a achetée et elle ne
coûte que soixante-quinze mille
francs. J'estime qu'une pièce de cette
collection vaut 3.000 fr. quelques autres
objets ensemble 3000 fr. et que tout
le reste n'intéresserait même pas
pour rien le dernier bazar de
Constantinople !.... [Monsieur Culin est
un très gentil collectionneur de boutons
de culotte. Il y a aussi à Paris des
collectionneurs qui ont deux mille
croûtes ; j'aime mieux la
photo d'un seul de vos Renoir !
____ Néanmoins, dans la
collection achetée par M. Culin
les choses les plus intéressantes
sont les armes ornées du
genre de celle dessinée ci-contre :
deux pièces sont assez jolies
deux autres sont intéressantes
le reste, si j'ai bonne mémoire,
était sans intérêt. Il
doit y avoir aussi quelques

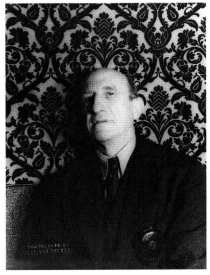

6

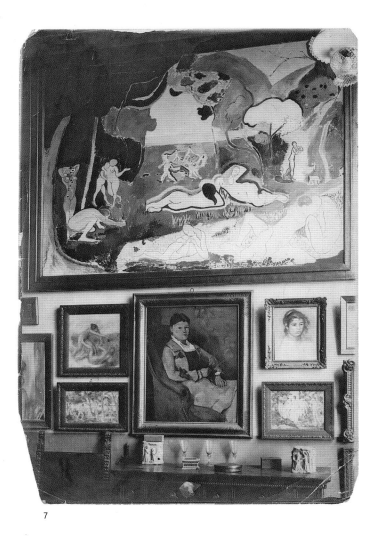

7

8

his prominent client and the fledgling foundation, Guillaume published a number of articles on Barnes, his collection, and his educational program in his journal *Les Arts à Paris*. Guillaume's title also reflected the intoxicating atmosphere of cultural exchange that Barnes found at his gallery:

> I have seen six chiefs of African tribes there at the same time with four principals of the Russian ballet. Like a stream of worshippers all nationalities flow into... Paul Guillaume's, English, Japanese, Norwegian, German, American, Italian artists — painters, sculptors, composers, poets, critics — whom I had only known by name. I have heard there criticism more penetrating and more comprehensive than I had ever heard or read elsewhere.[37]

Guillaume championed a generation of foreign-born artists, such as Giorgio de Chirico, Jacques Lipchitz, Modigliani, Jules Pascin, and Soutine, who worked and lived in Paris. An immediate admirer of Soutine's work, Barnes purchased more than fifty of his paintings in one sale in the company of Guillaume. As Guillaume promised "the painters of La Rotonde,"[38] Barnes served as their advocate, publishing an article on Soutine and thereby identifying him as an artist to watch.[39] As the newspapers reported, Barnes had already provided a spirited defense of avant-garde American painters when physicians likened the paintings in a 1921 exhibition at the Pennsylvania Academy of the Fine Arts to the work of the mentally ill.[40]

In January 1923, Guillaume organized a well-received exhibition at his gallery of the purchases of the Foundation, including African art, which Barnes had begun to buy — press-worthy news at home in Philadelphia.[41] Prizing African art for its aesthetic and formal qualities rather than ethnographic interest distinguished Barnes as an early and important American collector of this material, along with attorney and Armory Show organizer John Quinn and Walter and Louise Arensberg.[42] Just as Maurer had a decade earlier, Guillaume wrote letters to Barnes accompanied by sketches of African objects and regions (fig. 8). Barnes read avidly about African art — again Bell and Fry, as well as Carl Einstein — but dismissed most of it as the work of "people who have no real knowledge of the subject."[43] As demanding in his pursuit of African art as in his acquisition of paintings, Barnes admonished Guillaume in more or less the same terms as he had Durand-Ruel: "Please remember I intend to try to have the best private collection of Negro sculpture in the world."[44] He assembled his African collection of more than one hundred pieces in several large purchases between 1922 and 1924. "My negro sculpture is a constant joy and my pictures look all the better for having the carvings for company," he wrote to Guillaume, anticipating the distinctive installation to come at the Foundation.[45]

Establishing the Foundation: "An Approach to Art"

Roughly ten years and seven hundred paintings into assembling the collection,[46] Barnes established a foundation devoted to "the promotion of the advancement of education and the appreciation of the fine arts."[47] His vision for the Foundation, five succinct points scribbled on stationery from the Plaza Hotel in New York in April 1922,[48] reflected his progressive educational agenda devoted to the development of critical thinking. This program traced its roots to a similar one initiated at his Argyrol factory nearly twenty years before. In a 1923 article in the *New Republic* Barnes described the cooperative nature of his company, which proved so efficient that his employees — fewer than ten in the earliest days and never more than about twenty[49] — accomplished their tasks within six hours, allowing for two hours of education in the standard workday and "affording a sensible use of leisure in a class of people to whom such doors are usually locked."[50] In an article published in *Opportunity: Journal of Negro Life* in 1926, factory-employee-turned-Foundation-stalwart Mary Mullen further noted that, for this racially mixed workforce, "particular attention was paid to race problems, to the social and economic handicaps under which the Negro suffers, their cause and their cure."[51] The classes matched Barnes's ideals for educational reform and the advancement of African Americans with improved worker performance.[52]

Though their levels of literacy varied, the workers read or listened to texts on philosophy and psychology by John Dewey, William James, and Bertrand Russell. In response to their enthusiastic reception of writings on art and aesthetics by Roger Fry, George Santayana, and Percy Moore Turner, Barnes introduced his collection of modern paintings into the factory and class discussions. Mullen's records include observations of the workers' understanding of the texts and their reactions to the paintings. One note indicated that a worker called Alice struggled with vocabulary, "but when we looked at the pictures she could point out many of the qualities we had been talking about"[53] and seemed to understand what Barnes would later call "the universal language of art."[54]

In Dewey's pragmatist philosophy — the primacy of learning through lived experience — Barnes found confirmation for the collecting practices he had described in "How to Judge a Painting" in 1915 and for the experimental educational program at the factory. Alice's engagement with the paintings themselves, rather than with the texts, further proved the theory. "I worshipped at your shrine long, long before I knew you," he wrote to Dewey, acknowledging their shared philosophies and practice.[55] In 1917, Barnes took Dewey's graduate seminar at Columbia University and launched a decades-long correspondence and friendship. Describing him as "the real 'daddy' of the Foundation,"[56] Barnes indicated that Dewey urged him to establish a more expansive and officially acknowledged educational program — an idea realized when the Foundation received its charter

from the Commonwealth of Pennsylvania in December 1922. A month later, Barnes invited Dewey to serve as first director of education, honoring the philosopher's critical role in formalizing his educational ideals.

Following his five-point plan, Barnes purchased a house and twelve-acre arboretum with two hundred specimens on Latch's Lane that he and Laura, an avid horticulturist, had long eyed — a property that permitted a complementary program for "the study of arboriculture and forestry."[57] After razing the house, Barnes erected a gallery and adjoining residence of French limestone, designed by Cret in a classicizing style that evoked Renaissance precedents. In keeping with the contemporary holdings of his client, the architect devised a building of "an entirely new type, fulfilling the needs of painting exhibitions in a novel manner, yet simply and economically constructed and practical in plan."[58] Cret's design paired a double-height Main Gallery with flanking side-lit rooms of varying but intimate scale and simple, corridor-free circulation — an innovative solution to the usual monotony of the enfilades of the traditional top-lit museum galleries. Despite the presence of a large window in most rooms — two on the second floor were top-lit — Cret noted that the reduction of ornament in the interior design left ample space for installation, asserting that the design would "avoid crowding too many paintings in a single room" and allow the paintings to "harmonize."[59]

The architect also particularly noted the Main Gallery's intended use for performances — hinting at the synthesis of aesthetic experiences to be offered in the Foundation's activities.[60] In 1926, Barnes invited the singers of the Bordentown Manual and Industrial School for Youth to sing African American spirituals — a profoundly affecting influence of his youth — in a program that included a poetry reading by Charles S. Johnson and lectures by Guillaume and Barnes on African sculpture and African American music, respectively. The chorus performed on other occasions as well. The musical subject matter of several cubist reliefs by Lipchitz on the Gallery's façade further suggested Barnes's passion for music and his rhythmic installations (fig. 9). Inside, these allusions were later reinforced by *The Dance*, commissioned by Barnes in 1930 from Matisse for the lunettes of the Main Gallery (p. 50). A Victrola in the Gallery stands as a reminder of the importance of music to Barnes, who paired musical selections with paintings discussed in his lectures (p. 32).

At the entrance to the Gallery, Barnes further enunciated formal links between the contemporary art he was collecting and some of its sources, using tiles commissioned from Enfield Pottery and Tile Works (Enfield, Pennsylvania) and decorated with forms from African art recently purchased from Guillaume. The crocodile and mask motifs from a Baule door appear on either side of the entrance and are surmounted by low-relief figures by Bamana, Bembe, Fang,

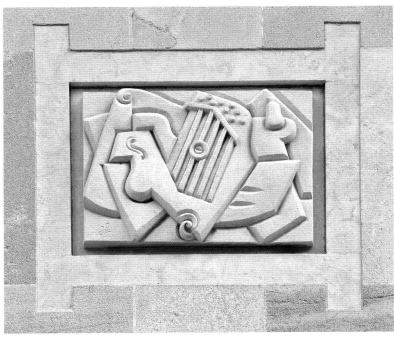

9

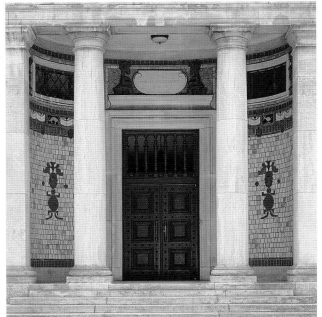

10

11

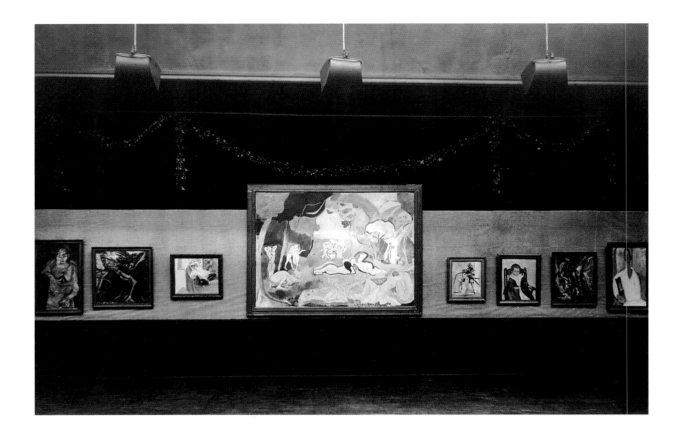

and Senufo peoples (p. 298; figs. 10, 11). With a palette meant to "give an effect something like a late Matisse in color combinations," Barnes aimed to harmonize inside and outside.[61]

The establishment of the Foundation was welcomed by Forbes Watson, editor of *Arts*, in lavishly illustrated articles. He praised the collector—and distinguished his enterprise from that of larger public institutions—for the singularity, boldness, and independence of his vision.[62] Philadelphia headlines, meanwhile, registered incredulity: "Merion to House Art of 'Radicals,'" blared the *Evening Bulletin*, while the *Philadelphia Inquirer* devoted a portion of its April magazine to "America's $6,000,000 Shrine to All the Craziest 'Art.'"[63]

As construction of the Gallery continued, Barnes planned his educational program and arranged for the paintings included in the 1923 exhibition at Guillaume's gallery to be presented at the Pennsylvania Academy of the Fine Arts in April. Lending *Le Bonheur de vivre* by Matisse, as well as works by Modigliani, Soutine, and Lipchitz (fig. 12), Barnes envisioned the exhibition as "the

most important show of modern art ever held in America."[64] Although he wrote the foreword to the catalogue, he did not attach his name or that of the Foundation to the exhibition, instead promoting Guillaume as the organizer.

In his text, Barnes likened contemporary painting to avant-garde music, which was initially met with "snickers, jeers and scoffs" when first introduced by conductor Leopold Stokowski at the Philadelphia Orchestra, but eventually accepted.[65] The optimism of the essay proved unfounded. The Philadelphia press, no less conservative than it had been two years earlier, described the works, particularly the paintings, as "horrible and grotesque blobs of violent color," "mad art," "debased," and "unclean."[66] Barnes lashed out at the newspapers in letters, astonished that they could not understand the magnitude of his efforts: "I am trying to do the biggest thing for Philadelphia that any one man has ever attempted."[67]

Barnes inaugurated the Foundation in March 1925. While Dewey dedicated it to "the cause of Education," Stokowski, an important ally for Barnes, appeared "on behalf of the artists of America."[68] Barnes assembled a teaching and administrative staff, including former factory employees Mullen and her sister Nelle, as well as Princeton University professor Laurence Buermeyer, and launched educational courses and a robust publishing program. Mary Mullen's *An Approach to Art* appeared before the opening, in 1923. Summarizing her factory lessons in plain language, it blended discussions of aesthetics with references to activities of daily life, such as selecting fabric for a dress.[69]

Keen to provide a new means of apprehending art, Barnes worked with his staff to adumbrate the primacy of aesthetic experience in *The Art in Painting* (1925). Analyzing painting in terms of "plastic" elements of design — light, line, color, and space — he placed particular emphasis on understanding the vision of the artist: "So to draw out and make clear the true character of anything is the task of the artist … the person who comprehends and appreciates the work of art shares the emotions which prompted the artist to create. The artist gives us satisfaction by seeing for us more clearly than we could see for ourselves, and showing us what an experience more sensitive and profound than our own has shown him."[70] Following this publication, which saw additional editions and revisions, Barnes worked closely with Violette de Mazia, an instructor in the program and later director of education for the art department, and other members of the Foundation staff to publish a series of books, including *The Art of Henri-Matisse* (1933), *The Art of Renoir* (1935), and *The Art of Cézanne* (1939). In 1926, Guillaume and Thomas Munro, another Foundation instructor, published *Primitive Negro Sculpture*, a seminal formal analysis of African art, at Barnes's request and according to his aesthetic criteria.[71] Over the course of the following decades, Barnes also wrote introductory essays for exhibitions dedicated to De Chirico, Soutine, and Horace Pippin, a student at the Foundation.

Arrangement for Main wall in room 14

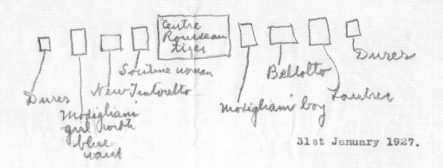

Centre
Rousseau
tiger

Durer

Soutine woman

New Tintoretto

Modigliani
girl north
blue
waist

Modigliani boy

Bellotto

Laudrec

Durer

31st January 1927.

Renoir family replaces Riffian in 14, flanked by Cezanne landscape
and Renoir landscape now each side of Mme Cezanne in room 13.

above above
Put in places in 13, the Cezanne house now in room 8 and Renoir
2 women in park, now next to Daumier in room 2

Renoir promenade replaces Rousseau tiger in room 14, flanked by
the Renoirs now alongside of Renoir sailor boy in room 9; in these
empty places in 9, put Rousseau rabbit and Rousseau family now in
room 11; in these empty places in room 11, put Matisse nude now in
room 9 not and the Pascin blue girl now in room 6; in these empty places
in room 6, put the Pascin girl seated that was formerly in 14.
Put Renoir fat nude (now in room 8) to replace Renoir women in park
in room 2. New Manet goes where Monet landscape is now in room 8;
flank Manet by Monet landscape just mentioned and by Cezanne lands-
cape now in room 7, replace latter by Renoir flowers now on same
wall; replace latter by Berthe Morrisot, replace latter by a Pascin
(red boy in room 18, or another one).
 Put Riffian to replace big Blue Picasso man with beard (now in
room 23, put latter Picasso in room 7 where the Cranach was.
 Put Rousseau tiger in centre of big wall in room 14, flanked
by Soutine and Modigliani now on that wall; put blue Modigliani
(that now flanks Rousseau tiger on the main wall in room 14) and the
Lautrec portrait.

New Tintoretto (landscape with figures replaces Utrello on main
wall of 14. Note these changes in above arrangement. Renoir fat
nude 2 women in park replaces Renoir landscape now next to
Embroiders in centre of side wall in room 13; latter landscape goes alongside
of Mme Cezanne (shawl) on main wall of room 13. Renoir promenade is
flanked by Renoir red boat & Renoir red girl & post now in room 3; replace
these 2 latter by the 2 Renoirs that now flank Renoir sailor boy in room 9.

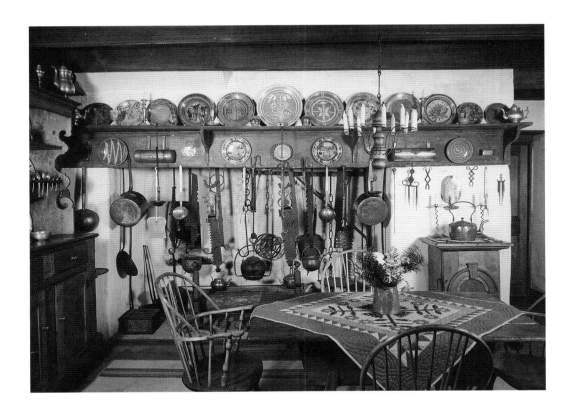

The Collector as Artist: The Evolution of the Ensembles

In *An Approach to Art*, Mullen described the generative role of the insightful collector:

> When the connoisseur acquires paintings and sculpture which he knows are expressions of the artists' true feelings.... He arranges the pictures and sculpture of the different artists in such a way that each individual work contributes its share to the making of a perfect whole. The result is a wonderful creation, comparable in unity and loveliness with the separate paintings; in that case the collector is the artist.[72]

Barnes had not yet begun to install his Gallery, but Mullen's text evokes ensemble arrangement — perhaps an allusion to precursor assemblages at Lauraston and at the factory, although no interior photographs of these spaces are known. Barnes provided neither comprehensive wall-by-wall documentation of his rearrangements nor explanations for the specific juxtapositions of works, but archival and photographic records reflect the Gallery's dynamism.

From the moment the visitor steps across the shallow threshold of the Gallery foyer into the double-height Main Room, the ensembles, densely installed in

FIG. 13
Enclosure from Dr. Barnes,
Paul Guillaume
correspondence, 1927
Barnes Foundation Archives

FIG. 14
Ker-Feal, photograph
by Angelo Pinto, 1952
Barnes Foundation Archives

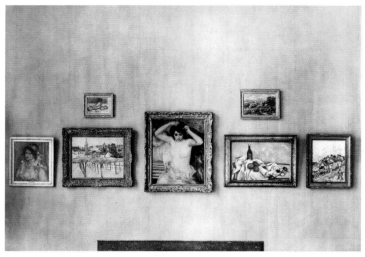

15

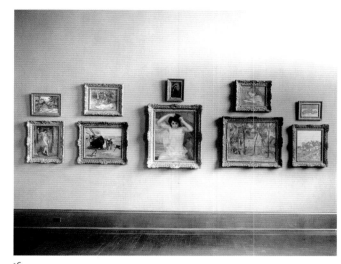

16

multiple tiers of metalwork and paintings, astound, provoke, and overwhelm. With this room—and all others—Barnes challenged expectations of chronology, style, and geography, as well as traditions of exhibition and interpretation. *Two Prophets* and *Two Apostles* by sixteenth-century Venetian painters Bonifazio Veronese and Tintoretto, respectively, flank *The Artist's Family* by the nineteenth-century French-man Renoir, creating a lineage of colorists. An iron barn hinge hovers above Matisse's painting of the fierce *Seated Riffian*, echoing the figure's neckline. Refined carved and gilded frames nestle against rough burlap. Minor genres such as still life sit above hierarchically nobler portraits, while genre scenes such as *Models* by Seurat assume the monumental proportions and Salon-style positions of history painting. The collector's cabinet, the English country home, and the French Salon seemingly provide visual precedents for the cheek-by-jowl installations at the Foundation. Yet Barnes confounded the associations with scholarly and grand-tour connoisseurship, accumulations and accretions of distinguished lineages, and hierarchies among the academic genres as well as the fine, decorative, and industrial arts, promoting instead the universally accessible formal relationships of light, line, color, and space.

From the moment the Gallery became available, Barnes excitedly installed his collection as he wrote proudly to Guillaume: "We started to move the paintings into the gallery yesterday and expect to start hanging them tomorrow. The gallery is perfectly wonderful and I am sure there will not be another

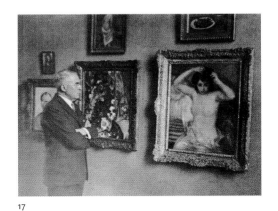

17

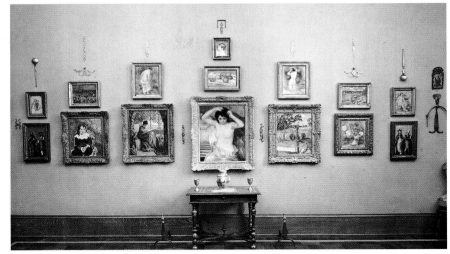

18

collection of paintings in the world that will be equal to ours when we have them ready to show."[73] Nearly a year later, Barnes again reported spending long hours in the Gallery—until ten or eleven o'clock at night—as he rearranged the paintings and fitted new frames.[74] As the central focus of an education program that emphasized direct visual experience, these ensembles changed to provoke new insights and conversations.[75] Documents in the Foundation's archives detail the instructions Barnes gave for adjustments to the ensembles, including a sketch that clearly refers to the symmetry governing these wall compositions (fig. 13). "New Rosseau [*sic*] balances other Rousseau, woman + church," advised Barnes, employing a verb that appears three times in another set of directions in pencil on S.S. *Olympic* stationery.[76] The same emphasis on symmetry is repeated in the installation of metalwork and ceramics at Barnes's Chester County country home, Ker-Feal, purchased in 1940 (fig. 14).

In Barnes's written instructions, mentions of the "Pascin drawing room," "Joie de vivre room," or the "Greek room" suggest the contents of the various galleries but do not identify the particular spaces, which have long since been known by numerical designations. Vague descriptors such as "fat Renoir nude" or "Cézanne landscape"—difficult to pinpoint among the Foundation's myriad pneumatic bathers and sun-drenched Provençal views—make it challenging to track the changing installations.[77] Four photographs spanning approximately twenty-five years provide rare documentation of a single work—*Before the Bath* by Renoir—in

FIG. 17
Dr. Barnes with Renoir's *Before the Bath (Avant le bain)*, photograph by Pierre Matisse, 1932

FIG. 18
Wall ensemble, photograph by Angelo Pinto, 1952
Barnes Foundation Archives

a variety of ensembles (figs. 15–18). Early on, Barnes decided to use the painting as an anchor for the walls it occupied—varied wall trims suggest its itinerary through the Gallery—while works by Cézanne, Daumier, Gauguin, and Claude Monet as well as old master paintings moved in and out of flanking positions.

Although Barnes bought paintings in the last two decades of his life, working primarily with Georges Keller, Étienne Bignou, Galerie Barbazanges, and occasionally Durand-Ruel, his collecting interests broadened to include examples of the industrial and decorative arts. He added these objects to his ensembles. The furniture and utilitarian items placed in corners—the backs of Windsor chairs, the arms of candlestands, the spouts and handles of coffeepots—provided gentle transitions across the walls, extending the formal connections beyond a single ensemble, as well as offering their own distinctive and rhyming forms. Placed beneath paintings by Renoir, ceramics by the painter's son, Jean Renoir, who later became an important filmmaker, attest to the continuity of artisanal and creative traditions (fig. 19). Barnes explained the inclusion of the metalwork, which he introduced into the Gallery in the late 1930s, in a letter to the American painter Stuart Davis: "First—the motives, such as arabesques, patterns, etc., discernible in a picture have their analogue, sometimes a very close one, in the iron work. Second—we regard the creators of antique wrought iron, just as authentic an artist as a Titian, Renoir, or Cézanne."[78]

In addition to the formal connections Barnes sought to make between his holdings, his instructions also suggest that ensembles may have been changed to bolster quality while he expanded and refined his collection through trades negotiated with dealers: "Remove Lebourg in Greek room + replace with good painting (Pascin or Modigliani)....Bring up quality of the two large *back rooms* on 2nd floor. Above changes make this possible."[79] The definition of quality may have evolved for the collector over time. Barnes prominently installed *Bather and Maid* by Renoir at the center of the north wall of Room 2 (p. 82), although he had denigrated the work in *The Art of Renoir* in 1935 before purchasing it the same year: "With all its exquisite passages of painting, its skillful placing of volumes in space, and its very effective pictorial organization, the painting is banal and academic; it lacks the spark of life and seems as if Renoir had painted a parody of… what the official Salon would pronounce excellence in art."[80]

Barnes may have favorably revised his opinion of the work after further study, in keeping with the philosophy expressed in "How to Judge a Painting." Or, departing from the association of "important" with traditional qualitative distinctions between "good" and "bad," he may have wished to demonstrate for instructional purposes both the successes and struggles in a painter's oeuvre. In his installations of African art, Barnes purposefully alternated "better" works with "lesser"

examples, their relative formal qualities elaborated in *Primitive Negro Sculpture*.[81] Certainly, the rhythmic balance of forms in Renoir's painting—qualities seized upon by critics[82]—may have appealed to the sense of harmony that he attempted to achieve in the ensembles, even if he remained unconvinced by the painting on its own. Indeed, decisions to "bring up the quality" may have applied as much to the wall as to the individual objects in his collection.

While Barnes spent nearly forty years trying "to see as the artist sees," his collections and the ensembles proved revelatory for artists, as Matisse noted: "One of the most striking things in America is the Barnes collection, which is exhibited in a spirit very beneficial for the formation of American artists. There the old master paintings are put beside the modern ones, a Douanier Rousseau next to a Primitive, and this bringing together helps students understand a lot of things the academies don't teach."[83] As the ensembles demonstrate, Barnes had developed his own particular vision, carefully selecting the holdings of the Foundation and composing their distinctive, handcrafted presentation.

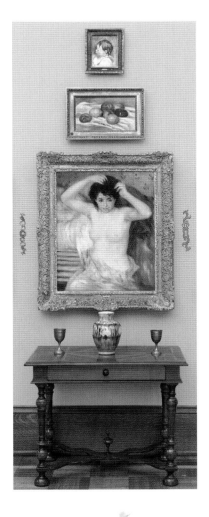

FIG. 19
Ensemble view, Room 7, west wall, detail

NOTES

I am extremely grateful to my colleagues Martha Lucy, associate curator; Katy Rawdon, archivist and librarian; Barbara Beaucar, assistant archivist; and Allison Jai O'Dell, assistant archivist and librarian, for illuminating conversations about Albert Barnes's collecting and display practices, as well as his aesthetic and educational theories. I am especially grateful for their insights into Barnes's complexity, humor, and humanity. Dr. Lucy and Ms. Rawdon provided important suggestions for this text, along with Derek Gillman, executive director and president of the Barnes Foundation. Ulrike Mills expertly and gently edited this essay, while Johanna Halford-MacLeod, publications manager, provided critical guidance for the tone and shape of the text.

This essay depends heavily on the work of Richard J. Wattenmaker, who has devotedly studied the evolution of the collections and the history of the Foundation. Yve-Alain Bois, Karen K. Butler, and Claudine Grammont have made important discoveries about the work of Henri Matisse that inform this catalogue. Martha Lucy and John House have made revelatory finds concerning Barnes's vast holdings by Pierre-Auguste Renoir. Colleagues eagerly provided insights into individual objects in the collection, and thanks are extended here to Richard Aste, David Barquist, Mark Castro, Laurence Kanter, Mitchell Merling, Fabrizio Moretti, Jon Seydl, Larry Silver, and Carl Strehlke.

1 Archival evidence in the form of canceled checks dating to 1904 suggests that Barnes purchased paintings before 1912, but the extent and depth of these holdings are not clear; see Wattenmaker 2010, 53 n. 33. His active and avid collecting career is typically said to have begun in 1912.

2 Leo Stein to Albert C. Barnes, 1916. Barnes Foundation Archives (BFA).

3 "John G. Johnson, Noted Lawyer, Dies," *New York Times*, April 15, 1917.

4 Barnes to William Glackens, January 19, 1912, London Collection, cited in Wattenmaker 2010, 18.

5 Wattenmaker 2010, 16.

6 Barnes 1915, 248; also discussed in Wattenmaker 2010, 66.

7 Barnes to Edgar A. Singer Jr., November 16, 1915. BFA; also discussed in Wattenmaker 2010, 65.

8 Barnes 1937, 7.

9 Barnes to Singer, November 16, 1915. BFA; also discussed in Wattenmaker 2010, 65.

10 Barnes to Glackens, January 30, 1912, London Collection, cited in Wattenmaker 2010, 18.

11 Ibid.

12 Ira Glackens, *William Glackens and the Ashcan Group* (New York, 1957), 157–159, cited in Wattenmaker 2010, 18.

13 Other works from the 1912 purchase made by Glackens that remain in the collection include *Mother and Child (Maternité)* (BF335) by Maurice Denis; *Along the Seine (Rouen)* (BF563) by Albert Lebourg; *Garden (Le Jardin au grand soleil)* (BF324) by Camille Pissarro; *Two Girls with Hats (Jeunes filles aux chapeaux)* (BF130), *View from Montmartre (Vue de Montmartre)* (BF144), *Girl Reading (Fille lisant)* (BF51), and *Woman's Head with Red Hat* (BF63) by Pierre-Auguste Renoir; and *Sèvres Bridge* (BF231) by Alfred Sisley.

14 Barnes to Durand-Ruel, New York, April 3, 1915. BFA.

15 Barnes to Paul Guillaume, February 20, 1923. BFA.

16 Guillaume 1923, 1. Translation by the author.

17 For more on Barnes's acquisition of American art, see Wattenmaker 2010.

18 Barnes 1915, 246.

19 Barnes to Alfred Maurer, July 12, 1912. BFA.

20 Maurer to Barnes, October 15, 1912. BFA.

21 Barnes to Nina Stein, August 1, 1947. BFA.

22 Barnes to Leo Stein, March 30, 1913. Yale Collection of American Literature, Beinecke Rare Book and Manuscript Library, Yale University, cited in Richard Wattenmaker, "Dr. Albert C. Barnes and the Barnes Foundation," in *Great French Paintings* 2008, 8. For an excellent essay that describes the interest Barnes and Stein shared in the works of Renoir, see Martha Lucy, "Late Renoir in the Collections of Albert C. Barnes and Leo Stein," in Einecke and Patry 2010, 110–121.

23 Barnes to Leo Stein, July 17, 1914. BFA; also discussed in Wattenmaker 2010, 23.

24 Ibid.

25 Ibid.

26 Barnes 1915, 248.

27 Albert C. Barnes, "An Epoch in Art," transcript of radio address, May 8, 1936. BFA.

28 Barnes 1915, 248.

29 Barnes 1916, 121–124; Barnes to Scofield Thayer, September 17, 1923. BFA. Wattenmaker has identified this work by Pablo Picasso as *Violin, Sheet Music, and Bottle*, 1914 (BF673). See Wattenmaker 2010, 250.

30 Barnes made direct purchases from other important dealers and galleries, including Barbazanges, Bernheim-Jeune, Étienne Bignou, Roger Levesque de Blives, Reid and Lefèvre, and Paul Rosenberg.

31 Barnes to Durand-Ruel, New York, May 18, 1915. BFA.

32 Joseph Durand-Ruel to Barnes, March 16, 1916. BFA.

33 Barnes to Durand-Ruel, New York, January 11, 1921. BFA.

34 Barnes to Durand-Ruel, Paris, February 7, 1913. BFA.

35 Barnes to Guillaume, February 27, 1923. BFA.

36 Guillaume to Barnes, December 23, 1925. BFA.

37 Albert C. Barnes, "The Temple," *Opportunity* (May 1924): 139, cited in Meyers 2004, 64.

38 Guillaume 1923, 2.

39 "Dr. Barnes Makes Soutine Hero of Paris Art World," *Public Ledger*, February 24, 1923. Albert C. Barnes, "Soutine," *Les Arts à Paris* 10 (November 1924): 6–8. Barnes also saw an opportunity for speculation with Soutine's work and urged his dealer to corner the market; see Barnes to Guillaume, January 16, 1923. BFA. Although Barnes sold a number of works from his initial purchase, he remained convinced of Soutine's talent and wrote the introduction for the pamphlet for a 1943 exhibition at the Bignou Gallery.

40 "Cubist and Futurist Work Compared with That of Lunatics by Scientists," *Public Ledger*, September 11, 1921; "Dr. Barnes Defends Modernists' Art," *Philadelphia Inquirer*, September 7, 1921. For more on this exhibition and the critical and public response, see Yount and Johns 1996.

41 "Dr. Barnes Exhibits His Art Treasures," *Public Ledger*, February 1, 1923; "African Work for Merion Museum Is Most Comprehensive in the World," *Public Ledger*, February 5, 1923.

42 For more on this area of Barnes's distinctive role as an early American collector of this material, see Christa Clarke, "African Art at the Barnes Foundation: The Triumph of l'Art Nègre," in Berzock and Clarke 2011, 81–103.

43 Barnes to Guillaume, March 28, 1924. BFA.

44 Barnes to Guillaume, November 27, 1922. BFA.

45 Barnes to Guillaume, September 12, 1922. BFA.

46 Barnes 1923, 65.

47 "Charter: The Barnes Foundation." Board of Trustees Minutes, December 4, 1922. BFA. Even as early as 1912, Barnes pondered the disposition of his nascent collection in a letter to his attorney John G. Johnson and suggested the possibility of a bequest of the collection to the city of Philadelphia. Barnes to John G. Johnson, June 22, 1912. BFA.

48 Barnes, "Plans for the Barnes Foundation," April 30, 1922. BFA.

49 In his *New Republic* article, Barnes indicates that there were nine employees. However, Mary Ann Meyers states that these numbers later grew to include up to twenty employees. See Barnes 1923, 65; Meyers 2004, 16.

50 Barnes 1923, 66.

51 Mary Mullen, "An Experiment in Adult Negro Education," *Opportunity: Journal of Negro Life* 4, no. 41 (May 1926): 161, cited in Wattenmaker 2010, 17.

52 Wattenmaker 2010, 14; for more on Barnes's engagement with African American culture and his support of African American causes, see Meyers 2004.

53 Notes on "Alice" in A. C. Barnes Factory Class, c. 1920s. BFA.

54 Barnes, "An Epoch in Art," 1936.

55 Barnes to John Dewey, July 19, 1929. John Dewey Papers, Special Collections Research Center, Morris Library, Southern Illinois University, Carbondale, cited in Meyers 2004, 42.

56 Barnes to Gilbert F. White, August 11, 1948. BFA.

57 "Charter" 1922.

58 Cret 1923, 8.

59 Ibid.

60 Ibid.

61 Barnes to Paul Cret, March 12, 1924. BFA, cited in Berzock and Clarke 2011, 90.

62 Forbes Watson, "The Barnes Foundation. Part I," *Arts* 3, no. 1 (January 1923): 9–22; Forbes Watson, "The Barnes Foundation. Part II," *Arts* 3, no. 2 (February 1923): 140–149.

63 "Merion to House Art of 'Radicals,'" *Evening Bulletin*, January 13, 1923; "America's $6,000,000 Shrine to All the Craziest 'Art,'" *Philadelphia Inquirer*, April 29, 1923, Magazine Section.

64 Barnes to Guillaume, January 15, 1923. BFA.

65 *Catalogue of an Exhibition* 1923, 3. In a March 21 letter to Guillaume, Barnes anticipated that "everyone connected with the exhibition will be denounced by the academicians and fossils as crazy."

66 Dorothy Grafly, "Old Portraits Are Praised, Modernists' Art Decried," *North American*, April 15, 1923; Francis J. Ziegler, "Many Paintings of Many Different Kinds," *Philadelphia Record*, April 15, 1923; "The Contrast," *Public Ledger*, April 28, 1923.

67 Barnes to *Public Ledger*, April 30, 1923. BFA.

68 Invitation to dedication ceremony, 1925. BFA.

69 Mullen 1923, 8, 16; also discussed in Meyers 2004, 90.

70 Barnes 1925, 26–27; also discussed in Meyers 2004, 91, 92, and Wattenmaker 2010, 36–39.

71 See Berzock and Clarke 2011 on *Primitive Negro Sculpture*. Other publications released in Barnes's lifetime include *The French Primitives and Their Forms from Their Origin to the End of the Fifteenth Century* (1931); *Art and Education* (1929); *Journal of the Barnes Foundation* (1925–1926).

72 Mullen 1923, 11–12; also discussed in Meyers 2004, 90.

73 Barnes to Guillaume, November 25, 1924. BFA.

74 Barnes to Guillaume, September 16, 1925. BFA.

75 Wattenmaker 2010, 37.

76 Directions for arrangement of collection on S.S. *Olympic* stationery, undated. BFA.

77 "Arrangement for Main wall in room 14," January 31, 1927. BFA.

78 Barnes to Stuart Davis, April 1, 1942. BFA.

79 Directions for arrangement of collection on S.S. *Olympic* stationery, undated. BFA.

80 Barnes and De Mazia 1935, 424. See also Christopher Riopelle, "Bather and Maid (La Toilette)," in *Great French Paintings* 2008, 80; Martha Lucy, "Bather and Maid (La Toilette de la baigneuse)," in Lucy and House 2012.

81 Christa Clarke, "African Art at the Barnes Foundation: The Triumph of l'Art Nègre," in Berzock and Clarke 2011, 90.

82 Wright 1915, 125; cited in Lucy and House 2012.

83 Henri Matisse, "Statement to Tériade: On Travel," in Flam 1995, 92.

SELECTED
ENSEMBLES AND
MASTERWORKS

For Albert Barnes, all art — whatever its time or place of origin — was connected by a shared vocabulary of forms. His astonishing wall arrangements, known as "ensembles," express formal relationships in tightly symmetrical groupings that include surprising juxtapositions of objects from different cultures and historical periods, sometimes with strikingly incongruous subjects. Though Barnes published a general philosophy of art and education, he did not leave a written explanation of his wall compositions. The insights contained in this book are those of its authors and of Foundation instructor John Gatti, and they echo some shared by Richard Wattenmaker in *Great French Paintings from the Barnes Foundation*. Readers and visitors will likely find other formal connections between the works in each ensemble.

Taking a cue from the unconventional approach to display at the Barnes Foundation, this section offers a sampling of walls and works, rather than the standard arrangement of content by artist, medium, nationality, or period. Twenty-one ensembles, a fraction of the total number of walls at the Barnes, are presented in numbered room sequence and examined according to the formal principles espoused by Barnes. However, there is no prescribed itinerary through the collection — any room is a good place to start. Each ensemble discussion is followed by reproductions of selected individual works from the featured wall (and sometimes of other important works elsewhere in the same room). A notice for each work considers the context and culture of its creation.

Dimensions are given in inches followed by centimeters. Height precedes width.

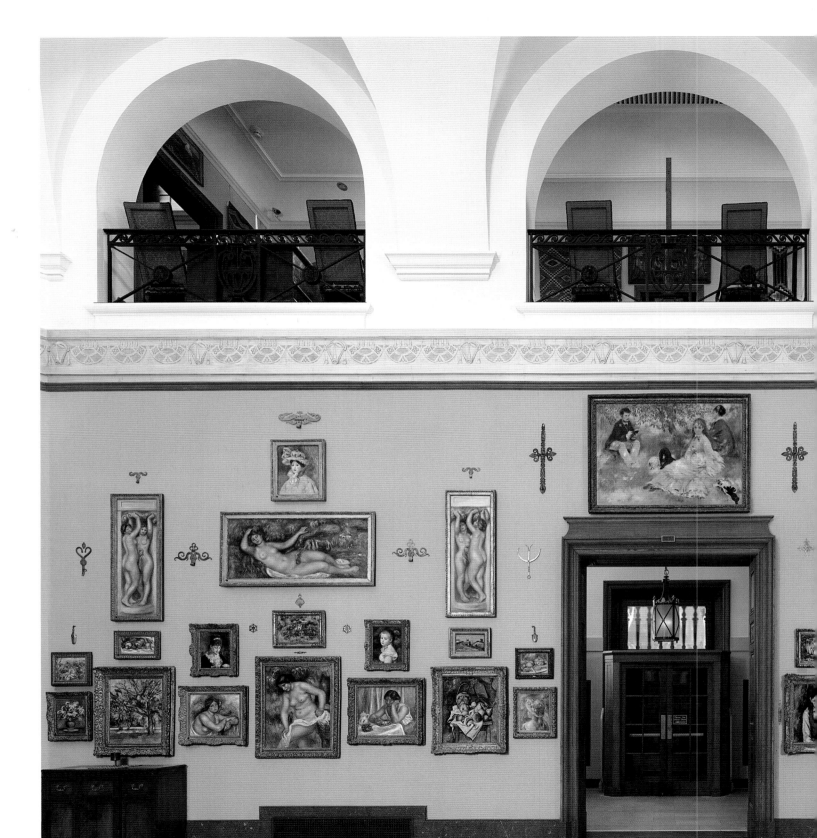

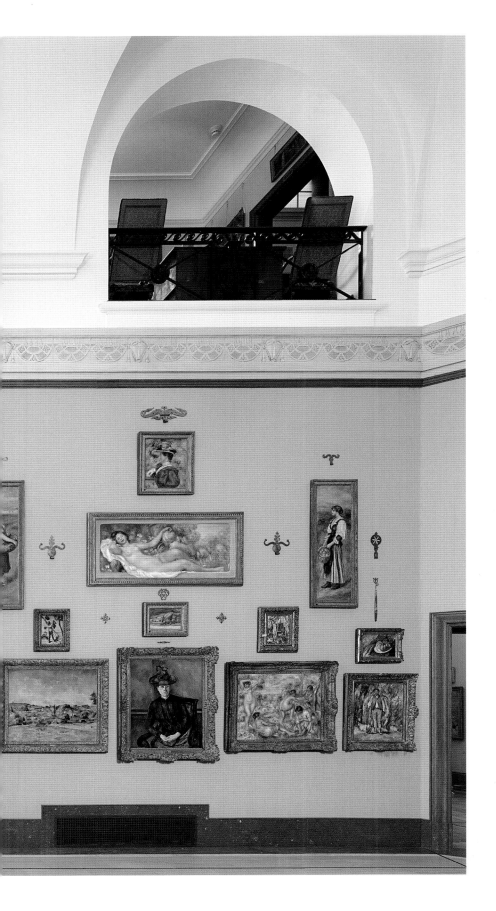

MAIN ROOM
NORTH WALL

This wall is devoted to two of the core artists in the collection: Paul Cézanne and Pierre-Auguste Renoir. Barnes regarded both painters as central to developments in modern art, and juxtapositions here and throughout the galleries seem designed to reveal both the differences and the similarities in their artistic approaches. In the bottom row on the right, for example, Renoir's *Bathing Group* balances Cézanne's *The Bellevue Plain*. While one landscape is empty and the other filled with nude bodies, both artists are equally concerned with surface; moreover, their palettes are nearly identical. Between them is Cézanne's portrait of his wife, whose cool rigidity stands in marked contrast to her counterpart on the left side of the wall—a sensual Renoir bather.

More sensual Renoir nudes hang above, including two horizontal panels of reclining figures. These are set between pairs of caryatids and clothed peasant girls. Carefully interspersed among the paintings are ordinary metal objects—hinges, keyhole escutcheons, and hooks—whose forms are in dialogue with the paintings. The curling design of the hinges at left relates to the sinuous lines of the caryatids; calipers near the door seem to mimic the raised arms of these same figures. In placing metalworks and paintings together on the same wall, Barnes does much more than reveal formal affinities. He essentially levels the traditional hierarchies between fine art and industrial art. ML

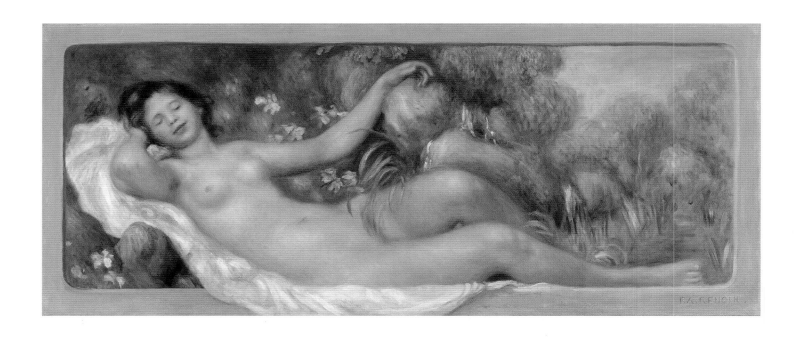

Pierre-Auguste Renoir
Reclining Nude (La Source), c. 1895
PAGE 42

Pierre-Auguste Renoir
Bathing Group (Les Baigneuses), 1916
PAGE 42

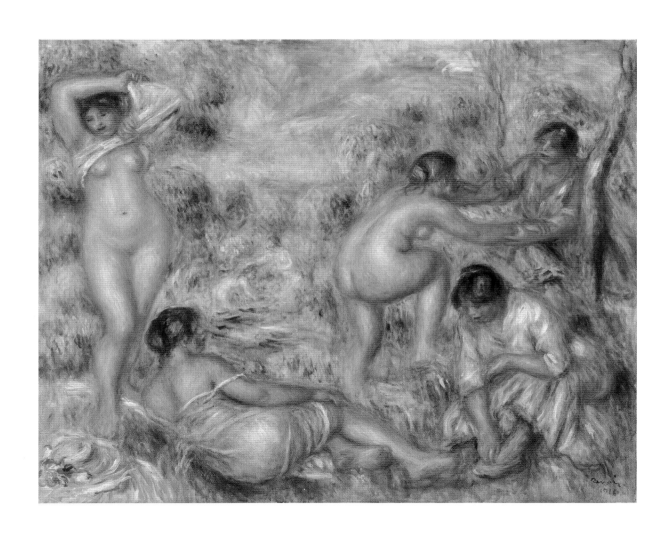

Pierre-Auguste Renoir
Caryatids, c. 1910
PAGE 43

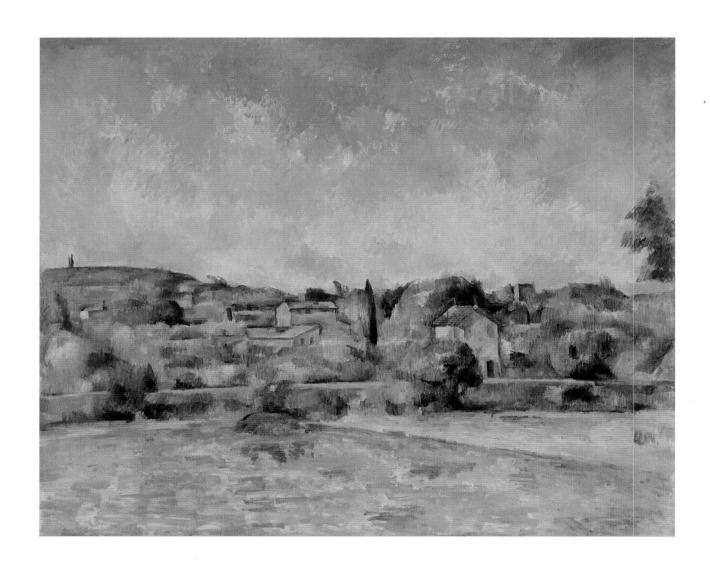

Paul Cézanne
The Bellevue Plain, also
called *The Red Earth* (*La Plaine
de Bellevue*, dit aussi *Les
Terres rouges*), 1890–1892
PAGE 43

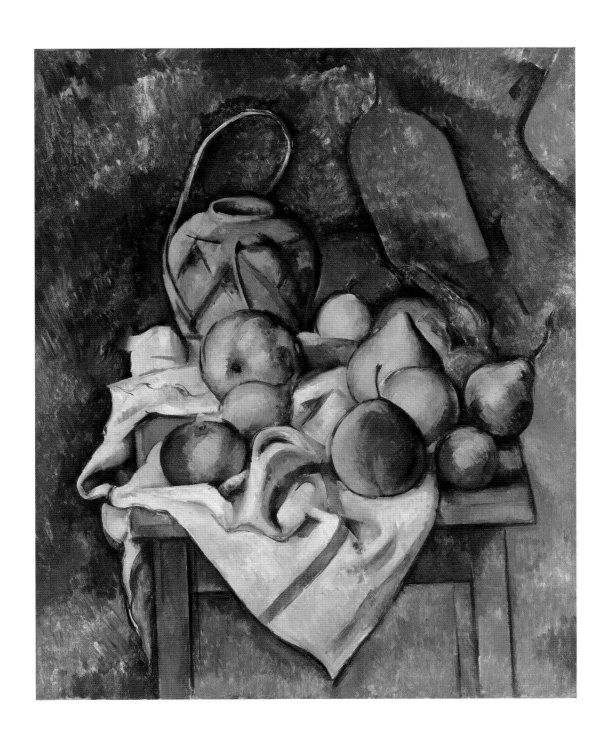

Paul Cézanne
Ginger Jar (Pot de gingembre), c. 1895
PAGE 44

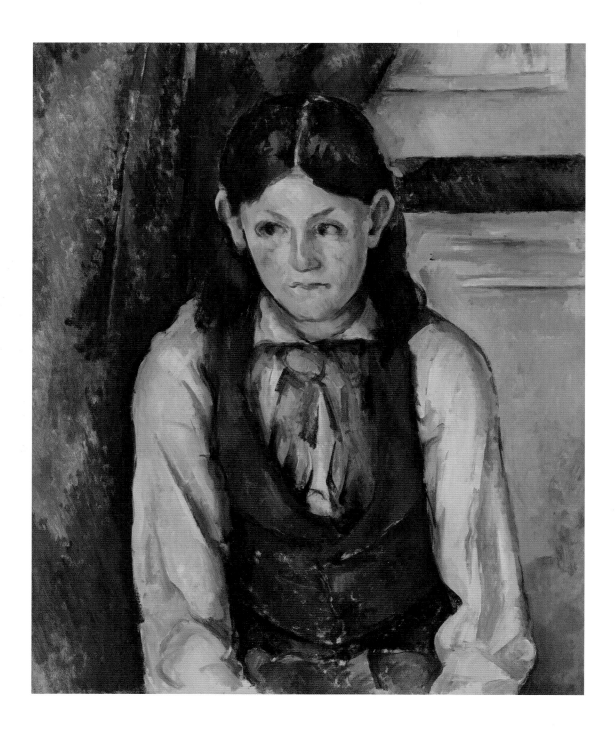

Paul Cézanne
*Boy in a Red Vest (Le Garçon
au gilet rouge),* 1888–1890
PAGE 44

Pierre-Auguste Renoir
*Henriot Family (La Famille
Henriot),* c. 1875
PAGE 45

Pierre-Auguste Renoir (French, 1841–1919)
Reclining Nude (La Source), c. 1895
Oil on canvas. 25 ³/₄ x 61 ³/₈ (65.4 x 155.9). BF903

A woman's smooth, porcelain-like body, cradled by silky fabric, stretches across the canvas. Her eyes are closed in reverie and her cheeks are flushed, while foliage brushes against her groin. This is a highly sensual picture, a fantasy of the female body as ceaselessly available; it is also a dream of woman in perfect harmony with nature. The figure melds into the landscape, her head sinking back into the grass, her forms rhyming with the surrounding elements. She is in and of the landscape.

Pierre-Auguste Renoir produced several of these reclining figures in wide, horizontal formats, beginning in the 1890s. This, the first, was done as a commission for the home of his patron Paul Gallimard, where it was probably meant to hang over a door. The work's placement in a particular architectural setting is perhaps the reason Renoir chose to enclose his scene with a trompe l'oeil stone frame, with white fabric hanging playfully over its edge; he even "carved" his signature into the stone at bottom right.

The painted stone surround for the figure also hints at Renoir's abiding interest in creating the effects of sculpture on canvas. Many of his important figure paintings correspond, in both theme and composition, to specific bas-relief sculptures made by Renoir and by earlier artists. Indeed, *La Source* seems to derive directly from a carving of a reclining nymph on the sixteenth-century fontaine des Innocents in Paris. In *La Source*, the body gently projects, as if about to spill out of the picture—like a figure carved in relief. ML

Pierre-Auguste Renoir (French, 1841–1919)
Bathing Group (Les Baigneuses), 1916
Oil on canvas. 28 ³/₄ x 36 ¹/₄ (73 x 92.1). BF709

Pierre-Auguste Renoir painted *Bathing Group* three years before his death, when he was living in Cagnes-sur-Mer, far from the city of Paris. The canvas presents a timeless, almost abstract universe inhabited by healthy, robust bodies; the signs of modern life, with its speeding trains and bustling cafés, are nowhere to be seen. When asked in a 1924 letter to name his favorite work by Renoir, Albert Barnes landed firmly on this painting. "My large canvas, 'Les Baigneuses'... represents the summation of [Renoir's] powers," he wrote. Unlike other collectors of the time, who generally favored Renoir's impressionist pictures, Barnes considered the artist's later work the pinnacle of his career.

What Barnes and other critics admired about Renoir's late production was the premium placed on design. A work such as *Bathing Group* was sensual but not lacking in control: compositionally, all parts added up to a unified whole. A tree trunk at right balances the standing nude at left, and bright foliage forms a perfect frame for each of the bodies, echoing the contours and setting off the opalescent tones of the flesh. Renoir considered himself the artistic heir to eighteenth-century painters such as François Boucher and Jean-Honoré Fragonard, which is evident in the bright palette and in the light sensuality of the subject. The velvety flesh, so abundantly available here from every angle, recalls the work of Venetian painters such as

Giorgione and Titian. For Barnes, who argued passionately that modernism be understood as a continuation of past traditions rather than as a complete break from them, works such as *Bathing Group* were enormously significant. ML

Pierre-Auguste Renoir (French, 1841–1919)
Caryatids, c. 1910

Oil on canvas. 51 ³⁄₈ x 17 ⁷⁄₈ (130.5 x 45.4); 51 ³⁄₈ x 17 ³⁄₄ (130.5 x 45.1). BF918 and BF919

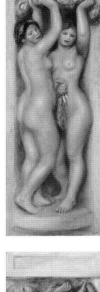

Caryatids are sculpted figures that serve as structural supports in classical Greek architecture, and here Pierre-Auguste Renoir translates them into paint. Each canvas presents a pair of nudes standing side by side in a stone niche, the long serpentine curves of their bodies stretching from the top to the bottom of the cramped space. Although the panels look as though they may have been intended for some specific architectural placement, none has been identified. They were among the hundreds of canvases found in Renoir's studio at Cagnes-sur-Mer at his death, and photographs show them there hanging high on the wall. Another very similar and now divided pair, one in a collection in France and the other in Japan, may have been commissioned by Renoir's patron Paul Gallimard.

Renoir's choice of caryatids as a subject reflects the profound influence of the classical tradition on his oeuvre. It also points to his concern with achieving the effects of sculpture on canvas. In his late bathing scenes, he increasingly presented nudes that appear volumetric and palpable, as if defying the flatness of the canvas support. This loss of distinction between painting and sculpture is taken even further in *Caryatids*, where bodies are painted as if they actually *are* pieces of sculpture standing in architectural niches. As in the artist's other late works, a sense of volume is achieved here through subtle shifts in color. The way the figures are positioned also reinforces the illusion of roundness: in each pair the two women, near-perfect mirrors of one another, seem to collapse into a single body of which the viewer sees both front and back. ML

Paul Cézanne (French, 1839–1906)
The Bellevue Plain, also called *The Red Earth (La Plaine de Bellevue*, dit aussi *Les Terres rouges)*, 1890–1892

Oil on canvas. 31 ⁷⁄₈ x 39 ³⁄₈ (81 x 100). BF909

Between 1885 and 1895 Paul Cézanne painted a number of works at Bellevue, an estate southwest of Aix-en-Provence owned by his younger sister Rose Conil. While the large property afforded the artist views of the distinctive, soaring profile of Mont Sainte-Victoire (p. 86), he also embraced the vastness of the surrounding landscape, painting panoramas of the area's broad plain and modest habitations. In this work, Cézanne gave primacy to the richly colored earth and the active, infinite sky, locating the squat, angular buildings of ocher stone, topped with terracotta tiles, at a remove in the middle ground. He established spatial recession with a bright orange wedge that darts into the composition, terminating in a mound at the low stone wall that runs laterally across the canvas and arcs with the gentle roll of the terrain. While the wall and buildings hint at a human presence in the landscape, they are nearly swallowed by the dense, brushy foliage Cézanne rendered in short vertical strokes in a range of greens and smoky blues, creating a mosaic of warm and cool hues. His even paint handling for the village conveys its stillness, yet he animated his blue, green, and purple sky by varying the direction of his brushwork. Covering passages of his canvas with thin layers of paint, Cézanne cleverly exploited his primed support and allowed it to stand for the changing cloud formations. JFD

Paul Cézanne (French, 1839–1906)
Ginger Jar (Pot de gingembre), c. 1895
Oil on canvas. 28 7/8 x 23 3/4 (73.3 x 60.3). BF23

During the 1890s Paul Cézanne produced some of the most stunning still lifes of his career, focusing on a fairly select group of household items placed in varying arrangements. Several of his favorites are seen here: the wooden table, the napkin with the red stripe, and the blue ginger jar are familiar from other canvases. Whereas traditional still-life painting often carries metaphorical meanings—a rotting piece of fruit, for example, could serve as a reminder of life's transience—Cézanne concentrated on his objects as physical things in the world, exploring their individual structures and their relationships to surrounding space and to other objects. Often these relationships are deliberately ambiguous.

Ginger Jar, like many of Cézanne's works, is built around subtle contradictions that undermine the possibility of a stable viewpoint. The table is presented from two different perspectives at once, from straight on and also from above. While the table tilts to the left, a pear at right leans improbably in the opposite direction, teetering at the edge. This small moment of tension is echoed in the background, where a left-tilting breadboard hanging on the wall is countered by the straw handle of the ginger jar. The still-life objects are solid, consisting of massive pears and apples,

and a napkin is rendered with the weight and drama of drapery from a baroque painting. The space containing these objects, however, is murky and illegible, creating yet another perceptual ambiguity. ML

Paul Cézanne (French, 1839–1906)
Boy in a Red Vest (Le Garçon au gilet rouge), 1888–1890
Oil on canvas. 25 3/4 x 21 1/2 (65.4 x 54.6). BF20

Paul Cézanne painted this portrait in his Paris apartment on the Île Saint-Louis. The sitter is an Italian boy named Michelangelo di Rosa, a professional model who also posed for two other oil paintings and a watercolor, wearing the same red vest, white shirt, and blue cravat. In the other depictions the model is turned at an angle and set further back so that the viewer sees more of his body. Here, however, the boy is confronted head on. As the curtain pushes him forward in space, the viewer meets an awkward face bearing oversized ears and a pinched mouth. The aggressively oval shape of the face is announced by an insistent blue line along the left side and echoed in the elliptical opening of the vest. With slouching shoulders and a sidelong glance, the boy shows an expression of melancholy, even timidity.

The canvas is a study in psychology but also in color: the peach skin is really a prism of many hues, with green touches at the mouth, eyebrows, and along the right side.

A heavy blue line curving around the corner of the left eye adds to the intensity of the sitter's stare. The sleeves are beautifully painted, composed of long, luscious strokes; toward the bottom, bare canvas peeks through. In several areas paint seems to take on a life of its own—for example, in the way the blue from the background overlaps the boy's head, and peach paint belonging to the face does the same, dragged upward from the temple into the hair. ML

of blues, lavenders, and yellows. Round patches of light fall on Edmond's shoulder and legs, on the blue dress of the woman in the background, and, most jarringly, on Henriot's forehead, where the fleck is built of especially thick paint. The paint application is alternately thick and thin, shifting suddenly from impasto areas in the dress to extremely thin passages in the grass and around Henriot's feet, which are mere touches of black. Yet despite these moments of experimentation, Renoir did not forget the composition: the figures are arranged in a balanced triangle, and black paint strikes three even notes across the canvas, moving from ribbon to dog to jacket. ML

Pierre-Auguste Renoir (French, 1841–1919)
Henriot Family (La Famille Henriot), c. 1875
Oil on canvas. 45 ½ x 64 ⅝ (115.6 x 164.1). BF949

Unlike other impressionist paintings depicting figures outdoors, where they are often mere suggestions in the distance, this canvas by Pierre-Auguste Renoir brings the viewer up close to its subjects. The figure in front is the red-haired Henriette Henriot, an actress who modeled frequently for Renoir during the 1870s. Attired in a fashionable white dress, she sits looking out at the viewer. The man behind her is almost certainly Renoir's brother Edmond, a writer, who posed in other pictures with Henriot. He gazes up at her and pens something in his notebook. Based on the picture's title, the third figure might be Henriot's mother, the only other family member of the young actress.

Renoir was probably working out of doors here. The painting is a masterful study of natural light—of the way it filters through the trees to cast patchy blue shadows on the grass and turns Henriot's white dress into a prism

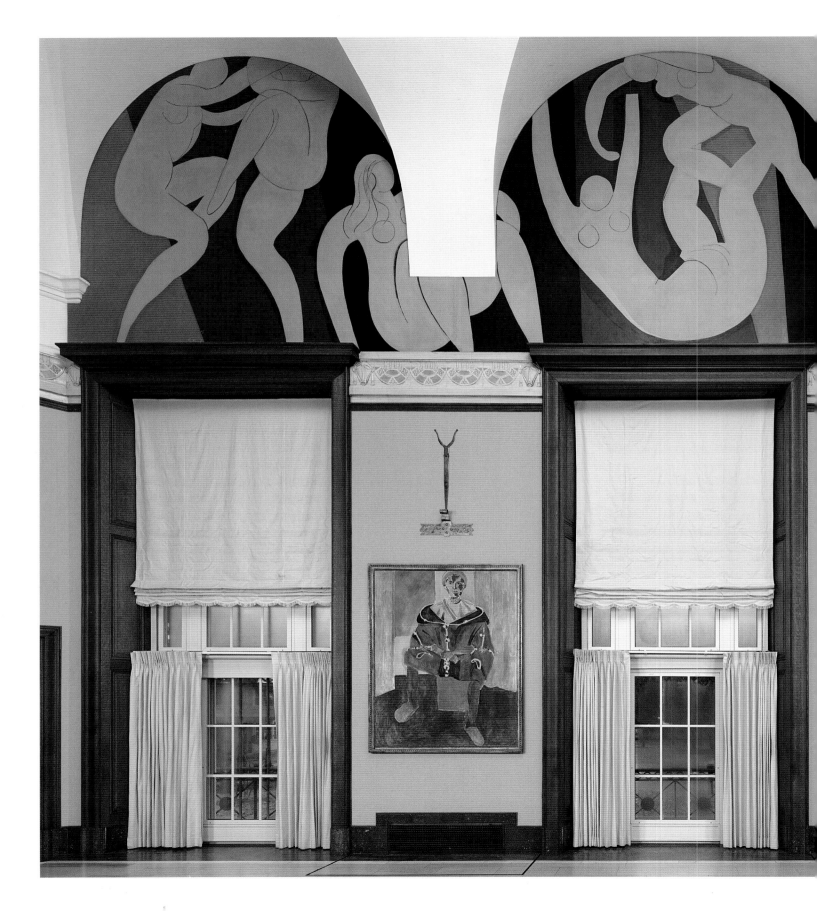

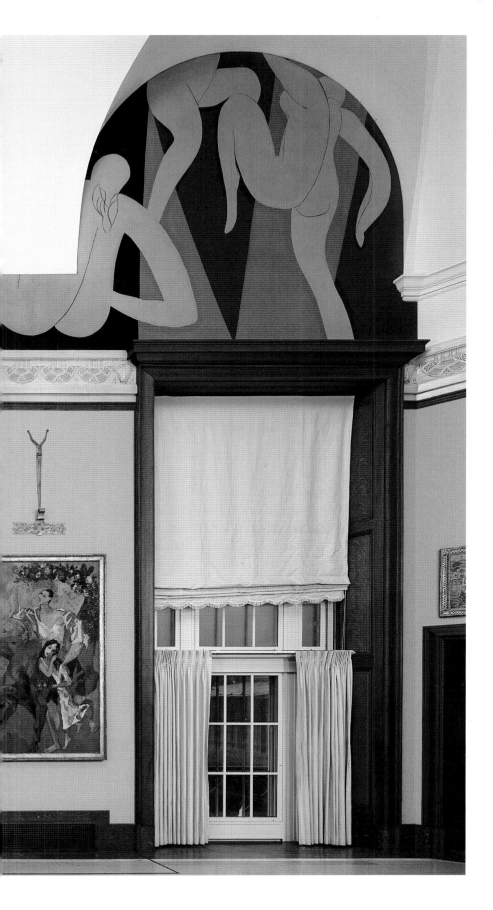

MAIN ROOM
SOUTH WALL

While Albert Barnes sought formal relationships between the objects on each wall as he constructed his ensembles in individual rooms, here the selection may also reflect the soaring architecture of Paul Cret's design for the double-height Main Gallery and its complementary relationships of curved and rectilinear forms. The vertical orientation of the monumental *Seated Riffian* by Henri Matisse and *Composition: The Peasants* by Pablo Picasso echoes the fenestration of the room. Matisse and Picasso explored color and structure, respectively, in their canvases, mirroring the formal concerns of Pierre-Auguste Renoir and Paul Cézanne, two of their most revered predecessors, whose works occupy the facing wall. The hinges that hover over each of these paintings—a combination of horizontal German door hinges and Y-shaped American barn-door hinges—draw the eye upward to the pendentives between the arches containing the canvases of Matisse's *The Dance*. Matisse's panels also marry round and angular forms—the ample curves of the dancers complement the flat shards of pink, blue, and black. While paired figures energetically leap and dive in the arches, two recumbent figures link the panels below the pendentives and lead the eye across *The Dance*'s dynamic expanse. JFD

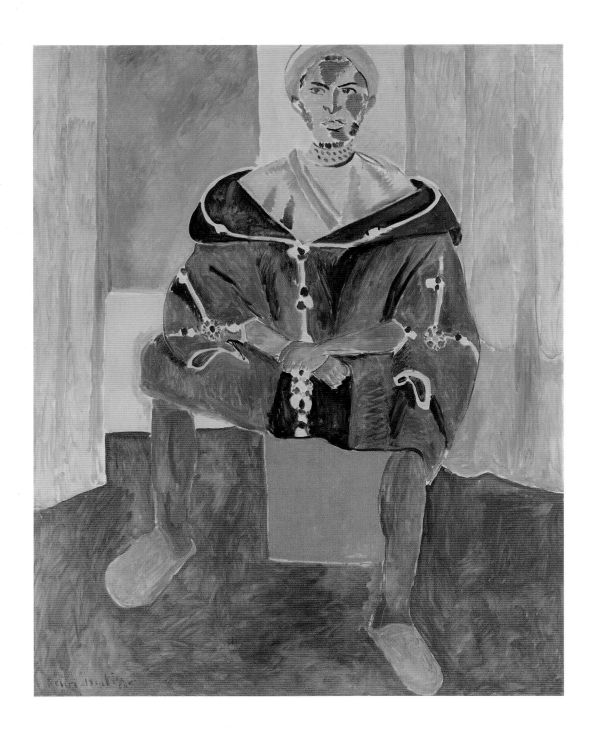

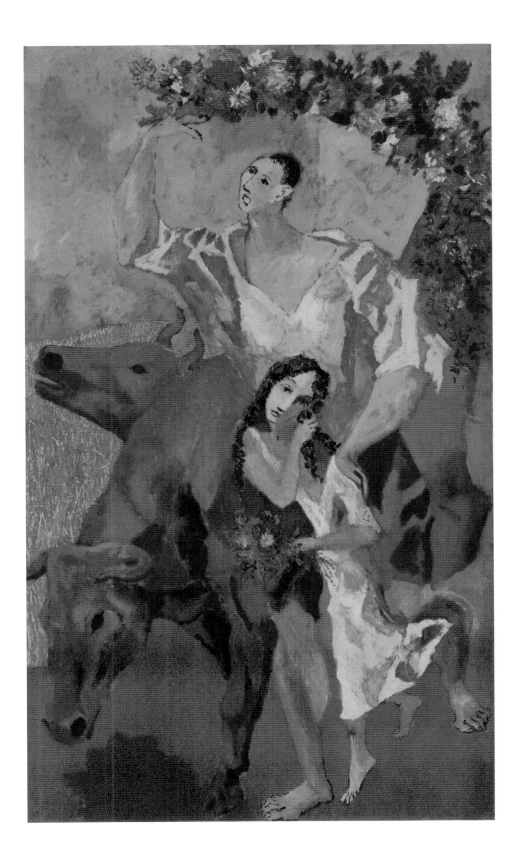

Henri Matisse
*Seated Riffian
(Le Rifain assis)*,
between November
and December 1912
PAGE 54

Pablo Picasso
*Composition:
The Peasants*, 1906
PAGE 55

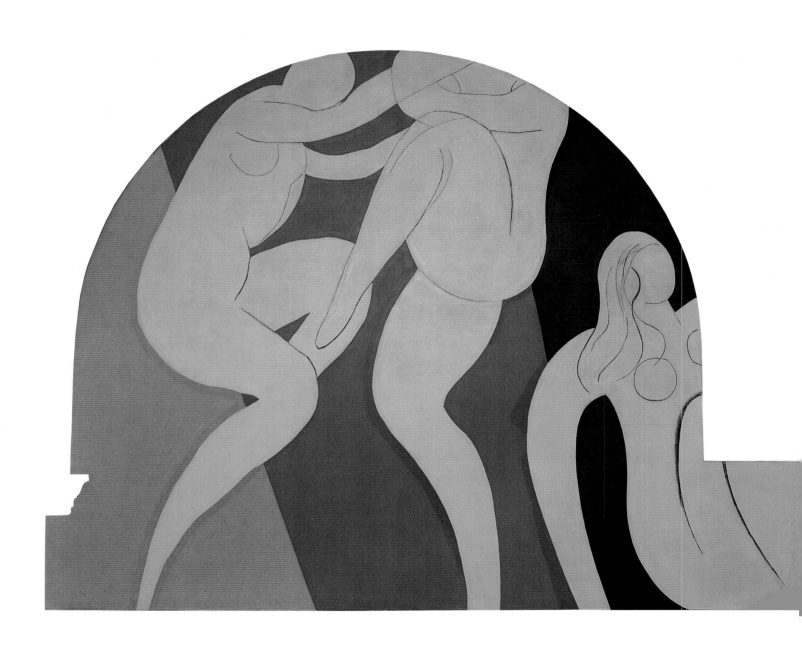

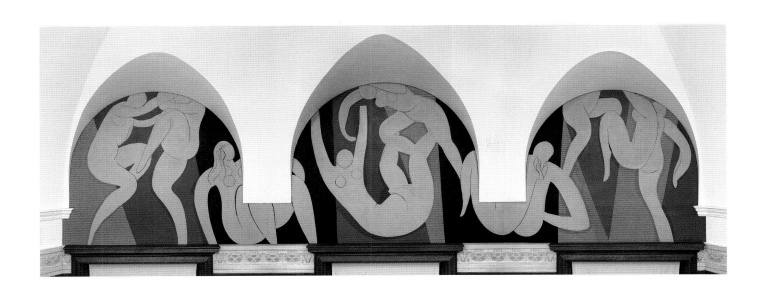

Henri Matisse
The Dance, 1932–1933
PAGE 56

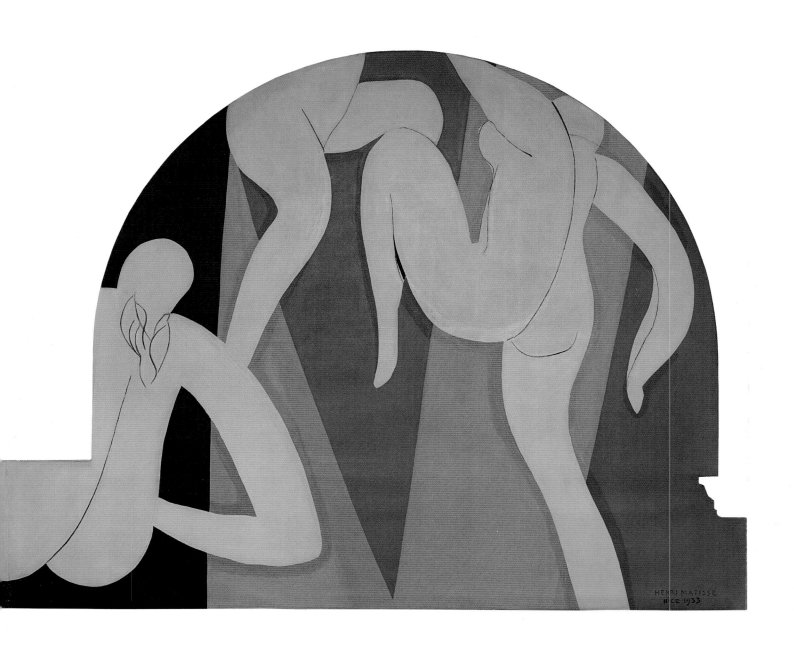

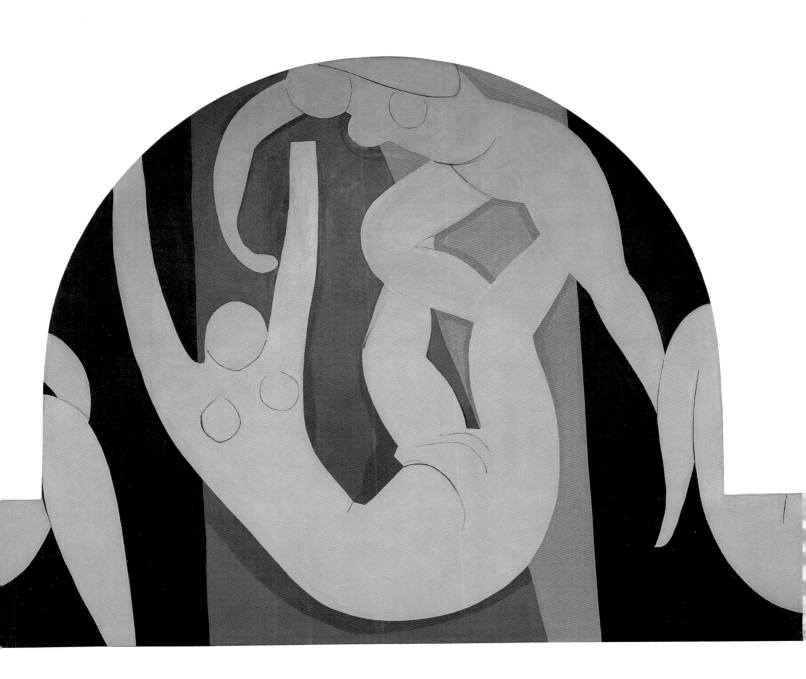

Henri Matisse (French, 1869–1954)
Seated Riffian (Le Rifain assis), between November and December 1912
Oil on canvas. 78 7/8 x 63 1/4 (200.3 x 160.7). BF264

In 1912, Henri Matisse traveled to Morocco twice for extended sojourns that permitted a direct encounter with a region that had long intrigued him. He not only knew well the respective artistic and literary legacies of Eugène Delacroix and Pierre Loti but he had also traveled to Biskra in Algeria in 1906 and visited an important exhibition of Islamic art in Munich in 1910.[1] Subsequent trips to the Moorish monuments at Cordoba in Spain and to Russia, where he encountered Byzantine icons, prompted him to match the direction of his decorative aesthetic — vibrating pattern, saturated color, spatial ambiguity — with a new emphasis on direct observation of his subjects.[2]

While Matisse painted the landscape during his first visit to Tangier, he focused on a series of single figures during his second stay. Described as "a magnificent mountaineer, savage as a jackal" by the painter in a letter to his family,[3] the young man depicted here came from Er Rif, a mountainous region in northern Morocco whose tribesmen had earned a fearsome reputation for banditry, kidnapping, and resistance to colonization.[4] The painter devoted a number of drawings to the Riffian and painted another half-length portrait of this sitter (The State Hermitage Museum, St. Petersburg).

Cropping the Riffian's *rezza*-covered head at the top and slipper-clad foot at the bottom of the massive canvas, Matisse underscored his commanding presence. The young man assumes a virile, but unselfconscious, pose as he sits on the edge of a spartan box, his thin legs widely planted. With his left foot at the edge of the picture plane, he seems ready to spring forward with the feral quickness to which Matisse alluded in his letter. The lowered hood of the Riffian's ample green djellaba falls over his broad shoulders, further lending the figure a powerful monumentality. His face

an uneven patchwork of greens, yellows, and oranges — and just a hint of pink for his full, mustache-fringed lips — the Riffian looks out of the canvas with a glower. He occupies an indeterminate space of colored planes, which suggests a doorway or window filled with blue sky framed by patterned textiles.[5] While Matisse deployed a daring modernist idiom in the depiction of his sitter — saturated, non-naturalistic hues laid on in visible and vigorous brushstrokes — he endowed his subject with an exoticism and inscrutability that echoed long-standing Orientalist practices.[6]

Despite his critique of colonialist policies and aggression, the socialist politician and journalist Marcel Sembat revealed deeply ingrained cultural attitudes as he remarked on the sitter's fierce demeanor: "And the Riffian! Isn't he fine, this great devil of a Riffian with his angular face and ferocious bearing! …Can you look at this splendid barbarian without dreaming of the warriors of yesteryear? The Moors of the *Chanson de Roland* had this wild look."[7] Albert Barnes purchased this painting in 1925 and seemingly moved it around with some frequency, until he installed it on the south wall of the Main Gallery. Although Matisse suggested that the *Seated Riffian* might detract from *The Dance* (p. 50) in its placement there, Barnes refused to find another location for it. JFD

1 John Elderfield, "Matisse in Morocco: An Interpretive Guide," in Cowart et al. 1990, 202.
2 Ibid., 207–208.
3 Letter from Henri Matisse to Marguerite Matisse, November 21, 1912, Archives Matisse, Paris, cited in Pierre Schneider, "The Moroccan Hinge," in Cowart et al. 1990, 42.
4 Elderfield in Cowart et al. 1990, 94. See also Benjamin 2003, 175–179.
5 Claudine Grammont, "Seated Riffian," in *Matisse in the Barnes Foundation* forthcoming.
6 Benjamin 2003, 160.
7 Marcel Sembat, "Henri Matisse," *Cahiers d'Aujourd'hui* 4 (April 1913): 194, translated and cited in Benjamin 2003, 179.

Pablo Picasso (Spanish, 1881–1973)
Composition: The Peasants, 1906
Oil on canvas. 87 x 51 ¾ (221 x 131.4). BF140

After a two-year stint in Paris marked not only by tremendous creativity and productivity but also by poverty, Pablo Picasso returned to his native Spain in the spring of 1906, flush from the recent sale of several works to the dealer Ambroise Vollard. Traveling with his new muse and companion, Fernande Olivier, Picasso stopped first in Barcelona to celebrate his success with friends and family. After a couple of weeks in the Catalan capital, Picasso and Olivier decamped to Gósol, a remote village in the Pyrenees accessed only after a train journey and a treacherous eight-hour mule ride over narrow mountain passes.[1]

While most of Picasso's creative efforts from this Pyrenean sojourn echo the serene classicizing idiom he explored in *Girl with a Goat* (p. 321), the artist dramatically changed direction toward the end of his stay with the conception of *Composition: The Peasants*, which reveals a summary of his previous pictorial explorations—as well as a hint of developments to come. In this monumental work, the painter called on themes and forms of his previous Blue and Rose Periods and invoked the vibrating dynamism and exaggerated proportions of his revered predecessor El Greco. While in Barcelona, Picasso had received the first published catalogue of the Spanish master's work from its author, his friend Miguel Utrillo. Evoking the composition of El Greco's *Saint Joseph with the Christ Child*, circa 1600 (Museo de Santa Cruz, Toledo), included in that volume, Picasso paired a towering flower seller with a fragile waif who leads him as he peddles his colorful bounty.[2] Often described as blind, the flower seller, despite his hulking musculature, recalls the marginalized and suffering figures of Picasso's earlier Blue Period works as well as the itinerant commedia dell'arte performers of the Rose Period (pp. 181, 265, 284). Though physically mismatched, both figures retain the stylized, masklike visages of the Iberian-inspired classicism evident in works from Picasso's Gósol summer.

While Picasso conceived this project in Spain, he completed the painting in Paris after an outbreak of typhoid in his inn prompted his flight from the village. The beasts recall the herding tradition of Gósol, yet they also serve as a clever screening device, filling the foreground. Rendered nearly indistinguishable from one another in the reduced palette of browns, reds, and pinks, the unlikely companions lurch along the sloping red terrain. For his treatment of the play of light over the costumes of the figures and the musculature of the oxen, Picasso painted irregularly shaped, flatly applied patches in these earthy hues, as well as white, blue, and gray. These jostling passages anticipated the dangerously angular forms that characterize the forbidding space of *Les Demoiselles d'Avignon*, 1907 (The Museum of Modern Art, New York; see p. 313), and the facets of analytical cubism, likewise painted in a limited, monochromatic palette. JFD

1 Richardson 2007, vol. 1, *The Prodigy, 1881–1906*, 433–436.
2 Alfred H. Barr Jr., *Picasso: Fifty Years of His Art* (The Museum of Modern Art, New York, 1946), 46, cited in Tinterow and Stein 2010, 104.

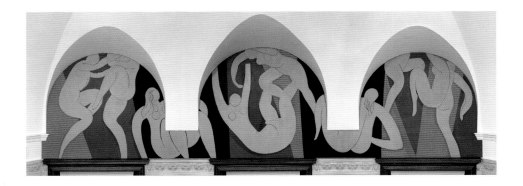

Henri Matisse (French, 1869–1954)
The Dance, 1932–1933

Oil on canvas. Left 133 ³/₄ x 173 ³/₄ (339.7 x 441.3);
center 140 ¹/₈ x 198 ¹/₈ (355.9 x 503.2); right 133 ³/₈ x 173
(338.8 x 439.4). 2001.25.50

En route to the Carnegie International juried exhibition in Pittsburgh in September 1930, Henri Matisse cabled Albert Barnes from New York and asked to come to the Foundation, which held twenty-five of his works, including *Le Bonheur de vivre*, *Red Madras Headdress*, *The Music Lesson*, and *Seated Riffian* (pp. 272, 247, 279, 48). During Matisse's short visit, Barnes offered him a commission to paint a decoration for the three lunettes in the Main Gallery. Agreeing to the ambitious project—the largest endeavor of his career to date—Matisse traveled again to the United States in December to further examine the challenging space with its deep, shadowed recesses. Provided by Barnes with paper templates of the lunettes for scale, Matisse returned to Nice and rented a garage, the only space large enough to work on the monumental decoration.

Almost immediately, the artist had decided on the subject of the dance, a theme he had treated in the background of *Le Bonheur de vivre* and in *Dance II*, a 1909–1910 commission for the Russian collector Sergey Shchukin (State Hermitage Museum, St. Petersburg). While his original design followed the dynamic rounds of dancers in these earlier works and is preserved in unfinished, full-scale canvases now at the Musée d'art moderne de la Ville de Paris,

Matisse ultimately reduced the spatial depth of the composition and arranged the figures in a frieze. He used painted paper cutouts pinned to the surface of his canvas to make changes, which he found otherwise challenging on such a large scale. After he abandoned his first conception, Matisse fastened his colored papers to these canvases to advance a second version on new supports. The method ultimately permitted him to apply paint more uniformly—an effect aided by the skills of a housepainter he hired for the project. Working with a palette of blue, pink, black, and gray, Matisse carefully calibrated the color scheme to the architecture. Making allusion to the sky, blue wedges were to top the trees visible through the windows. Although rendered in a cool gray, the abstracted forms of the dancers depart from the lithe profiles of their counterparts in *Le Bonheur de vivre* and *Dance II*, echoing instead the ample proportions of the fleshy bathers by Pierre-Auguste Renoir and Paul Cézanne in the collection.

In February 1932, more than a year into the project, Matisse realized that he had miscalculated the width of the pendentives and began a third set of canvases. The new dimensions required adjustment to the composition to unify each panel across the broad intervening architectural elements. Matisse responded with a pair of recumbent figures—viewed from front and back—that span the pendentives, linking the three panels. With their curved backs and fluid limbs, the figures at the

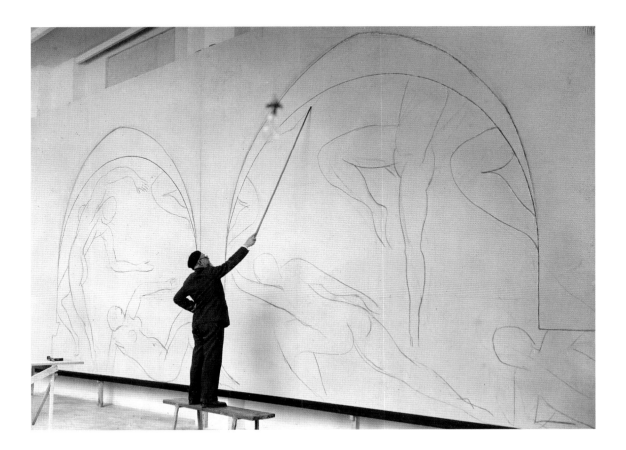

far left, far right, and top center echo the rounded contours of the panels. The dancers' vertical leaps complement tumbling central figures, which endow the panel with a whirling energy. In all three panels, the figures extend beyond the edges of the canvas, further contributing to its expansive monumentality.

When Matisse finished the third and final version of *The Dance* in 1933, he accompanied his finished canvases across the Atlantic, supervising their installation. Although the three-year project proved arduous for the painter — and perhaps equally challenging for his impatient patron — the artist contentedly reflected on its completion: "It has a splendor that one can't imagine unless one sees it — because both the whole ceiling and its arched vaults come alive through radiation and the main effect continues right down to the floor.... I am profoundly tired but very pleased."[1] The transformative project also proved critical to the development of Matisse's working method as he continued to explore paper cutouts in independent works. He returned to the second iteration of his decoration, completing that work in 1933.[2] JFD

1 Henri Matisse to Simon Bussy, May 17, 1933, cited in Flam 1993, 62.
2 For more extensive discussions of *The Dance* that inform this entry, see Flam 1993 and Karen K. Butler, "The Dance," in *Matisse in the Barnes Foundation* forthcoming.

Matisse in his studio in Nice, drawing *The Dance* with a piece of charcoal attached to a long bamboo stick, 1931

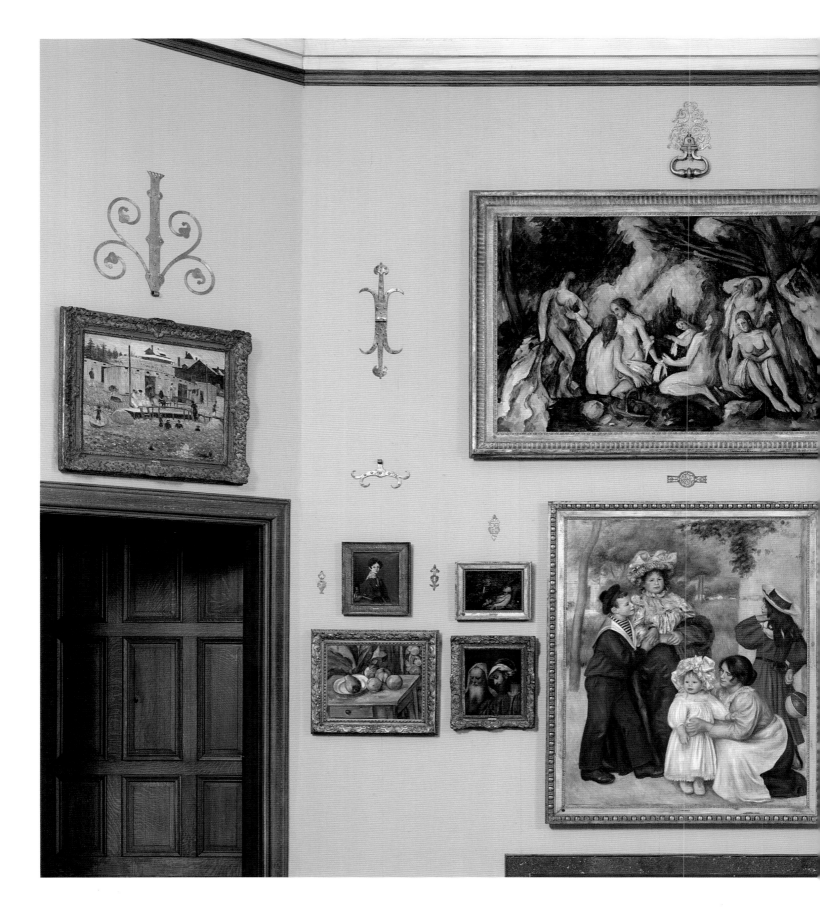

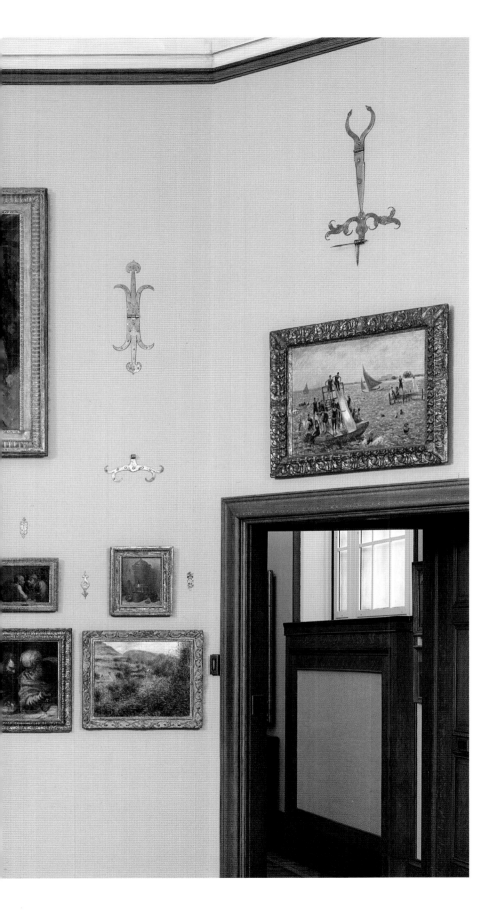

MAIN ROOM
EAST WALL

The two monumental canvases juxtaposed here offer one of the most striking contrasts in the collection. At bottom is Pierre-Auguste Renoir's *The Artist's Family*, showing a group of cheerful, rosy-cheeked figures arranged with a reassuringly stable geometry. Above it hangs Paul Cézanne's *The Large Bathers*, a challenging painting with distorted, disconnected figures in a space that is difficult to read. These are two of the major artists of the nineteenth and twentieth centuries, with two very different idioms, and their influence on later generations reverberates throughout the galleries (works by William Glackens, a great admirer of Renoir, are above the doors). In presenting Renoir and Cézanne together here, Albert Barnes affirms the artists' central place in the collection.

Both artists drew heavily on past traditions, and the ensemble highlights those influences by flanking the large canvas by Renoir with two sixteenth-century Venetian paintings. Tintoretto's *Two Apostles* hangs on the right, and on the left is a canvas attributed to Bonifazio Veronese; both display figures swathed in deep red tones that repeat those in the painting by Renoir. A landscape by Renoir placed at far right seems to correspond to the still life by Cézanne across the wall, perhaps as another point of contrast. While one dissolves solid form behind a veil of light, the other displays objects with a firm materiality.

A theme of couplets connects the Venetian paintings to the two smaller works by Honoré Daumier above. In all four, figures are presented up close, allowing comparison of the way artists from different traditions use color, light, and gesture to convey expressivity. Metal objects activate the spaces between the paintings and often relate to pictorial forms. Large door hinges are placed at either side of the central painting by Cézanne, for example, and in their deliberate vertical orientation they seem to echo the standing bathers at the picture's edges. ML

French
Door Knocker and Plate,
18th century
PAGE 66

Pierre-Auguste Renoir
The Artist's Family (La Famille de l'artiste), 1896
PAGE 66

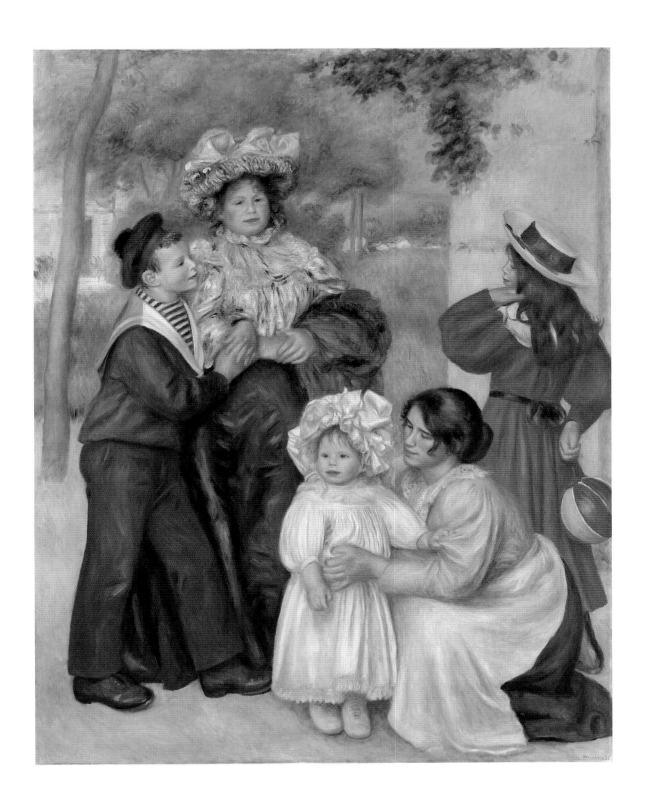

Paul Cézanne
The Large Bathers (Les Grandes baigneuses), 1895–1906
PAGE 66

William James Glackens
The Bathing Hour,
Chester, Nova Scotia, 1910
PAGE 67

Door Knocker, 18th century
France
Iron. 11 x 8 ⁷/₈ x 2 ³/₈ (27.9 x 22.5 x 6). 01.01.45a

Door Knocker Plate, 18th century
France
Iron. 11 ³/₄ x 10 x ¹/₂ (29.8 x 25.4 x 1.3). 01.01.45b

This monumental door knocker and plate combine a robustly sonorous heft with an airy and elegant tracery. JFD

Pierre-Auguste Renoir (French, 1841–1919)
The Artist's Family (La Famille de l'artiste), 1896
Oil on canvas. 68 x 54 (172.7 x 137.2). BF819

In the largest portrait of his career, Pierre-Auguste Renoir presents his family standing in the courtyard across from the Château de Brouillards in Montmartre, where they lived for several years. At the center is Renoir's wife, Aline, with their eleven-year-old son Pierre leaning affectionately against her. Two-year-old Jean, wearing a beautifully painted bonnet, toddles in the foreground, attended by the beloved nursemaid Gabrielle Renard; the third son, Claude, was not born until 1901. The girl opposite Pierre is probably a neighbor. In depicting full-length figures of near life-size, all of whom have a certain monumentality and weight, Renoir draws on the traditions of seventeenth-century portraiture.

The warmth among the group is palpable, as figures exchange fond glances and make nonchalant physical contact. Everyone is clearly dressed for a portrait, with clothing that signals the family's newly acquired bourgeois status: Madame Renoir wears a bright green hat that rivals the baby's bonnet in its elaborateness, and Pierre sports a sailor suit customarily worn by children of the well-to-do. Yet despite these notes of status and formality, there is also a casualness to the group, as Pierre leans slightly off-balance and Gabrielle crouches down. Subtle narrative elements place the portrait in the realm of genre painting. With Madame Renoir standing, coat in hand, the family appears poised for a stroll; meanwhile, the girl gazes at Pierre, self-consciously touching her hair and hiding a ball behind her back, perhaps in an attempt to appear more grown-up.

The Artist's Family is a prime example of Renoir's concern for compositional balance.

Heads are arranged in a near-perfect circle—a shape that is repeated several times, in the hats and the ball. Black and dark blue accents are distributed at even intervals throughout the group's clothing. Even the gazes, especially that between Pierre and the girl, function as part of Renoir's highly designed geometry, as its path locks the two sides of the circle together. By creating such a tightly composed picture, Renoir surely intended to emphasize the stability of the family unit. ML

Paul Cézanne (French, 1839–1906)
The Large Bathers (Les Grandes baigneuses), 1895–1906
Oil on canvas. 52 ¹/₈ x 86 ¹/₄ (132.4 x 219.1). BF934

In the last decade of his life, Paul Cézanne produced three enormous multifigure bathing scenes that are often regarded as the culminating works of his career. Of these, the largest and most resolved is at the Philadelphia Museum of Art; another is at the National Gallery, London. The present canvas, which Albert Barnes acquired in 1933, is in many ways the most ambitious of the trio. Probably begun around 1895, *The Large Bathers* is an intensely physical painting that seems to have consumed Cézanne for roughly ten years; a photograph taken in 1904 shows the picture in a still unfinished state. But even without this documentary evidence, the canvas bears the marks of a long, labored working process, with a surface so impossibly thick with paint that it rises up in clumps in some areas and forms sculptural ridges in others.

The subject is perfectly conventional: a group of nudes relaxes in a landscape, with trees arching overhead and still-life elements

in the foreground, tropes borrowed from a long tradition of pastoral imagery. There is nothing conventional, however, about the way this scene is painted. While Cézanne's contemporaries often presented bathers in harmony with the landscape, here nature seems menacing, and the landscape's relationship to its human inhabitants is difficult to understand. Clouds are heavy, with an almost oppressive weight, and the blue sky peeking through them is rendered with paint so thick that it literally projects. One tree leans into the center, its sharp branches cutting aggressively across the sky in three parallel spokes. One wonders why, in this scene that presumably takes place in summer, these branches are bare; patches of green in the background suggest foliage, but the foreground trees around which the bathers gather are emphatically, eerily, dead.

The figures themselves are at once beautiful and unsightly. They are elegantly arranged, in postures borrowed from classical sculpture and baroque painting. An unusual ridge of thick blue paint surrounding each of the figures lends the group an air of slowness, or serenity, even as it suggests artistic struggle. Colors are often breathtaking, as in the reds that spread across cheeks and hair, and in the pale blues and lavenders that suggest shadows. At the same time, Cézanne undermines nineteenth-century standards of beauty: skin is composed of patches that shift suddenly from one color to the next, and gender is difficult to read. Is the bather leaning against the tree a man or a woman? Paint pulled down between that figure's legs seems to want to obliterate sex. Anatomies are distorted, sometimes to disturbing effect—feet, hands, and fingertips often do not exist. The face of the figure leaning against the tree registers as a blank, with features buried beneath a blanket of brushstrokes. Even more jarring is the walking figure at left, whose towel cascades theatrically into the foreground but whose head is a mere knob of flesh. The 1904 photograph reveals that this figure did at one time have a fully resolved face and head, but Cézanne painted it out, in just one of this picture's many radical moments. ML

William James Glackens (American, 1870–1938)
The Bathing Hour, Chester, Nova Scotia, 1910
Oil on canvas. 26 x 32 (66 x 81.3). BF149

In this scene painted in Nova Scotia, William Glackens captures the pleasures of summertime leisure. As one figure floats across the water on his back, bright white paint describing the spray from his foot, four women cool off in the center; a boy teeters in a boat while another runs along the dock, perhaps readying himself for a dive. Fashionably dressed women chat by the waterfront while a nursemaid accompanies a small child into the bathhouse. Wet bathing clothes hang from a laundry line stretching across the middle ground. The inclusion of such mundane details helped Glackens build a convincingly realistic scene.

Glackens was keenly interested in European modernism, convinced of its importance for the advancement of American painting. Here one can readily see the influence of artists such as Claude Monet and Pierre-Auguste Renoir, whose bathing scenes at La Grenouillère were certainly known to Glackens. The water is composed of lively purple and blue strokes, with dabs of white creating the illusion of sunlight sparkling on the crests of tiny waves. Colors are audaciously high-keyed, with electric-green grass setting off a shock of orange paint in the bathhouse. Glackens's broken brushwork evokes a feeling of spontaneously observed realism, yet at the same time the picture is carefully composed. The arc of the dock's railing mimics the curve of the bathhouse roof, which is mirrored by the sweep of the laundry line.

The Bathing Hour was exhibited at the famous Armory Show in New York in 1913; Barnes purchased it directly from Glackens, his good friend, the following year. ML

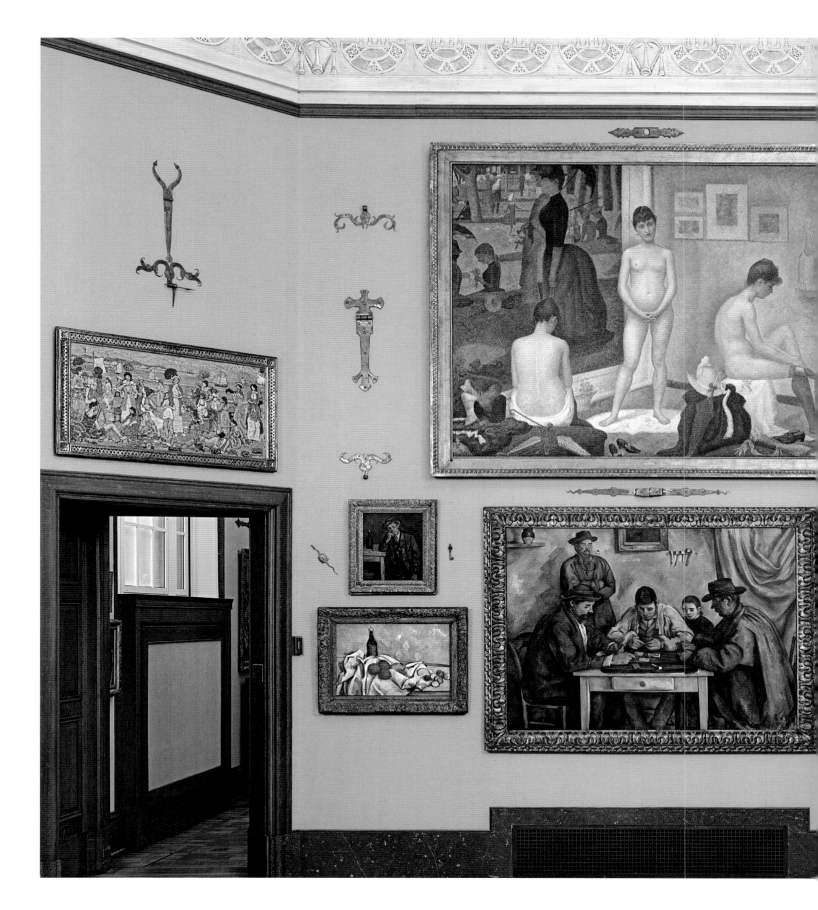

MAIN ROOM
WEST WALL

Models by Georges Seurat and *The Card Players* by Paul Cézanne offer monumental genre scenes with disparate subjects — the work of models in the artist's studio and the pastime of peasants. However, these canvases echo each other in the rhythmic arrangement of their figures. The woman wearing a bustle in *A Sunday on La Grande Jatte — 1884*, the painting within Seurat's painting, occupies a transitional position, much like the standing peasant in *The Card Players*. The hat to the right of center in *Models* corresponds to the little girl who watches the game. The friezelike arrangement of figures across these large canvases recurs in Maurice Prendergast's *The Beach No. "3"* and in the row of pointed trees in Henri Rousseau's *View of the Quai at Asnières*, both above the doorways.

The triangle formed by the stance of the central model is mirrored by the V of the central card player's legs and the zigzagged elbow-to-elbow placement of the peasants' arms. The sleek nude bodies of the women contrast with the sturdy frames and roomy attire of the card players, just as the precisely placed touches of Seurat's pointillist technique complement the broad paint handling in Cézanne's work.

Through the installation of smaller flanking paintings by Cézanne and Jean-Baptiste-Camille Corot, as well as metalwork, Barnes created an ensemble of balanced form and palette. The descent from left to right of the still-life props, at left, matches the angled incline of the figure in *Leda and the Swan*, at right. A snaky keyhole escutcheon and a pastry cutter reinforce these diagonals. Metal keys mimic the row of pipes in *The Card Players* and draw the eye to two small portraits by Cézanne and Corot, whose muted smoky browns and grays match the tonality of the framed painting at the center of *The Card Players*. JFD

Paul Cézanne
The Card Players (Les Joueurs de cartes), 1890–1892
PAGE 77

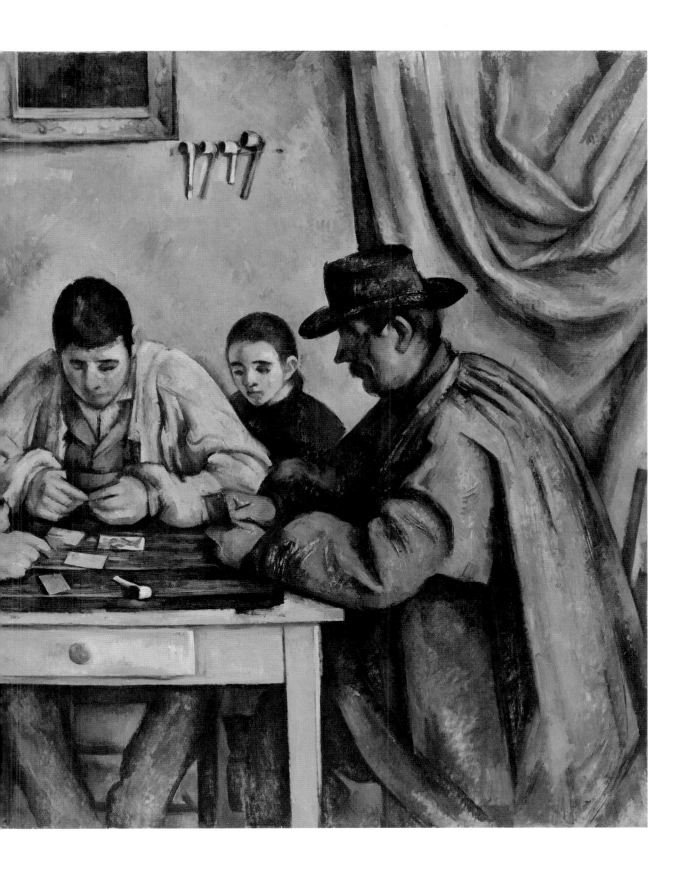

Georges Seurat
Models (Poseuses), 1886–1888
PAGE 78

Paul Cézanne
*Leda and the Swan (Léda
au cygne)*, c. 1880–1883
PAGE 79

Paul Cézanne (French, 1839–1906)
The Card Players (Les Joueurs de cartes),
1890–1892
Oil on canvas. 53 ¼ x 71 ⅝ (135.3 x 181.9). BF564

In one of the most ambitious paintings of his career, Paul Cézanne presents three men seated around a humble wooden table playing cards while a standing man and a little girl look on. The scene was probably painted at the Jas de Bouffan, the family estate in Aix-en-Provence where Cézanne lived for much of the 1890s. Dressed in simple work clothes, the figures are gardeners and farmhands who were employed on the estate; the standing man, identified as Père Alexandre, appears in the same position in *Peasant Standing with Arms Crossed* (p. 85). While the painting's subject is modest, its scale is monumental: it measures almost six feet across, and the seated men have an imposing, even heroic, presence.

In presenting this slice-of-life moment, Cézanne draws on the traditions of genre painting from both Holland and France—especially animated tavern scenes, usually with a strong anecdotal element, showing card players, gamblers, or bawdy drinkers. Yet Cézanne's picture could scarcely be more different from such earlier depictions. This is hardly a rowdy tavern scene, but rather a quiet moment, almost frozen, without beginning or end. Facial expressions are blank, movements muted. While one might expect a measure of sociability and exchange among a group playing a game, there is no interaction; instead, each member of the trio looks down, each an isolated tower

of concentration. The action is contained strictly in the six hands perched on the game board, as the figure on the left seems to be playing a card, while across from him a fist subtly constricts, betraying a hint of tension.

The extraordinary sense of stillness in this picture is reinforced by its careful compositional balance. The front-facing figure sits at the exact center of the canvas, flanked by opponents who create perfect symmetry; this is underlined by their corresponding hats and postures. The symmetry reads vertically, too, as the central figure's triangular upper body mirrors the V-shape of his legs beneath the table. Even the objects on the game board conform to an orderly arrangement. Such spatial clarity is somewhat unusual for Cézanne, whose canvases often reveal deliberately conflicting points of view. Yet on close observation some moments of ambiguity do surface: the area under the table is difficult to read; the standing man seems out of scale; and while the table seems depicted straight on, considering its legs and drawer, it is also shown from above, as its surface tilts slightly toward the viewer.

The theme of card players was clearly important for Cézanne. During the 1890s he made an entire series devoted to the subject, of which this painting is the largest. In these canvases Cézanne experimented with smaller and larger groupings of figures, arranging them in different positions and swapping in a variety of props. Although there is some debate as to the position of this canvas within the sequence, it was likely painted last, given especially its monumental size. ML

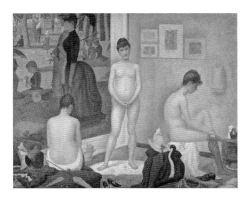

Georges Seurat (French, 1859–1891)
Models (Poseuses), 1886–1888
Oil on canvas. 78 ¾ x 98 ⅜ (200 x 249.9). BF811

When Georges Seurat debuted *Models* at the Salon des Indépendants in 1888, he delivered a bold riposte to his critics, asserting that pointillism, his daring neo-impressionist painting technique, could be applied to one of the noblest and most revered subjects in the history of art: the nude. Two years earlier, at the eighth and final impressionist exhibition, he had presented *A Sunday on La Grande Jatte — 1884*, 1884–1886 (fig. 1), a scene of middle-class leisure that served as a monumental declaration of his aesthetic principles. Informed by scientific theories of light, color, and optics, Seurat methodically juxtaposed individual touches of pure color on his canvas. According to the artist, these hues mixed with greater vibrancy in the eye of the beholder. However, some commentators suggested that this intricate lattice of brush-strokes was best suited to the representation of the landscape and atmospheric effects. Seurat's prominent citation of *La Grande Jatte* in this canvas explicitly announced the connection between the debate of 1886 and his latest

"battle canvas" (*toile de lutte*), as he referred to his most provocative manifesto works.[1]

Accepting the challenge, Seurat simultaneously embraced and subverted art-historical tradition with *Models*. Although scaled to the dimensions of the great machines of history painting — mythological, historical, and religious subjects that occupied the pinnacle of the hierarchy of the genres — this work offers a commonplace of the annual Salon: a genre scene of models disrobing, posing, and dressing in a corner of the artist's studio. While the narrative of *Models* remains elusive, these women are perhaps "auditioning" in the hopes of securing modeling work, a quick succession of commercial exchanges at odds with the elevating narratives of history painting.[2] But the conceit of this parade of models permitted Seurat to demonstrate his own virtuosity with three views of the nude — from the front, side, and back — and the suitability of his technique to the subject. Seurat simultaneously and wittily positioned his models against *La Grande Jatte* at left on the studio wall, permitting a comparison of nude and clothed, interior and exterior, and demonstrating the process and artifice of picture-making.[3]

While subverting the hierarchy of the genres, Seurat included a wealth of references to classical, Renaissance, and nineteenth-century academic and avant-garde sources that would have been readily recognized by critics and sophisticated viewers. The three

FIG. 1 **Georges Seurat**
A Sunday on La Grande Jatte — 1884, 1884–1886
Oil on canvas, The Art Institute of Chicago, Helen Birch Bartlett Memorial Collection

women collectively invoke the Three Graces of antiquity — as well as Raphael's depiction of the subject — but their physical separation from one another, their modern bodies, and their quiet introspection challenged traditional representations that depict three voluptuous figures linked in a graceful dance. Such an ironic borrowing evoked the example of Édouard Manet's *Luncheon on the Grass (Le Déjeuner sur l'herbe)*, 1863 (Musée d'Orsay, Paris). While the figure at right recalls the antique Spinario, the model with her back to the viewer invites comparison to *Bathing Woman*, 1806, by Jean-Auguste-Dominique Ingres, an 1879 addition to the Musée du Louvre (fig. 2). With their fashionable clothes and accessories heaped at their feet, the models in their recognizable poses link past and present.[4]

Critics praised the work, admiring its "superior, smiling serenity."[5] For the iconoclast Albert Barnes, the painting's simultaneous adoption and rejection of tradition must have been immensely appealing. He purchased the work in 1926, as he was acquiring the most ambitious paintings for the towering Main Gallery, which served as an audacious introduction to his aesthetic principles. JFD

FIG. 2 **Jean-Auguste-Dominique Ingres**
Bathing Woman (Baigneuse de Valpinçon), 1806
Oil on canvas, Musée du Louvre, Paris

1 Georges Seurat to Maurice Beaubourg, 1890, quoted in Herbert et al. 1991, 273, 381; Françoise Cachin, "Models (Poseuses)," in *Great French Paintings* 2008, 174.
2 Thomson 1985, 146.
3 Cachin in *Great French Paintings* 2008, 177.
4 Ibid., 174; Herbert et al. 1991, 273–277.
5 Félix Fenéon in *L'Art moderne*, April 15, 1888, cited in *Great French Paintings* 2008, 177.

Paul Cézanne (French, 1839–1906)
Leda and the Swan (Léda au cygne), c. 1880–1883
Oil on canvas. 23 ½ x 29 ½ (59.7 x 74.9). BF36

This picture is unusual in Paul Cézanne's oeuvre for its specific literary narrative. It represents the mythological story from Ovid's *Metamorphoses* in which Zeus disguises himself as a swan to seduce Leda, the daughter of King Thestius. Cézanne captures the moment before consummation as the swan's beak wraps around Leda's wrist as if taking possession of her.

Cézanne produced many paintings of the female nude, and this is one of the most overtly sensual. As Leda displays herself for the viewer, the swelling curve of her hip, a form so central to the painting's erotic charge, reverberates throughout the canvas — in her extended arm, the swan's neck and wing, the drapery, and even the waves of her hair. Her cheeks are emphatically flushed. The navel marks the center of the canvas.

Yet if the painting adheres to conventional nineteenth-century vocabularies of the erotic, it also refutes them. The skin, for example, is not smooth and palpable but aggressively patchy, built from thick parallel strokes of green, orange, and lavender. Indeed, Cézanne applied these unblended parallel marks throughout the canvas, in all areas except the background — a technique he developed during the 1880s. He made two drawings in preparation for the painting, one of which shows the figure without the swan, holding a champagne flute in her extended hand. The drawing derives directly from the label of a champagne bottle, confounding the general understanding that Cézanne avoided using popular imagery as a source. ML

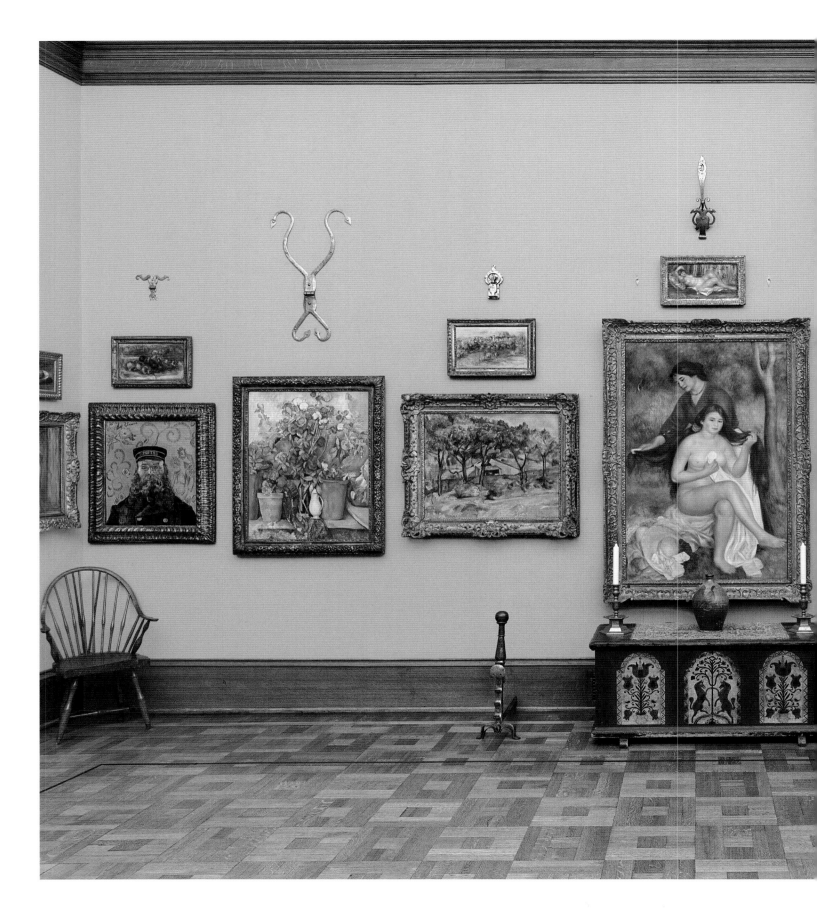

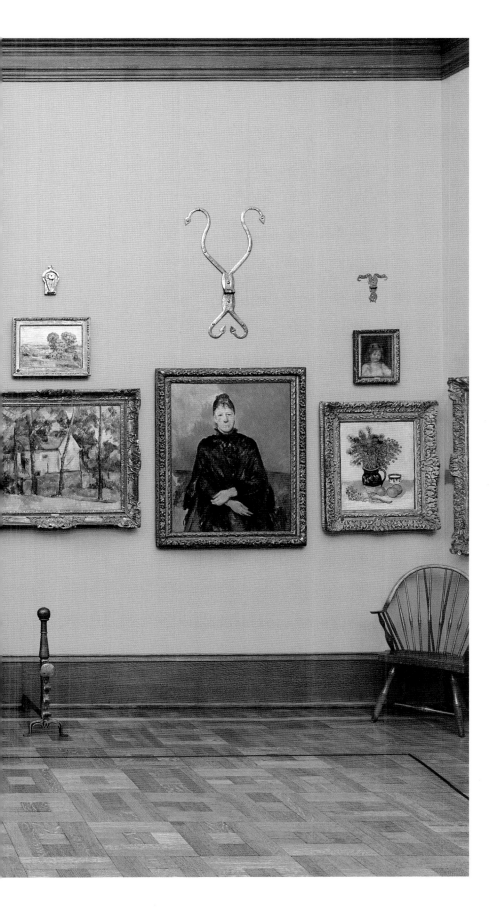

ROOM 2

NORTH WALL

This grouping is organized around Pierre-Auguste Renoir's large canvas *Bather and Maid*. The painting is striking for its compositional balance, as the monumental bather sits squarely in the center, her long hair falling in two equal sweeps around her body. Renoir's symmetry finds counterparts in the Pennsylvania German chest below, which bears painted designs that mirror each other perfectly, and in the arrangement of the ensemble itself. The painting by Renoir is framed by two landscapes by Paul Cézanne of nearly identical size; next to those are two additional works by Cézanne—*Terracotta Pots and Flowers* and a portrait of Madame Cézanne—both vertical in format. Two masterpieces by Vincent van Gogh, *The Postman* and *Still Life*, complete the row.

The dominant colors in this grouping are cool greens and blues, seen especially in the portrait by Cézanne and in *Terracotta Pots and Flowers*, and in the embroidered table cover resting on the chest. These colors are also prominent in the neighboring works by Van Gogh, but there they are compartmentalized into separate zones. The maid's red blouse in the central painting by Renoir stands out brilliantly against the ensemble's overall palette. Small touches of red are repeated in several of the surrounding paintings, including the landscape by Cézanne to the left, the reclining nude by Renoir above, and the two small works, also by Renoir, at either end of the upper row—*Portrait of Jean Renoir* and *Pomegranate and Figs*. Two large iron hinges pick up the forms in the paintings. Their Y-shaped design corresponds to the tree in *Bather and Maid*, and their curls relate to the scrolling vine pattern in the background of *The Postman*. ML

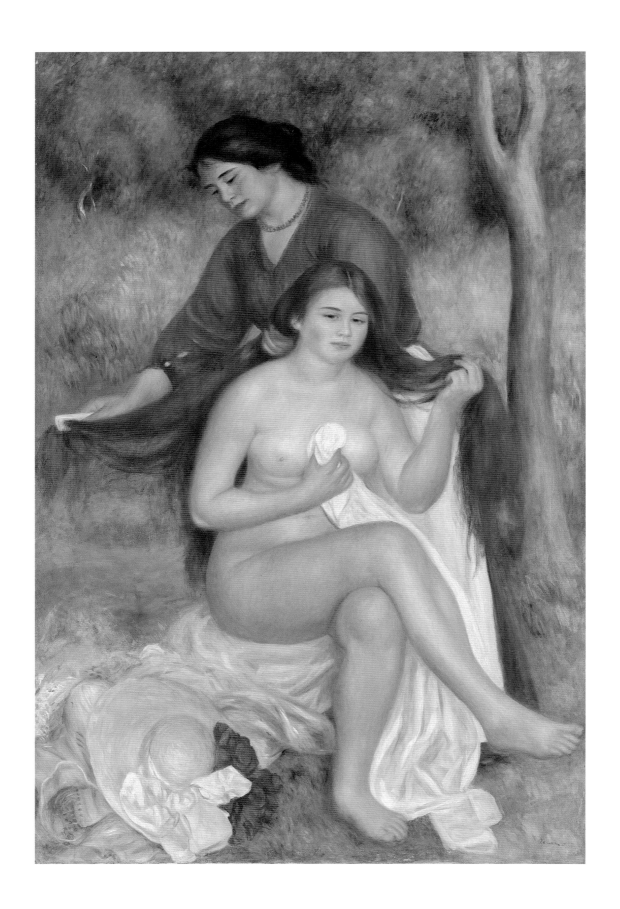

Pierre-Auguste Renoir
*Bather and Maid (La Toilette
de la baigneuse)*, 1900–1901
PAGE 94

American, Pennsylvania German
Chest, 18th century
PAGE 94

German
Door Knocker, 18th century
PAGE 95

Paul Cézanne
Madame Cézanne (Portrait de Madame Cézanne), 1888–1890
PAGE 95

Paul Cézanne
*Peasant Standing with Arms Crossed
(Paysan debout, les bras croisés)*, c. 1895
PAGE 96

Paul Cézanne
*Mont Sainte-Victoire (La Montagne
Sainte-Victoire)*, 1892–1895
PAGE 96

Édouard Manet
Laundry (Le Linge), 1875
PAGE 97

Vincent van Gogh
The Postman (Joseph-Étienne Roulin), 1889
PAGE 97

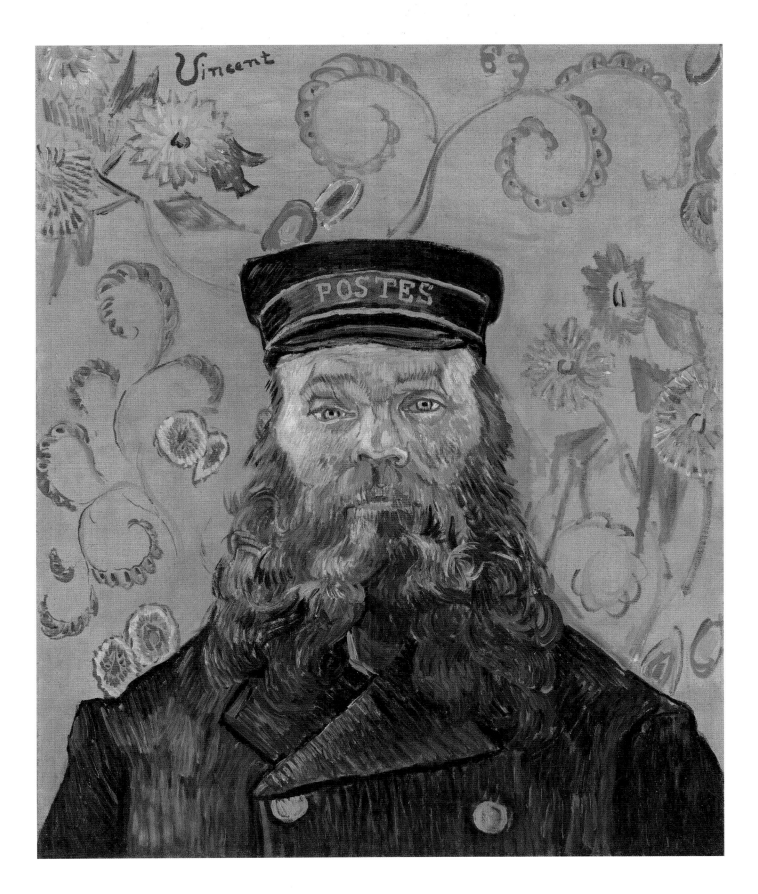

El Greco
*Apparition of the Virgin and Child
to Saint Hyacinth*, c. 1605–1610
PAGE 98

Paul Cézanne
*Still Life with Skull (Nature morte
au crâne)*, 1896–1898
PAGE 98

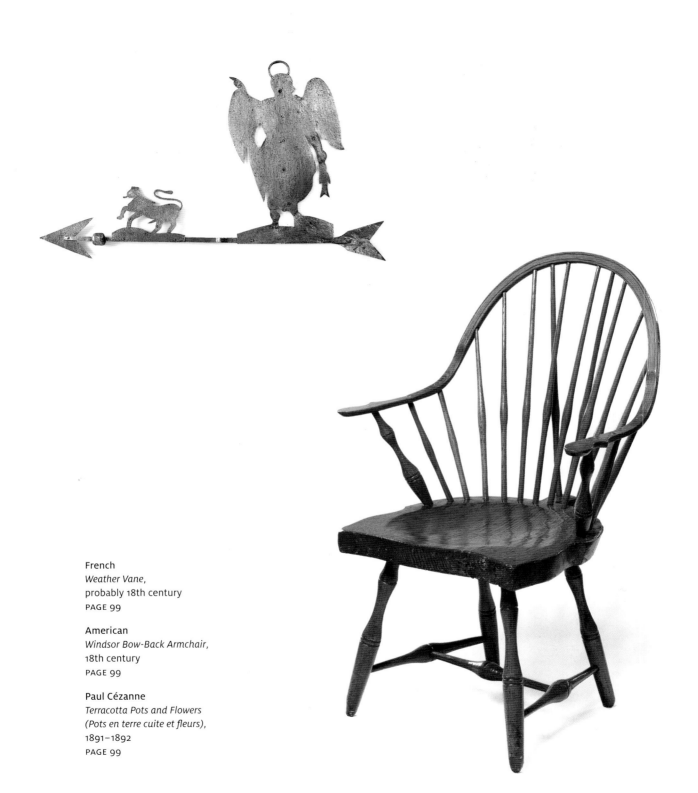

French
Weather Vane,
probably 18th century
PAGE 99

American
Windsor Bow-Back Armchair,
18th century
PAGE 99

Paul Cézanne
Terracotta Pots and Flowers
(*Pots en terre cuite et fleurs*),
1891–1892
PAGE 99

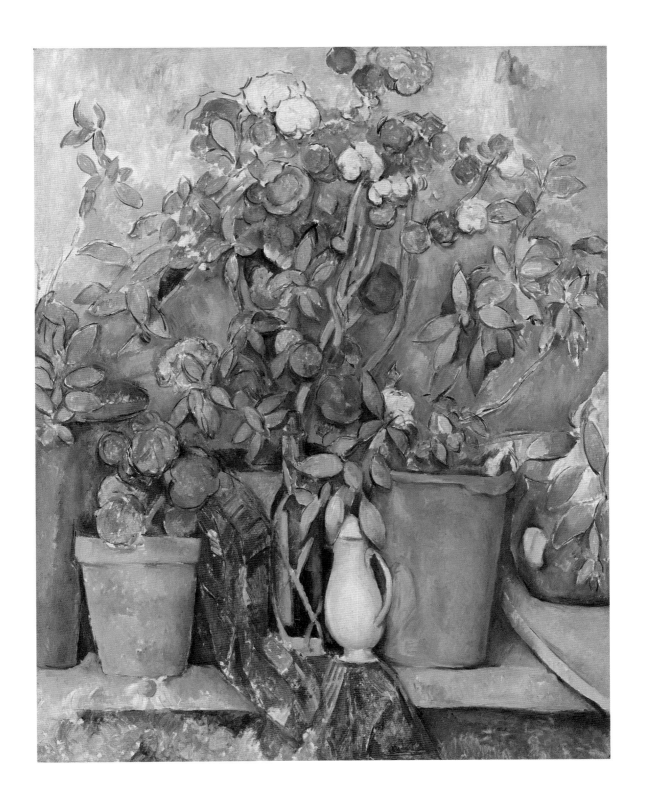

Pierre-Auguste Renoir (French, 1841–1919)
Bather and Maid (La Toilette de la baigneuse), 1900–1901
Oil on canvas. 57 5/16 x 38 3/8 (145.5 x 97.5). BF899

Albert Barnes acquired *Bather and Maid* the same year in which he described the picture as "banal and academic" in his book *The Art of Renoir* (1935). Perhaps Barnes had a change of heart about the painting, or perhaps not—he often said he wanted his collection to include an artist's failings as well as successes. Barnes's feelings aside, *Bather and Maid* was one of Pierre-Auguste Renoir's most celebrated paintings in the early twentieth century. For many years it hung in the prestigious Bernheim-Jeune collection in Paris, and in the literature it was continually praised for its design, as a picture in which naturalism was subsumed by art.

The painting is nothing if not tightly designed. It shows a nude bather, her clothes piled in the foreground, with an attendant brushing out long, chestnut locks that form a frame for the body. The figures are solidly anchored in space, and a single tree mimics their vertical arrangement, down to the V-shape of its branches picking up the neckline of the red blouse. Renoir took great pains with the composition, making a full-size preparatory drawing in red and white chalk.

Like so many of Renoir's paintings, *Bather and Maid* presents a fantasy of ideal feminine beauty. Both figures are given pretty, almost identical features, and the bather's body is soft and full, her breasts occupying the exact center of the composition. It is a beauty that is emphatically free of artificial modern constraints; the corset sits cast off in the lower left corner, and the hair, long and flowing, is a rebuff to the fussy styles that were fashionable at the time. ML

Chest, 18th century
United States, Pennsylvania, Berks County
Painted pine and iron. 22 1/4 x 50 1/2 x 23 (56.5 x 128.3 x 58.4). 01.02.09

Beginning in the seventeenth century, German speakers from the Palatinate, Switzerland, Alsace, and Holland immigrated to the Dutch, and then British, colony now known as Pennsylvania. Following the traditions of their native lands, Pennsylvania Germans provided their adolescent children—both young men and women—with chests, or *Kisten*, for the storage of personal articles, documents, and household goods. Such gifts of furniture underscored the virtue of caring for one's own belongings[1] and, by extension, the home. Serving functional needs both as receptacles for personal items and as seating, these chests with hinged lids were often painted with elaborate, colorful motifs.

In the three arched and sawtooth-edged insets on the front of this chest, potted tulips flank a central design of two unicorns confronting each other, painted flatly in silhouette. Although unicorns traditionally symbolize chastity and virtue, this device may be derived from the British coat of arms, which pairs a rearing but chained unicorn with a rampant lion. Another source includes the emblem of the Commonwealth of Pennsylvania, which is flanked by horses—an intriguing integration of German and British traditions.[2] Chests with the unicorn motif are linked to a handful of painters who worked in Berks County, Pennsylvania.

Albert Barnes began collecting in 1912 with the acquisition of paintings, but in the 1930s he also turned to the decorative and industrial arts. Pennsylvania German furniture had a

personal resonance for him, as he revealed in a letter: "My interest in The Pennsylvania Dutch comes naturally for my grandmother was one of them, and early in life I became acquainted with their furniture, their cooking, and their wonderful houses and gardens. When I got on 'easy street' I started to collect Pennsylvania Dutch articles."[3] JFD

1 *Pennsylvania German Art* 1984, 137.
2 Fabian 2004, 59–60; Keller 1991, 592–605.
3 Letter from Albert C. Barnes to J. J. Cabrey, November 29, 1950. BFA.

Door Knocker, 18th century
Germany

Iron. 21 5/16 x 6 3/8 x 4 (54.1 x 16.2 x 10.2). 01.02.11

This door knocker takes the form of a double-headed eagle, an ancient symbol traced to Mesopotamian, Roman, and Byzantine precedents and later adopted by several princely European states to represent twinned secular and religious sovereignties. The maker of this door knocker cleverly exploited the bird's long tail feathers, curling them into a volute for the hand grip. Incised lines define the varied plumage of the eagle — short, horizontal arcs for the overlapping neck and body feathers, and longer contours for the wings and tail. JFD

Paul Cézanne (French, 1839–1906)
Madame Cézanne (Portrait de Madame Cézanne), 1888–1890

Oil on canvas. 36 1/2 x 28 3/4 (92.7 x 73). BF710

An artist's model, nineteen-year-old Hortense Fiquet met Paul Cézanne in 1869 and became his companion, bearing him a son — also called Paul — in 1872. As the artist traveled back and forth from their shared quarters in Paris to his family's residence at the Jas de Bouffan near Aix-en-Provence, the couple kept their liaison and domestic arrangements secret from his father until they married in 1886. Despite their long separations and difficult marriage, Fiquet served as Cézanne's most frequent model, sitting for more than forty paintings and many drawings — evidence of a willing pliability that seems incompatible with the melancholy

insolence she appears to display in this work with her downturned mouth and averted glance.

Positioning Fiquet close to the picture plane with shoulders squared, bearing erect, and hands folded across her lap, Cézanne endows her with a quiet, immovable monumentality, an effect underscored by the pyramidal shape of the dark cloak that falls over her brown skirt. The painter lavished attention on rendering the texture of his fashionable wife's garment, alternating applications of his pigments — as well as unpainted passages — to capture the play of light over its folds and the closure at the neck.

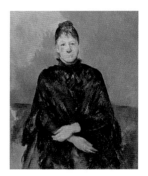

Despite the seeming solidity of the composition, Cézanne also imbues the work with a precarious imbalance. While the fingers of Fiquet's left hand terminate in squared-off stubs, those on her right taper into pointy claws. The slight leftward cant of Fiquet's head contrasts with the wainscoting's more precipitous downward slope to the right. The turn of the head exposes her right ear, introducing a discordant asymmetry to the perfect oval of her face, and the regularity of her features is further undermined by the painter's highly varied application of touches to her face. While her slight frown echoes the curves of her unevenly raised eyebrows and the almond shape of her piercing yet vacant black eyes, the lack of finish at the right corner of her mouth finds its complement in the flurry of green strokes that obscure the left side. Similarly, her ruddy right cheek is paired with a more subtle treatment of pale pinks for her left.[1] In a compressed space marked by an uneven, mottled background, the encounter with Fiquet proves disquietingly claustrophobic. JFD

1 For a recent and extensive discussion of Cézanne's portraits of Hortense Fiquet, see Sidlauskas 2009, specifically 97–99, 108 on the treatment of her face and hands.

Paul Cézanne (French, 1839–1906)
Peasant Standing with Arms Crossed (Paysan debout, les bras croisés), c. 1895
Oil on canvas. 32 ½ x 23 ¼ (82.6 x 59.1). BF209

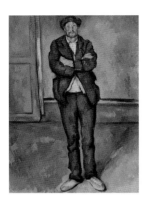

A tall peasant stares frankly out at the viewer. With brown hat, mustache, and arms folded across his torso, he is the same figure who stands in the background of *The Card Players* (p. 70) with a pipe dangling from his mouth. According to Paul Cézanne's son, this is probably Père Alexandre, who worked on the Jas de Bouffan, the estate of Cézanne's father. The artist lived there during the mid-1890s, focusing on painting the surrounding landscape and the handful of people who were at his disposal, especially gardeners and farmhands.

As in all his paintings of peasants from around the estate, Cézanne gives this figure a pronounced sense of dignity without being sentimental. Never are his laborers shown in the process of back-breaking work, as in the romantic Salon pictures of Jules Breton. Rather, Cézanne presents them relaxing, playing cards, smoking cigarettes, or, as here, simply posing. The figure's heroism is expressed in his imposing stance—his frank, no-nonsense posture, the strong features of his face, and the body that stretches from the very top to the very bottom of the canvas.

The man's tall presence is reinforced by the door in the background, with its pronounced vertical lines that tilt slightly to the left, at the same angle as the model. The horizontal band running across the back wall does little to diminish the dominant verticality. A white triangle forms at the opening of the man's jacket, around his stomach, echoed in the V-shaped placement of his feet. As in so many of Cézanne's paintings, the point of view is deliberately confusing: the peasant is shown straight on but also slightly from above, as the floor tilts toward the picture plane. ML

Paul Cézanne (French, 1839–1906)
Mont Sainte-Victoire (La Montagne Sainte-Victoire), 1892–1895
Oil on canvas. 28 ¾ x 36 ¼ (73 x 92). BF13

A native of Aix-en-Provence, Paul Cézanne knew well the terrain and legend of Mont Sainte-Victoire—a site inextricably linked to Provençal identity and to the oeuvre of this artist, who painted thirty canvases devoted to the motif. The mountain's distinctive, lopsided conical peak and long ridge, known as Le Cengle, dominates the Arc River valley, a landscape Cézanne explored with his childhood friend Émile Zola. According to tradition, the mountain's name commemorates a victory in the region by the Roman general Marius over the Teutons and Cimbri in 102 BC—a campaign recounted by historians Plutarch and Livy. In subsequent centuries, the mountain served as a site for religious devotion with the establishment of a chapel at the summit.[1]

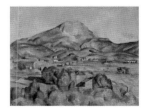

During the course of his decades-long engagement with the motif, Cézanne painted the peak from a variety of vantage points. Here, he centered the elevation in his composition and underscored its monumental presence. Using blues and mauves for shadow and pinks for light, the painter lavished his attention on modeling the volumes—the dips and protrusions—of the gray limestone mountain. Just beyond the dense, seemingly impenetrable screen of brush in the foreground lie the valley's squarely built habitations and neatly bounded cultivations. Three adjoining planes of ocher, red, and green at left differentiate the terrain and also establish a measured recession in space. The pointy angularity of the structures complements the curving contours of the mountain's peak and the gently rolling foothills, as well as the rounded fullness of the trees. At right, a hint of the repeating arches of the valley's railway trestle suggests an ancient Roman aqueduct, simultaneously evoking the region's ancient past and its burgeoning modernity.[2] JFD

1 For a recent examination of Cézanne's connection to Provence and the works specifically devoted to Mont Sainte-Victoire, see Conisbee and Coutagne 2006, 280–290.
2 Cachin et al. 1996, 259.

Édouard Manet (French, 1832–1883)
Laundry (Le Linge), 1875
Oil on canvas. 57 1/4 x 45 1/4 (145.4 x 114.9). BF957

Like the other avant-garde artists of his time, Édouard Manet dispensed with the high-minded historical and mythological subjects of the Salon to focus on painting contemporary life around him, often with a note of detached irony. Here, however, in one of his more tender pictures, no irony is felt. A woman and small child stand in a garden hanging laundry. As the woman wrings out a garment, the child toddles at the wash bucket's edge, entranced by the small waterfall. It is a scene of utter domestic contentment: warm sun flickers across the fresh laundry, some flowers fill the foreground while another peeks over the clothesline, and the woman gazes at the child with an amused expression, evoking the feeling that nothing matters beyond the present moment. The figures are traditionally centered, with none of the radical cropping seen elsewhere in Manet's work, furthering the sense of domestic stability.

The woman is probably a model named Alice Legouve, who was part of Manet's circle and posed for several paintings; the child is likely her daughter. While the journalist Antonin Proust remembered Manet referring to the woman as "Jeanne Lorgon," an inventory of the artist's studio drawn up in 1883 identifies the figures as "le modèle Alice Legouve/et sa fille/fait dans un jardin de la rue de Rome" (the model Alice Legouve/and her daughter/done in a garden on rue de Rome). Moreover, Manet refers in letters to Legouve posing for him in 1875. Manet included *Laundry* in a showing of his most recent work at his studio in 1876; that same year, the critic Stéphane Mallarmé wrote at length about this painting in his famous article "The Impressionists and Édouard Manet," noting the simplicity of the subject. ML

Vincent van Gogh (Dutch, 1853–1890)
The Postman (Joseph-Étienne Roulin), 1889
Oil on canvas. 25 7/8 x 21 3/4 (65.7 x 55.2). BF37

For most of 1888, Vincent van Gogh rented a room above the Café de la Gare in Arles, near the train station. It was probably there that he met Joseph-Étienne Roulin, a mail handler who became his close friend as well as an important subject for his paintings. Between July 1888 and April 1889, Van Gogh painted six portraits of Roulin (as well as several of Roulin's wife and children). In each Roulin wears his dark blue uniform, with the word "Postes" clearly legible across his hat. Clothing plays a central role in this series, describing not only the sitter's occupation but also perhaps his political leanings; as an ardent socialist, he would have worn his worker identity proudly. Moreover, the uniform announces that portraiture is no longer reserved for the upper class.

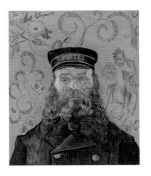

Roulin is shown here from the shoulders up, his body centered and perfectly square to the picture plane. His gaze is steady yet gentle. In contrast to the symmetry of the composition, his features are slightly uneven: the nose is lopsided and the eyes are too, an irregularity that is accentuated by the heavier touches of red around one eyelid. The mustache hangs in uneven clumps over his lips. All these details add to the naturalism of Roulin's face, which is even more striking for the picture's many decorative qualities.

In *The Postman*, one of the first works to enter Albert Barnes's collection, Van Gogh turns an ordinary salt-and-pepper beard into a brilliant ocean of color. Thick licks of paint—green, black, purple, red—curl around one another, each stroke distinct and unblended; in a few areas the bare canvas can be glimpsed between them. The forms and colors of the beard are magnified in the background, showing bold chartreuse wallpaper with curling vines and flowers. The paint here is thin and fluid and of a completely different quality than that in the figure. A green shadow brushed quickly along the sitter's right side offers a hint of dimensionality; it is also possible that the artist was simply experimenting with this green as a darker background color. ML

El Greco (Greek, active in Spain, 1541–1614)
Apparition of the Virgin and Child to Saint Hyacinth, c. 1605–1610

Oil on canvas. 62 ⅜ x 38 ⅞ (158.4 x 98.7). BF876

Paul Cézanne (French, 1839–1906)
Still Life with Skull (Nature morte au crâne), 1896–1898

Oil on canvas. 21 ⅜ x 25 ¾ (54.3 x 65.4). BF329

Hyacinth, a Polish Dominican priest born in 1185, is said to have witnessed an apparition of the Virgin and Child on the feast day of the Virgin's assumption into heaven. Here, the mystical vision hovers in a burst of light and cloud while the priest kneels before it, enraptured. Several columns and a sculptural niche place the scene in a church or monastery. As Hyacinth looks up, cool light flickers across his face, revealing an expression of awe. But the scene's real expressiveness is concentrated in the saint's hands — one clutched dramatically to his chest, the other extended toward the viewer, almost as an invitation into the image.

Born in Crete, El Greco was heavily influenced by Venetian Renaissance painters such as Titian and Veronese; he spent the majority of his artistic life in Spain, painting commissions for churches. This canvas was executed around 1605, just a few decades after Hyacinth was granted sainthood by Pope Clement VIII. It is a good example of El Greco's late style: fingers are twisty and elongated, and there is a special emphasis on perspective, as the geometric floor pattern establishes a sense of depth. In this dark interior, the saint's white robe has a mysterious glow. It is a bravura passage of light and shadow, with deep folds and crevices that give the fabric a sculptural quality.

When Albert Barnes bought this picture in 1930, El Greco was enjoying a revival among American collectors after several centuries of obscurity. Duncan Phillips and Robert Hudson Tannahill both purchased canvases, attracted by the artist's eccentric, expressive manner. Barnes seems to have been particularly interested in the stylistic similarities between El Greco and Paul Cézanne. ML

Common accessories of the painter's studio, skulls were frequently included in vanitas subjects, meditations on mortality and transience. Although Paul Cézanne had addressed this tradition very early in his career in at least two canvases from the 1860s, he turned again to the macabre studio prop in the last decade of his life in a series of still lifes and in *Young Man and Skull* (p. 223).[1] Here, the death's head appears to reign over seven pieces of fruit — pears, apples, and possibly a pomegranate, all in varying stages of ripeness.[2] A mainstay of Cézanne's still lifes, a white cloth with red stripes, bunched in peaks and valleys, covers the left side of the plain wood table and cradles one of the multihued pears as well as the skull. The volumes of the fleshy fruits echo the rounded dome of the cranium and its eye sockets,[3] the bright red, yellow, and green skins contrasting with its tenebrous cavities. Poignant complements to the skull, which has yellowed with age, the freshly picked fruit at center retains its green leaves, and even the painted vegetation on the screen in the background shows signs of life.

Although Cézanne focused primarily on explorations of form, volume, space, and structure in his many still lifes, constantly rearranging his stock props to experiment with these relationships, his decision to include the skull prompts inquiries about his motivations for returning the death's head to the rotation after such a long absence. With the passing of his mother in 1897 and his increasingly fragile health, the artist's thoughts may have turned to his own death.[4] Although Cézanne's props are often precariously arranged, as they are here — on the edge of the table or on a tilted plate — the addition of the skull perhaps heightens the sense of vulnerability.

A streak of orange pigment slashes horizontally across the skull's right eye socket and a similar smudge appears a bit further

to the left on the canvas—traces of another canvas that was leaned against this work before it had dried.[5] JFD

1 Cachin et al. 1996, 87.
2 These fruits have been identified variously in the literature; see Joseph Rishel, "Still Life with Skull (Nature morte au crâne)," in *Great French Paintings* 2008, 148; Cachin et al. 1996, 490.
3 Cachin et al. 1996, 490.
4 Ibid.
5 Rishel in *Great French Paintings* 2008, 148.

Weather Vane, probably 18th century
France

Iron. 28 x 45 ³/₄ x 1 ³/₄ (71.1 x 116.2 x 4.4). 01.02.31

Although the original location for this weather vane remains a mystery, it may have crowned a pilgrimage church in France, in keeping with the guardian role that the archangel Raphael served for travelers, as told in the Book of Tobit. In human guise in this narrative, Raphael accompanies the young Tobias and his dog to distant Media (in present-day Iran), where Tobias, a dutiful son, will retrieve money that his now blind father, Tobit, had left behind. Attacked by a large fish while bathing during the journey, Tobias captures the fish at Raphael's urging and removes its organs for medicines. Tobias returns home with the money and cures his father's blindness with the fish gall, as instructed by Raphael, who later reveals his true identity.

Rendered in silhouette with flowing robes, outstretched wings, and prominent halo, the archangel carries a fish as his attribute. Notably, the shadow-figure treatment seen here is echoed by other objects in the Barnes Foundation's Room 2: the unicorns on the Pennsylvania German chest, the bird on the jug atop the chest, and the double-headed eagle door knocker. JFD

Windsor Bow-Back Armchair, 18th century
United States

Wood. 34 ¹/₂ x 17 x 19 ¹/₄ (87.6 x 43.2 x 48.9). 01.02.01

Paul Cézanne (French, 1839–1906)
Terracotta Pots and Flowers (Pots en terre cuite et fleurs), 1891–1892

Oil on canvas. 36 ¹/₄ x 28 ⁷/₈ (92.1 x 73.3). BF235

Deploying a predominantly muted palette of smoky earth tones—a departure from the vibrant, saturated hues that animate other still lifes in Paul Cézanne's oeuvre—the artist here mingles familiar studio props with the potted geraniums in the greenhouse at the Jas de Bouffan, his father's residence just outside Aix-en-Provence. Cézanne worked in the conservatory on the property during the winter when painting outdoors proved challenging, and other pictures from the 1880s of geraniums indicate that he addressed this motif more than once during these chilly, housebound months.[1]

On a shallow ledge, four conical terracotta pots of varying heights stand in double rows with a cylindrical rum bottle and a sinuously profiled white pitcher, while a round-bottomed blue vase enters the lineup at right on a curved and precariously tilted ledge. The regularized, hard-edged geometries of these vessels contrast with the organic forms of the flowering plants with their twisting, meandering stems and full white, pink, and green-sheathed blossoms. At the same time, the criss-crossed straw binding on the rum bottle appears purposefully placed to echo the hardy, intertwined stems at the center of the composition. The red and orange textile adds a punch of color to the work and, with its graceful slither, suggests a vibrant vitality.

In this already shallow composition with its close-up view, the space seems further compressed by the screen of leaves that spreads across the width of the canvas, obstructing the indistinct background. Cézanne also under-scored the flatness of this support with a trace of a pink geranium that mysteriously floats untethered in the lower left corner of the canvas. JFD

1 Cachin et al. 1996, 272.

ROOM 3

WEST WALL

Installed with paintings of small or modest format, this ensemble paradoxically but intriguingly offers an exploration of the vastness of space. A pastoral landscape attributed to the sixteenth-century Venetian painter Titian provides a panorama of rolling hills, a tower-filled townscape, and rugged mountains. Just below, a chest topped with tiny pewter spoons and vessels contributes to the sense of expansiveness by virtue of its miniature scale. A *Crucifixion* by Juan de Flandes rivals the precision of the atmospheric perspective in the Venetian panel. Pastel-hued landscapes by Pierre-Auguste Renoir offer fluid transitions from foreground to background. Two French naive paintings of girls in landscapes provide simple but effective methods for marking recession in space—diminutive trees define the middle ground, while low mountain peaks establish the distant horizon. By contrast, the monochromatic backgrounds of the Italian and Northern portraits on the lowest register, the gold grounds of the central *Crucifixion* and the *Virgin and Child with Saints Paul and Peter*, and the close-up views of apples by Paul Cézanne and Renoir offer no hint of spatial depth.

While Albert Barnes gave primacy to formal concerns in the arrangement of his ensembles, he did not exclude the viewer's narrative or art-historical associations. Although his placement of Renoir's still life of apples above the Austrian *Crucifixion* at the center of the wall subverts traditional genre hierarchies, Barnes may have been making allusion to the sin of Adam, whose skull commonly appears at the foot of the cross in such scenes, as it does in this gold-ground panel and in the work by Juan de Flandes. Above the still life by Renoir, Barnes combined a hinge, buckle, and decorative element into a birdlike form in a creative evocation of the Holy Spirit. JFD

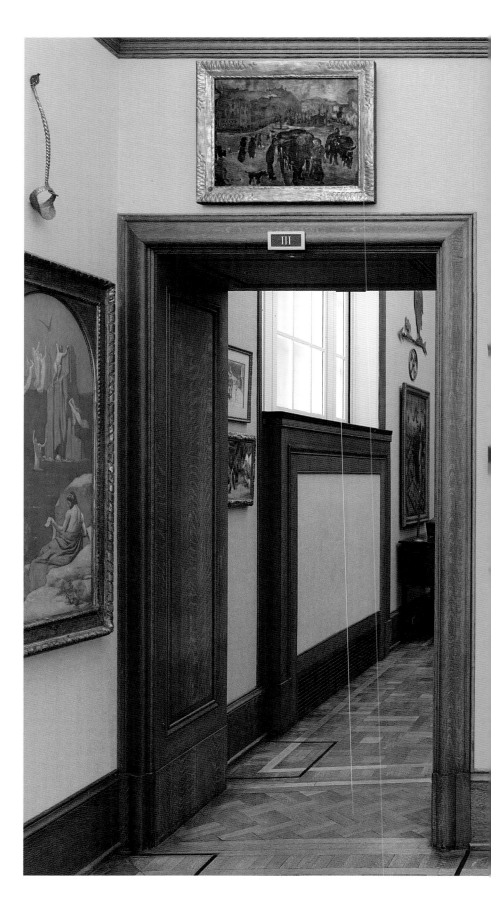

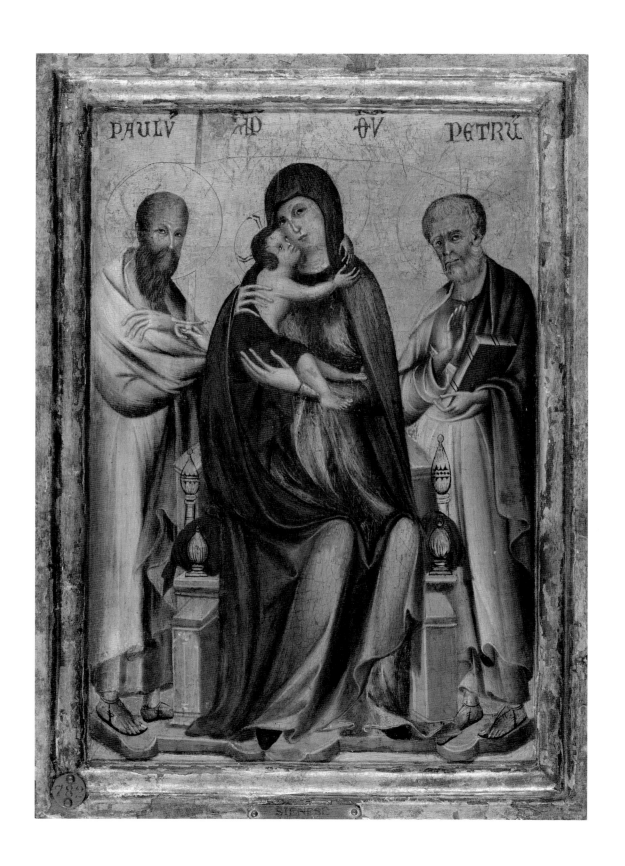

PAULV̄ MD �θV PETRV̄

Italian
Virgin and Child with Saints
Paul and Peter, mid-13th century
PAGE 110

Hans Baldung Grien
Madonna and Child, 1539
PAGE 110

Austrian Master
Crucifixion, c. 1400–1420
PAGE 110

Attributed to Titian
Sleeping Shepherd, c. 1500–1510
PAGE 111

Italian
Virgin and Child with Saints Paul and Peter,
mid-13th century
Tempera and gold on panel. 11 ¹³/₁₆ x 8 ³/₈ (30 x 21.3). BF782

As the Queen of Heaven, the Virgin Mary sits
in majesty on an imposing throne adorned
with golden finials, the hard-edged architectural
forms of the carved stone seat softened by
a rounded, red cushion. The Virgin, guardian
and intercessor, cradles the Christ Child in
her arms — her long, elegant fingers caress his
back — while he adoringly presses his cheek
against hers and wraps his arm around her neck
in a moving and evocatively tactile gesture
possibly derived from Byzantine precedents.
The artist conveys the humanity of the infant
Christ with a small but insightful rendering of
his legs and feet — one foot dangles over the
arm of Mary, and the other nestles in the warm
crook of her elbow. Mary's blue mantle, a
symbol of her regal status, provides the barest
measure of protection to her young son, whose
later sacrifice is depicted in a Crucifixion scene
on an accompanying valve, long separated
from this panel and now in private hands.

While the Virgin and Child are the devo-
tional focus of this panel and, accordingly,
appear larger than the other figures, the saints
Paul and Peter stalwartly flank the Virgin
and Child as the faithful apostles who spread
Christ's teachings after his death and who
died as martyrs in turn. Recognizable by his
prominent forehead, receding hairline, and
long, pointed beard, Paul holds the sword of
his beheading. Although Peter carries just
a book — rather than his usual keys — his curly
white hair and short beard remain familiar
attributes. The artist endows each saint with a
wealth of particularizing details, including
precisely painted whiskers, furrowed brows,
and crow's feet. Similarly, the careful attention
to the modeling of the draped garments, as
well as the play of light and shadow over the
throne, demonstrate his experimentation
with volume and spatial recession.

This panel has been the subject of much
debate among specialists who have sought
to identify the specific regional origin of the
panels — if not their hand — noting the con-
fluence of Byzantine, Tuscan, Venetian, and
Bolognese stylistic features. JFD

Hans Baldung Grien (German, 1484/85–1545)
Madonna and Child, 1539
Oil and tempera on panel. 13 ⁹/₁₆ x 10 ³/₄
(34.4 x 27.3). BF316

Hans Baldung Grien, who studied under
Albrecht Dürer, is one of the great artists of the
Northern Renaissance. Working primarily
in Strasbourg, Alsace, he distinguished himself
as a printmaker but also produced important
altarpieces, portraits, and smaller panel paint-
ings such as this *Madonna and Child.* The
painting is a replica of one of the artist's earlier
works, now in a private collection in Switzer-
land; he replicated his own work on several
occasions. The earlier Madonna was probably
painted around 1515–1518 and is identical
except for the inclusion of an elaborate crown.

While the Madonna, who gently cradles the
baby as he reaches up, radiates a certain
warmth and humanity, she also conveys a
higher spiritual presence. Her expression
is serene yet detached, and her halo glows with
a cool, bluish light that filters down onto the
figures. The drama of her flowing red drapery
and hair — a striking contrast to the cool
tones of the background — adds to the sense
of otherworldliness. The veil around the
Madonna's head is skillfully painted; minimal
touches of white around its edges render
the fabric present yet totally transparent. The
modeling around her neck and chin is especially
delicate, and in her hair, small ripples of
white paint at regular intervals create the effect
of shimmering waves. ML

Austrian Master
Crucifixion, c. 1400–1420
Tempera and gold on panel. 18 ³/₈ x 11 ¹/₈
(46.7 x 28.3). BF828

Presenting several episodes of Christ's
Crucifixion in a single synoptic scene, this
artist underscored the pathos of Jesus
Christ's sufferings, the many cruelties of his
persecutors, and the profound grief of his
devoted followers. Condemned by the Roman
procurator Pontius Pilate, Jesus bore his cross
through Jerusalem to the site of his execution
outside the walls of the city at Golgotha,
translated as "the place of the skull" by the
Gospel writers. Once there, Roman soldiers

stripped him of his clothing and cast lots to divide his belongings among themselves — a scene represented in the lower right corner where three men, dice at the ready, huddle conspiratorially over his robe. Subsequent events include the vinegar offered to Jesus on a sponge and the blow of the Roman lance, with a daring attempt at intervention by one of Christ's adherents. In keeping with the panel's episodic layering, the attenuated body of the living Christ is taut with the agony of his torments, while his bowed head and closed eyes signal his subsequent death. At right, the Roman centurion Longinus, elaborately attired in ermine, points to the dead Christ, recognizing his divinity. Longinus's shield, emblazoned with a frowning sun, may make allusion to the darkness that fell over the proceedings. At left, Saint John the Evangelist, in green, comforts the distraught Virgin Mary. With the earthquake that immediately followed Christ's demise, fissures appear in the earth, revealing the skulls of Golgotha's legend — perhaps including Adam's, which was buried there according to tradition.

This panel likely formed part of a larger altarpiece with scenes from the life of Christ. While the gold ground, traditional for devotional works of this period, emphasizes the transcendent otherworldliness of the divine narrative, the painter also provided a wealth of detail in the costumes and physiognomies of the figures, lending the scene specificity and veracity. JFD

Attributed to Titian (Italian, c. 1488–1576)
Sleeping Shepherd, c. 1500–1510
Oil on panel. 10 ⁷⁄₈ x 50 ¼ (27.6 x 127.6). BF977

The pastoral landscape became popular in the first decades of the sixteenth century, pioneered by the short-lived but influential Venetian painter Giorgione and further developed among his followers and students such as Titian. Although landscape had previously served as a backdrop to the divine and human actions of the great historical, mythological, and biblical narratives, the genre proved alluring to ambitious painters who sought to capture nature's atmospheric effects and varied textures, and to sophisticated

patrons who appreciated visual delectation. Pastoral poetry — once available only to readers of Greek and Latin — enjoyed a revival in literary circles as Renaissance poets wrote Virgilian eclogues in Italian.[1]

Most likely painted as part of a room decoration, this long but narrow panel provides a panoramic view of a bucolic landscape of ancient trees, rolling hills, monumental peaks, and rushing waters — an abundance of sounds, colors, and surfaces. Nestled among these natural wonders, a townscape — a marker of civilization — appears in the middle distance with a cluster of sturdy vertical towers, a point of contrast to the jagged, irregular contours of the mountains just beyond. While his already plump goats chew the plentiful greenery in the foreground, a shepherd reclines on a grass-carpeted ledge lost in his dreams, his face turned toward the viewer — perhaps an invitation to join in the contemplation of the natural world. JFD

1 Rosand 1988, 21–81.

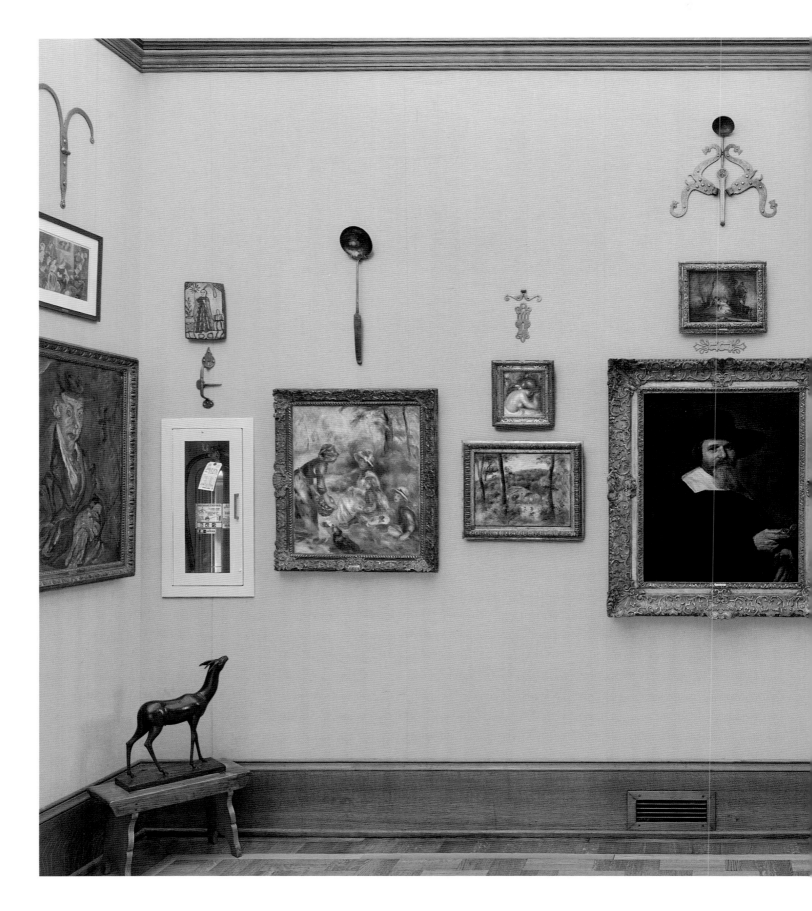

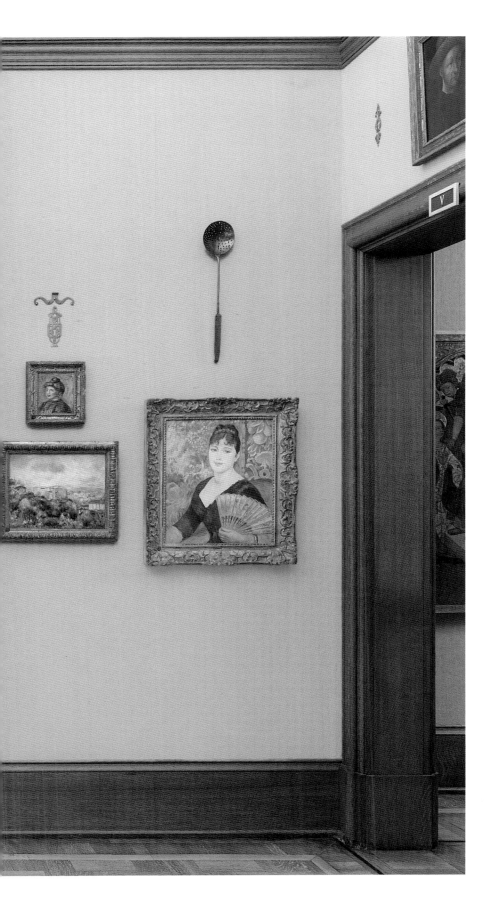

ROOM 5

EAST WALL

At the apex of this arrangement, a ladle and two hinges mimic the head and pyramidal body of the sitter in the ensemble's centerpiece, *Portrait of a Man Holding a Watch* by Frans Hals. Flanking the work by Hals are six paintings by Pierre-Auguste Renoir hung in two identical clusters, including *Apple Vendor* at far left and *Woman with Fan* at far right. Created in 1643, Hals's portrait is saturated with deep blacks that form a striking contrast with the bright, vivid colors and airy spaces of Renoir's canvases, produced more than three centuries later. Yet the juxtaposition reveals continuity, too: Hals's brushwork conveys a liveliness, particularly in the figure's face and hands, that connects this painting to the later ones. Another, perhaps more expected, link is established between older and newer traditions by the inclusion of Jean-Baptiste Pater's erotic *Figures in Landscape*, which hangs above the painting by Hals; Renoir considered himself the artistic heir of such eighteenth-century painters.

One theme in this grouping might be the different modes of portraiture across centuries, especially if Chaim Soutine's *Woman with Round Eyes*, circa 1919, on the adjacent wall is included. In the works by Hals and Soutine, and in Renoir's *Woman with Fan*, 1886, the sitters are all shown at a slight angle with their hands just above the bottom edge of the canvas, and in each, dark clothing is set off by bright white around the neck. Yet it is their differences that are the most interesting. Whereas Hals captures naturalistic details such as creases around the man's eyes, Renoir's approach is far more decorative, revealing little of his sitter's personality. The portrait by Soutine, however, is bursting with expression, as fiery color and undulating lines seem to convey the sitter's inner emotional state. ML

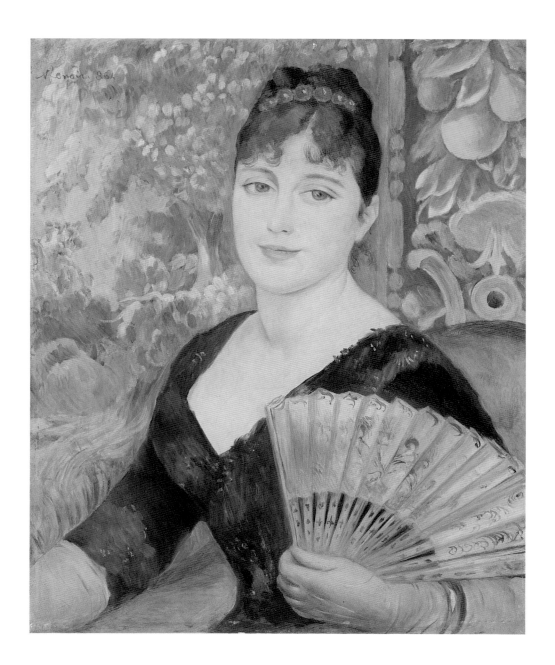

Pierre-Auguste Renoir
Woman with Fan
(Femme à l'éventail), 1886
PAGE 118

Frans Hals
*Portrait of a Man Holding
a Watch*, 1643
PAGE 118

Chaim Soutine
Flayed Rabbit
(*Le Lapin écorché*), c. 1921
PAGE 119

Pierre-Auguste Renoir (French, 1841–1919)
Woman with Fan (Femme à l'éventail), 1886
Oil on canvas. 22 x 18 (55.9 x 45.7). BF938

After exhibiting with the impressionists for
several years during the 1870s, Pierre-Auguste
Renoir reevaluated his approach to painting.
The impressionist emphasis on working quickly
and on capturing fleeting effects of light
and atmosphere now seemed untenable; he
wished to return to the principles of drawing
and sought something more eternal in his art.
Woman with Fan, created at the height of the
artist's self-described "crisis," represents
the enormous shift that occurred in his style
in the mid-1880s.

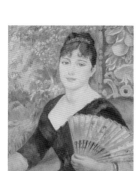

The model is Renoir's friend the artist
Suzanne Valadon, who also posed for the
famous *Large Bathers*, 1884–1887 (Philadelphia
Museum of Art). The broken brushwork of
his earlier style is here exchanged for hard lines
that carefully define the edges of forms—the
paint is smooth, blended, each stroke barely
perceptible. Impressionist spontaneity has
given way to order, not just in the handling of
the paint but also in the composition. The
design is tightly controlled, with recurring
forms such as the sharp V of Valadon's
neckline that mimics the corner of the fan, and
the beads of her headpiece that are repeated
on the edge of the screen. The palette is muted,
and the light is pale and even.

Renoir was famously wary of modern
technology. In 1884 he drafted a theoretical
treatise in which he passionately argued
against the regularizing effect of the machine,
especially in painting, architecture, and
the decorative arts. With the hand-painted fan
held open to display its artistry, one might
read this painting as an expression of these
ideas—as a celebration of the beauty of the
handmade object. ML

Frans Hals (Dutch, c. 1581–1666)
Portrait of a Man Holding a Watch, 1643
Oil on canvas. 32 ½ x 26 ¼ (82.6 x 66.7). BF262

"Hammer into your head that master Frans
Hals, that painter of all kinds of portraits,
of a whole gallant, live, immortal republic,"
wrote an admiring Vincent van Gogh to
his brother Theo in 1888 of their seventeenth-
century countryman.[1] Primarily a portraitist,
the Haarlem-based Hals painted prosperous
merchants, respected clergymen, brilliant
scholars, and dutiful civic leaders—along with
their well-turned-out wives. While portraying
his sitters with the grandeur and dignity of
their rank, Hals also endowed them with an
enduring liveliness and immediacy through his
careful attention to their poses and with his
vigorous brushwork, referred to as his "rough
style" by his contemporaries. For Van Gogh
and other nineteenth-century avant-garde
painters such as Gustave Courbet and Édouard
Manet, the bravura paint handling and the
seeming naturalism of Hals's work anticipated
their own aesthetic interests.

Hals presented his unidentified sitter with
his body turned in a three-quarter pose—toward
a pendant portrait of his wife (now National-
museum, Stockholm)—but with his face look-
ing at the viewer. His alert eyes and parted
lips, paired with the proffered gold watch and
chain, suggest a conversation interrupted.
While the timepiece may be a literal reference
to the sitter's profession or collecting interests,
some scholars have suggested that it may also
serve as an allusion to mortality and as an
entreaty to use time well.[2]

Typical of his practice in the 1640s, Hals
employed a nearly monochromatic palette,
setting his black-clad sitter against an
indistinct, tenebrous backdrop. Displaying
some of the "twenty-seven blacks"[3] that
Van Gogh observed in Hals's work, the painter
modeled the folds of the cloak wrapped
around the man's ample frame and suggested
the varying textures of his garments. Despite
the seeming austerity of the palette, a warm,
animating light bathes the sitter's broad,
fleshy face, illuminating the gray whiskers on
his chin, his crisp white collar, and the hand

holding the glittering watch. Carefully observed shadows obscure the sitter's forehead — a silhouette cast by the broad-brimmed hat — and left hand, while the bright, visible brushstrokes that give contour to the sitter's right hand demonstrate the technical flair so esteemed by Van Gogh and others. JFD

1 Vincent van Gogh, *The Complete Letters of Vincent van Gogh*, 3 vols. (Greenwich, CT, 1958), 3: 506, Letter B13 (July 1888), cited in Slive 1970–1974, 78.
2 Slive 1970–1974, 3: 75–76, no. 146.
3 Vincent van Gogh to Theo van Gogh, Letter 536, on or about October 20, 1885. Van Gogh Museum, Amsterdam, inv. nos. b468 a-b V/1962. http://vangoghletters.org/vg/letters/let536/letter.html.

Chaim Soutine (Russian, active in France, 1893–1943)
Flayed Rabbit (Le Lapin écorché), c. 1921
Oil on canvas. 28 3/4 x 23 5/8 (73 x 60). BF333

In 1913, Chaim Soutine fled the poverty and cultural isolation of Lithuania for Paris, with the help of funding from a generous patron who championed his talent. Although Soutine enrolled at the studio of the academic painter Fernand Cormon for formal instruction, he immersed himself in the collections of the Musée du Louvre and avidly studied the lessons of his predecessors, whose legacies he emulated and also challenged.

Departing from still-life traditions that celebrated the delectation of plenty, Soutine's rendering of the flayed rabbit conveys violence and suffering. The tawny, soft fur still sheathing the animal's hind legs starkly contrasts with the bloodied, exposed flesh of the rest of the carcass. Hallmarks of the artist's technical verve, the energetic brushwork and thick impasto — lurid reds and pinks for the raw meat, yellows and browns for the grimy, stained cloth — heighten the sense of brutality. Moreover, the permanent stare of the rabbit's clouded eye further underscores the subject's pathos. JFD

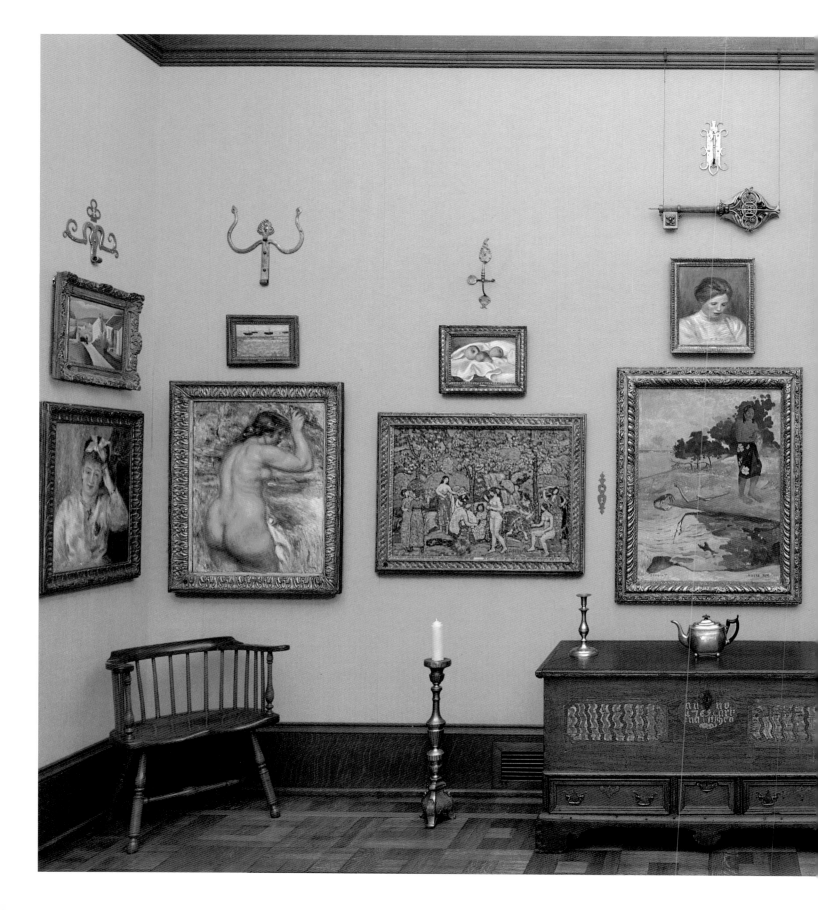

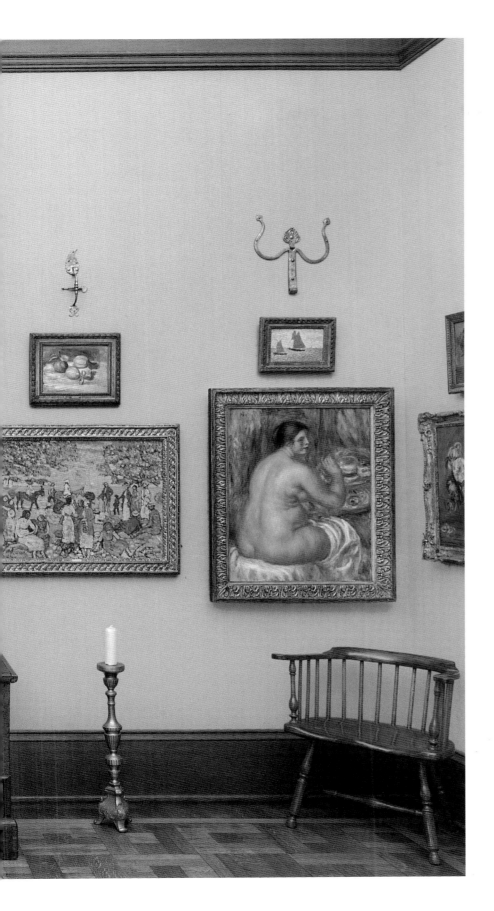

ROOM 6

SOUTH WALL

Paul Gauguin's *Haere pape* of 1892 hangs between two early twentieth-century canvases by American painter Maurice Prendergast. Below, a pewter teapot, probably English, sits atop a Pennsylvania German chest made in 1769. This array of objects, while disparate in time periods, cultures, and media, is connected by formal affinities. The paintings by Gauguin and Prendergast, for example, share a certain decorative approach to the landscape, in which trees, sky, and water are translated into repeating surface patterns. The wavy painted designs on the chest, which have a vibrating, almost rhythmic quality, seem to correspond to the striations on the three frames and perhaps to the animated surfaces of the paintings the frames surround. Even the teapot bears a relationship to the work by Gauguin, as its spout mirrors the shape of the stick resting on the beach.

In the gallery ensembles, paintings by Pierre-Auguste Renoir are often arranged along axes that constitute simple geometric shapes. Here, five canvases by the artist form a pyramid, with a small head of a girl presiding at the apex. Two fleshy nudes fill out the corners, perhaps relating to the nearby paintings by Prendergast in terms of their compressed pictorial space. The more obvious relationship, however—and one that certainly reveals Albert Barnes's sense of humor—is with the eighteenth-century Windsor armchairs below; with their wide seats, they seem like a translation of the painted bodies into three dimensions. Curvaceous door hinges at the top left and top right of the wall seem also to correspond to the fleshy bodies of Renoir's women. ML

French
Sign for a Locksmith,
18th or early 19th century
PAGE 130

Francisco de Goya y Lucientes
Portrait of Jacques Galos, 1826
PAGE 130

Pierre-Auguste Renoir
*Nude in a Landscape (Nu dans
un paysage)*, C. 1917
PAGE 131

Georges Seurat
Two Sailboats at Grandcamp, C. 1885
PAGE 131

Édouard Manet
Tarring the Boat (Le Bateau goudronné), July–August 1873
PAGE 132

Maurice Brazil Prendergast
Idyl, C. 1912–1915
PAGE 132

Paul Gauguin
Haere pape, 1892
PAGE 133

Sign for a Locksmith, 18th or early 19th century
France
Iron. 24 ⅛ x 8 ⅝ x 2 ⅝ (61.3 x 21.9 x 6.7). 01.06.28

Unlike many of the metalwork objects in the collection created for everyday use — small items such as ladles, scissors, and hinges — this eighteenth-century key originally served a more decorative purpose. Measuring about two feet in length, it was made as a sign for a locksmith's shop in France. The decoration is ornate, perhaps to show off the skills of the artisan who owned the shop.

The key's head features three overlapping circles, inside of which tendrils curl into delicate spirals in a virtuoso display of metal forging. Areas of repoussé (low relief created by hammering the metal from the reverse) are also seen in the key's head, specifically in the heavier border enclosing the central design, where the metal is molded into sculptural shapes that stretch over the circles like fingers. The key's head is left open so that a long, thin stake protrudes just slightly, its looped end serving as one of the sign's hanging elements; joined to the larger piece only at the circle, the stake touches nothing else along its path. ML

Francisco de Goya y Lucientes (Spanish, 1746–1828)
Portrait of Jacques Galos, 1826
Oil on canvas. 21 ¾ x 18 ¼ (55.2 x 46.4). BF5

In 1824, citing illness and the need for a foreign cure, Francisco de Goya left behind his native Spain for self-imposed exile in France. He settled in Bordeaux, where he found a colony of politically progressive Spanish expatriates who feared the repressive rule of their monarch, Ferdinand VII. Goya remained creatively engaged there and worked daringly in a variety of media — drawing, lithography, miniatures, and painting — although his production was necessarily limited by his declining health. He painted hundreds of portraits during the course of his career but executed just over a dozen in his last eight years — largely of members of his circle.

Jacques Galos, addressed as "Santiago" in Goya's Spanish inscription at lower left, served as the governor of the Bank of Bordeaux and managed the artist's financial affairs, a source of deep concern to Goya, who wished to guarantee an inheritance for his grandson Mariano. Goya worked with a subdued palette of black, olive, and blue, using the white of Galos's stiff collar, elegantly knotted cravat, and graying hair to frame his sitter's face. Goya conveyed the barely contained vibrancy and intelligence of his friend in his treatment of Galos's pink cheeks and lively gaze. As scholars have noted, the artist routinely inscribed these last works with an indication of his age — eighty — demonstrating his pride in his continued productivity.[1] JFD

1 For more on Goya's Bordeaux works, see Brown 2006, especially page 84 on this painting.

Pierre-Auguste Renoir (French, 1841–1919)
Nude in a Landscape (Nu dans un paysage), c. 1917
Oil on canvas. 32 × 24 ⅛ (81.3 × 61). BF975

Nude bodies presented outdoors were a staple for Pierre-Auguste Renoir over the course of his long career. It was only during the last decade of his life, however, that they began filling his canvases to the bursting point, as he became increasingly obsessed with rendering the nuances of flesh and conveying its particular tactility. Pushed up close to the picture plane, the bather here seems too large for the canvas, the expanse of her back taking up nearly half the composition. The background churns around her, pushing her forward rather than absorbing her into the pictorial space—an effect that only augments this figure's inescapable palpability. In the flesh itself, patterns of purples, reds, and blues along her spine mimic the swirling motions surrounding her. This is a portrait of the body's surface, of its dimples and pinkish color, but one that also hints at bones, blood, and veins.

In these very late canvases, Renoir worked with paint diluted with linseed oil or turpentine, a medium at times so liquid that it would run down the canvas. The thinned paint was then applied in layers that gradually resulted in massive forms, such as the nude in this picture. Some of the dripped paint is evident near the bottom, especially around the signature. The thin glazes allowed not only the colors beneath to show through but also the canvas weave, the texture of which helps to lend the figure its velvety appearance. The model here is Andrée Heuschling, a red-haired young woman who appears in countless pictures from the artist's last few years and who later married Renoir's son Jean. ML

Georges Seurat (French, 1859–1891)
Two Sailboats at Grandcamp, c. 1885
Oil on panel. 6 ¼ × 9 ¹³⁄₁₆ (15.8 × 25). BF1153

Embarking on a series of marine landscapes—a favored subject matter for ambitious painters who wished to tackle the challenges of ever-changing weather and light conditions—Georges Seurat spent the summer of 1885 painting in Grandcamp, a small fishing village on the Normandy coast. Although the artist conceived and executed his methodically planned exhibition paintings in the studio, he often made small preliminary studies on wood panels, or *croquetons*, before the motif, revealing an improvisational handling in stark opposition to the precisely placed touches of the pointillism he pioneered in manifesto works such as *A Sunday on La Grande Jatte—1884*, 1884–1886 (The Art Institute of Chicago), and *Models* (p. 75).

In this small work, Seurat cleverly but simply established the seeming infinitude of the seascape with two lateral bands for sky and sea stretching from end to end on the panel. While two pleasure boats skimming across the placid blue-green water dominate the fore- and middle ground, the hint of a sail—a single wedge-shaped stroke—on the horizon marks the spatial depth of his composition. Consistent with the seascape's emphatic horizontality, Seurat rendered air and water in a staccato of horizontal dashes, making them slightly longer for the pale sky. He exploited the warm, dark tones of his panel, leaving portions unpainted to capture the *contre-jour*, or silhouette, effect of the bright light obscured by the angular sails of the pleasure boats. JFD

Édouard Manet (French, 1832–1883)
Tarring the Boat (Le Bateau goudronné),
July–August 1873
Oil on canvas. 19 11/₁₆ x 24 ⅛ (50 x 61.2). BF166

Édouard Manet made his name with provocative scenes of Parisian life, but his summer retreats to seaside resorts offered an opportunity to paint *en plein air* and to explore one of his earliest interests—the ephemeral conditions of the sea, sky, and coast. In the hopes of joining the navy as a young man, Manet made a transatlantic voyage from Le Havre to Rio de Janeiro in 1848. It allowed for an in-depth contemplation—if not recording—of the elements, as he later described to a fellow painter: "I spent countless nights watching the play of light and shadow in the ship's wake. During the day, I stood on the upper deck gazing at the horizon. That's how I learned to construct a sky."[1]

In 1873, Manet and his family visited Berck-sur-Mer, a quiet fishing village on the Channel coast well known for its restorative hydrotherapies. Without a port in which to shelter their boats, the fishermen of Berck beached their flat-bottomed vessels on the nine-mile stretch of coast that extended to Le Touquet.[2] The shank and crown of a large anchor in the lower left foreground draw the eye toward the center of the canvas, where a fishing boat with a mast lists to the left, its bowsprit and riggings pointing toward the high horizon. Two men apply flaming tar to the side of the boat to make the overlapping planks of its hull watertight. Spewing a greasy black smoke carried by the sea breeze, the fiery blaze glows in pinks, reds, and yellows, a

stark contrast to the gleaming black of the hull and the grays, beiges, and yellows of the sand. With a few white horizontal streaks, Manet suggests the chop of the waves and the clouds in the sky. JFD

1 The art dealer Ambroise Vollard included this quote in his *Souvenirs d'un marchand de tableaux*, first published in 1937, repeating a quote attributed to Manet and relayed to him by the painter Charles Toché. See Juliet Wilson-Bareau and David Degener, "Manet and the Sea," in Wilson-Bareau and Degener 2003, 56.
2 Wilson-Bareau and Degener 2003, 81–84.

Maurice Brazil Prendergast (American, 1858–1924)
Idyl, c. 1912–1915
Oil on canvas. 24 x 32 ⅛ (61 x 81.6). BF113

For this scene of urbanites at their leisure in the countryside—a subject of frequent exploration for Maurice Prendergast—the painter drew on the traditions of the classical landscape and the aristocratic *fête champêtre*, or outdoor entertainment. His clothed and nude female figures frolic in the lushly verdant landscape with its full trees, rolling hills, sturdy boulders, and teeming waterfall. Prendergast's subject summoned the rich art-historical legacies of Giorgione, Nicolas Poussin, and Antoine Watteau, but it also evoked more contemporaneous avant-garde directions. The Edenic sensibility echoes Paul Gauguin's Tahitian fantasies, while the friezelike composition calls to mind the French artist's manifesto work of 1897–1898, *Where Do We Come From? What Are We? Where Are We Going?* (Museum of Fine Arts, Boston).[1] Evenly bunching his figures in

conversational groupings, Prendergast provided the veneer of narrative but focused on creating a rhythm that draws the eye across the canvas: a screen of regularly spaced trees, a zigzag of standing and seated figures, and an alternation of patterned and solid clothing (for the attired). Prendergast's distinctive, individualized touches, which lend the canvas its rough texture, drew on the mosaic tradition that he knew well from his 1898–1899 trip to Venice, as well as the pointillism of Georges Seurat and the decorative patterning of the Nabis. JFD

1 Wattenmaker 1994, 120–123.

who exists in perfect harmony with the landscape. Standing barefoot on the shore and wearing nothing but a flowered Polynesian skirt, she is uninhibited, comfortable in her nakedness. The figure's unity with her surroundings is reinforced by the triangle of land and trees forming a perfect frame for her body, and by the patterns in the water at lower right that echo the print of her skirt. Her expression is serene, and she stands stiff and immovable—an effect that may derive from Gauguin's use of Javanese relief sculpture as inspiration for her pose but that also reinforces the sense of a culture frozen in time.

The painting unfolds in a series of triangular zones moving from foreground to background, with a salmon pink triangle anchoring the center. At the bottom, the inscription "Haere pape" reflects Gauguin's idiosyncratic take on the Tahitian language. It cannot be directly translated, but its general meaning is "she goes down to the fresh water." ML

Paul Gauguin (French, 1848–1903)
Haere pape, 1892
Oil on canvas. 36 x 26 ½ (91.4 x 67.3). BF109

After painting in Brittany for several years, Paul Gauguin set sail for Tahiti in 1891 in search of an exoticism that he could not find in Europe. For Gauguin, Tahiti represented a place of untouched innocence—a culture frozen in some perpetually primitive state, uncorrupted by modern industry and uptight European social mores. Although the island was in fact modernizing, Gauguin nevertheless depicted the Tahiti of his fantasy, focusing especially on its beautiful brown-skinned women.

In *Haere pape*, Gauguin presents a young Tahitian woman as a lovely, natural creature

ROOM 7

WEST WALL

At the core of this ensemble is a cross-shaped arrangement of canvases by Pierre-Auguste Renoir. The artist's 1875 *Before the Bath* marks the center; two smaller nudes hang above, near a still life of apples and lemons whose pearly surfaces seem to imitate the skin of the nude bodies. Below is a glazed earthenware vase made by the painter's son, Jean. (Albert Barnes often paired Jean's pottery with the work of his father, as in Room 13, north wall.) Renoir's painting of Jean as a baby hangs at the apex of this grouping, extending the vertical axis.

Before the Bath is placed between Paul Cézanne's *Spring House* and Claude Monet's *Madame Monet Embroidering*, forming a trio of French works all painted in the 1870s. Their differences are significant, however, especially in terms of the use of light. While the Renoir torso glows against the dark blues of the interior setting, the Cézanne landscape is flooded with an even, outdoor light. Monet brings natural light through the window, using it to dissolve, slightly, the forms of his interior. Paintings by Paul Gauguin and Georges Seurat round out the grouping, and slipped in among these are two landscapes by the American painter Maurice Prendergast, whose debt to the French masters is evident.

Two paintings revealing an entirely different sensibility frame the ensemble. These are *Saints John the Baptist and Jerome* and *Saints Barbara and Mary Magdalene*, an important pair of fifteenth-century German panels hanging at far left and far right, respectively. In both subject and style, these religious works seem surprisingly out of place on this wall. Yet their abstract, gold-leaf backgrounds, against which the figures float ambiguously, are perhaps not so far removed from the flattened bands of color in modern pictures such as the one by Gauguin. ML

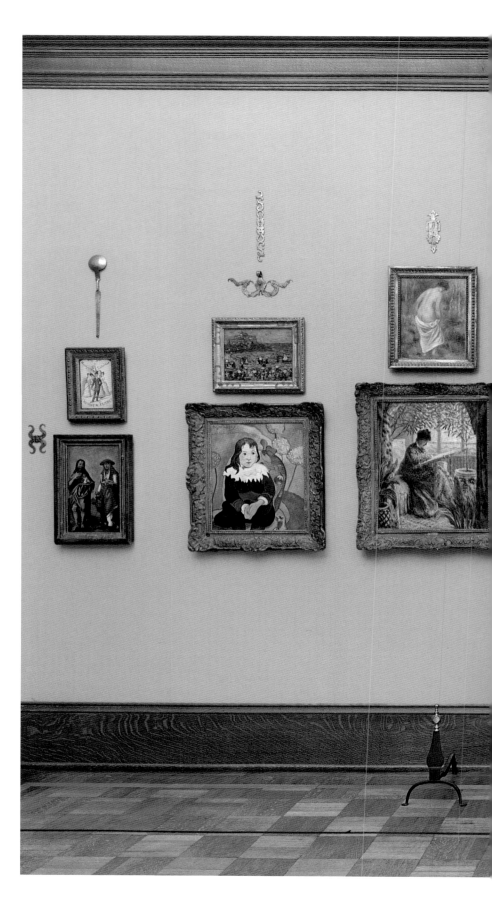

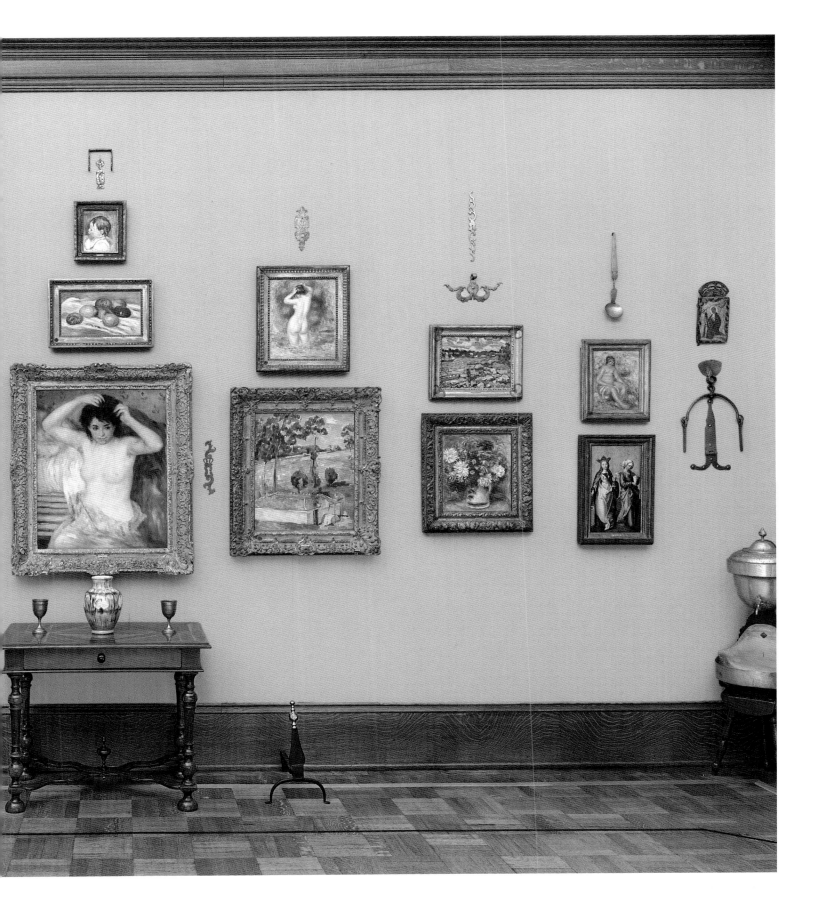

Paul Gauguin
Mr. Loulou (Louis Le Ray), 1890
PAGE 144

Claude Monet
*Madame Monet Embroidering
(Camille au métier)*, 1875
PAGE 144

Edgar Degas
Bathers, c. 1895–1900
PAGE 145

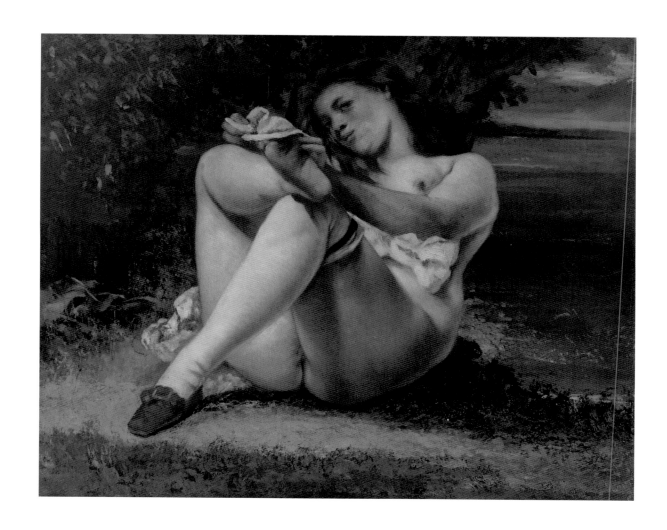

Gustave Courbet
*Woman with White Stockings
(La Femme aux bas blancs)*, 1864
PAGE 145

Pierre-Auguste Renoir
Before the Bath (Avant le bain),
c. 1875
PAGE 146

Rhenish Master
Saints John the Baptist and Jerome, c. 1475–1480
PAGE 147

Georges Seurat
The Ladies' Man (L'Homme à femmes), 1890
PAGE 147

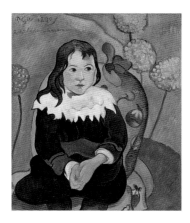

Paul Gauguin (French, 1848–1903)
Mr. Loulou (Louis Le Ray), 1890
Oil on canvas. 21 ¾ x 18 ¼ (55.2 x 46.4). BF589

Earning a lucrative living as a stockbroker, Paul Gauguin came belatedly to his artistic career. He first collected works by the impressionists and then painted and exhibited in their idiom under the tutelage of Camille Pissarro. After the stock market crash of 1882, Gauguin definitively left behind his career in finance and passionately pursued his new vocation. Like the painters Émile Bernard, Paul Sérusier, and Maurice Denis, Gauguin ambitiously sought to define a distinctive style—synthetism. This mode fused direct observation with the emotional and imaginative response of the painter, resulting in boldly painted images in non-naturalistic, unmodulated colors that evoked the dream and the mystical.

Beginning in 1886, Gauguin sojourned in Brittany, whose inhabitants, seemingly untouched by modernization, remained dedicated to their customs. Moreover, their devout adherence to their Catholic faith proved appealing to and influential for the painter's visionary interests. Here, Gauguin paints Louis Le Ray, the son of friends in Le Pouldu, a coastal Breton village where the painter worked in the summer of 1890. With a thick black line that became associated with his style, known as "cloisonnism" for its formal affinities to enamelwork, Gauguin traced the sinuous contours of the boy's long tresses, white collar, and blue smock as well as the vegetal motifs on the pink floral chair on which he sits; these curling lines enliven an otherwise still portrait. The artist further introduced a note of the fantastical into his portrait, placing his sitter against saturated fields of green and orange with towering hydrangeas and a violet-colored flower creeping over the back of the chair. Although these full blossoms and the bright bands of color suggest the rolling hills of a lush landscape, the sitter's disconnected sidelong glance suggests access to the realm of his dreams and imagination.[1] JFD

1 Marla Prather, "M. Loulou," in *Great French Paintings* 2008, 164.

Claude Monet (French, 1840–1926)
Madame Monet Embroidering (Camille au métier), 1875
Oil on canvas. 25 ¾ x 22 (65.4 x 55.9). BF197

Although Claude Monet's daring handling of nature's transient effects, his subjects of modern life, and his affiliation with the impressionists established his avant-garde credentials, this painting of his wife, Camille Doncieux, at her embroidery loom recalls seventeenth- and eighteenth-century Dutch and French depictions of women diligently attending to needlework—a sign of virtuous devotion to the home and family.[1] Absorbed in her handiwork, Madame Monet sits by the window in the cozily appointed home that the artist rented in Argenteuil, a suburb of Paris, in 1874.

Monet painted interiors infrequently, preferring the open-air challenges of the field, the river, the sea, and the sky. Without a glimpse of the world beyond the drawn shade, he turns his hand here to a domesticated aspect of nature. Floral-patterned curtains along with potted plants and laurel trees frame Madame Monet, ensconcing her within a natural realm and its attendant associations with femininity and fecundity. These organic forms contrast with the geometric patterns of the wall covering, the rug, and the blue-and-white urns. Monet bathes his wife in the soft light that filters through the translucent shade, subtly highlighting her eyelid and right cheek as well as the embroidery on her loom and the details of her elaborately

decorated dress. Often celebrated for the broad brushwork seen in contemporaneous paintings such as *The Studio Boat* (p. 167), Monet here produced an uncommonly delicate lattice of twinkling touches. JFD

1 For more on avant-garde depictions of this traditional subject, see Gedo 1995, 407–416.

Edgar Degas (French, 1834–1917)
Bathers, c. 1895–1900
Pastel with charcoal on blue (?) wove paper. 23 ¼ x 29 (59.1 x 73.7). BF153

Like his contemporaries Pierre-Auguste Renoir and Paul Cézanne, Edgar Degas maintained a long-standing interest in the subject of female bathers, nimbly addressing the theme in an impressive array of media—paintings, drawings, pastels, prints, and even sculpture. While Degas sited these scenes primarily in interiors—bedrooms and brothels—in the 1870s and 1880s, pastels from the second half of the 1890s placed his bathers in lushly verdant, if somewhat mysterious and oddly claustrophobic, landscapes. Here, the recumbent and standing nudes are enveloped by a vivid green carpet of grass that contrasts with their glowing pink flesh and vibrantly hued textiles, which are gathered in pools of solid turquoise as well as patterned green on coral and purple on red. Paradoxically, the fluid line of Degas's skilled draftsmanship captures in black charcoal the ungainly, angular contours of the folded and contorted bodies of the reclining nudes as well as the knock-knees of the cropped standing figure in the foreground. These unusual postures recall the painter's much earlier and disconcertingly

violent *Scene of War in the Middle Ages*, 1863–1865 (Musée d'Orsay, Paris).[1] The position of the figure at right and the bright green drapery that runs along her right leg disturbingly obscure the face of the central bather, revealing a red slash for the mouth and a blue smudge for the eye. JFD

1 For recent examination of Degas's bather scenes, see Shackelford et al. 2011. George T. M. Shackelford specifically discusses the late bather scenes and the relationship to *Scene of War in the Middle Ages* in "The Body Transformed: Degas's Late Nudes," in Shackelford et al. 2011, 155–211.

Gustave Courbet (French, 1819–1877)
Woman with White Stockings (La Femme aux bas blancs), 1864
Oil on canvas. 25 9/16 x 31 7/8 (65 x 81). BF810

Woman with White Stockings is one of several explicitly sexual paintings Gustave Courbet produced during the 1860s. *Sleepers* (Musée du Petit Palais, Paris), for example, a scandalous canvas of 1866, shows two nude women entwined in erotic abandon; *The Origin of the World* (fig. 1, p. 146), though it does not show a sexual act, is even more radical for its frank, close-up view of female genitalia. In the latter painting, the body is truncated at the knees and breasts.

The present work shows a nude woman reclining outdoors, wearing only one red shoe and a long stocking pulled up over her knee. Her clothing sits piled in the grass, while a body of water appears at right; in a sense, then, the painting contains the conventional tropes of the bather-in-a-landscape subject. Yet here, the contained sensuality of the traditional bather picture is turned inside out, and the viewer is given a full glimpse of the woman's

sex. Indeed, this is the picture's subject, as it is in *The Origin of the World*, though here a hint of narrative heightens the erotic effect. While the sexual act is not shown, it is implied. The nude looks seductively at a presence outside the frame—this is perhaps a moment post-copulation, as she sits awkwardly pulling on her clothes. The setting is strange, uncomfortable, as she leans near a precipice and rests her naked bottom next to a dirt path. This is not nature in harmony with the female body, à la Pierre-Auguste Renoir, but rather nature used, hastily, as a place for sex.

Both *Sleepers* and *The Origin of the World* were commissioned by the Turkish diplomat Khalil Bey. While the early ownership history of *Woman with White Stockings* is unknown (Albert Barnes bought it from the dealer Henri Barbazanges in 1926), it is likely that it, too, was originally a commission made for private enjoyment; the work was never exhibited during the nineteenth century. There is some speculation that the painting represents Courbet's mistress, Léontine Renaude. This seems unlikely, however, as Courbet ended the relationship with Renaude in 1862, two years before completing this picture. ML

Pierre-Auguste Renoir (French, 1841–1919)
Before the Bath (Avant le bain), c. 1875
Oil on canvas. 32 3/16 x 26 3/16 (81.7 x 66.5). BF9

A woman seated in a modest interior undresses for a bath. The scene is intimate: nude from the waist up, she rummages with her fingers through disheveled hair, as if removing pins. Rumpled bedclothes can be glimpsed in the background, and a blue garment, perhaps her dress, is thrown casually in a heap. As the bather's clothing falls around her waist, her dark eyes glance up with a look of modesty rather than one of seduction. The space is shallow and cramped, her body close to the picture plane; the viewer has entered this woman's private space.

Fabric surrounds the bather on all sides, rendered with lively purples, yellows, and

whites applied in long, thick strokes. The rendering of the figure is more reserved, however. Classically proportioned and carefully modeled, the torso demonstrates little of the daring of the artist's famous *Effect of Sunlight*, 1875–1876 (Musée d'Orsay, Paris), in which the surface of the body, this time set outdoors, is disrupted by splotches of pale green light and purple shadows.

If *Before the Bath* seems relatively subdued to our eyes, the picture caused a fair degree of commotion when it was first displayed in 1875. That year, with several of his fellow impressionists, Pierre-Auguste Renoir offered a number of new works at a public auction that scandalized Parisian audiences. We do not know exactly what it was about this picture that offended, but one can guess it was its strange mixture of the real and the ideal. For while the bather, on the one hand, is a beautiful Venus de Milo torso, on the other she is also an ordinary French woman. Her features, though not unattractive, are certainly not ideal, and the underarm hair was too realistic a detail that French audiences were not accustomed to seeing in their art. ML

Rhenish Master
Saints John the Baptist and Jerome,
c. 1475–1480
Oil and gold on panel. 17 ¾ x 10 ¼ (45.1 x 26). BF95

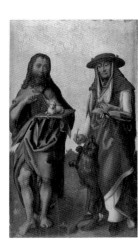

Saint John the Baptist stands at left, his traditional camel-hair tunic peeking out from beneath blue robes. The small lamb refers to his legendary recognition of Jesus as the sacrificial Lamb of God. Saint Jerome, at right, is also presented with the traditional attributes symbolizing his life: a book with open pages, referring to his vocation as a scholar and translator; a red robe and hat signifying his status as a cardinal; and the lion whose paw he tended while exiled in the desert, reaching up affectionately. This and a similar panel showing Saints Barbara and Mary Magdalene may have formed the wings of a small devotional triptych. In Albert Barnes's collection, the two paintings form a set of wings around an ensemble of paintings; he bought the panels together in 1914 and chose to display them at opposite ends of the wall.

This panel is finely painted, with individual strands of hair discernible in John's beard and tunic, and in the lion's fur. An elaborately tooled gold background, possibly modern, filled with vinelike forms spreading all around the figures, suggests an abstract, otherworldly space. The bodies, by contrast, are rendered with a stunning naturalism. The legs in particular are carefully modeled with light and shadow and stand solidly in the space defined by the grass, while the faces bear convincing wrinkles. Though stylistically the work is often associated with the school of Albrecht Dürer, it seems more in the manner of other German painters, such as Martin Schongauer of Strasbourg or the Master of the Saint Bartholomew Altar in Cologne. ML

Georges Seurat (French, 1859–1891)
The Ladies' Man (L'Homme à femmes), 1890
Oil on panel. 9 ¹³/₁₆ x 6 ⁵/₁₆ (25 x 16). BF1149

This small painting is a study for the cover of *L'Homme à femmes*, a novel by the Polish writer Victor Joze that offered a droll critique of Parisian Belle Époque society. Part of a series called "La Ménagerie sociale," the book tells the story of a writer, pictured here in a top hat, and his scandalous relations with a prostitute, a stage actress, and a *café-concert* singer—all entertainers of a sort. Georges Seurat also produced an ink drawing of the same dimensions and layout that ultimately became the book's cover. While the oil painting was made first, the drawing, more legible and rendered with greater detail, probably translated more readily to the cover format.

As in his other paintings related to the theme of entertainment, Seurat here took a satirical attitude toward his subjects, also following the tone of the book. The man stands with silly confidence, holding a phallic cane; a troupe of admiring women steal glances as they huddle behind him. The women's curiosity is exaggerated by the figure in red craning her neck and by the pair of opera glasses held by the woman in yellow (a detail that is clearer in the pen drawing). Layers of brightly colored dots animate the work, filling it with energy, while the upward sweep of the text evokes gaiety. In the man's theatrical address of the viewer and in the arrangement of image and text, the painting is indebted to the popular poster art of Jules Chéret, whose work Seurat collected. ML

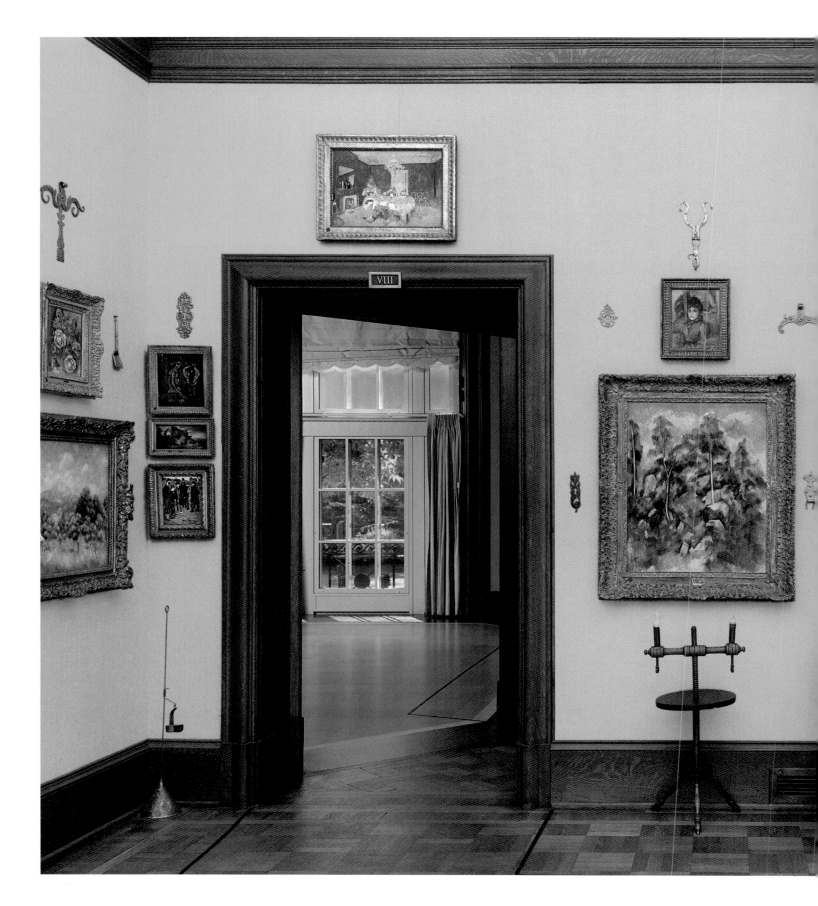

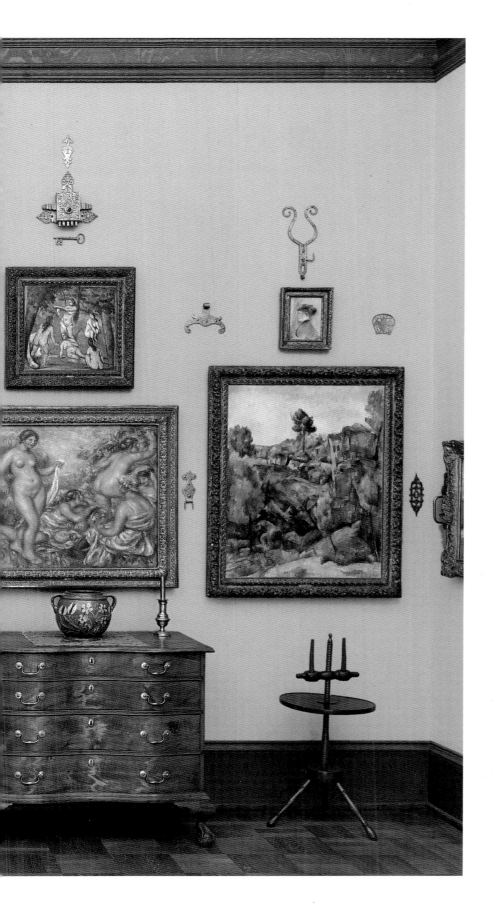

ROOM 8

SOUTH WALL

This is one of the most tightly designed ensembles in the Gallery. Pierre-Auguste Renoir's *Composition, Five Bathers* occupies the center, and two small portraits by the artist hang at upper left and right. This V-shape of works by Renoir interlocks with an upside-down V of paintings by Paul Cézanne — a small picture of bathers and two large landscapes. The overall hanging structure mimics the pyramidal arrangement of the figures depicted in the two bathing scenes.

Renoir's *Composition, Five Bathers* is a painting devoted to curves. These are echoed in the eighteenth-century American chest below, the front of which is carved in gentle waves that catch the light, much like Renoir's volumes, and in a pair of hinges on either side that in this context recall the female body's silhouette. Still more curves are found in the American redware pot and in the two candlestands. The landscapes by Cézanne offer a sharp contrast to these undulations, with angular, jutting forms, and yet their earthy red tones link them to the painting by Renoir and also to the furniture and decorative objects along this wall.

The juxtaposition of bathing groups by Renoir and Cézanne is fruitful, if unexpected. Here are two artists whose conception of the female body could hardly be more different, one offering soft, rolling forms and the other hard, angular ones. Yet the installation reveals a certain commonality to their artistic projects that is often missed. In each of these bathing scenes, the human body has an emphatic physical presence, and in each the figures are arranged in a shallow space that flattens out so that the eye moves continually around the composition. ML

American
Pot, 1780–1810
PAGE 158

Charles Prendergast
Angels, c. 1917
PAGE 158

Paul Cézanne
Still Life (Nature morte),
1892–1894
PAGE 158

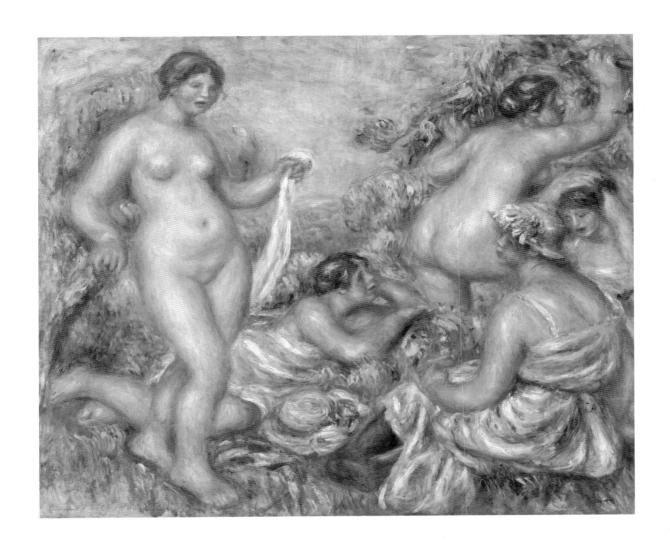

Paul Cézanne
Rocks and Trees (Rochers et arbres), c. 1904
PAGE 159

Pierre-Auguste Renoir
*Composition, Five Bathers (Composition,
cinq baigneuses)*, c. 1918
PAGE 160

Paul Cézanne
Five Bathers (Cinq baigneuses), 1877–1878
PAGE 160

Paul Cézanne
Bathers at Rest (Baigneurs au repos),
1876–1877
PAGE 161

Pot, 1780–1810
United States, Maryland
Redware. 8 ³/₈ x 11 ³/₄ x 9 ³/₈ (21.3 x 29.8 x 23.8). 01.08.49

Charles Prendergast (American, born Canada, 1863–1948)
Angels, c. 1917
Tempera, graphite, silver and gold leaf on carved, incised, gessoed panel. 25 ¹/₈ x 33 ¹/₂ (63.8 x 85.1). BF520

Charles Prendergast was a craftsman and frame maker before he became a painter. He is best known for his finely carved frames, many of which surround paintings in the collection of the Barnes Foundation. He used a multitude of materials in his distinctive gessoed, carved, and gilded panel paintings, chests, and screens, which he began to produce in 1912. With their flattened spaces, rich gilding, unmodulated tempera application, delicately incised surfaces, and allusions to biblical subject matter, Prendergast's panels evoke Byzantine mosaics as well as the frescoes and panel paintings of the early Renaissance. The artist absorbed these sources firsthand when he traveled to Italy with his brother Maurice in 1911 to 1912. He later also described the lure and influence

of the collection of Persian miniatures at the Museum of Fine Arts, Boston, where he studied in his youth.[1]

In this richly worked panel, Prendergast created an Edenic scene of plenitude with a landscape filled with bright flowers, regal animals, full trees, rounded hills, vast lakes, and gently sloping mountains. He established spatial recession with overlapping and vertically stacked planes of saturated color. The rhythmic rise and fall of the stones, hills, and mountains, as well as the friezelike arrangement of the figures, carry the eye across the composition. Incising his gessoed panel, Prendergast delineated clear contours for the geographical features of the landscape and for each petal, leaf, and tress of hair. While his spatial composition is legible if simplified, the narrative of the work remains elusive: winged and haloed angels mingle among the inhabitants of this otherworldly realm, who, save for one nude figure at right, wear exotic costumes that simultaneously suggest the artist's varied European and Eastern sources. JFD

1 Ross Anderson, "Charles Prendergast," in Clarke, Mathews, and Owens 1990, 88.

Paul Cézanne (French, 1839–1906)
Still Life (Nature morte), 1892–1894
Oil on canvas. 28 ³/₄ x 36 ³/₈ (73 x 92.4). BF910

Paul Cézanne focused on still life during the 1890s, studying the relationships between fruit, fabric, and kitchen items such as the faience milk pitcher shown here. If this is one of the most stunning still lifes of Cézanne's career, it is also one of the most complex. A bowl of oranges marks the composition's center; apples at the arrangement's outer edges create symmetry. Bright yellows appear at regular intervals across the fruit in the foreground, while repeating geometric shapes, especially circles and triangles, lend the composition a tight order. Yet this order is jeopardized by the tilting perspective of the table and by its diagonal edge cutting across the foreground. Indeed, the whole arrangement looks as though it might slide off the

table — a few apples and lemons are precariously close to the edge — so that the picture is at once about stasis and motion, stability and instability.

A brilliant colorist, Cézanne here created the illusion of luscious round apples through the simple juxtaposition of reds and yellows; no shadows are necessary. Also striking is the use of fabric, not just in setting off the colors of the fruit, but in actively organizing the space of the tabletop. The bright white napkin that so dominates the composition is a complicated structure in its own right, filled with shadows, peaks, and valleys. Its presence adds depth and establishes the space between objects; several pieces of fruit are cradled within the napkin's crevices, while others sit behind it. A patterned curtain establishes the table's back edge and comes to a triangular peak above three limes. Together with the white napkin, it forms a landscape against which the still-life objects exist and articulate themselves. ML

Paul Cézanne (French, 1839–1906)
Rocks and Trees (Rochers et arbres), c. 1904
Oil on canvas. 32 ¼ x 26 (81.9 x 66). BF286

Having widely explored the landscape around his native Aix-en-Provence as a schoolboy and again as a mature painter in search of motifs, Paul Cézanne intimately knew the territory around the ancient sandstone quarries of Bibémus and the complex of buildings of the Château Noir, a manor house about two and a half miles east of the city. In the mid-1890s, he rented a small cabin near the quarries to store his painting materials and pass the

occasional night, establishing a base for excursions in this region in the last decade of his life. Painting this rugged terrain, Cézanne deployed warm ochers and reds for the sandstone bluffs, neutral grays for the limestone boulders, cool mauves and blues for sky and shadow, and crisp greens for the bristly underbrush and the needles of the coniferous trees. With limited use of line or contour, the artist's parallel brushstrokes — grouped in facets and juxtaposed in varying orientations — describe the volumes of the jagged rocky and bushy vegetal forms of the steep elevation. Despite the isolation of the locale, three trees rise resolutely toward the sky, exerting a tenacious and noble presence. Their thin, straight trunks complement the blocky, jumbled masses of the rocky hillside.

Sometimes leaving the primed but unpainted canvas bare, Cézanne applied his paints in both thin films and thick touches. This is especially evident in the sky, where these alternate treatments convey the animation of the sky and its changing cloud formations. JFD

Pierre-Auguste Renoir (French, 1841–1919)
Composition, Five Bathers (Composition, cinq baigneuses), c. 1918
Oil on canvas. 26 ½ x 32 (67.3 x 81.3). BF902

In the last ten years of his life, when Pierre-Auguste Renoir was living in Cagnes-sur-Mer, bathing scenes like this picture came to dominate his production. Gone are the glimpses of contemporary urban and suburban life from his impressionist years; boulevard scenes and boaters' lunches have been exchanged for timeless visions of Arcadia. In *Composition, Five Bathers*, idealized nudes are cradled by a sun-dappled Mediterranean landscape. Bodies are fleshy and palpable, with a heavy round-ness that evokes sculpture; indeed, the standing figure on the left was also realized in bronze, in a work called *Danseuse au voile (Dancer with Veil)*, c. 1913 (private collection). These are wholly corporeal creatures with little psychic dimension, and their flesh fills the canvas from corner to corner—an antimodern fantasy, perhaps, of the body in its natural state.

As in so many of his works, Renoir presents a perfectly harmonious relationship between the female body and the natural world. Foliage follows the contours of each bather, arching around the standing figure and the one climb-ing at right. Pinkish tints in the skin are carried through every part of the landscape. Yet as much as Renoir was interested in "the natural," throughout the composition nature is continually subsumed by artifice. The figures are not so much actors in a real space as elements of a larger decorative scheme, and their poses are motivated entirely by the artist's compositional goals. ML

Paul Cézanne (French, 1839–1906)
Five Bathers (Cinq baigneuses), 1877–1878
Oil on canvas. 16 x 16 ⅞ (40.6 x 42.9). BF93

In the 1870s, Paul Cézanne painted several small works devoted to the subject of bathers—a theme with which he engaged continually over his career, culminating in *The Large Bathers*, 1895–1906 (p. 62). Deploying a compositional strategy that became a hallmark of his approach to such scenes, Cézanne used a shady canopy of angled trees to frame the standing, seated, and reclining female bathers gathered in a pyramidal arrangement, a deft echo of the foreground trees. Uncomfortable sketching or painting the female nude from life, he endowed his figures with sturdy physiques but differentiated them with varying poses and coiffures. Although Cézanne stacked his figures vertically to suggest spatial recession, he did not diminish their scale, as is particularly noticeable in the bather at the upper right. Executed with a distinctive stroke—parallel touches applied visibly but evenly across the canvas—his variation of greens, yellows, and blues establishes the patterns of light and shadow created by the sunlight filtering through the leaves, and suggests the contours of the hill. A similar treatment for the trees and the bathers conveys the texture of the bark and the rosy softness of flesh, respectively.

Albert Barnes bought this small canvas at the posthumous sale of works belonging to the industrialist and collector Henri Rouart in Paris in December 1912, in his first year of major

collecting efforts. This purchase prompted consternation in more conservative quarters, as *Burlington Magazine* noted: "It was amusing to watch a certain section of those present at the Rouart sale while what they had been accustomed to consider secondary pictures went up to prices hitherto undreamed of. When Cézanne's little *Baigneuses*, measuring only 16 by 17 inches was put up to 18,000 [francs] at which price it was bought by Mr. Barnes, an American collector, there was derisive laughter from some of the worthy dealers and others in my neighborhood. Who, they evidently thought, are the lunatics let loose among us? As the sale proceeded, their derision turned to indignation, for they saw all of their standards of value shattered."[1] JFD

1 R.E.D. 1913, 240; also cited in Wattenmaker 2010, 22.

Paul Cézanne (French, 1839–1906)
Bathers at Rest (Baigneurs au repos), 1876–1877
Oil on canvas. 32 5/16 x 39 7/8 (82 x 101.3). BF906

Paul Cézanne exhibited *Bathers at Rest* at the third impressionist exhibition in 1877. In the 1870s he had been working closely with Camille Pissarro, who encouraged him to paint directly from nature — a central tenet of the impressionist approach. Cézanne wrestles here with the naturalist lessons of Pissarro and his colleagues but ultimately throws off the yoke to produce one of the great masterworks of his career, a painting unlike anything that had come before it.

The canvas shows a group of male bathers in a landscape around Aix-en-Provence, with Mont Sainte-Victoire towering in the distance. Two bathers wade in the water, another reclines on the grass, and a fourth seems to be either stretching or undressing. Despite their physical proximity, there is no interaction among the figures; each occupies a separate zone and looks in a distinctly different direction. If critics in 1877 were perplexed by the bathers' strange behavior, they also disapproved of their aggressively strange anatomies. The gender of the reclining figure, for example, is difficult to read, and the bather in the foreground — to whom Cézanne would return years later, in his *Bather* of 1885 (The Museum of Modern Art, New York) — stands with hunched shoulders and pawlike hands of a jarring reddish color. In this figure especially, the paint is so thick as to be almost sculptural. Across his torso, the colors shift suddenly in patches of green and yellow, while a disruptive blue shadow cuts into his shoulder, its sharp edge mimicking the shape of the mountain.

In *Bathers at Rest*, the impressionist concern with the fleeting effects of light and atmosphere is exchanged for something much more structural. Paint is deployed to build solid forms that are insistent in their physicality — the nude bodies, for example, which are reiterated in the structure of the landscape. Clouds are not misty and vaporous, as one might expect, but thick, material entities that seem carved into the sky. Perhaps the most radical moment in this picture is the bright green patch of light falling in a perfect triangle. Cézanne is working from nature, observing it intently and yet developing his own idiosyncratic vocabulary for representing it. This was the central contradiction of the artist's project, and he would struggle with it, to brilliant result, for the rest of his life. ML

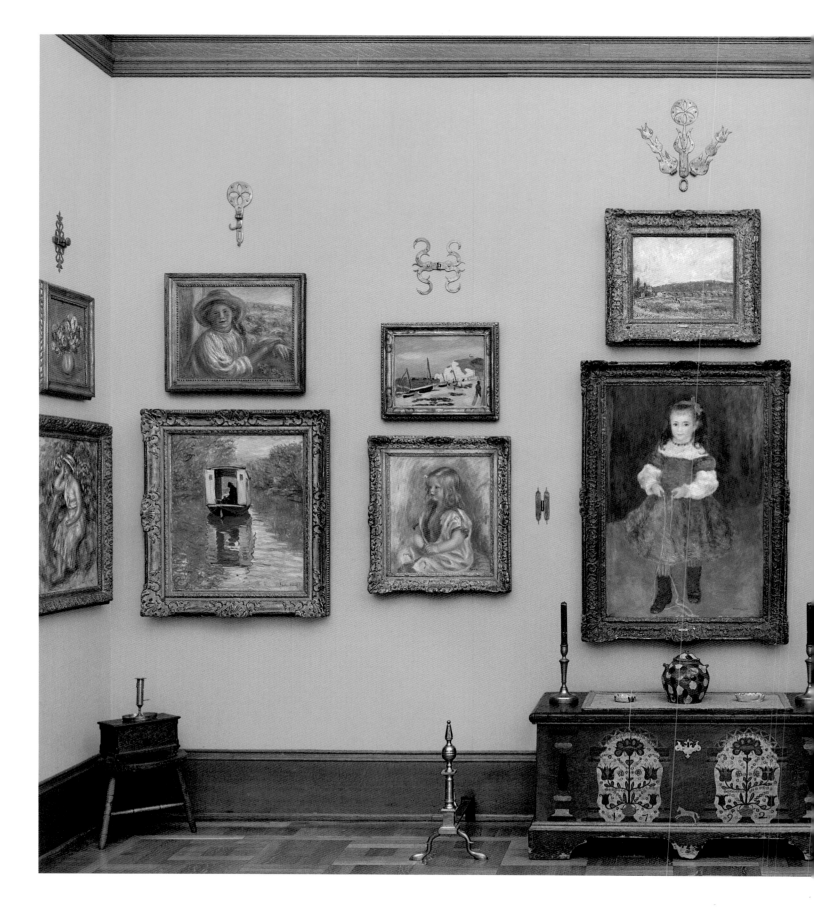

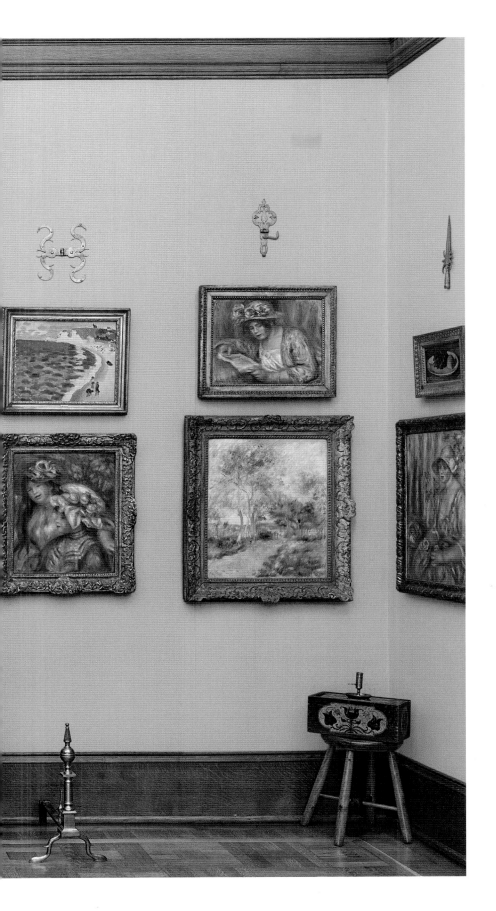

ROOM 9

SOUTH WALL

A painted Pennsylvania German chest, dated 1792 and decorated with tulip cartouches flanked by sturdy columns, occupies the center of the wall under *Girl with a Jump Rope* by Pierre-Auguste Renoir. The chest contrasts the vivid blue of the girl's dress with the subtler variant used on the furniture. The galloping horse at the bottom center of the chest finds its match in a cookie cutter (p. 168) on the west wall of the room. As is common among the ensembles, a pair of brass-topped andirons flanks the chest and broadens the rhythmic, horizontal march of verticals across its surface. Pewter candlesticks with red tapers, placed precisely above the outermost painted columns on the chest, take their place in this measured progression and draw the eye up toward the wall-bound objects. An arrangement of tulip-ended hinges and a hasp presiding at the top of the wall formally unify this central vertical column.

While the wall composition may be read in horizontal registers or vertical columns, an intriguing arrangement of interlocking V-shapes contrasts the depth in the landscapes with the compression in portraits and figural scenes. Scenes of spatial recession, *The Studio Boat* by Claude Monet and *Autumn Landscape* by Renoir, anchor the ends of an inverted V, which crests with *Sèvres Bridge* by Alfred Sisley. The diagonal reflection in the work by Monet and the angled path in that by Renoir echo the orientation of the tulip hinges at the apex of the wall. Two coastal scenes of Étretat by Henri Matisse join this clutch of landscapes, and the curling coastlines in these works find formal affinities in the contours of the double hinges above them. In the V of figural scenes — all works by Renoir — the figures are positioned close to the picture plane, increasing the feeling of intimacy but reducing the spatial expansion within the canvas. JFD

Edgar Degas
*Group of Dancers (Groupe
de danseuses)*, c. 1900
PAGE 171

Pierre-Auguste Renoir
*Girl with a Jump
Rope (Portrait of Delphine
Legrand)*, 1876
PAGE 171

Henri Matisse
High Tide (Pleine mer), between July
and September 1920
PAGE 172

Claude Monet
The Studio Boat (Le Bateau-atelier), 1876
PAGE 172

American
Cookie Cutter, 19th century
PAGE 173

Pierre-Auguste Renoir
Sailor Boy (Portrait of Robert Nunès), 1883
PAGE 173

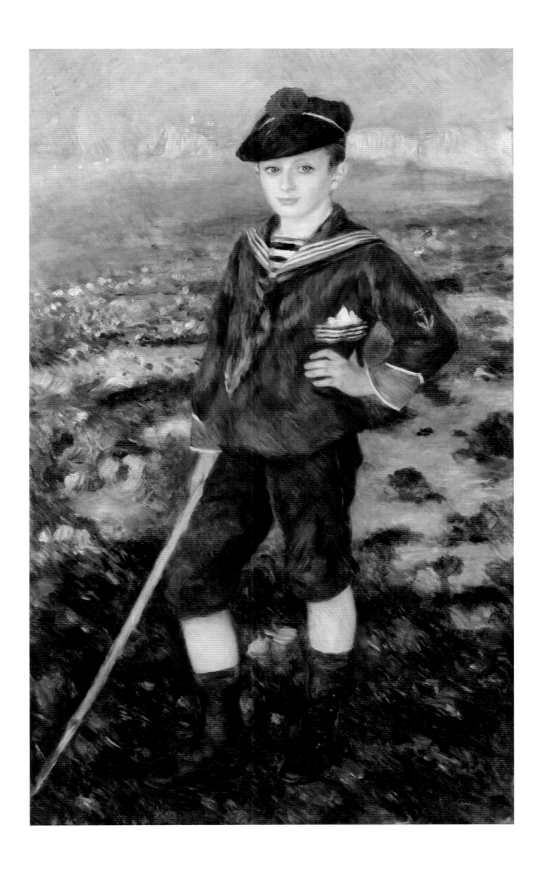

American, Pennsylvania German
Chest, 1792
PAGE 173

Edgar Degas (French, 1834–1917)
Group of Dancers (Groupe de danseuses), c. 1900
Oil pastel on three pieces of paper pieced together
and adhered overall to thin paperboard. 22 ³/₄ x 16 ¹/₈
(57.8 x 41). BF121

Three ballerinas are shown backstage, perhaps
waiting in the wings between acts or having
just finished a performance. The composition
is tightly cropped and the vantage point is
from above. One dancer, seated, leans forward
to rub her foot while the others crowd around
her, resting, one with her wrist propped casually
on her hip. A cool white light pours down
from above, illuminating limbs and landing
especially on the central figure's arched neck
and shoulders, almost distorting the area
as if to emphasize the body's fatigue. Such un-
graceful poses are a far cry from the poised
dancers we normally see on the stage. Shatter-
ing the illusion of its effortlessness, Edgar
Degas, the realist, shows ballet as grueling labor.

Dance was one of Degas's favorite subjects.
He had a subscription to the Paris opera, where
he studied its corps of ballerinas, capturing
them in intimate moments backstage — lacing
up slippers, adjusting costumes, rehears-
ing their steps unglamorously. While Degas
occasionally painted his dancers in oil, most
often he chose pastel, as the crayon's chalky
texture was ideally suited to capturing the
light, gauzy fabric of the costumes. Here, three

electric-yellow tutus are heightened with
bright greens, pinks, and whites; the crayon's
strokes extend outward and in layers, in
imitation of the garments' structure. The tutus
fill out more than half the composition,
extending beyond its edges, engulfing the
dancers and making it difficult to locate
them spatially. ML

Pierre-Auguste Renoir (French, 1841–1919)
*Girl with a Jump Rope (Portrait of Delphine
Legrand)*, 1876
Oil on canvas. 42 ¹/₄ x 27 ¹⁵/₁₆ (107.3 x 71). BF137

In 1876, Pierre-Auguste Renoir had just begun
to establish himself as a portraitist, earning
important commissions from his dealer, Paul
Durand-Ruel (p. 218), and other members of
the artistic and literary elite in Paris. Presented
here is Delphine Legrand, the daughter of the
art dealer Alphonse Legrand, who participated
with Durand-Ruel in mounting the second
impressionist exhibition.

Standing in a blank, tonally neutral space,
the gaily attired girl commands the eye's
full attention; with big brown eyes and rosy
cheeks and lips, she has the prettified features
that have come to be associated with Renoir.
Her bright blue dress is a lively passage — a
flurry of brushstrokes moving in different
directions, each one visible and unblended,
with occasional touches of green. Blue tones
brushed into the ground describe a shadow
falling around the girl's feet. Yet despite its bold
colors and adventurous handling of paint,
compositionally the portrait is firmly lodged in
tradition. Renoir drew here on seventeenth-
century court portraiture, in particular Diego
Velázquez's portraits of the Spanish infantas.

Though Delphine is clearly posing, there is
a subtle slice-of-life quality to the picture, as
she seems to be in the midst of using the jump
rope, which loops around her foot, rather
than merely holding it as a prop. This natural-
ism, this ability to capture childlike behavior
and gestures in even the most composed of
his young sitters, soon made Renoir one of the
most sought-after portraitists of his time. ML

Henri Matisse (French, 1869–1954)
High Tide (Pleine mer), between July and
September 1920
Oil on canvas (later mounted to fiberboard). 15 x 18
(38.1 x 45.7). BF894

In the summer of 1920, Henri Matisse traveled
with his wife and daughter to Étretat, a
resort town on the Normandy coast known for
its distinctive white cliffs. Étretat had long
been a draw for landscape painters, both for
its cliffs and for its natural rocky archways
stretching out into the water. One of these, the
Pont d'Amont, was made famous in a series
of paintings by Claude Monet. Here, the Pont
d'Amont arch is but a tiny point far in the
distance, at the very end of the visible coast-
line; Matisse concentrated instead on the
simple curve of water meeting sand at high tide.

While three sketchily painted figures at
bottom right, their limbs the color of wet sand,
convey a glimpse of life at Étretat, it is the
ocean that is the real subject, and it takes up
most of the canvas. Rather than a traditional
view straight out to sea, Matisse chose a high
vantage point, perhaps looking down from
the cliffs above, so that the ocean's arcing contour
becomes the dominant form. Composed of
broad strokes of light and dark blues, the water
reads as a flat zone stretching upward, parallel
to the picture plane, even as the coastline
draws the eye back into the distance. Mauve-
colored clouds suggest a beach at sunset.
These hues are picked up along the water's
foamy edge and in the vertical stripe that
indicates the long reach of the sun's reflection.
In the end, the famous Pont d'Amont that
is so minimized here seems still to have a
presence; its contours are mirrored by the
Y-shaped meeting of the stripe and the pink-
ish foam along the water's edge. ML

Claude Monet (French, 1840–1926)
The Studio Boat (Le Bateau-atelier), 1876
Oil on canvas. 28 5/8 x 23 5/8 (72.7 x 60). BF730

Claude Monet frequently took to his studio
boat to paint the Seine and its lush banks—emu-
lating the habit of the Barbizon painter Charles-
François Daubigny, his artistic predecessor,
who worked from a floating studio known as
Le Bottin. For this self-referential scene, Monet
selected a viewpoint in the center of the
waterway, as though he were painting from
the studio boat rather than depicting his
silhouetted form inside its cabin. The artist
rendered the dense vegetation lining the
riverbank in overlapping, curling strokes of
various greens, blues, violet, and even ver-
milion. Placing the boat left of center and high
on the canvas, Monet established a raised
horizon line, forcing the eye to focus on the
reflections of the foliage and the boat on the
water's surface. The artist's use of asymmetry
reveals his embrace of the compositional
hallmarks of Japanese woodblock prints, which
many of the impressionists avidly collected.
The river's gentle current dissolves the vertically
brushed forms of the cabin's doors into a
shimmer of long, serpentine squiggles and
short horizontal strokes. For his sky, Monet
lightly brushed blue paint over his canvas,
allowing the white ground or base layer to
stand for clouds. JFD

Cookie Cutter, 19th century
United States
Iron. 5 3/8 x 4 11/16 x 11/16 (13.7 x 11.9 x 1.7). 01.09.54

Pierre-Auguste Renoir (French, 1841–1919)
Sailor Boy (Portrait of Robert Nunès), 1883
Oil on canvas. 51 9/16 x 31 1/2 (131 x 80). BF325

Pierre-Auguste Renoir spent August and September of 1883 in the coastal town of Yport in Normandy, painting the children of the town's mayor, Alfred Nunès. Apparently Renoir had a difficult time with his subjects, complaining in a letter to his friend and patron Paul Berard that he was "busy … with two brats who make me furious." Depicted here is Robert Nunès, nearly ten years old; the companion portrait, of his sister, Aline, is almost identical in format. Albert Barnes bought them together in 1914 before exchanging the portrait of Aline sometime after 1935.

Wearing a sailor suit and cap topped with a striking red pom-pom, the boy stands confidently, hand on hip, before a marshy landscape. The suit is a brilliant blue, with touches of dark purple that deepen the color. Though Robert holds a metal-tipped stick designed to cull oysters from the rocks, he is clearly not in the process of digging; the utensil is merely a prop. Renoir is drawing here from seventeenth-century traditions of aristocratic portraiture, in which male children were often represented in adult garb, such as hunting outfits, with manly attributes such as guns or swords. The shellfish utensil seems to stand in for the gun, a nautical take on the hunting theme.

The boy's face is carefully painted, but the landscape has a much looser quality. In the left middle ground, a flurry of brushstrokes moving in different directions creates the sense of a windswept vista sparkling with light. Renoir made a separate painting of the landscape without the figure, perhaps working directly in front of it; the boy was undoubtedly painted indoors at the Nunès villa. ML

Chest, 1792
United States, Pennsylvania
Painted wood. 23 5/8 x 50 1/4 x 22 1/4 (60 x 127.6 x 56.5). 01.09.35

Wooden chests were used in Pennsylvania German households of the eighteenth and nineteenth centuries to store personal items and documents, and occasionally they also served as seating (p. 94). The front of this chest is decorated with two elaborate floral motifs presented in careful symmetry. Not only do the motifs mirror each other, but each one is also perfectly balanced, with identical flowers sprouting from the side of each stem. A small silhouette of a horse fills out the bottom of the decoration between the floral designs.

Importantly, the chest bears a host of architectural elements. A pair of columns flanks the design on the front, while smaller pillars support arches extending over the flowers. Additional columns are on the sides of the chest, and the lid shows faint traces of arches resembling those on the front. Many of these architectural elements had a symbolic function — the larger columns may refer to Solomon's Temple — but they also evoke the structure of the European chests from which these objects derive. Renaissance chests produced for the German upper classes typically featured elaborately carved pillars and arches as well as recessed panels. Here, in this less sophisticated folk object, such carved architectural elements are translated into painted decoration. ML

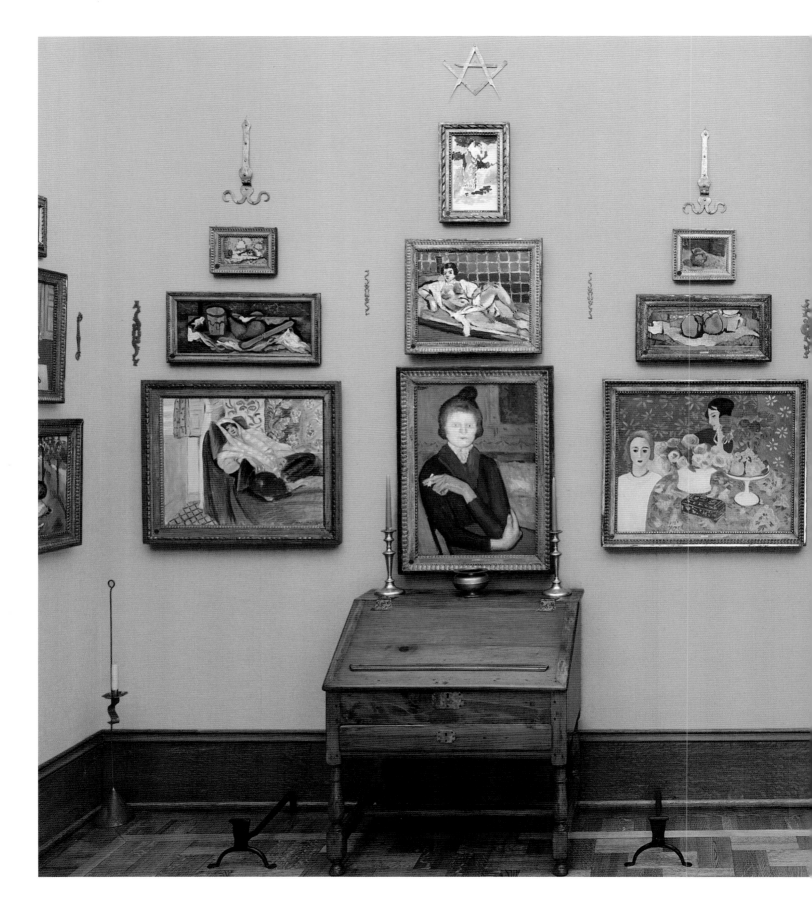

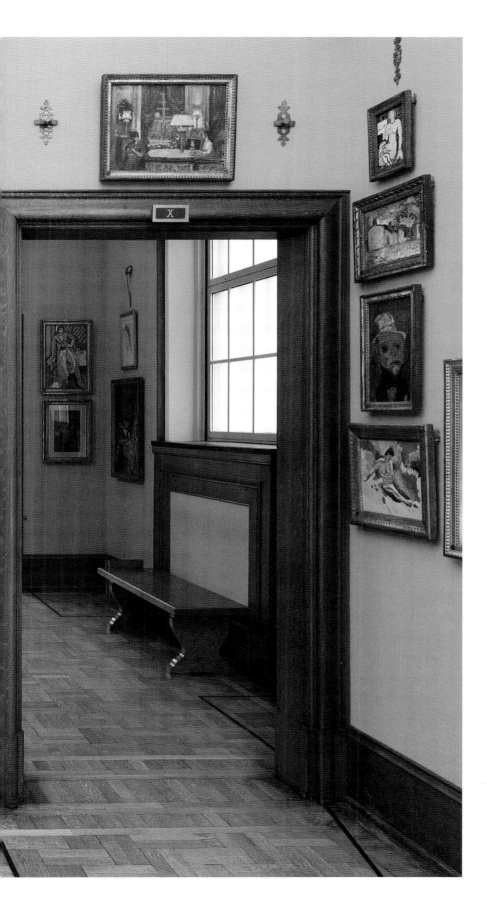

ROOM 10

SOUTH WALL

Blue creates a subtle and unifying chromatic link among some of the works on this wall, a triangular arrangement echoed in the compass form of the Masonic symbol at the apex. *Young Woman Holding a Cigarette* by Pablo Picasso occupies the center of this ensemble. Brilliant turquoise tapers on the desk below echo the tonalities of Picasso's palette and provide a measured and rhythmic step toward the blues in *Woman Reclining* and *Chinese Casket* by Henri Matisse immediately to the left and right. A bright punch of the same hue appears in the costume of Matisse's *Standing Figure*. The carpenter's square at the bottom of the emblem also serves as a visual repeat of the bent elbow of Picasso's young woman.

Matisse explored decorative and spatial complexity, deploying vibrant patterns in his works in the bottom register and in the *Reclining Odalisque* just above the work by Picasso, yet another triangle of formal correspondence. Albert Barnes cleverly placed a spiky-topped hinge fragment to the right of *Chinese Casket*—a nod to its floral wallpaper and bouquet of flowers. Similarly, the scraper just beneath this fragment finds formal affinity with the fruit-filled compote.

The figure in *Woman Reclining* creates a diagonal recession and confines the pattern in the upper right corner—a treatment mirrored in the arrangement of the figures' heads in *Chinese Casket*, which likewise defines a wedge of the purple and mauve floral pattern in the upper left. JFD

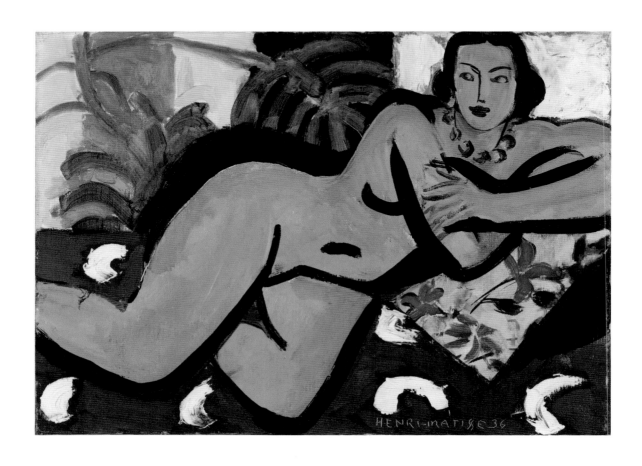

Henri Matisse
Reclining Nude with Blue Eyes
(*Nu couché aux yeux bleus*), January 1936
PAGE 182

Henri Matisse
Chinese Casket (Le Coffret chinois), 1922
PAGE 182

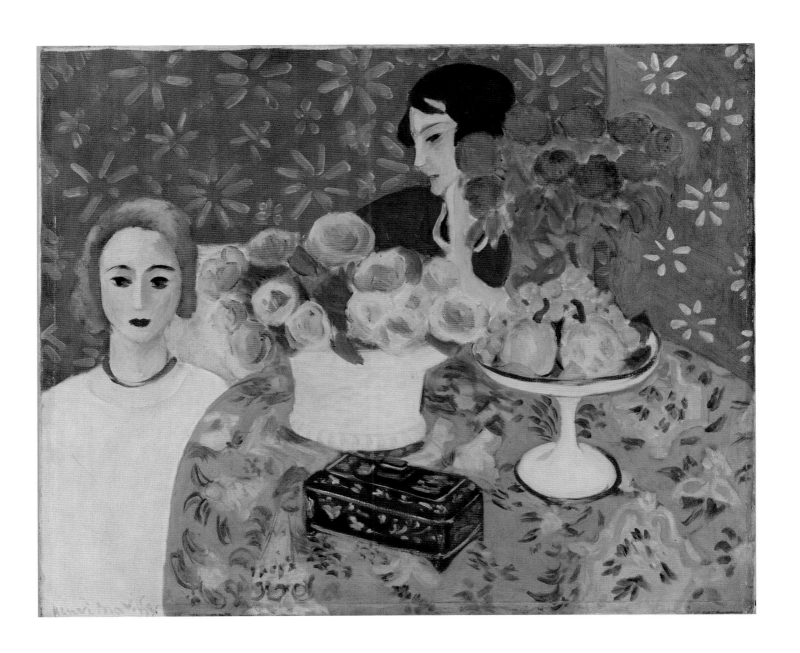

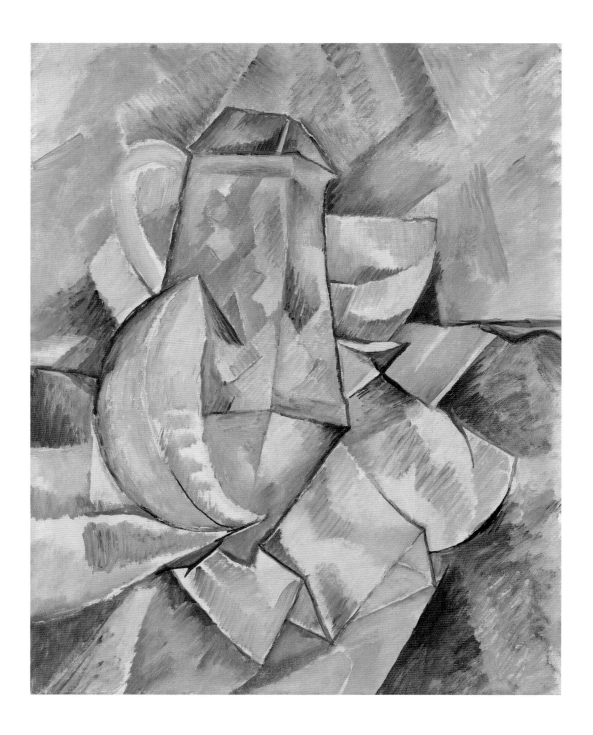

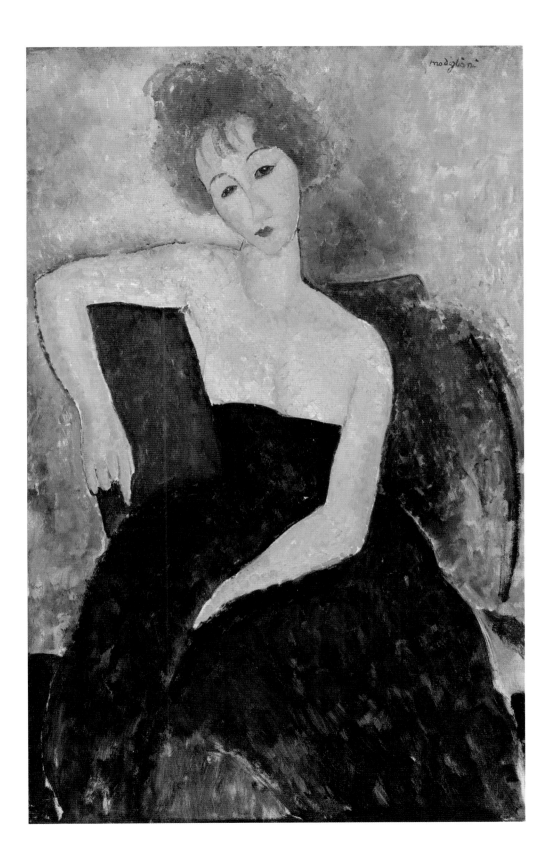

Georges Braque
The Pitcher (Le Broc), 1909
PAGE 183

Amedeo Modigliani
*Redheaded Girl in Evening
Dress (Jeune fille rousse en
robe de soir)*, 1918
PAGE 183

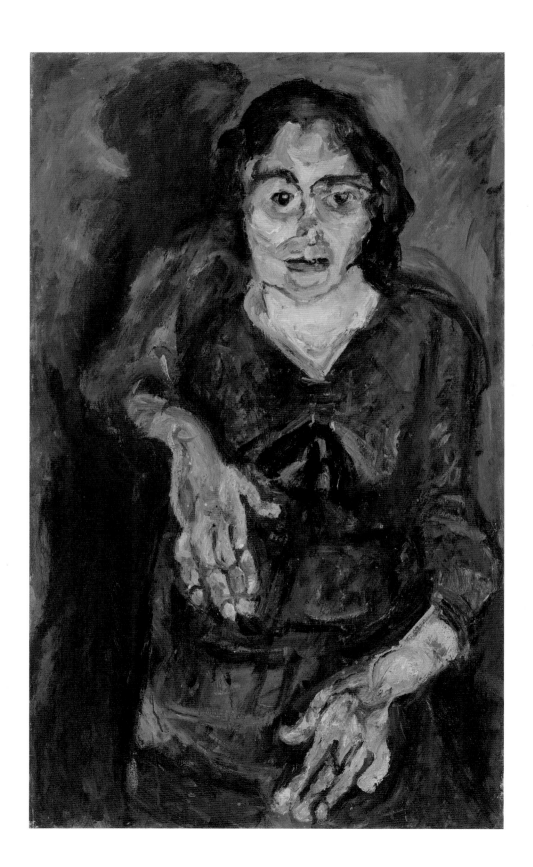

Chaim Soutine
Woman in Blue (La Femme en bleu), C. 1919
PAGE 184

Pablo Picasso
Young Woman Holding a Cigarette (Jeune femme tenant une cigarette), 1901
PAGE 185

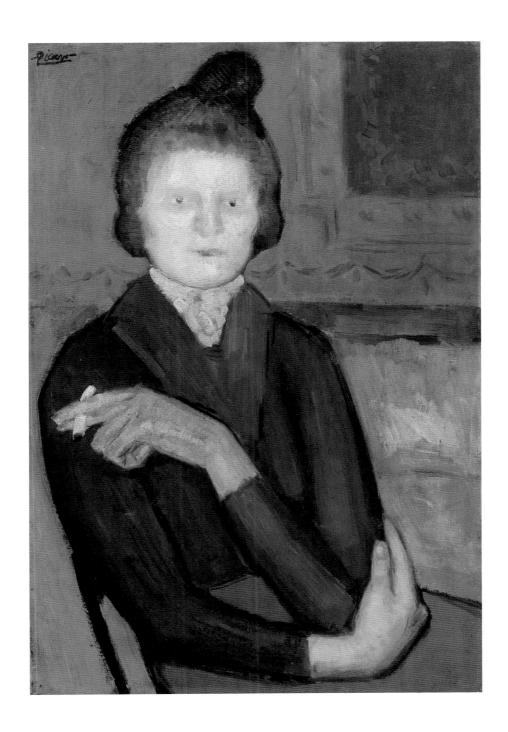

Henri Matisse (French, 1869–1954)
Reclining Nude with Blue Eyes (Nu couché aux yeux bleus), January 1936
Oil on canvas. 13 x 18 ⅛ (33 x 46). BF955

Propped on a floral pillow, Matisse's model Lydia Delectorskaya stretches across the composition, her piercing blue eyes directly greeting the gaze of the viewer. Her right ankle and left elbow extend beyond the edges of the canvas, while her head and knee graze the top and bottom, lending the small painting an unexpected monumentality. With thick black lines that emphatically define the contours of her body, Matisse underscored the undulations of her slinky pose, which pairs curved hips and breasts with angular knees and elbows. He matched these rhythms with variously sized vertical planes of color in the background—as he did in *Reclining Nude* (p. 263)—and countered this measured cadence with the uniform, horizontal sweep of the red-and-white-patterned fabric on which she reclines. The painter drastically reduced the modeling of his figure, which, like the rich textiles in the works of this period, assumes a flat, decorative quality—perhaps at some cost to the languorous sensuality of the previous decade.[1] JFD

1 For more extensive discussion that informs this notice, see Claudine Grammont, "Nude on a Blue Couch (Nu au divan bleu)," in *Matisse in the Barnes Foundation* forthcoming.

Henri Matisse (French, 1869–1954)
Chinese Casket (Le Coffret chinois), 1922
Oil on canvas. 23 ¾ x 29 ⅛ (60.4 x 74). BF916

Much of Henri Matisse's work of the 1920s is characterized by a conventional arrangement of figures in three-dimensional space; here, however, he returns to the more compressed configuration of his earlier pictures. Two women sit in an interior decorated with juxtaposed bold patterns. Though the patterns describe distinct areas of the room, they appear as one flattened design—a collage in paint that keeps the eye moving. The meeting of rose and gray fabrics in the corner, for example, reads almost as a flat wall, and the tabletop tilts up to such a drastic degree that it is almost parallel with the picture plane. While the objects on the table provide a sense of depth—the small decorative box is placed in front of the roses and fruit dish—the table itself, a stretch of elaborate blue and yellow design, rises up into a flat half-circle.

The Chinese box from which the painting derives its title reflects Matisse's interest in non-Western design. The artist owned many such objects, and they are regularly included in his canvases. The dark-haired model is Henriette Darricarrère, an aspiring actress and dancer who posed frequently for Matisse during the 1920s; the blond woman is unidentified. They, too, are flattened out—especially the blond figure, whose white blouse mimics the shape of the blue cloth—and there seems to be no interaction between them. Their treatment as blank decoration creates a certain equivalence between the women and the items on the table. ML

scoring the flatness of the support. Working toward the multiple perspectives of the analytic cubism he pioneered with Pablo Picasso, Braque deployed several points of view here, simultaneously depicting the profiles as well as the mouths of the vessels.

Typical of the punning that characterized his later work, the French title for the painting—*Le Broc*—is a homonym for the artist's surname.[1] JFD

1 Jeffrey S. Weiss, "The Pitcher (Le Broc)," in *Great French Paintings* 2008, 210.

Georges Braque (French, 1882–1963)
The Pitcher (Le Broc), 1909
Oil on canvas. 16 ½ x 13 ¼ (41.9 x 33.6). BF430

Georges Braque, once an adherent of fauvism's non-naturalistic hues, flatly applied color, and fluid arabesques, dramatically shifted his artistic focus in 1908 and 1909. During two transformative painting campaigns he challenged himself to engage with Paul Cézanne's legacy in landscape; Cézanne's recent death had prompted a watershed 1907 exhibition of his works at the Salon d'Automne. Working at L'Estaque and La Roche-Guyon—sites favored by Cézanne—and with a muted palette of earth tones, Braque explored the blocky geometries of these hillside towns nestled in lush landscapes.

Braque soon turned this new aesthetic to other genres, including still life, which dominated his oeuvre for the remainder of his career. Juxtaposing rounded contours and squared edges, he arranged a pitcher, a cup, and a slice of melon on a tabletop covered with a gathered cloth. The gravity-defying curved melon rind stands on its pointed end parallel to the handle of the pitcher—echoing the lower lip of the cup—while the white cloth unexpectedly assumes a spiky, hard-edged vitality. Green, gray, and brown facets of parallel, hatched strokes—along with primed but unpainted passages of canvas, a hallmark of Cézanne's—overlap and jostle against one another, at times defining the edges of objects but not their dimension and ultimately under-

Amedeo Modigliani (Italian, 1884–1920)
Redheaded Girl in Evening Dress (Jeune fille rousse en robe de soir), 1918
Oil on canvas. 45 ¾ x 28 ¾ (116.2 x 73). BF206

Amedeo Modigliani dedicated his painting practice largely to portraiture, developing a highly stylized approach to representing the visages of his sitters. Often likened to masks, the elongated faces, flattened features, pursed mouths, and almond-shaped eyes of Modigliani's distinctive physiognomies likely drew on archaic Greek, Cycladic, ancient Egyptian, African (Baule, Fang, and Yaure peoples), and Khmer precedents.[1] Describing Modigliani's simultaneously idiosyncratic and generic faces, the French writer, artist, and filmmaker Jean Cocteau made a connection

between the work of Modigliani and that of Pierre-Auguste Renoir, whose work Albert Barnes most avidly collected: "If his models end by looking like one another, this is in the same way that Renoir's models all look alike. He adapted everyone to his own style, to a type that he carried within himself, and he usually looked for faces that bore some resemblance to that type, be it a man or a woman."[2]

While Modigliani created formal affinities in the treatment of his sitters' features, the poses in the Barnes paintings suggest individual attitudes: passivity (p. 190), calm (p. 309), cheekiness (p. 288), and, in this work, a defiant wantonness.[3] Presented frontally, head cocked to one side, eyebrows raised, with dress in disarray, and right arm slung over her chair—revealing a thatch of dark underarm hair—the redheaded young woman in this painting challenges the viewer with her confrontational posture. Modigliani applied his pigments in thick, visible touches, lending the woman's skin a scaly, reptilian quality. Treating the background in overlapping strokes of blues and green, which complement her brilliant red hair, Modigliani energized the space around her. JFD

1 Mason Klein, "Modigliani against the Grain," in *Modigliani* 2004, 9.
2 Tamar Garb, "Making and Masking: Modigliani and the Problematic of Portraiture," in *Modigliani* 2004, 43.
3 Ibid., 43–53.

Chaim Soutine (Russian, active in France, 1893–1943)
Woman in Blue (La Femme en bleu), c. 1919
Oil on canvas. 39 1/2 x 23 3/4 (100.3 x 60.3). BF886

Although Chaim Soutine did not identify his sitter, he endowed her with an unforgettable, even terrifying, specificity in his rendering of her hunched posture, enormous misshapen hands, and lopsided staring eyes. Soutine suggested the back of a chair behind the uneven shoulders of the model, but the blues of her dress and the upholstery merge, further heightening the sense of deformity and contortion. With the seat of the chair indistinctly rendered, this long-torsoed figure appears on the verge of lurching through the picture plane with her crooked stoop, an effect heightened by the ill-defined, claustrophobic space she occupies. The woman casts a shadow, suggesting depth, but the vigorously applied strokes and streaks of green, blue, and red in the background both activate and compress the space.

While the model's unfocused gaze, still mouth, and dangling hands suggest impassivity or resignation, Soutine lavishly painted her face and hands with a complex and garish weave of red, yellow, blues, green, pinks, and orange, investing the figure with an intense expressive quality that belies her countenance. JFD

Pablo Picasso (Spanish, 1881–1973)
Young Woman Holding a Cigarette
(Jeune femme tenant une cigarette), 1901
Oil on canvas. 29 x 20 ⅛ (73.7 X 51.1). BF318

During his first three-month sojourn in Paris in 1900—on the occasion of the Exposition Universelle, where one of his paintings was exhibited—Pablo Picasso heartily plunged into the city's renowned and debauched nightlife. He immediately began to paint colorful images of dance halls and demimondaines, executed with an exuberant divisionist touch. These works garnered great interest when presented at the Galerie Vollard in June 1901, although some critics noted the artist's heavy debt to—or nimble assimilation of—predecessors such as Théophile-Alexandre Steinlen, Henri de Toulouse-Lautrec, Vincent van Gogh, and Édouard Vuillard.[1]

Picasso began to make such subjects distinctively his own as he incorporated the cerulean tonalities and melancholy mood of his ascendant Blue Period, a change in direction prompted by the violent 1901 suicide of his friend Carles Casagemas, a poet and fellow painter. While Picasso presented his chignon-crowned model close to the picture plane and against the backdrop of a decorated café wall—ostensibly a scene of intimate sociability—the sitter's distant gaze and tightly folded arms defensively reject such conviviality. Set in a cadaverous face—a mix of white and green brushstrokes—the figure's beady, red-rimmed eyes and pursed mouth convey a world-weariness. Picasso outlined the figure's torso and skirt in thick black strokes that appear to bind her introspection. Likewise, her massive right hand, tightly clasped around her elbow, limits any hint of movement. Although this work moves gradually toward the cold, despairing tones of the Blue Period, the warmer red proves an equally troubling marker, drawing attention to exhausted eyes and worn hands.

When Albert Barnes sent William Glackens to Paris in 1912 on a buying trip for modern painting—the commencement of the physician and pharmaceutical magnate's ambitious collecting career—the painter returned with this work by Picasso, along with thirty-two other paintings and prints, making *Young Woman Holding a Cigarette* a foundational object in the collection. JFD

1 Tinterow and Stein 2010, 36.

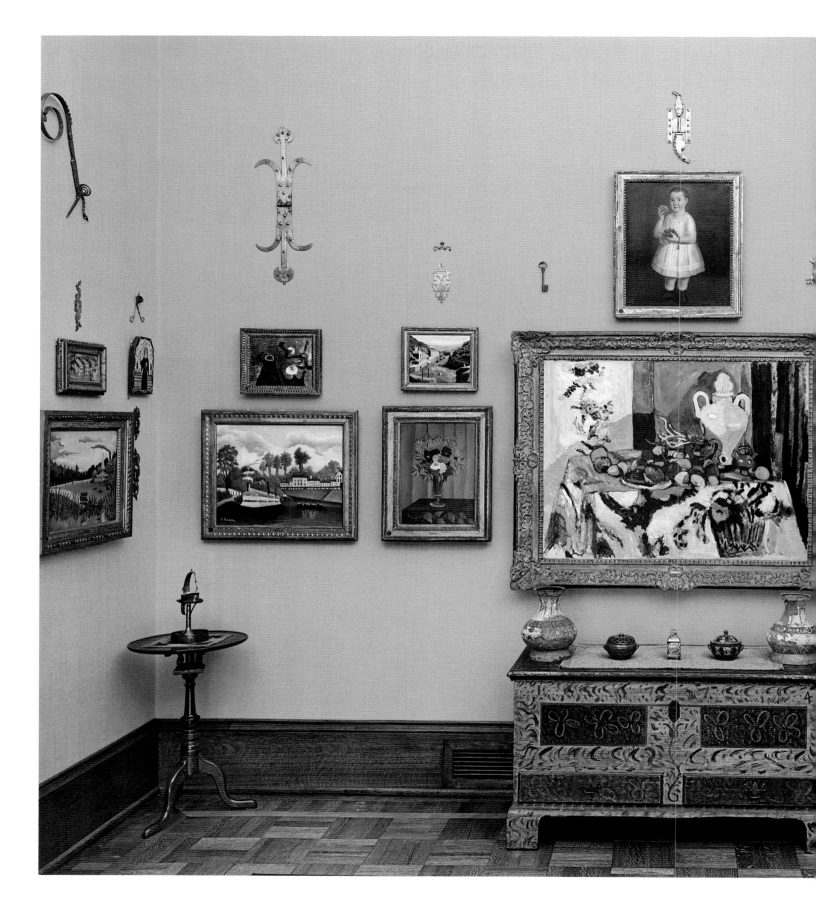

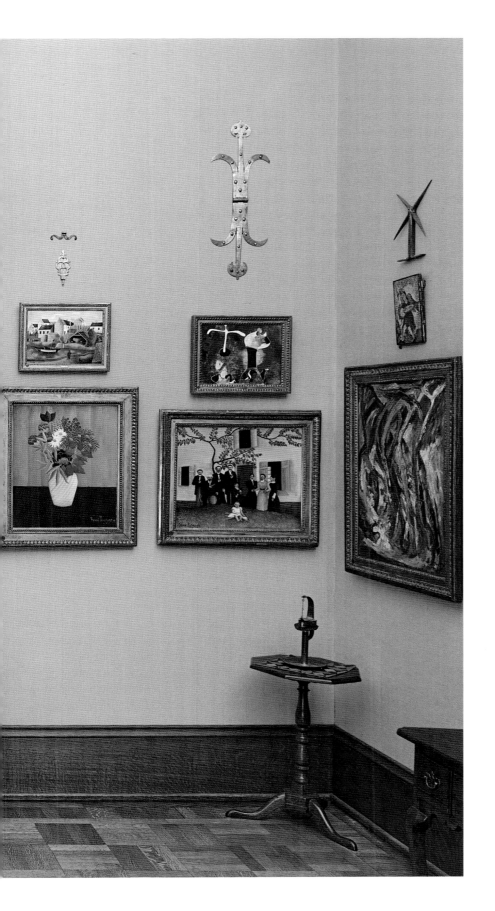

ROOM 11

EAST WALL

Henri Matisse's *Blue Still Life*, 1907, anchors this ensemble, surrounded by a triangle of three paintings that echo its theme of flowers and fruit. These include two bouquets of circa 1909–1910 by Henri Rousseau and a mid-nineteenth-century portrait of a girl by an unidentified French artist. Holding grapes and an apple, the child looks as though she has just plucked these items from Matisse's table below.

The juxtaposition of still lifes by Matisse and Rousseau highlights the divergent modes of two of the most influential painters of the early twentieth-century Parisian avant-garde. While Matisse's paint is thick and physical, Rousseau worked with painstaking precision; each flower petal is carefully outlined. Through different means, both artists manage to achieve a "primitive" style — Rousseau through awkward-looking forms and Matisse through a certain gestural crudeness. Other stylistically primitive objects fill out the wall, including two more canvases by Rousseau in the bottom row, a pair of small landscapes by the self-taught painter Jean Hugo, and, next to them, two figural paintings by Joan Miró that evoke a primal quality.

The canvases by Miró are two of the more abstract works in the collection, and in their compressed space and distorted forms (which mirror the shape of the hinges placed on the wall above them), they present an interesting contrast with the more naturalistic works by Hugo and Rousseau. Throughout the ensemble, the correspondences between individual objects seem endless: second-century Chinese pots mirror the vase in the painting by Matisse, and the vines spreading across the work by Rousseau at far right echo the patterns in Matisse's tablecloth. This pattern also relates to the lively painted decoration on the Pennsylvania German chest. ML

Henri Matisse
Blue Still Life (Nature morte bleue), summer 1907
PAGE 198

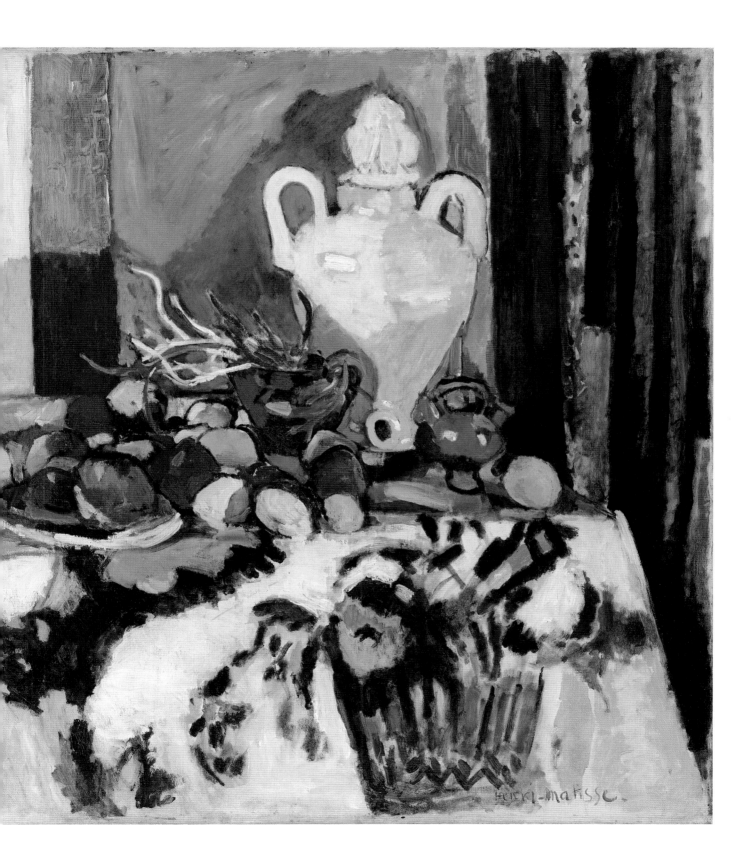

Amedeo Modigliani
*Girl with a Polka-Dot Blouse
(Jeune fille au corsage à pois)*, 1919
PAGE 198

Joan Miró
*Group of Women (Groupe de
femmes)*, July 15, 1938
PAGE 199

Henri Rousseau
Woman Walking in an Exotic Forest (Femme se promenant dans un forêt exotique), 1905
PAGE 199

Chaim Soutine
Group of Trees (Groupe d'arbres), c. 1922
PAGE 200

German
Tankard, 1766, inscribed 1792
PAGE 200

Pedro Antonio Fresquís
Our Lady of Protection (Nuestra Señora del Patrocinio), c. 1815
PAGE 201

Nuestra Señora
del Patrosinio,
abogada de todos los
Asidentes

ROOM 11

Henri Matisse (French, 1869–1954)
Blue Still Life (Nature morte bleue),
summer 1907
Oil on canvas. 35 ¼ x 46 (89.5 x 116.8). BF185

A trail of fruit winds across a table draped with
an elaborately patterned cloth. A pale blue
vase presides at right, next to a potted plant
with tendril-like leaves; a painted screen
fills out the background. If *Blue Still Life* is a
collection of beautiful objects, it is also a
study of the way color and line can move the
eye around a canvas.

One may note, for example, the rhyth-
mic distribution of colors in the fruit, with
yellows, oranges, and reds weaving their way
through the arrangement — all warm tones
that advance the still-life objects against the
receding blues of the background. A lone
orange pulls the eye to the right. The serpentine
fruit trail curves along the table and onto
the painted screen, where it translates into
flowers, drawing the eye up and back; this
procession is mirrored by the mauve shadow
cutting an undulating line against the wall.
All these forms are echoed in the patterns of
the tablecloth below.

Blue Still Life was painted when Paul
Cézanne's work first sent shock waves through
the Paris art world, and Henri Matisse grapples
here — to spectacular ends — with the master's
lessons. The pieces of fruit are built of thick,

broad strokes, and the viewer senses Matisse
struggling to bring a Cézannian physicality
to each object; even the tablecloth conveys
mass as it looks weighed down by paint.
Yet in its long, sweeping lines, the painting
has a lightness — a lyricism — that is purely
Matisse. The artist exhibited this work at the
1908 Salon d'Automne. ML

Amedeo Modigliani (Italian, 1884–1920)
*Girl with a Polka-Dot Blouse (Jeune fille au
corsage à pois),* 1919
Oil on canvas. 45 ½ x 28 ¾ (115.6 x 73). BF180

A woman with piercing blue eyes sits staring
out at the viewer. Her full red mouth is
arranged in a position of calm resolve and her
hands rest in her lap, with fingers interlaced.
She is casual yet stiff, in an insistently frontal
position: we cannot glimpse the sides of her
face. The shoulders are square to the picture
plane, and they merge uninterrupted into
the curve of the arms and hands to form the
perimeter of the composition's central oval
shape. Only the woman's legs provide a hint of
depth, as they are shifted slightly to the side.

Given the rigid frontality of the face
especially, the portrait seems a translation into
paint of the stone heads Amedeo Modigliani
created in 1911 and 1912. In those, stretched-out
ovals rest on elongated necks, much like the
format seen here. Moreover, in the stone works
the features are a composite of simplified
geometric parts, with blank almond shapes
for eyes and rectangles and circles serving
as noses and mouths. Here, the eyes have a
similar blankness, the irises barely visible
under the pools of pale blue.

Compared to the precise graphic outlines
of the head and face, the rest of the picture
reveals a much freer handling of paint. The
background is brushed with broad strokes
of browns and grays. The woman's blouse is
animated with quick, blue touches, and her
skirt is a field of thinly painted pink brushed
over with white. Most interesting are the
places where flesh meets blouse. These are
crude junctures, with bare canvas showing
through. They remind the viewer that "flesh"
is merely paint, and that the subject is noth-
ing more than an arrangement of colors
on a canvas. ML

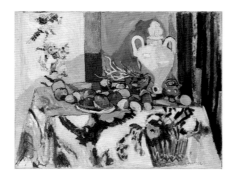

Joan Miró (Spanish, 1893–1983)
Group of Women (Groupe de femmes),
July 15, 1938
Oil on canvas. 10 ⁷/₈ x 14 (27.6 x 35.6). BF1188

A Spanish painter with strong ties to the land
and heritage of Catalonia, Joan Miró found
himself in exile in France in 1936 when the
hostilities of the Spanish Civil War made it
impossible for the staunchly Republican artist
to return to his homeland after one of his
annual painting campaigns in Paris. Remain-
ing with his family in France until 1940, Miró
painted works that express apprehension,
using the language of biomorphic symbols
that marked his distinctive exploration of
surrealism and abstraction.

The three fantastical figures in *Group of
Women* convey the anxiety and uncertainty of
the era with their arms mournfully thrown
in the air as they swirl against an indistinctly
defined, claustrophobic background of
mottled colors. The women at left, with their
variously proportioned physiognomies
and calligraphic appendages, display Miró's
signature approach to the body. The monu-
mental figure at right, with neck outstretched,
eyes upraised, mouth agape, teeth bared,
and tongue extended, appears to shriek with
sorrow and fear. Miró precisely dated his
works, providing a pictorial chronology of this
difficult period. JFD

Henri Rousseau (French, 1844–1910)
*Woman Walking in an Exotic Forest (Femme se
promenant dans un forêt exotique)*, 1905
Oil on canvas. 39 ³/₈ x 31 ³/₄ (100 x 80.6). BF388

Here Henri Rousseau takes a seemingly ordinary
subject—a woman out for a stroll in the
woods—and makes it strange. Most startling
perhaps is the scale of the solitary figure,
who stands dwarfed by oversize plants and
invented purple flowers. Giant leaves, each
the size of her torso, eclipse part of her face,
while oranges almost twice the size of her
head dangle from trees high above. Wearing
a hat and a long pink dress cinched at the
waist, the woman appears better suited for a
manicured Parisian park. She is clearly out
of her element, to an absurd degree, and this
is underlined by the fact that there is no
clear path on which she might continue.

Throughout his career Rousseau produced
many pictures with unexpected juxtaposi-
tions, such as *Carnival Evening*, 1886 (Philadelphia
Museum of Art), which shows a clown and
female companion in a moonlit forest. Here,
however, the theme of incongruity receives
a distinctly tropical setting. In 1904 Rousseau
had just returned to a sustained focus on
jungle landscapes after a thirteen-year hiatus
from the subject. Gazing at the viewer with
a look of vague surprise, the woman recalls the
startled animals peering out from the artist's

FIG. 1 **Henri Rousseau**
*Monkeys and Parrot in the
Virgin Forest (Singes
et perroquet dans la forêt
vierge)*, c. 1905–1906
Oil on canvas, The Barnes
Foundation, BF397

jungle pictures, as in *Monkeys and Parrot in the Virgin Forest* (fig. 1). But while in those works the monkeys' bewildered expressions convey the sense that the viewer has encroached upon their territory, here the woman's appearance only adds to the mystery, and the viewer is left to wonder why she is wandering through this overgrown landscape. Stylistically, the canvas is painted with the utmost precision: each individual leaf, each blade of grass, has its own fixed outline, a clarity that heightens the contrast with the obscured meaning of the scene. ML

Chaim Soutine (Russian, active in France, 1893–1943)
Group of Trees (Groupe d'arbres), c. 1922
Oil on canvas. 28 ⅞ x 23 ⅞ (73.3 x 60.6). BF331

Following the 1918 German bombing of Paris during World War I, Chaim Soutine escaped the hostilities with the help of his patron and dealer, Leopold Zborowski. The painter first traveled to Cagnes-sur-Mer, the home of Pierre-Auguste Renoir, and later to Céret, a French village near the Spanish border. Even though the conclusion of the war that year permitted his return to the French capital, Soutine remained in Céret for the next three years—with occasional trips to Paris—and painted hundreds of landscapes in and around the town.

 Here, Soutine fragments the view of a seemingly wind-blown, leaning townscape—a cluster of white buildings capped by red tile roofs—with a lattice of impossibly twisted and intertwined tree trunks and branches in the foreground. The artist exploits the verticality of the canvas to underscore the monumental effect of his screen of trees, whose crowns extend beyond the top edge of the painting. Although he suggests a path

at left and, accordingly, a gradual recession of space, his vigorous brushwork, applied without differentiation between foreground and background, flattens the space. With his vigorous handling of paint Soutine infuses the canvas with the swirling dynamism that became associated with his landscapes. JFD

Tankard, 1766, inscribed 1792
Germany
Pewter. 12 ¾ x 5 ¾ x 7 ⅞ (32.4 x 14.6 x 20). 01.11.60

Functional and decorative pewter objects, far less expensive than the gold or silver trappings of princely or aristocratic houses, found their way into taverns, churches, and middle- and upper-middle-class homes in Europe from the Middle Ages through the early nineteenth century, when they were replaced by porcelain and glass for domestic use. Cast in bronze molds, pewter vessels typically had simple profiles, but engraved embellishments individualized these modest objects.[1] This eighteenth-century German tankard bears the emblem of the bakers guild, which received its coat of arms—a pretzel and loaves of bread flanked by rampant lions and topped with a coronet—in recognition of the vigilance of Viennese bakers, who, according to legend, alerted their city to the invasion of the Turks in the sixteenth century. Accompanying the coat of arms, an inscription dated 1792 reads: "May God in heaven bless the field/Bake big bread so that we can make a little money." A member of the guild may have owned this tankard and employed it for his personal use at home, or it may have been stored at the gathering place for the guild. JFD

1 Barkin et al. 2002.

Pedro Antonio Fresquís (1749–1831)
*Our Lady of Protection (Nuestra Señora
del Patrocinio)*, c. 1815
United States, New Mexico (formerly New Spain)
Gesso and water-based paints on pine panel. 9 ³⁄₈ x 6 ¹⁄₂
(23.8 x 16.5). BF1019

Retablos, small panels intended for private
devotion, typically include imagery of the
Virgin in one of her many appellations, the
Christ Child, the saints, and angels. New
Mexican *santeros*, or painters of saints, looked
to a variety of printed materials — religious
woodcuts and pamphlets, illustrated missals
and bibles — for their iconographies.[1] Cloaked
by a voluminous, patterned mantle that
underscores her role as a sheltering guardian,
the Virgin, as Our Lady of Protection, tradi-
tionally clothed in red, holds the Christ Child
in her arms. In keeping with her status as the
Queen of Heaven, she wears a crown and carries
a scepter. Supported by an angel, she stands
on a crescent moon, a symbol of her purity.

First identified as the "Calligraphic Santero"
for the fluidity and elegance of his line, Pedro
Antonio Fresquís appears to use a single sinuous
stroke to trace the Virgin's curved eyebrows
and long nose. The Virgin and Child share a
lobed halo that intersects with their crowns,
also a signature of the artist's style.[2] While the
lines describing the borders and folds of the
Virgin's robe lend her a columnar form, Fresquís
otherwise renders his figures flat by presenting
them frontally and without modeling. How-
ever, he places a small tree to her side, suggest-
ing a sense of spatial recession or depth.

For collectors of modern art such as Albert
Barnes, these panels, with their seemingly
stylized forms and simplified spaces, may have
echoed contemporary artistic practice, which
flouted academic conventions.[3] JFD

1 Cash 1999, 11.
2 Frank 1992, 35, 42.
3 Wroth 1982, ix.

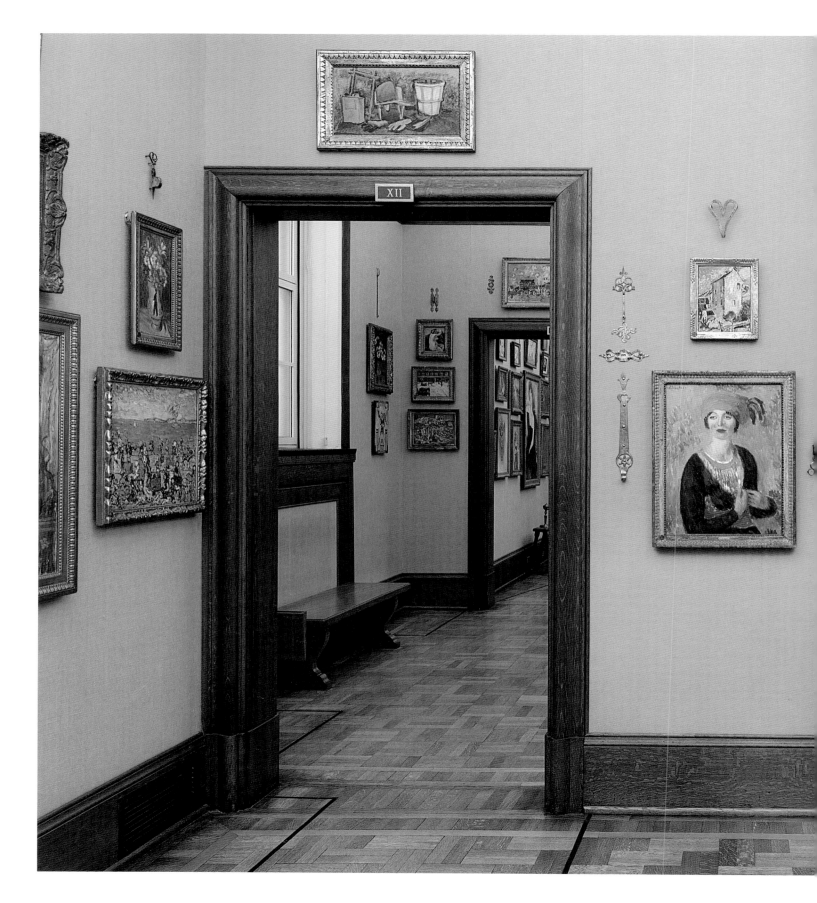

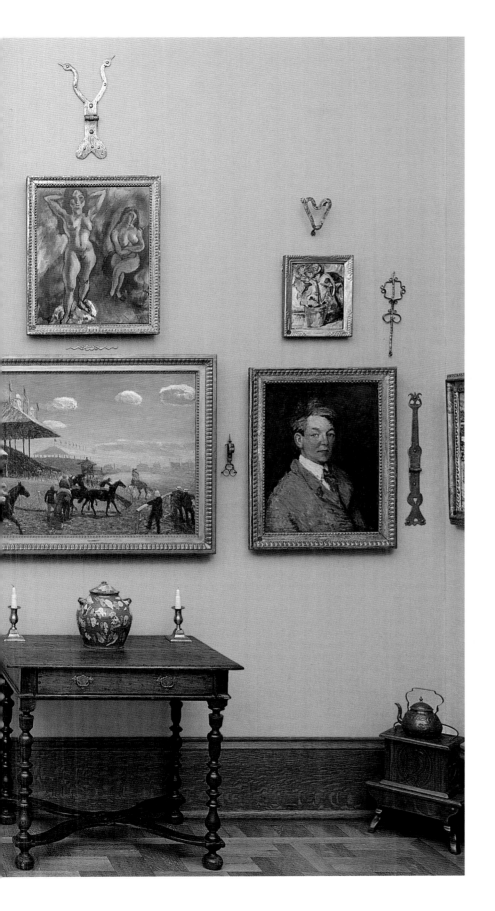

ROOM 12

NORTH WALL

Albert Barnes experimented with oscillations of spatial depth in the arrangement of paintings on this wall. At the center of the lower register of paintings, the electric-hued *Race Track* by William Glackens offers a deep recession measured by the long plunge of the grandstands and the stretch of vibrant orange racecourse that darts toward the horizon. Flanking this work, *Girl in Green Turban* and *Self-Portrait*—also by Glackens—present figures close to the picture plane in shallow spaces. While the floral motifs of the background wallpaper in *Girl in Green Turban* appear to vibrate on the surface of the support, the brushy treatment in *Self-Portrait* makes for a seemingly impenetrable void. Similarly, in the upper register, the relative scale of the figures in *Two Nudes — One Standing, One Sitting* by Jules Pascin provides a suggestion of depth, while *House* and *Pot of Flowers* by Alfred Maurer offer either no point of entry or the shallowest of fields.

The industrial and decorative objects on this wall establish and strengthen relationships between color and form and further unify the wall. The cheerful orange, green, and white Moravian pot on the table echoes tonalities of Glackens and Maurer. The central hinge that crowns the wall rhymes with the raised arms of the foreground nude in the work by Pascin. Similarly, the heart-shaped trivets echo, in *Girl in Green Turban*, the triangles formed by her joined arms and by the pleated blouse front, and in *Self-Portrait*, the white wedge of Glackens's shirt. Finally, the tapered hinges at either end of the wall at the bottom register rhyme with the upright postures of the portrait sitters. Barnes cleverly and wittily placed a "fringe"-topped hinge at right, perhaps in a nod to Glackens's spiky cowlick. JFD

American
Hinge, 18th–19th century
PAGE 210

William James Glackens
Race Track, 1907–1909
PAGE 210

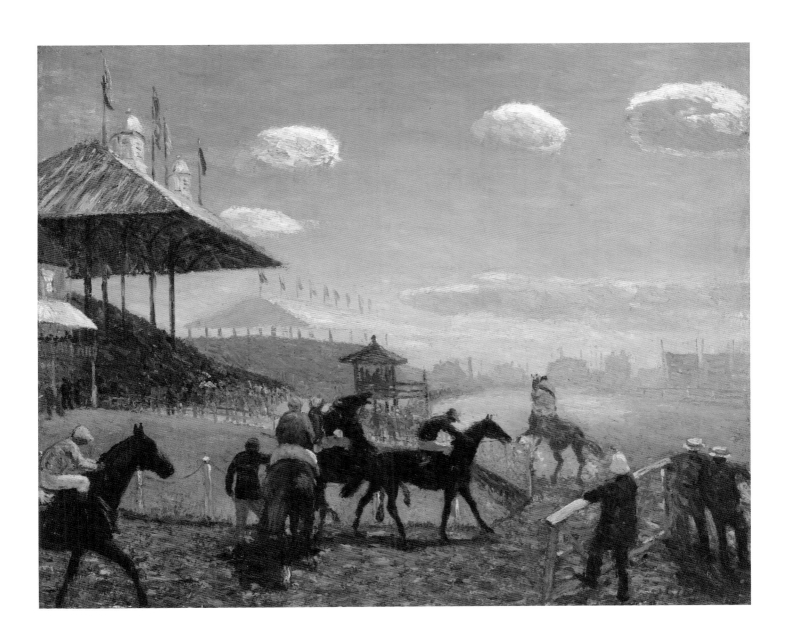

Horace Pippin
Supper Time, c. 1940
PAGE 211

Hinge, 18th–19th century
United States
Iron. 16 x 9 1/8 x 3/4 (40.6 x 23.2 x 1.9). 01.12.10

William James Glackens (American, 1870–1938)
Race Track, 1907–1909
Oil on canvas. 26 1/8 x 32 1/4 (66.4 x 81.9). BF138

Over the two years that William Glackens
worked on *Race Track*, the artist dramatically
changed aesthetic direction, moving from
the somber, dark tones of his urban realist
work—inspired by Robert Henri and Édouard
Manet—to bolder, non-naturalistic colors
that embraced recent American and European
currents.[1] While he adjusted his palette, he
remained committed to scenes of everyday
life, with a particular emphasis on leisure
pursuits. A celebrated newspaper illustrator
with a flair for anecdotal incident, Glackens
here captured jockeys in colorfully patterned
silks and their spirited mounts trotting,
capering, and bolting at the Brighton Beach
Race Track in Brooklyn. Under a brilliant
blue sky filled with plump but unthreatening
clouds, the bright orange course stretches
into the distance. The long pitched roofs of
the grandstands and their pennant-bedecked
flagpoles create a measured recession
in space. Glackens hinted at a cityscape far
back—including tall, blocky edifices and

smokestacks—underscoring the presence of
havens of leisure in an urban context.

At the painting's 1910 debut, critics remarked
on the "riot of tone"[2] and the "fearlessness in
the demarcation of color."[3] JFD

1 Wattenmaker 2010, 66, 75–76.
2 Arthur Hoeber, "Art and Artists," *Globe and Commercial
 Advertiser*, April 5, 1913, cited in Wattenmaker 2010, 66.
3 [Mary Fanton Roberts], "Art in New York This Season,"
 Craftsman (April 1913): 135–136, cited in Wattenmaker
 2010, 75.

Horace Pippin (American, 1888–1946)
Supper Time, c. 1940
Oil on burnt-wood panel. 12 x 15 (30.5 x 38.4). BF985

In this small work painted on wood, Horace Pippin leaves much of the panel exposed so that it becomes an active part of the composition. Unpainted wood establishes the table and the view through the window; it also forms the skin of all three figures. An African American artist from West Chester, Pennsylvania, Pippin traveled to the South in 1940 "to paint landscapes and the life of the Negro people." Possibly the present work, showing a family in a humble interior, was produced on that trip.

Pippin, who received no formal art training, developed a technique of "carving" into his panels with a hot poker. Here, burnt-wood lines (incised over pencil) construct the chair, windowpanes, door panels, and contours of the figures. The contours are filled in with flat blocks of color that animate the details of everyday life. Bright white paint announces a range of objects, including cups and saucers, milk in a glass, laundry, steam, and snow piled on the windowpanes. The composition is carefully balanced: the laundry offsets the window, and an overall interplay takes place between horizontals and verticals. Only the table, with its diagonal lines, breaks from the work's gridlike structure.

Pippin had his first solo exhibition in 1940 at the Robert Carlen Galleries in Philadelphia, where several of these burnt-wood panels were displayed. Albert Barnes, who was increasingly interested in the work of self-taught artists, bought several paintings from the exhibition and invited Pippin to visit the Foundation. Pippin even enrolled briefly as a student. A great champion of the artist's work, Barnes wrote an essay for Pippin's second exhibition at Carlen Galleries in 1941. ML

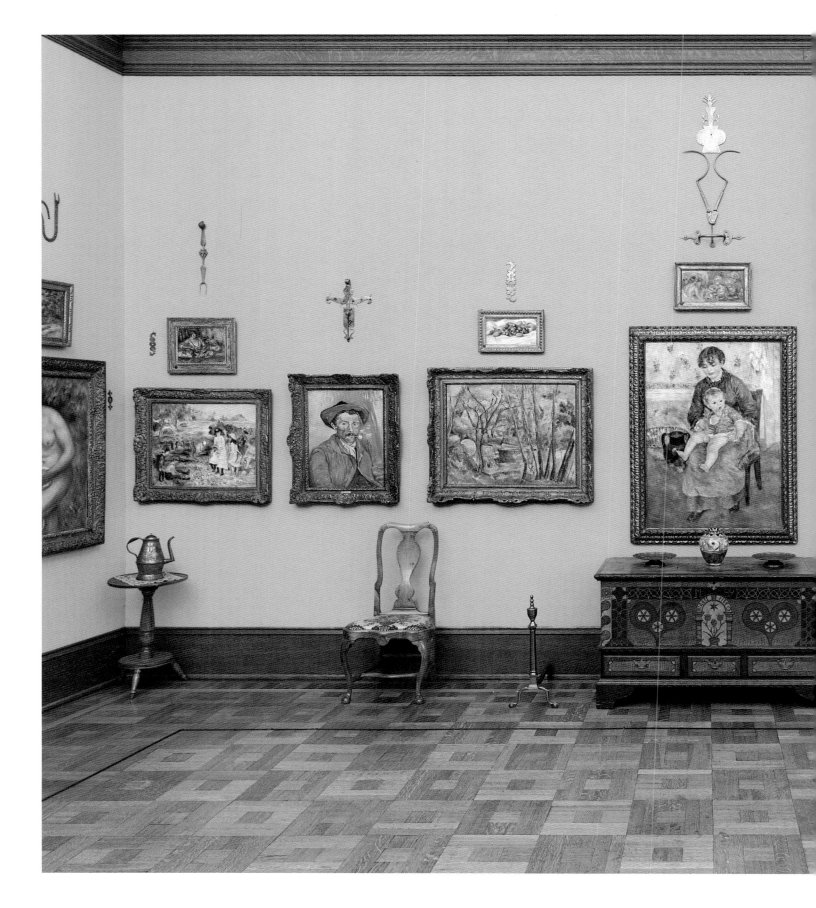

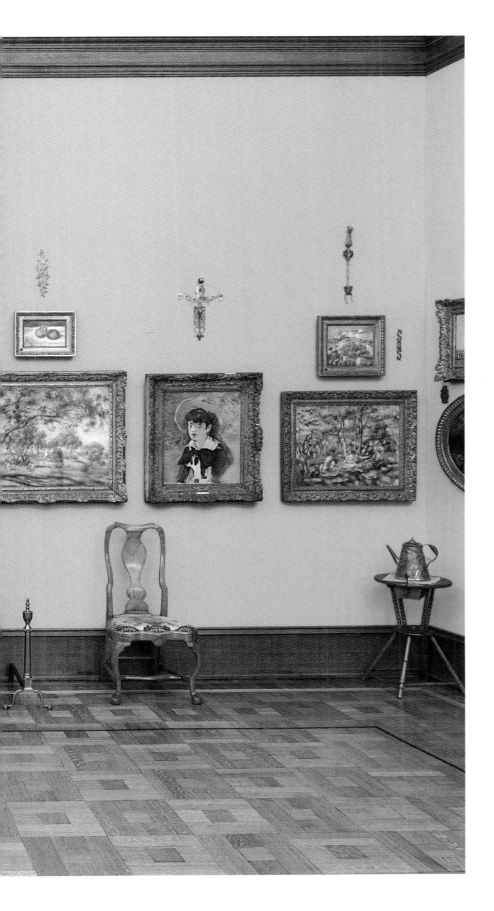

ROOM 13

NORTH WALL

Like so many of Albert Barnes's ensembles, this one is striking in its symmetry, with works of art meticulously organized along two main axes. At the center of the long horizontal line of paintings is Pierre-Auguste Renoir's *Young Mother*, flanked by landscapes of the same shape and size by Renoir and Paul Cézanne. Vincent van Gogh's *The Smoker* balances Édouard Manet's *Young Girl on a Bench* (down to the hats on the sitters' heads), and two additional landscapes by Renoir hang at each end. A perpendicular axis stretches from the Pennsylvania German chest below to the metal objects at the very top of the wall, bisecting the Jean Renoir vase and the vertically positioned heads of the mother and child figures. The crowning arrangement in metal consists of calipers, a door handle, and a wall decoration — unrelated objects that Barnes assembled into his own fanciful design, transforming their original utilitarian purposes into pure aesthetics.

If the ensemble reveals a collector obsessed with precision and order, it is also a highly instructive study of formal relationships across art-historical traditions. The works by Manet and Van Gogh, for example, both painted in France in the nineteenth century, present two distinct modes of paint application — one thick and graphic, the other more fluid. The landscapes by Renoir and Cézanne likewise use color and line to very different ends — Renoir's scene, at right, concentrates on surface effects, while the canvas by Cézanne examines the landscape's very structure. Yet all these modern paintings share a distinct subjective approach, and in their loose expressivity they offer a striking contrast to the precisely rendered design on the blanket chest. ML

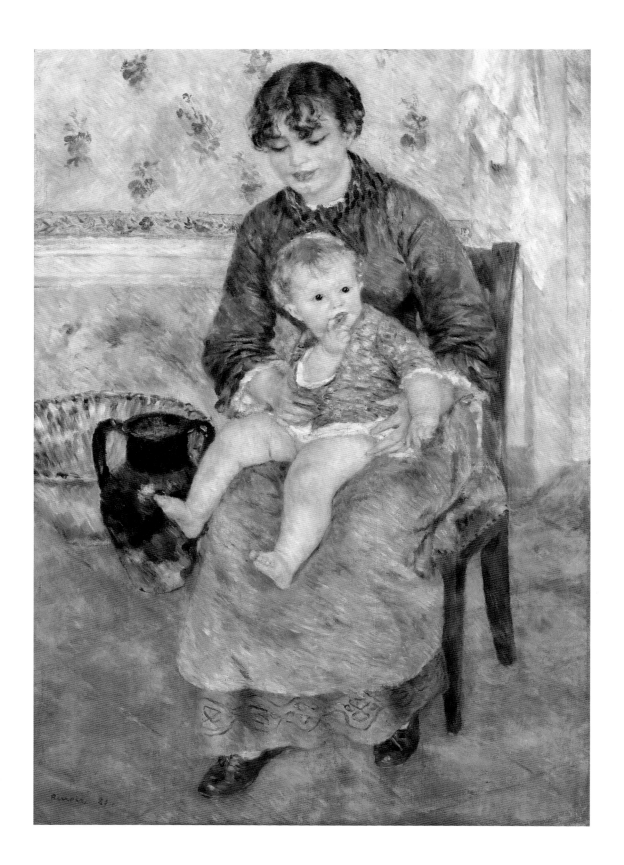

Pierre-Auguste Renoir
Young Mother (Jeune mère), 1881
PAGE 224

Jean Renoir
Vase, 1919–1922
PAGE 224

Attributed to John Bieber
Chest over Drawers, 1789
PAGE 224

Vincent van Gogh
The Smoker (Le Fumeur),
1888
PAGE 225

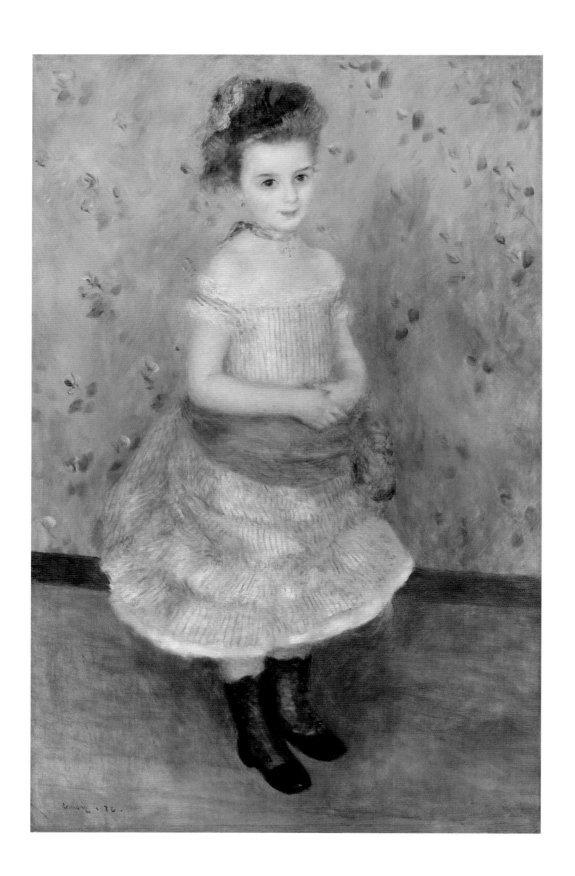

Pierre-Auguste Renoir
*Portrait of Jeanne Durand-Ruel
(Portrait de Mlle. J.)*, 1876
PAGE 226

Pierre-Auguste Renoir
Bois de la Chaise (Noirmoutier),
1892
PAGE 226

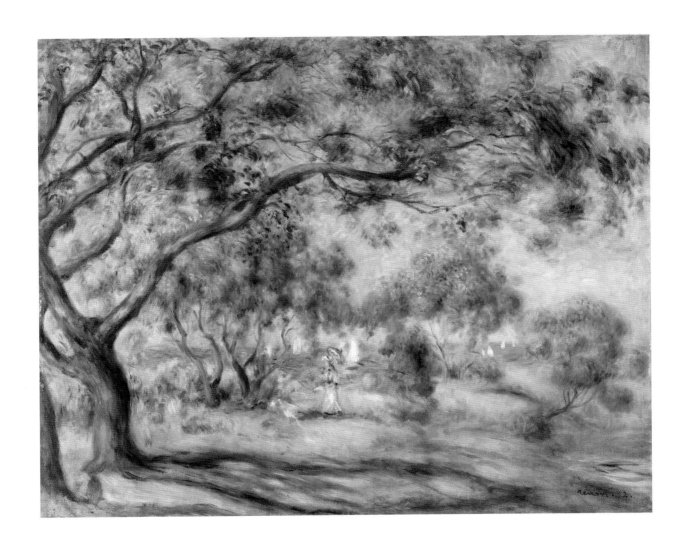

Pierre-Auguste Renoir
The Luncheon (Le Déjeuner),
1875
PAGE 226

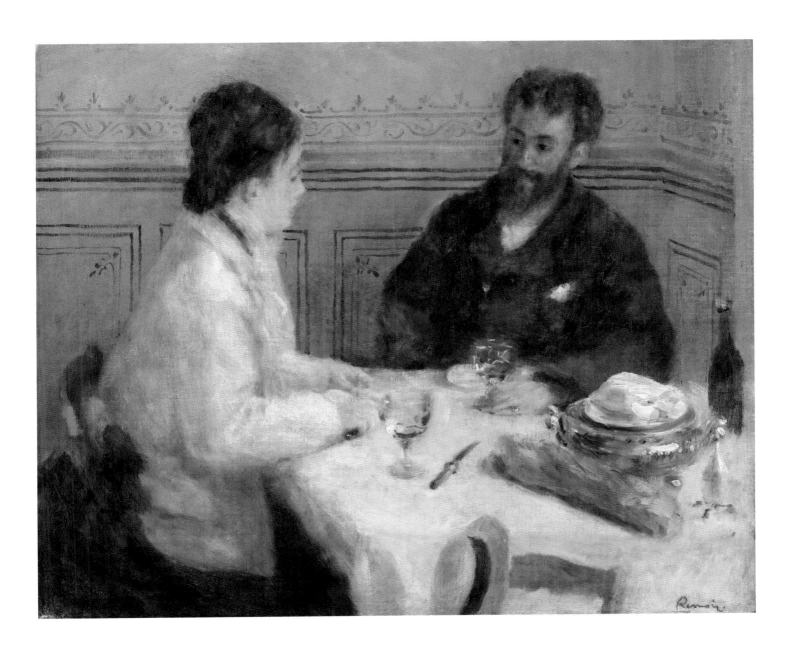

Willoughby Shade
Coffeepot, 1840s
PAGE 227

Paul Cézanne
Young Man and Skull
(Jeune homme à la tête
de mort), 1896–1898
PAGE 227

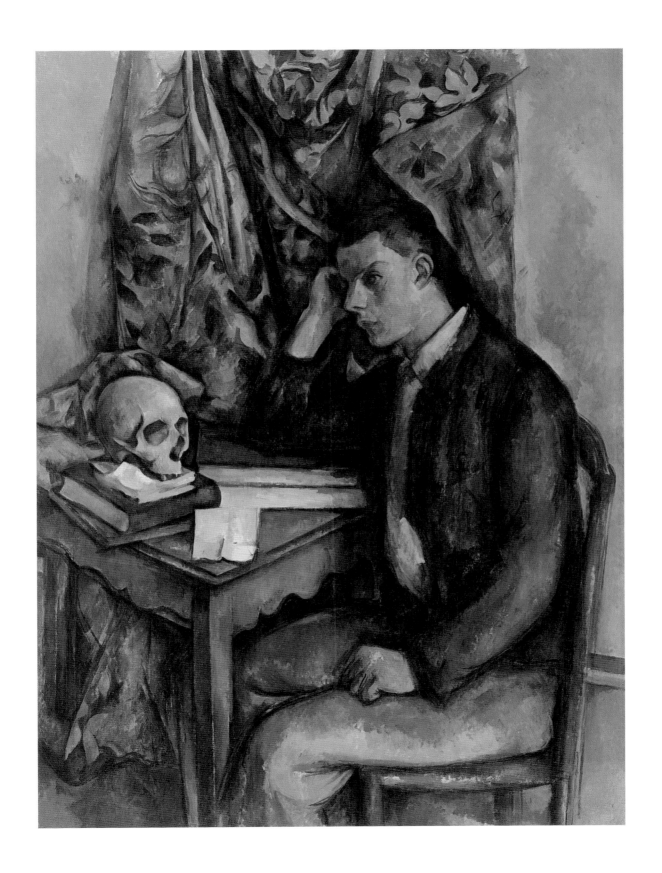

Pierre-Auguste Renoir (French, 1841–1919)
Young Mother (Jeune mère), 1881
Oil on canvas. 47 3/4 x 33 3/4 (121.3 x 85.7). BF15

For Pierre-Auguste Renoir, the bond between mother and child was the most natural of human relationships. The artist produced many paintings celebrating the essential physicality of this connection, such as the famous series depicting his wife nursing their son Pierre. Here, in this work painted in Naples in November of 1881, an Italian peasant girl holds a baby whose dimpled flesh looks deliciously soft and touchable. The girl is the very picture of earthy beauty, with full eyelashes, rosy lips, and chestnut hair laced with strokes of purple. As she steadies the squirming child, she gazes down with a serene, slightly amused expression.

Renoir's 1881 trip to Italy marked an important turning point in his career. Dissatisfied with his drawing skills and with the impressionist emphasis on surface appearances, he immersed himself in the art of antiquity and the Renaissance, visiting Venice, Florence, Rome, and Naples. Renoir was particularly awed by Raphael, whose paintings he described as having a "simplicity and grandeur." Raphael is in evidence here, in the stable geometry of the composition, in the way the child is enclosed in the form of the girl's body, and in the grace with which the figures interact. In effect, this is Renoir's version of the Madonna and Child, with the religious figures recast as rosy-cheeked peasants.

The painting was exhibited during Renoir's lifetime as *Young Mother*, but another early title suggests that the girl might actually be the infant's older sister. Whatever the relationship, the canvas seems to have encouraged the artist during a time when he was often frustrated with his work. "I'm very pleased and I'm going to bring you back some pretty things," he wrote to his dealer, Paul Durand-Ruel, from Naples. "I've started the figure of a girl with a child, if I don't scrape it off." ML

Chest over Drawers, 1789
Attributed to John Bieber (American, 1763–1825)
Pennsylvania, Berks or Lehigh County
Painted pine, iron, and brass. 30 3/16 x 52 1/2 x 23 1/2
(76.7 x 133.4 x 59.7). 01.13.18

A third-generation carpenter, John Bieber worked in Berks and Lehigh Counties, Pennsylvania, constructing and decorating chests with the signature flat-heart motif associated with Alsace, the French region from which his Huguenot forebears emigrated in 1744.[1] Made for Michael Finck in 1789, as the inscription on the front indicates, the chest has painted decoration that combines delicate sponging in complementary greens and reds (to mimic wood graining) with precise, compass-drawn hearts and stars.

In keeping with the usual arrangement of chests over drawers, two larger drawers flank a smaller, central one. The brass keyhole escutcheons and pulls incorporate British furniture-making practices and add a cosmopolitan note to this traditional rural form.[2] JFD

1 Shaner 2006, 123–126.
2 Fabian 2004, 47–49.

Vase, 1919–1922
Jean Renoir (French, 1894–1979)
Earthenware with polychrome decoration over slip, with tin-glazed interior. 8 3/8 x 6 3/4 (21.3 x 17.1). 01.13.16

Jean Renoir, son of Pierre-Auguste Renoir, is best known as the director of classic films such as *The Rules of the Game (La Règle du jeu)* and *Grand Illusion (La Grande illusion)*. He also made ceramics, turning out dozens of glazed earthenware pots in the years before he embarked on his film career. This handmade vase is greenish blue, decorated with a

painted band of leaves and fruit that encircles its widest part. The pieces of fruit, perhaps peaches or apples, are outlined in brown and given a hint of three-dimensionality by the simple juxtaposition of yellow and red paints. This is perhaps a paean to the still-life paintings of Jean's father, who so brilliantly rendered the coloristic nuances of luscious round fruit. Following his father's love of irregularity, no two shapes are the same, here or in any of Jean's ceramic work.

As a porcelain painter early in his career, the elder Renoir had always been interested in handmade decoration; he encouraged his son to pursue pottery, installing a kiln for him at his home and studio in the south of France. Jean worked there, at Les Collettes, in the years immediately following his father's death in 1919, using the clay from the fields surrounding the estate. "At Renoir's wish we did everything by hand," Jean wrote in his autobiography. Albert Barnes knew the Renoir sons well, having collected enormous quantities of their father's work, and he may well have seen Jean's pottery on his 1921 trip to Les Collettes. He purchased forty-two ceramic works by Jean in two batches in 1921 and 1922 through the dealer Paul Durand-Ruel, who described them as "old country porcelains, quite rough." The Barnes Foundation's holding of ceramics by Jean Renoir is the largest in the world. ML

Vincent van Gogh (Dutch, 1853–1890)
The Smoker (Le Fumeur), 1888
Oil on canvas. 24 ³/₄ x 18 ³/₄ (62.9 x 47.6). BF119

Vincent van Gogh revered the works by his seventeenth-century Dutch predecessors Rembrandt van Rijn and Frans Hals. Extolling the verve of their paint handling, he noted: "The best paintings—precisely the most perfect from a technical point of view—seen from close to are touches of colour next to one another, and create their effect at a certain distance."[1] While his countrymen provided lessons of technique, Van Gogh also found great inspiration in the work of the Barbizon painter Jean-François Millet, whose fatalistic paintings of the rigors of rural life echoed his own observations as a lay minister to coal miners. Although Van Gogh ultimately

pursued an artistic career instead of the ministry, the working classes—shown at their labor or in portraits—served as his frequent subjects, and he presented them with empathy, candor, and dignity.

Van Gogh painted his smoker in 1888, when he settled in Arles with the hopes of establishing a community of artists. He positioned his sitter close to the picture plane, endowing him with a monumental presence. His body and face turned slightly to his left, the smoker glances to the right with alert, olive-colored eyes, establishing a sense of immediacy—though not intimacy—with a slightly skeptical look. Van Gogh further heightened this sense of the fleeting moment with a series of white strokes for the puffs of smoke rising from the bowl of the sitter's clay pipe. Using short, visible dots and dashes and a patchwork of unmixed hues—pink, olive, gray, yellow—the artist captured the smoker's high cheekbones, ruddy cheeks, graying temples, and ragged mustache. Brilliant curling strokes of yellow delineate the contours of the smoker's exposed ear. By contrast, longer strokes, mixed with passages of unpainted or lightly brushed canvas, define the sitter's plain, worn jacket.

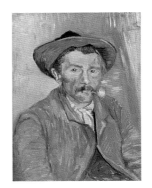

Set back on the crown of the smoker's head, the broad-brimmed blue hat evokes a saint's nimbus, an effect Van Gogh wished to achieve through his vigorous handling and striking palette: "I'd like to paint men or women with that *je ne sais quoi* of the eternal, of which the halo used to be the symbol, and which we try to achieve through the radiance itself, through the vibrancy of our colorations."[2] JFD

1 Letter from Vincent van Gogh to Theo van Gogh, on or about November 7, 1885, Van Gogh Museum, Amsterdam, Letter 539, inv. b471 a-b V/1962, http://vangoghletters.org/vg/letters/let539/letter.html.
2 Letter from Vincent van Gogh to Theo van Gogh, September 3, 1888, Van Gogh Museum, Amsterdam, Letter 673, inv. b573 a-b V/1962, http://vangoghletters.org/vg/letters/let673/letter.html.

Pierre-Auguste Renoir (French, 1841–1919)
Portrait of Jeanne Durand-Ruel
(Portrait de Mlle. J.), 1876
Oil on canvas. 44 7/8 x 29 1/8 (114 x 74). BF950

This portrait presents Jeanne Durand-Ruel, the youngest child of the famous art dealer Paul Durand-Ruel. A major champion of Pierre-Auguste Renoir's work from the 1880s on, Durand-Ruel held an enormous stock of the artist's paintings and was extremely important in the formation of Albert Barnes's collection. Jeanne is depicted here at age six, wearing a fashionable striped dress and green sash; a gold cross around her neck signals her family's religious background. With her hands clasped daintily at her waist, she stands looking directly out at the viewer, her mouth curving into a practiced half-smile—she has the poise of an adult. Yet Renoir manages to capture, very subtly, the child beneath the grown-up posturing. Though she stands perfectly—dutifully—straight, her feet betray just the smallest hint of awkwardness, as if they do not quite have possession of solid ground.

This work falls relatively early in the span of Renoir's long career as a portrait painter. After the success of *Madame Charpentier and Her Children*, 1878 (The Metropolitan Museum of Art, New York), at the 1879 Salon, Renoir went on to receive many commissions, including several more from Durand-Ruel for portraits of himself and his other children. While Renoir is concerned here with capturing the girl's likeness—the face is carefully painted, and the flesh is a smooth pearly white—he also demonstrates formal daring. The girl's hair, for example, though from a distance a mono-chromatic brown, is really a tangle of color, with brilliant touches of blue, purple, and yellow above the forehead. ML

Pierre-Auguste Renoir (French, 1841–1919)
Bois de la Chaise (Noirmoutier), 1892
Oil on canvas. 25 13/16 x 31 7/8 (65.5 x 81). BF163

Pierre-Auguste Renoir spent August and September of 1892 in the resort town of Pornic in Brittany. While there, he made several trips by boat to the small island of Noirmoutier,

just off the coast, in search of landscape motifs. Though Renoir made his living primarily as a painter of figures, he worked in landscape throughout his career, as the subject allowed him the expressive freedom he found difficult when confronting a live model. He was often frustrated by the practicalities of landscape painting, however—the shifting light could be a challenge, and simply accessing his subject was sometimes laborious. After one trip to Noirmoutier, he reported to Berthe Morisot that the island "is superb and quite like the south, far superior to Jersey and Guernsey; but too far away, much too far."

Noirmoutier featured a woodsy grove called the Bois de la Chaise, and here Renoir painted from within the grove, capturing the view out to the ocean; he produced several other canvases from the same perspective. By 1892 he had moved beyond his impression-ist style, thinking it too ephemeral, yet the painting retains many aspects of impression-ist technique. The play of the light across the landscape, for example, is of primary concern. Brown tree trunks are really brilliant swirls of reds, yellows, and purples, as are the branches that snake their way across the sky. As their shadows hit the ground below, they dissolve into an eddy of colors moving over and around one another, with paint brushed wet-into-wet. The brushwork is varied, with long, sweeping strokes in the foreground and shorter dabs describing the treetops. ML

Pierre-Auguste Renoir (French, 1841–1919)
The Luncheon (Le Déjeuner), 1875
Oil on canvas. 19 3/8 x 23 5/8 (49.2 x 60). BF45

Like the other impressionists, Pierre-Auguste Renoir often focused on scenes of leisure, depicting Parisians strolling down city boule-vards or relaxing in the countryside. Here a couple is seated indoors enjoying a casual lunch. There is a note of intimacy in their interaction, as the man looks tenderly at his companion, his fingers lingering on the stem of his glass, while the woman leans slightly forward as if listening attentively. The still life on the table is delicately rendered, with a few dashes of red paint describing the last sips of wine, the

glasses themselves beautifully evoked through licks of bright white. Feathery red strokes are brushed through the baguette.

The boating hat hanging on the chair tells us that this pair is probably taking a break from a canoe outing. Day trips down the Seine were a popular form of leisure at the time, and many restaurants and cafés could be found along the way in towns such as Chatou. Indeed, the painting is in the same vein as *Lunch at the Restaurant Fournaise (The Rowers' Lunch)*, 1875 (The Art Institute of Chicago), and *Luncheon of the Boating Party* (fig. 1), both of which show groups of rosy-cheeked boaters gathered around tables laden with wine, bread, and fruit. *The Luncheon* is a much quieter picture, focusing on a single conversation, and the river is not glimpsed as it is in the other canvases. But the model for the male figure, the oarsman M. de Lauradour, also appears in the other two paintings, easily identifiable by his beard and curly hair parted down the middle. While we know *Luncheon of the Boating Party* was painted in Chatou, the location of the present scene has not been identified. ML

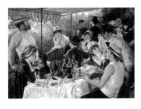

FIG. 1 Pierre-Auguste Renoir
Luncheon of the Boating Party, 1880–1881
Oil on canvas, The Phillips Collection, Washington, D.C.

Coffeepot, 1840s
Willoughby Shade (American, b. 1820)
Tin over sheet iron and brass. 10 ³/₄ x 6 ¹/₄ x 10 (27.3 x 15.9 x 25.4). 01.13.01

This tinned sheet-iron coffeepot bears an elaborate and delicate decoration of a lyre symmetrically flanked by birds and foliate motifs, most likely derived from Pennsylvania German Fraktur, the colorful ink and water-color designs that bordered birth, baptismal, and marriage certificates (p. 246). Although now showing traces of its age, the tin would have gleamed when first produced. The curving forms of the domed lid, rounded handle, and goose-necked spout handsomely complement the angularity of the double-conical body. The coffeepot carries the name of Mary Weisner, its original owner, on its flared base, and the name of its maker, Willoughby Shade, on top of the rounded handle. Shade worked in Montgomery and Bucks Counties in south-eastern Pennsylvania during the mid-nineteenth century and ultimately settled in

Philadelphia. With about three dozen coffee-pots of this kind known by Shade and others, this object occupies a distinctive place in the collection for its rarity, as well as for its fine craftsmanship.[1] JFD

1 Fennimore 2004, 366–369.

Paul Cézanne (French, 1839–1906)
Young Man and Skull (Jeune homme à la tête de mort), 1896–1898
Oil on canvas. 51 ³/₁₆ x 38 ³/₈ (130 x 97.5). BF929

In his 1921 biography of Paul Cézanne, Joachim Gasquet provided a firsthand recollection of the evolution of the artist's meditation on mortality: "One day he decided to bring together in a vertical canvas all these ideas that so haunted him, this 'motif' of the death's-head, and painted his *Young Man and Death*. Standing out against an opulent leaf-patterned drapery, the one he used in his still lifes, he sat a young man dressed in blue in front of a table of blond wood, a death's head before him."[1] Much like *Still Life with Skull* (p. 91), in which he paired plump, rounded fruits with the yellowed studio prop, here Cézanne matched the death's head with a sturdy youth whose smooth face and bright eyes serve as complements to the skull's jutting cheekbones and hollow, darkened eye sockets. Cézanne further underscored the poignancy of the confrontation by enveloping these vastly contrasting heads in the dense vegetation of the draped textile, whose elaborate folds and gathers suggest a dynamic vitality—especially the seemingly active creep around the skull. A branch or vine of the woven foliage appears to emerge from the pensive young man's head, climbing steeply and sinuously across the cloth. With his head cradled in his hand and his distant look, the youth summons long-standing iconographies for melancholy as well as traditional images of the hermit Saint Jerome and the penitent Mary Magdalene. JFD

1 Joachim Gasquet, *Cézanne* (Paris, 1921), 19–20, cited in Cachin et al. 1996, 490.

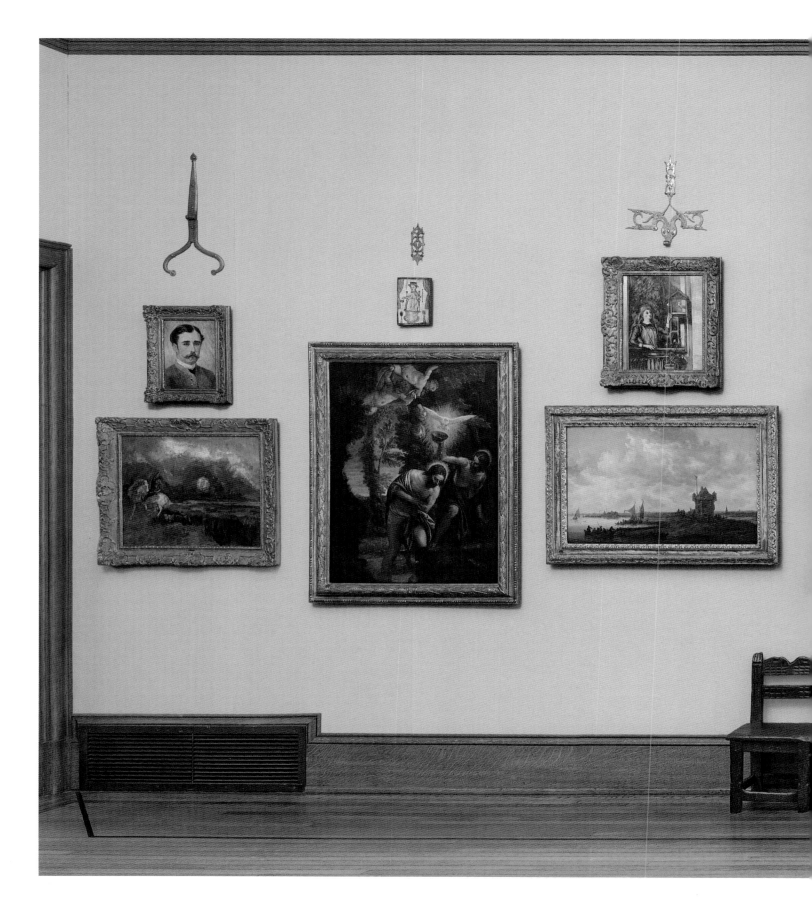

ROOM 14

NORTH WALL

Occasionally thematic links are evident in the ensembles. Here, an animal motif winds its way across the wall, with Henri Rousseau's dramatic *Scouts Attacked by a Tiger* at the center. Another struggle between man and beast occurs in Odilon Redon's *Saint George and the Dragon* at far left. Birds appear in Gustave Courbet's *Woman with Pigeons*, in Paul Cézanne's *Girl with Bird Cage* in the upper row at left, and in the sixteenth-century *Baptism of Christ* by Paolo Veronese, where a dove represents the Holy Spirit. These juxtapositions are perhaps meant to bring forward the difference between traditions. While Veronese gives the bird a symbolic role, Courbet, the nineteenth-century realist, presents birds as actual things in the world. Painted wood parrots carry the animal theme into three dimensions.

This ensemble is a dynamic mix of objects, with modern paintings, old masters—including two works by Tintoretto and a landscape by Jan van Goyen—and two small New Mexican retablos. A palette of mossy green connects the canvas by Rousseau to the Pennsylvania German chest and also to the redware jug and wood birds resting on top. A Maurice Utrillo landscape with deep greens hangs above the picture by Rousseau, completing this column of color. Bursts of fiery orange-red mark either end of the bottom row, describing a boat in Renoir's *The Seine at Argenteuil* and conveying the setting sun in the painting by Redon. In both instances this hot color is set off against an expanse of cool blue. Instructive differences also appear in the use of light across the bottom row, from the dappled impressionist sun in Renoir's landscape, to the theatrical lighting of Rousseau's work, to the chiaroscuro of Courbet's painting, to the emotional and color-infused light of Redon's canvas. ML

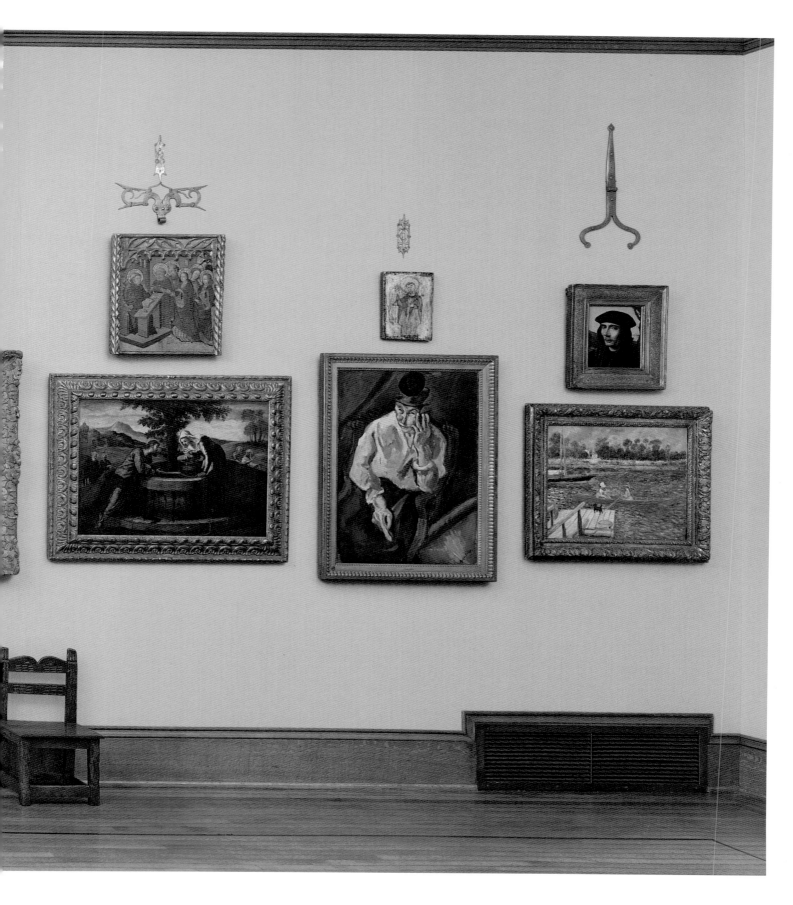

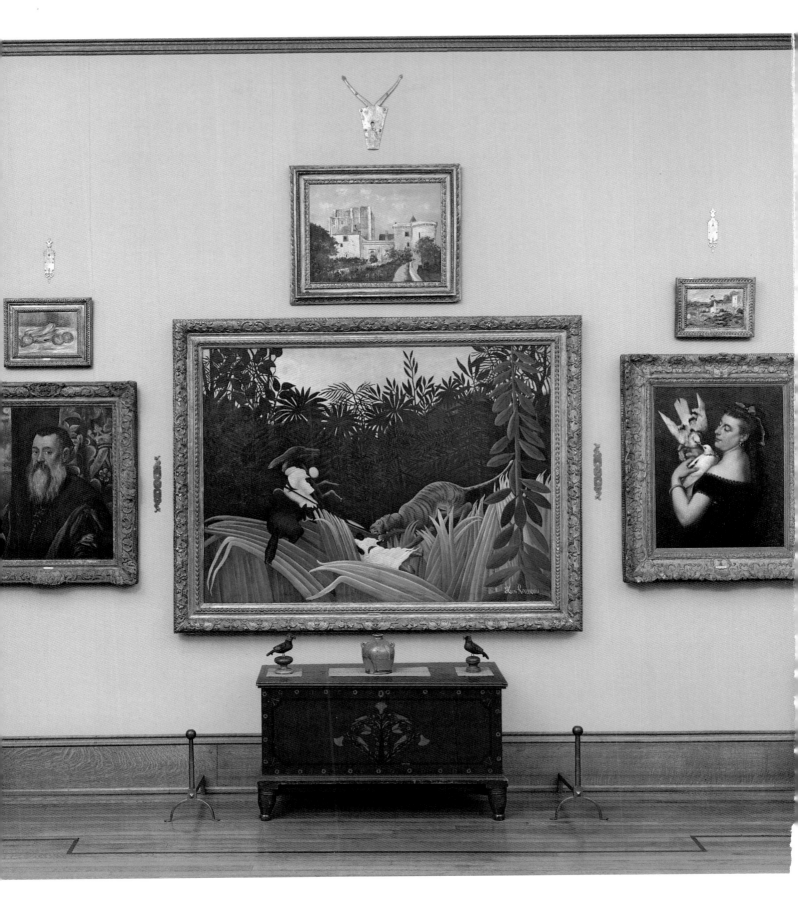

Pierre-Auguste Renoir
*Mussel-Fishers at Berneval
(Pêcheuses de moules à
Berneval, côte normande)*, 1879
PAGE 240

Odilon Redon
*Saint George and the Dragon
(Saint Georges et le dragon)*,
C. 1909–1910
PAGE 240

Gustave Courbet
Woman with Pigeons,
c. mid-1860s
PAGE 241

Jan van Goyen
The Square Watch-Tower, 1651
PAGE 241

Henri Rousseau
Scouts Attacked by a Tiger
(Éclaireurs attaqués
par un tigre), 1904
PAGE 242

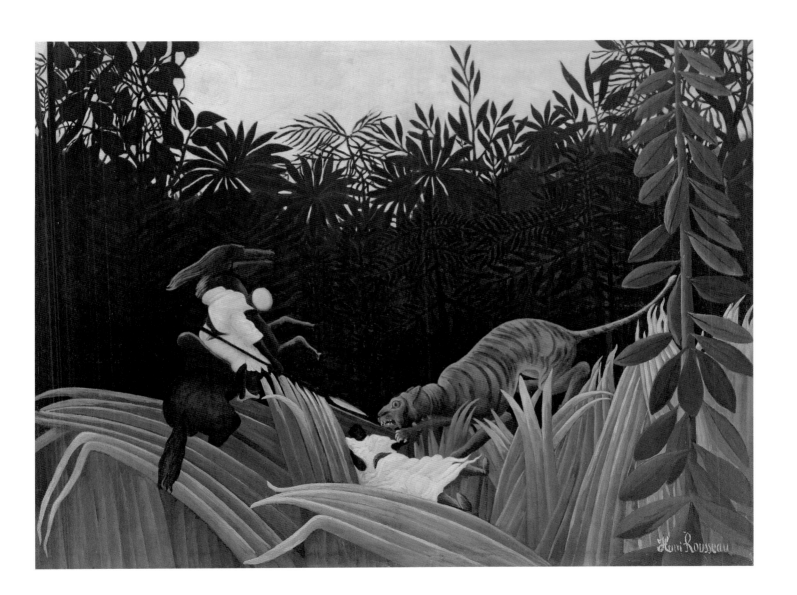

Paolo Veronese
Baptism of Christ,
mid-16th century
PAGE 242

Honoré Daumier
The Ribalds (Les Ribaudes),
1848–1849
PAGE 243

Pierre-Auguste Renoir (French, 1841–1919)
*Mussel-Fishers at Berneval (Pêcheuses
de moules à Berneval, côte normande)*, 1879
Oil on canvas. 69 3/8 x 51 1/4 (176.2 x 130.2). BF989

Pierre-Auguste Renoir spent the late summer
of 1879 at the Château de Wargemont, the estate
of his patron Paul Berard, on the Normandy
coast. His major project during this sojourn
was the *Mussel-Fishers*, a large canvas Renoir
eventually exhibited at the 1880 Paris Salon. A
peasant woman and three children stand on
a rocky coast, the signs of their mussel-gathering
readily apparent: shells are strewn around
their feet, and the woman carries a large basket
on her back used for hauling fish. The beach
is Berneval-sur-Mer, which was privately owned
by the Berards.

Paintings of peasants were common fare
for the Salon. Here, tattered clothing conveys
the figures' humble status, yet Renoir is care-
ful not to present them as downtrodden. On
the contrary, these mussel-gatherers all glow
with rosy cheeks, a picture of good health, and
the red-haired girl smiles as she tenderly
holds the hand of the smallest child. The blond
boy looks up at the woman and she returns
the gaze, hand on hip—a towering figure
against the horizon.

Certainly because it was intended for a
conservative exhibition venue, *Mussel-Fishers*
represents a shift away from the quick, radical
forms that characterize Renoir's impressionist
work. Though the colors are brilliant, domi-
nated by blues and purples, the emphasis here
is legibility; figures are carefully composed
and arranged in a stable triangle. Impressionist
technique is still present in the background,
however, as sea and sky meld into one continu-
ous veil of color, with tiny white sails just
visible on the horizon. In a sense, this work is
a perfect demonstration of an artist pulled in
two directions. ML

Odilon Redon (French, 1840–1916)
*Saint George and the Dragon (Saint Georges
et le dragon)*, c. 1909–1910
Oil on paperboard. 21 x 26 3/4 (53.3 x 67.9). BF2093

Early in his career Odilon Redon concentrated on
what are known as his "noirs"—lithographs
and black chalk drawings in which monstrous
hybrid creatures float in murky darkness. In
the oil painting seen here color has returned, in
jewel-like tones, and while the interest in
fantastical creatures remains, the subject is
now one with a well-established iconography.
The painting shows Saint George, a Roman
soldier who, according to Christian legend,
heroically slew a dragon that was terrorizing
a Libyan city, causing the grateful citizens
to convert to Christianity. The theme of heroes
battling monsters was a favorite for Redon,
and he drew from religion, mythology, and
literature in developing his own mystical vision.

Considering the subject's gory potential,
the action here is relatively muted and pushed
to the side of the composition. The hero and
dragon are small and their struggle is difficult
to see; the majority of the canvas is given over
to the landscape. Redon uses color to convey the
story's drama, as a hot red sun burns on the
horizon, melting into an emerald green ocean.
Heavy clouds, lit theatrically from above, fill
the sky. The meeting of sea and land is spatially
ambiguous; it is difficult to tell where one
ends and the other begins, and the land seems
to curl over the sea, acting like a wave that is
spraying bits of brown foam.

In other iterations of this subject, Redon
experiments with the composition but uses
the same general color scheme of browns, red,

and emerald green. In these, the sun has disappeared, however, and the hot red color is the dragon itself. This was one of Albert Barnes's last purchases. ML

Gustave Courbet (French, 1819–1877)
Woman with Pigeons, c. mid-1860s
Oil on canvas. 31 3/8 x 23 7/8 (79.7 x 60.6). BF824

Gustave Courbet first emerged as an artist of great daring in the late 1840s and early 1850s when he presented manifesto paintings such as *A Burial at Ornans*, 1849–1850 (Musée d'Orsay, Paris), which challenged academic standards, merging the monumental scale of history painting with the anecdotal narrative of genre scenes. Consistently flouting conventions of technique, composition, and propriety, Courbet, a prolific and nimble artist, painted landscapes, portraits, still lifes, nudes, and genre scenes.

Melding the physiognomic specificity of a portrait and the incident of genre scene, Courbet offers an unexpectedly provocative exploration of sensual pleasures in *Woman with Pigeons*. As she clutches one pigeon to her chest and permits another to perch delicately on her index finger, the woman closes her eyes, allowing the viewer unreservedly to take in and imagine a variety of sights and textures. In addition to the soft warmth of the bird on her skin, the young woman's long, curled tresses graze creamy shoulders revealed by the cut of a lustrous velvet dress that is edged with delicate, gauzy lace. The hefty gold bangle on her wrist, the large stone set in her earring, and the eye of the pink, beribboned bird sparkle in the bright light that enters from the left. An avid, skilled hunter, Courbet carefully described the white and brown plumage of the birds, particularly evident in the perched bird whose outstretched wings and raised tail feathers stand out against the monochromatic background and reveal a variety of shapes, sizes, and colors, rendered in an equally diverse range of brushstrokes. Although *Woman with Pigeons* has traditionally been attributed to Courbet and bears his signature and the hallmarks of his style, it merits further research. JFD

Jan van Goyen (Dutch, 1596–1656)
The Square Watch-Tower, 1651
Oil on panel. 22 3/4 x 35 1/4 (57.8 x 89.5). BF843

As highways for the transport of merchandise and livestock and as rich fishing grounds, the rivers and canals in the Netherlands linked countryside, city, and sea. Jan van Goyen devoted his career to painting the rhythms of these vital waterways in panoramic works dotted with ferries, fishing boats, castles, windmills, and church steeples. In this composition, the placid river zigzags from the right foreground to the low horizon at left—the pitched roofs of the buildings and the vertical masts of the vessels mark the gradual recession of space in the flat terrain. A ferry filled with soldiers lands on the riverbank, perhaps a change of guard for the watch gathered around the tower's cannon. Typical of the tonal and very liquid handling of his mature style, Van Goyen rendered the river scene in a reduced, nearly monochromatic array of browns, greens, and grays. However, the vast sky reveals a brighter palette of blues and pinks edged with white that defines the contours of the plump clouds. Similarly, the broader brushwork in the sky contrasts with the nearly calligraphic description of the landscape elements and figures. JFD

Henri Rousseau (French, 1844–1910)
Scouts Attacked by a Tiger (Éclaireurs attaqués par un tigre), 1904
Oil on canvas. 47 7/8 x 63 3/4 (121.6 x 161.9). BF584

Between 1904 and 1910, Henri Rousseau produced more than twenty large-scale "jungle pictures" showing tropical landscapes rife with themes of violence and struggle. Here, two scouts battle a fierce tiger that is all teeth and claws—a mirror image of the animal in the artist's *Surprise!*, 1891 (The National Gallery, London). While one man points his weapon from atop a rearing horse, the other lies defeated in the grass; a streak of dark red across his robe may be read either as a bloody gash or as a cummerbund matching that of his companion. The scene is highly theatrical; the tiger's wild eyes convey terror and excitement, and the meeting of arrow and snout at the picture's center, directly over the felled scout, is bursting with suspense. The composition, too, has a stagelike quality, as the action takes place in a brightly lit foreground against a flat backdrop.

Though it was long believed that Rousseau's jungle paintings derived from his direct observation of the Mexican rain forest, the artist never traveled to such distant locales. His study of jungle life occurred in the city—in the Jardin des Plantes in Paris, where plant specimens and taxidermy animals were on display. Despite such quasi-real sources, however, the jungle pictures are pure fantasy. Created during an era of rapid colonial expansion for France, such pictures imagine distant lands as places of terror. Stories

about the colonies circulated widely at the time and certainly informed Rousseau's work. The scouts are simply dark and faceless; together with the oddness of the landscape and its oversize blades of grass, they create a sense of distant lands as both mysterious and unknowable. ML

Paolo Veronese (Italian, 1528–1588)
Baptism of Christ, mid-16th century
Oil on canvas. 42 x 31 1/4 (106.7 x 79.4). BF800

Paolo Caliari, called Veronese—a reference to his native city of Verona—made his career in Venice, where he established himself as a highly sought-after painter thanks to his prodigious talent and diplomacy.[1] Veronese easily mastered allegorical, religious, and secular subject matter for his many commissions for altarpieces and narrative cycles in palace interiors and religious houses, endowing his work with the powerful theatricality, rich textures, and luminous color that became his hallmarks.

Here, Veronese paints the Baptism of Christ, an episode drawn from the Gospel of Matthew. Jesus travels from Galilee to Judea to be baptized by John the Baptist, who lived and preached in the desert, prophesying the

coming of Christ. With his hands crossed over his chest in a gesture of humility and prayer and his bent knee perched on the bank of the Jordan River, Jesus bows before the Baptist. Demonstrating equal modesty, John also stoops as he pours the water over the head of Jesus. The Holy Spirit descends from the heavens in the form of a dove with wings out-stretched—a formal complement to Christ's bent arms—as a handful of putti and cheru-bim witness the rite. The burst of light that accompanies the arrival of the Holy Spirit illuminates the scene, casting a glowing light over Jesus's sturdy musculature and the bony chest of the ascetic Baptist. To lend his subject intimacy, Veronese locates the scene in a leafy bower that frames this narrow stretch of the Jordan. JFD

1 For more on Veronese's reputation and place in the fiercely competitive system of Venetian patronage, see Patricia Fortini Brown, "Where the Money Flows: Art Patronage in Sixteenth-Century Venice," in Ilchman et al. 2009, 41–61.

donkey meet with constant criticism from passersby, all of whom have a different opinion about how the animal should be used. From the more detailed Glasgow painting we know that the figures here are meant to be gesturing at the father and son outside the frame. Rather than focus on the weary travelers, Daumier zooms in on the crude passersby. The vulgarity of their behavior is conveyed not through facial expression or physiognomy—which Daumier was very adept at capturing—but instead through exagger-ated gesture. Bodies are loosely comported, with wildly flinging limbs, jutting elbows, and hips thrust forward. Off-balance, the women twist into each other, and the steep path adds to a sense of the moral precariousness of their behavior. The dramatic contrasts of light and dark, the theatrical gestures, and the strong diagonals transmit a certain baroque sensibility. ML

FIG. 1 **Honoré Daumier**
The Miller, His Son, and the Ass, 1849
Oil on canvas, The Burrell Collection, Glasgow

Honoré Daumier (French, 1808–1879)
The Ribalds (Les Ribaudes), 1848–1849
Oil on canvas. 50 3/4 x 38 (128.9 x 96.5). BF22

Honoré Daumier was one of the greatest caricaturists of the nineteenth century. Work-ing primarily as a printmaker, he produced thousands of images capturing the various social types of Paris and satirizing French social and political life. In this large oil painting, two barefoot peasant women walk clumsily down a steep incline, their bodies twisting sideways and backward. A third woman who stands behind them holds a basket of fruit on her head; except for her forearm, her body is entirely submerged in shadow. While this work does not make a specific political point, it nevertheless relies on many of the devices of caricature.

The Ribalds is an early study for another painting called *The Miller, His Son, and the Ass* (fig. 1). It illustrates a well-known fable in which a father and son traveling with their

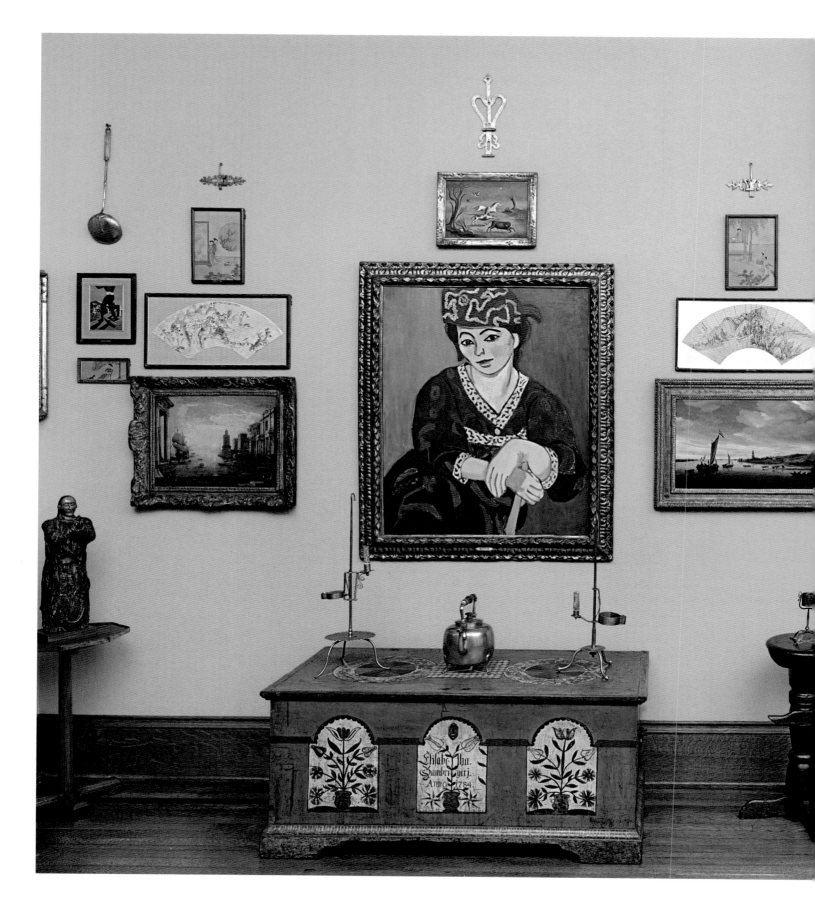

ROOM 15

SOUTH WALL

This is one of the most eclectic groupings in the collection, with Henri Matisse's stunning *Red Madras Headdress* at center juxtaposed with French and Dutch landscapes, seventeenth-century Chinese fans, American folk art, and various household items. Several of these disparate objects are connected by their dominant colors, which are applied in broad, flat zones. The abstract blue expanse surrounding Matisse's sitter corresponds to the sky in Jean Hugo's *The Flight*, above, and also to the small folk picture at bottom right called *Little Girl on Dog*, which is painted on glass. In the Pennsylvania German chest below, a more muted blue functions much as it does in the painting by Matisse — as a flat surround for pictorial elements.

The ensemble also seems to encourage comparison of the way space is represented across traditions. The picture by Matisse, for example, is all about surface, and its space is shallow and constricted. The landscapes on either side, by contrast — the one on the right is by Salomon van Ruysdael — show a deep recession into the distance, as colors blend gradually to produce atmosphere. The fans, decorated with mountain landscapes by Chinese artist Shen Shichong, display a panoramic field of vision that is wholly different from the European scenes placed below them. In the fans, the eye is pushed outward to the edges of the image rather than pulled back into a single vanishing point.

Albert Barnes's admiration for self-taught artists is evident in this grouping, which presents several Pennsylvania folk objects — including a Fraktur at right, hanging below the ladle — and paintings by Hugo and Angelo Pinto, neither of whom was professionally trained. The small rectangular work at far left is a crayon and pencil drawing by Lenna Glackens, the nine-year-old daughter of Barnes's good friend, the artist William Glackens. ML

Johann Adam Eyer
*Cover for a Book
of Copy Models
(Vorschriften-Büchlein)*, 1784
PAGE 252

Henri Matisse
*Red Madras Headdress
(Le Madras rouge)*,
late April–mid-July 1907
PAGE 252

CHINESE 5th Century
(WEI)

Chinese, Tang dynasty
(AD 618–906)
Head of a Bodhisattva,
early 8th century
PAGE 253

Navajo
Bow Guard (Ketoh),
c. 1900–1910
PAGE 254

Navajo
Squash Blossom Necklace,
c. 1900
PAGE 254

American, Pennsylvania German
Chest, 1784
PAGE 255

Paul Cézanne
Still Life (Nature morte),
1892–1894
PAGE 255

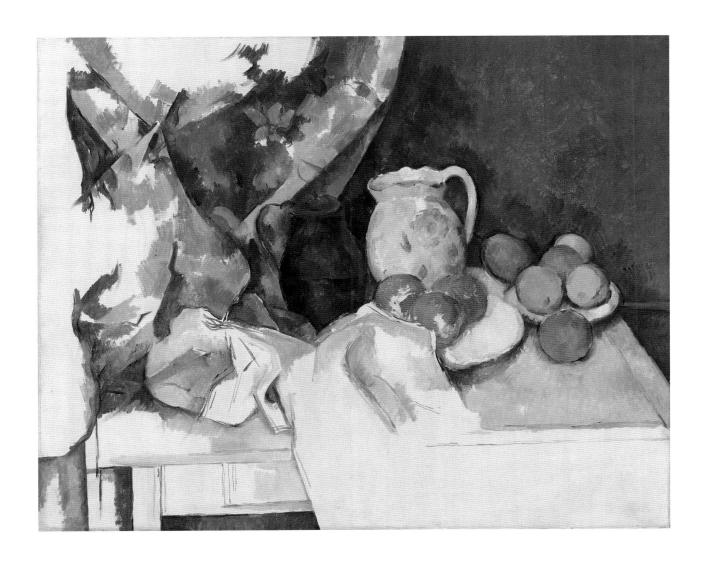

Johann Adam Eyer (American, 1755–1837, active c. 1779–1820)
Cover for a Book of Copy Models (Vorschriften-Büchlein), 1784
Watercolor, pen and iron gall ink, and pen and red watercolor on laid paper. 8 ⅛ x 6 ⁷⁄₁₆ (20.6 x 16.4). BF936

This work on paper is known as "Fraktur," a form of manuscript art practiced by Pennsylvania Germans in the eighteenth and early nineteenth centuries. Fraktur works are essentially elaborately decorated documents — ranging from birth certificates to book covers to love letters — with text surrounded by ornamental embellishment and symbols. The style, particularly the lettering, has roots in European folk culture, but Fraktur developed into a distinct form in America, with its own vocabulary of symbols and designs.

The present work was made as the cover of a *Vorschriften-Büchlein*, a type of book containing copy models for young students practicing writing exercises. The symmetrical design, principally in green, yellow, and red pigment, features a floral motif and two birds perched atop a heart. Enclosed within the heart is an elegantly drawn inscription in German, which translates as: "This little book of writing models belongs to Elisabetha Lädtermann, pupil of writing in the Deep Run School, written out for her the 16th of December Anno Domini 1784." The artist, Johann Adam Eyer, was a prolific Frakturist and schoolmaster who taught for many years at a Mennonite school in Bucks County, Pennsylvania. The quills at the bottom corners, one in an inkpot and the other held in a hand, are characteristic of Eyer's work. ML

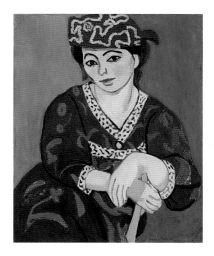

Henri Matisse (French, 1869–1954)
Red Madras Headdress (Le Madras rouge), late April–mid-July 1907
Oil on canvas. 39 ⅜ x 31 ⅞ (100 x 81). BF448

In 1907, Henri Matisse debuted *Red Madras Headdress*, which soon joined *Woman with a Hat*, 1905 (San Francisco Museum of Modern Art), and *Le Bonheur de vivre* (p. 272) as daring statements of his aesthetic innovation and ambition. As he had done in *Woman with a Hat*, Matisse took his wife, Amélie, as his subject. While the earlier portrait had shocked critics and the public with the treatment of Madame Matisse's face and stately bourgeois attire — a patch-work of non-naturalistic electric hues — this latest painting announced his move toward a decorative exoticism with its flatly applied color, vibrant patterns, and evocation of non-European sources, proving no less surprising to the critics.

Matisse positions his wife close to the picture plane with an undefined background behind her, painted in deep blues that move from more transparent applications at the left to a rich, opaque pigment at right. The flattened space marks a departure from a smaller, earlier version of the work — also at the Foundation (fig. 1) — in which Madame Matisse, garbed in the same dress and headscarf, sits beside

a table and a vase of flowers, a more traditional and recognizable domestic context marked by a gentle spatial recession with the curve of the tabletop.

Now turned in her chair with her left arm resting on its back—the barest hint of a setting—Madame Matisse directly engages the gaze of the viewer with her large black eyes, prominent lashes, and arched brows. The artist defined her nose with a single thick line of green, a color used at the neck and on her right hand for the few indications of modeling and shadow, while her slightly parted lips are similarly and simply defined by a pair of red strokes. He rouged her cheeks in distinct patches. However, her stony expression remains mysterious—possibly a reference to African and ancient Egyptian and European sculpture on view in Paris, sources that also interested Pablo Picasso and later Amedeo Modigliani. In contrast to her masklike visage, the decorative arabesques of her headscarf and the vegetal pattern on her dress—as well as the black and white trims at her sleeves, neckline, and bust—animate the surface of the canvas.[1] JFD

[1] For more extensive discussions that inform this notice, see Jack Flam, "The Red Madras Headdress (Mme. Matisse: Madras Rouge)," in *Great French Paintings* 2008, 238; Claudine Grammont, "Red Madras Headdress (Le Madras rouge)," in *Matisse in the Barnes Foundation* forthcoming.

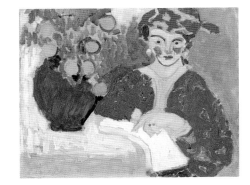

FIG. 1 **Henri Matisse**
The Madras (Le Madras),
December 1906–
March 1907

Oil on wood panel,
The Barnes Foundation,
BF 878

Head of a Bodhisattva, early 8th century
Tang dynasty (AD 618–906)
North China, Shanxi province,
Tianlongshan caves
Sandstone and white gesso. 12 ¾ x 7 ³/₁₆ x 7 ¾
(32.4 x 18.3 x 19.7). A142

In East Asian Buddhism, Bodhisattvas are divine beings who are sufficiently enlightened to enter Nirvana (the state of "cessation") but remain within the universe to accomplish the salvation of all sentient beings. In literary and visual representations, they are distinguished from Buddhas by their princely appearance, jewelry, and elaborately coiffed hair, and they often wear tiaras, the details of which help identify them: the Bodhisattva Guanyin, for example, bears an image of the Buddha Amithabha on his crown.

The earliest Chinese Buddhist images drew heavily on Central Asian and Indian prototypes, as they did again during the Tang period. The sinuous Indianized style of eighth-century figures at Tianlongshan is, however, impossible to appreciate from this detached head (which retains traces of its original polychrome decoration).

Cave temples at Tianlongshan ("heavenly dragon mountain") were thoroughly pillaged in the early twentieth century, after the fall of the empire in 1911. Looters were attracted by its relatively accessible location near the city of Taiyuan, by the softness of the sandstone itself, and especially by the high quality of much of the work, in evidence over several centuries. Tianlongshan heads are found in many collections across Europe and America, as are a number of complete figures. Albert Barnes acquired this and two other Tianlongshan heads from a French dealer in 1924, at a time when major Chinese and Japanese dealers had established their own galleries in Paris and New York. DG

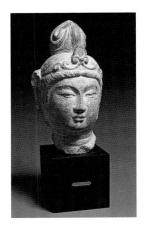

Navajo
Squash Blossom Necklace, c. 1900
United States, Southwest
Silver alloy, turquoise, leather, copper alloy.
15 ½ x ¾ x 6 ½ (39.4 x 1.9 x 16.5). A3

Navajo
Bow Guard (Ketoh), c. 1900–1910
United States, Southwest
Silver alloy, turquoise, copper alloy.
¾ x 2 9/16 x 3 7/16 (1.9 x 6.5 x 8.7). A91

For a few years following a trip to New Mexico during the winter of 1929–1930, Albert Barnes avidly collected American Indian textiles, jewelry, and ceramics from the Southwest. He corresponded with the premier dealers of the region as well as with Andrew Dasburg, an artist active in the Santa Fe and Taos artist colonies. Letters from these vendors indicate that Laura Barnes also selected and paid for items that were designated for her personal use.

Barnes demonstrated a particular interest in squash blossom necklaces, ultimately acquiring twenty-three, which he displayed alongside pueblo ceramics and ancient Greek antiquities. Introduced in the mid-nineteenth century when silversmithing technologies were brought to the Southwest, these silver necklaces alternate globular beads with pendant beads of a flaring petal. The blossom form most probably derives from a Spanish pomegranate motif. Similarly, the *naja*, or crescent-moon pendant, likely can be traced to a Moorish symbol that the Spanish conquistadors integrated into their horse bridles. This example, a particularly elaborate squash blossom necklace, features a variety of textures and techniques—twisted wire at the crown and in the center of the *naja* contrasts with the smooth finish of its inner and outer concentric bands. Insets of turquoise, a sacred stone, infuse this necklace with its healing properties, while stamping animates the crown of the *naja* and the mount for the drop.

Barnes also purchased two examples of Navajo bow guards, or *ketohs*, which protected the wearer from the stinging recoil of the released bowstring. Originally fashioned from leather, these functional items received silver adornments—again, with the introduction of silversmithing in the Southwest. Another magnificent example of metalworking, this delicate sand-cast bow guard exhibits the harmonious symmetry so prized by the Navajo (and Barnes), with the central placement of the turquoise cabochon stone flanked by heart-shaped designs and additional oblong stones. Mounted on a leather cuff, the bow guard would have been handsome with the contrasting colors and textures of its many materials.[1] JFD

1 For more on the Navajo forms, see Baxter and Bird-Romero 2000, 17–18, 113–114, 165–166; Bedinger 1973, 53–54.

Chest, 1784
United States, Pennsylvania
Painted tulip poplar. 23 x 23 ¾ (58.4 x 60.3). 01.15.34

Paul Cézanne (French, 1839–1906)
Still Life (Nature morte), 1892–1894
Oil on canvas. 25 ⅝ x 32 (65.1 x 81.3). BF148

This unfinished still life provides a fascinating glimpse into Paul Cézanne's working methods. In the large sections of canvas left unpainted — especially in the curtain and table — one sees that the artist's first step was to establish the contours of his subject. Black and dark blue paint articulates the table's edge, its legs, and its front drawer; the lines here are relatively straight and sure, though occasional overlapping strokes suggest moments of hesitation. Black paint applied in long, curving strokes defines the shape of the napkin as well, suggesting its twists and folds, but the area where the napkin overlaps the table's edge is unresolved. The objects here are recognizable from other still lifes; the faience milk pitcher is also featured in *Still Life* (p. 153).

If this painting discloses the importance of drawing in Cézanne's artistic project, it also shows the crucial role color plays in establishing space and building up form. A preliminary layer of pale blue paint fills in the pitcher and the plates, and follows the folds of the napkin; judging from the fully resolved *Still Life* (p. 158), these areas were likely meant to receive a second layer of white, and the role of blue was to lend a sense of depth to the objects. Oranges and lemons would receive further touches, perhaps of darker color to establish their roundness. The dabs of paint in the curtain reveal the complexity of the artist's approach to color, with overlapping patches of blue, yellows, and mauves that do not always obey preliminary contours. Particularly in the curtain, color establishes the roundness within Cézanne's boundaries; the juxtaposed patches gradually lend a sense of materiality and weight to an object that just inches away is nothing but flat canvas. ML

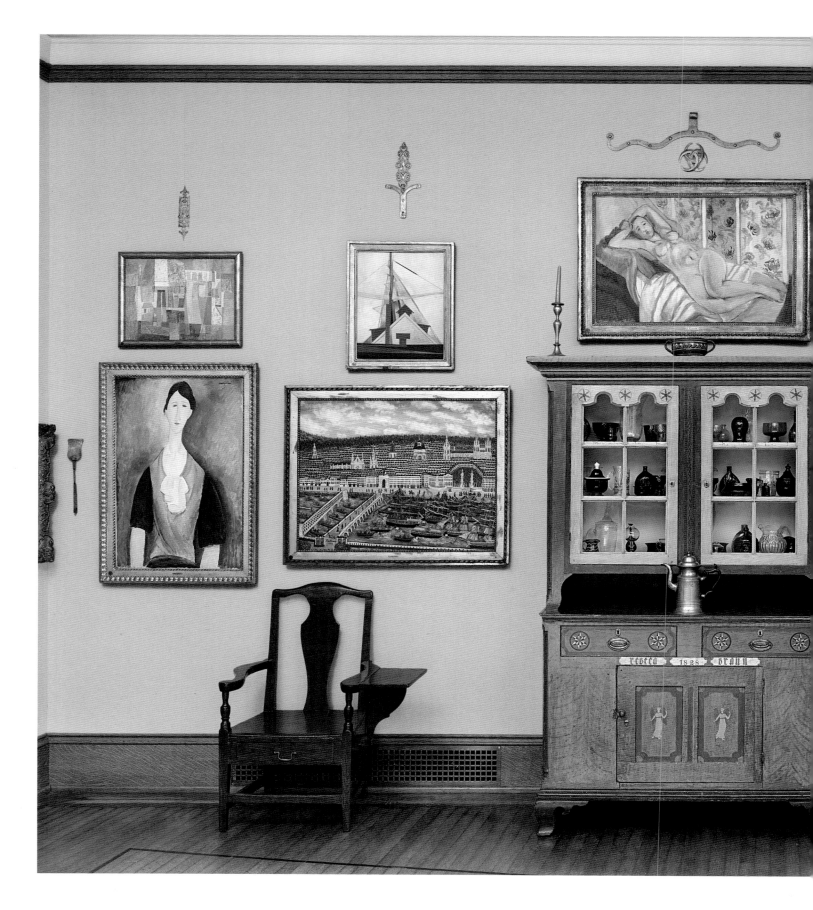

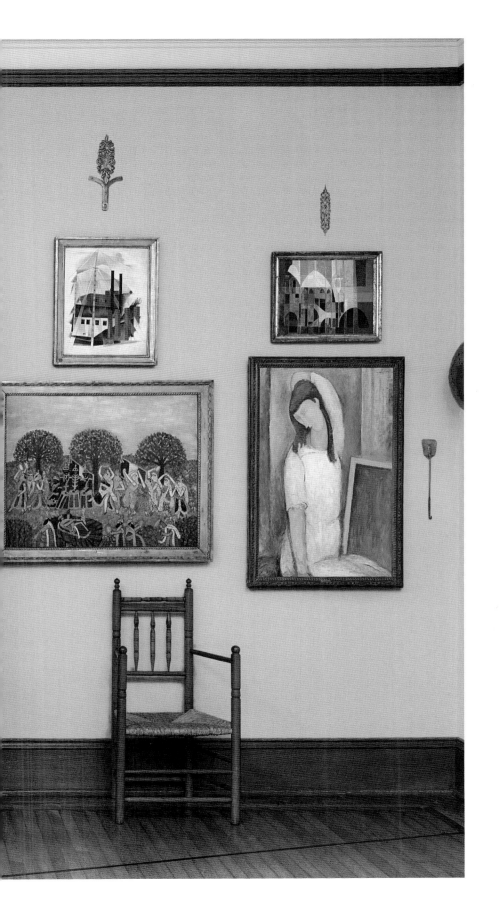

ROOM 18

EAST WALL

Nineteenth- and twentieth-century paintings by French, Italian, and American artists surround a hand-painted Pennsylvania German cupboard. American and European glassware fills the cupboard, pewter candlesticks and a pitcher are placed on top, and metal spatulas flank the arrangement. As in all the ensembles, this is a grouping of disparate objects from a range of cultures and traditions — encompassing fine art, craft, and utilitarian items — that creates a unit through their formal affinities.

The cupboard's bright colors establish the overall palette for the ensemble. Its rust-oranges are repeated in the striking mane of Amedeo Modigliani's model at far right and in the two paintings by little-known French artist Jean Baptiste Guiraud; the bright blue of the cupboard's trim recurs in many of the surrounding objects, even in the candles. The cabinet's gridlike panes correspond to the tiny geometric forms in Guiraud's *View of Bordeaux* at left, and the painted circular designs on its drawers are echoed in the three rounded treetops in his *Oriental Dancers*. In the top register of works, the vertical lines announced by the candlesticks mimic the background forms of Henri Matisse's *Reclining Nude* as well as the masts and chimneys depicted in the two works by Charles Demuth.

The placement of the paintings by Demuth above the canvases by Guiraud encourages a comparison of two vastly different approaches to the pictorial representation of space. While Guiraud's scenes create the illusion of deep recession into the distance, especially in the sweeping cityscape, the works by Demuth, like the abstracted paintings by Randall Morgan next to them, present a fractured, incoherent space that reflects the sensibility of early twentieth-century America. ML

Amedeo Modigliani
Jeanne Hébuterne, 1919
PAGE 266

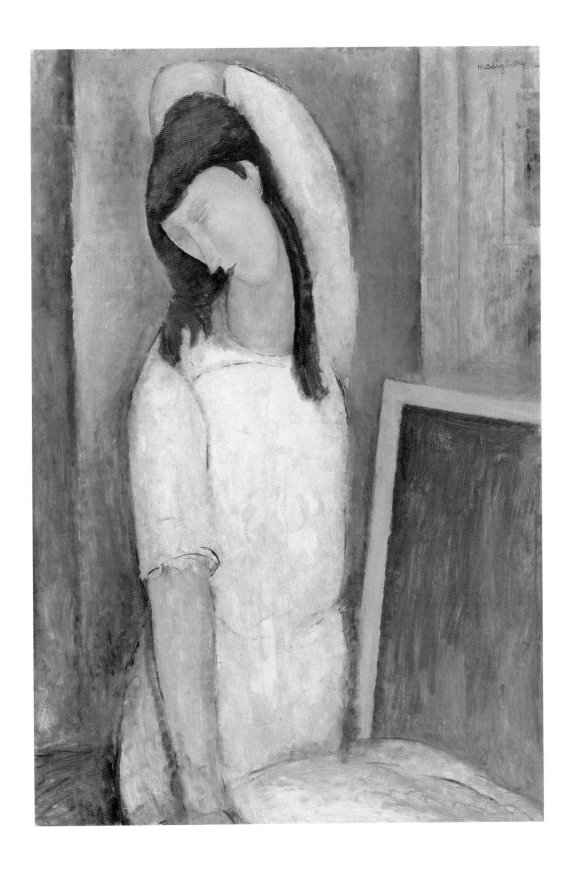

Workshop of Michael Braun
Cupboard, 1828
PAGE 266

Charles Demuth
Piano Mover's Holiday, 1919
PAGE 267

Henri Matisse
Reclining Nude (Nu couché),
fall 1923–spring 1924
PAGE 268

Pablo Picasso
The Ascetic (L'Ascète), 1903
PAGE 269

Amedeo Modigliani (Italian, 1884–1920)
Jeanne Hébuterne, 1919
Oil on canvas. 39 ½ x 25 ¾ (100.3 x 65.4). BF285

Painted the year before Amedeo Modigliani's death, this portrait presents Jeanne Hébuterne, the artist's lover during the last three years of his life. She poses here in his studio, the location announced by the painting turned back against the wall. When Modigliani met Hébuterne in 1917, she was an art student at the Académie Colarossi. They had a child together in 1918 and lived in Montparnasse, where she frequently posed for him. Though their relationship was often stormy, the turmoil never found its way into his paintings.

On the contrary, Hébuterne appears here as the embodiment of tranquillity and sensuality. A palette of cool blue-grays establishes a mood of calm. Complementary tones of burnt orange appear in three distinct zones, adding balance. Long, sweeping lines, such as the one that curves so slowly and gracefully along her raised arm, reinforce the sense of an almost classical serenity. Hébuterne's long neck follows this arc as her head falls languidly to the side. Her

features are schematic: simple ovals and triangles stand for eyes and nose, and her head is another oval appended to a cylindrical form. Modigliani was influenced by the stylized forms of African sculpture, which he knew well through his association with Pablo Picasso.

The pose of the arm propped up on the head has a long ancestry in Western art. As a standard signifier of sensuality, it was used by academic artists such as Jean-Auguste-Dominique Ingres and later repurposed by Paul Cézanne and Picasso—most famously in the latter's *Les Demoiselles d'Avignon* (The Museum of Modern Art, New York; p. 313) to create a female sexuality that appeared aggressive, almost threatening. Modigliani's interpretation is certainly meant to evoke the sensuality of his sitter. It must also spring from his love of exaggerated line and distortion, as the seemingly boneless arm curves up and around her head before peaking at the elbow in an impossible arc. ML

Cupboard, 1828
Workshop of Michael Braun (American, 1772–1851)
Pennsylvania, Mahantongo Valley
Painted pine and glass. 79 ½ x 49 x 21 ¼ (201.9 x 124.5 x 54). 01.18.30

The Pennsylvania German communities around the Schwaben Creek in the Mahantongo Valley in central Pennsylvania made painted furniture that combined the long-standing cabinetmaking and decorative traditions of their own culture with English forms, in a distinctive regional variation. While these cabinetmakers fashioned painted, lidded blanket chests such as those found in the collection of the Barnes Foundation, they also constructed and brightly decorated case furniture—desks, chests of drawers, and cupboards. An extremely rare inflection of Pennsylvania German culture, only approximately eighty pieces of Mahantongo

Valley furniture have been identified, many formerly owned by Lutheran and Reformed congregants of Himmel's Union Church.[1]

This cupboard, inscribed and dated on the front, belonged to Rebecca Braun, one of nine children born to Catharina and Michael Braun. Braun was a cabinetmaker who, along with his son John, produced some of the finest known examples of Mahantongo Valley furniture.[2] Although this cabinet has been substantially painted over, it demonstrates the inclusion of a trompe l'oeil graining effect fashioned of curved lines and dots, as well as compass-drawn stars and an angel motif found on Pennsylvania German baptismal certificates.[3] JFD

1 Weiser and Sullivan 1973, 932–939; Cooper and Minardi 2011, 94–98.
2 Reed 1987, 40.
3 See Weiser and Sullivan 1973, 938–939, for similar examples of angels.

Charles Demuth (American, 1883–1935)
Piano Mover's Holiday, 1919
Distemper on composition board. 20 x 16 (50.8 x 40.6). BF339

Versed in the European modernist styles that he encountered during his sojourns in Europe from 1907 to 1908 and 1912 to 1914, Charles Demuth practiced his own distinctive synthesis of cubism and futurism in hard-edged paintings that explored the cityscapes of New York, Provincetown and Gloucester, Massachusetts, and his native Lancaster, Pennsylvania. Here, Demuth took a high vantage point, looking across pitched black roofs to the chimneys, blocky warehouses, and factories beyond. He carefully attended to spatial depth in his composition by delineating the recession of the chimneys in the foreground and the flat-topped brick building in the background.

With their dark windows, these buildings appear quiet and vacant, although the billowing smoke at right — released in regularized, rounded puffs — suggests the whir of mechanized activity within the large structures. Tapering poles, perhaps the masts of boats, emphasize the verticality of the industrial landscape and appear to emit diagonal rays,

which energize the composition and bathe the buildings and smokestacks in fragmented, colored light.

Although this work bears a characteristically mysterious title for this period of Demuth's work, a document in the Foundation archives provides hints to the painter's art-historical and geographical sources, as Demuth frequently referred to Lancaster as "the province":

Piano Movers Holiday [sic]
The Sky after El Greco
Pyramids in amythist [sic]
The Rise of the Prism
In the Province #1
For W. Carlos W.
Chimnies [sic] Ventilators or whatever
Rec'd Aug 4 — 1921 from Chas Demuth.[1] JFD

1 Document transcribed by Nelle Mullen. BFA, cited in Wattenmaker 2010, 268.

Henri Matisse (French, 1869–1954)
Reclining Nude (Nu couché),
fall 1923–spring 1924
Oil on canvas. 23 5/8 x 36 1/4 (60 x 92). BF199

In 1917, Henri Matisse began a series of fall and winter painting campaigns in sun-bathed Nice, spending the first years of these creative sojourns living and working in hotel rooms and rented apartments whose large windows admitted the bright southern light and views of the blue waters of the baie des Anges. Matisse ultimately left behind his home and studio just outside Paris in Issy-les-Moulineaux and settled on the Mediterranean coast in 1921, where he remained for the rest of his life.

Either nude or garbed in oriental dress, female figures, languidly reclining or sitting in ornate interiors, became the principal subject matter of Matisse's work for the next several years — paintings characterized by sensual exoticism and decorative complexity. In a shallow space animated by a vividly patterned folding screen, Matisse's muse Henriette Darricarrère, a film extra at the local Studios de la Victorine, reclines on a yellow chaise that is tilted toward the picture plane, with her arms raised over her head, a posture that elongates her torso and emphasizes the rounded contours of her breasts and hips. The rectangular panels of the screen — variously shaded and illuminated as they project and recede in space — rhythmically correspond to the undulating twists of Darricarrère's body and pair rectilinear with curved, contrasts that recur in his work with frequency (p. 176). With a range of grays and highlights of white, Matisse carefully attended to the play of light over the model's muscular body — a physiognomy, if not a pose, that recalls Michelangelo's *Night*, 1519–1534 (Basilica di San Lorenzo, Sagrestia Nuova [New Sacristy], Medici Chapels, Florence), which fascinated Matisse, who had access to the cast from the Medici Chapel at the École des arts décoratifs in Nice.[1] JFD

1 For more extensive discussion that informs this notice, see Claudine Grammont, "Reclining Nude (Nu couché)," in *Matisse in the Barnes Foundation* forthcoming.

Pablo Picasso (Spanish, 1881–1973)
The Ascetic (L'Ascète), 1903
Oil on canvas. 46 ⅝ x 31 ¾ (118.4 x 80.6). BF115

In the wake of his friend Carles Casagemas's suicide in 1901, Pablo Picasso pursued bleak themes of suffering and alienation, taking the sick, the blind, the imprisoned, and the indigent as his subjects — marginalized people with whom he greatly identified as he struggled in the early years of his career. Cloaking his figures in a nearly monochromatic palette of cold, mournful blues, Picasso fell in step with symbolists Odilon Redon and Eugène Carrière, whose respective black and brown palettes evoked visionary dream states and the spiritual.[1] Picasso's use of blue, however, and the attenuation of his tormented figures more directly allude to the mysticism and mannerism of the revered El Greco, whose innovative and unconventional works were a constant source of inspiration for the young artist.

Facing the viewer, Picasso's gaunt ascetic sits behind a table whose expanse and spare repast further accentuate the pathos of his poverty and isolation — from the viewer and, accordingly, society. Apart from the cast shadow at right that suggests a wall, the locale lacks specificity, emphasizing the destitution and displacement of the sitter. The pitcher and bread — painted in pale browns that provide the only color contrast — suggest the Eucharist, layering associations with Christ's sacrifice and sufferings onto the skeletal figure.[2] Picasso roughly centered his sitter within the tall, vertical format of his canvas, underscoring the asymmetries and elongations of the ravaged physiognomy — the long, slanted nose; uneven, sloping shoulders; sunken, emaciated chest; sharp cheekbones; and hollowed cheeks. With one eye turned to the sitter's right and another directed toward the viewer, the gaze appears unfocused, possibly unseeing, perhaps another of the blind subjects who haunted Picasso's work of the Blue Period. JFD

1 Cowling 2002, 88.
2 See also a discussion of this eucharistic theme in Tinterow and Stein 2010, 60–62.

LE BONHEUR DE VIVRE ROOM

In *Le Bonheur de vivre* Henri Matisse imagines an earthly paradise in which existence is devoted to sensual pleasures: music, dance, and love. Nude figures recline luxuriously in a landscape, among them some amorous couples, while others dance in a circle (a motif that recurred in Matisse's work). Two figures play the pipes, one lying casually in the foreground and the other standing farther back with two goats, perhaps an allusion to the god Pan. If the work conjures a mythic Golden Age—a dream of classical Arcadia—it is also a radical revision of that well-worn subject.

The painting sent shock waves through Paris in 1906, when it was first unveiled to the public at the Salon des Indépendants. It was immediately understood, especially among young artists such as Pablo Picasso, as a work that would change the course of painting. Salon visitors found the canvas incomprehensible, even laughable; many critics disapproved of its irreverent style, especially as it was applied to such a time-honored theme as the pastoral landscape. Color was perhaps the picture's greatest offense; rather than tones subtly blending together, they seemed garish, almost violent, with masses of fiery reds crashing into violet and neon yellow. Nor was color any help in articulating a legible space—on the contrary, blocks of orange, green, and lavender, hovering in curtainlike panels over the yellow ground, have a dizzying effect. Lines, too, seem almost arbitrary at times, as if searching for an object to describe.

At the center are two reclining figures in coquettish poses, with curvy contours shown from two angles—the standard signs of the sensual nude. Elsewhere, however, these conventional tropes begin to erode, as bodies become more difficult to read and gender is not always so obvious. The reclining pipe player might be male or female, for example, and the crouching figure is also ambiguous. Standing nudes to the left are faceless, and at bottom right, the heads of two figures meld into one. The scale shifts suddenly, especially when moving from the reclining figures to the ring of dancers. The painting is full of such disjunctures, which create a strange tension with the overall theme of harmony. For audiences in 1906, this was a radical new vocabulary of forms, and the painting seemed a dangerous manifesto.

Le Bonheur de vivre signaled a significant shift in Matisse's work that had begun to emerge in 1905, during a summer spent working in Collioure. In canvases produced there, the artist moved away from a controlled, divisionist brushstroke to a cruder application of paint and an unprecedented boldness in terms of color; this new, primitivist style came to be termed "fauve." Matisse began working on the painting in October of 1905, shortly after returning to Paris from Collioure, producing several studies in pencil and oil for individual figures and for the overall composition. One study is at the Barnes Foundation, a tiny oil sketch on cardboard that maps out the large painting's chromatic structure.

Le Bonheur de vivre hung for years in the famous collection of Gertrude and Leo Stein in Paris, and it was there that Albert Barnes first saw it in 1912. He purchased it years later, in 1923, from the collector Christian Tetzen-Lund. ML

Henri Matisse (French, 1869–1954)
Le Bonheur de vivre, also called
The Joy of Life, 1905–1906
Oil on canvas. 69 ½ x 94 ¾ (176.5 x 240.7). BF719

ROOM 19

NORTH WALL

Spatial complexity animates this wall. Chairs, andirons, and roasting spits thrust themselves into the viewer's space; landscapes and cityscapes provide deep and expansive recesses; and portraits and figural paintings with sitters and models positioned close to the picture plane offer indeterminate or shallow realms, seemingly parallel to the wall itself. At the center of the wall, Henri Matisse's monumental *Music Lesson*, with its near life-size figures, provides a measured progression from interior to exterior, virtually moving from the contiguous space of the gallery into the salon of the painter's home and beyond to an exterior garden—a transition marked by Jean Matisse's presence at the picture plane and the slither of the pink piano lid's sinuous form. Arrayed on the bench in front of the painting, the fluid lamps, flowerpots, and cistern appear to be furnishings for the scene.

Flanking Matisse's masterwork, landscapes and cityscapes by Maurice Utrillo, Henri Rousseau, and Giorgio de Chirico offer a range of varyingly sophisticated and naive compositional strategies to relay depth. While Utrillo and De Chirico employ perspectives constructed of plunging orthogonals—a Montmartre street, a deserted square—or expansive bird's-eye views, Rousseau simply stacks horizontal bands of figures, water, trees, and buildings to construct the verdant space of his park scene.

Towering portraits by Chaim Soutine, with their lushly expressive paint handling, anchor each end of the wall, and a zigzag of figural images by Matisse and Amedeo Modigliani offers spaces compressed by decorative patterning. Positioned above Modigliani's *Boy in a Sailor Suit* and Rousseau's *The Past and the Present, or Philosophical Thought*, early nineteenth-century New Mexican retablos echo the frontality, reduced modeling, and spatial ambiguity of their immediate neighbors.

Albert Barnes wittily arranged the metalwork on this wall to reinforce and complement the forms of the paintings. The silhouettes of the spatulas echo the simplified, flattened figures installed just below. At each end of the wall, a double hinge and a keyhole escutcheon are combined to create a human form whose wide stance and open arms contrast with the folded arms and closed postures of Soutine's sitters. JFD

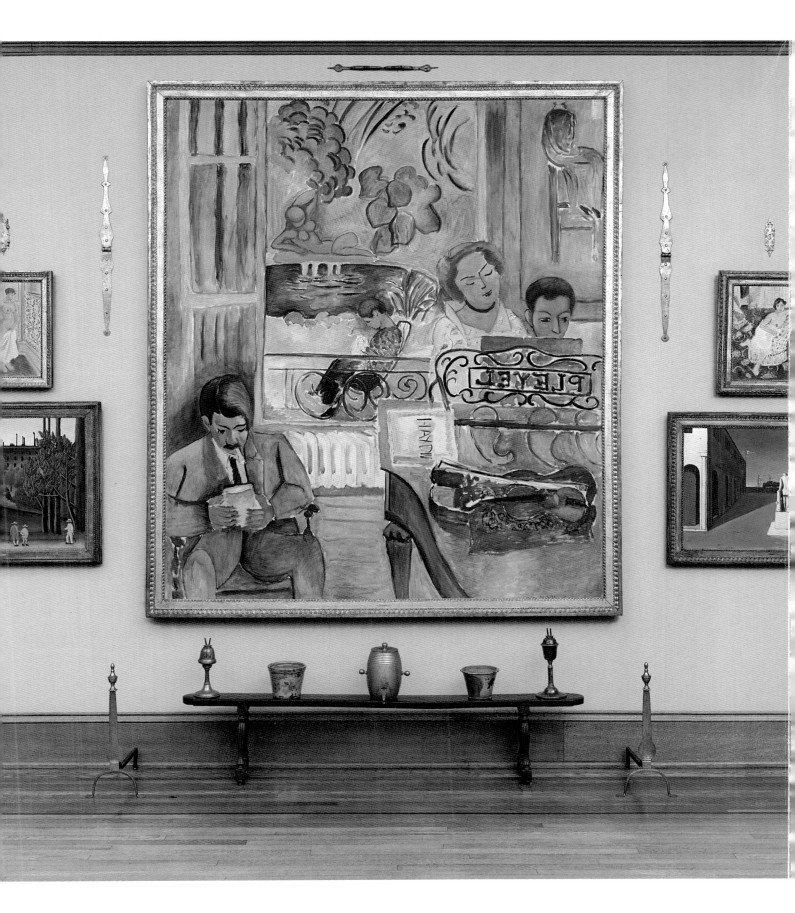

Henri Matisse
The Music Lesson,
summer 1917
PAGE 290

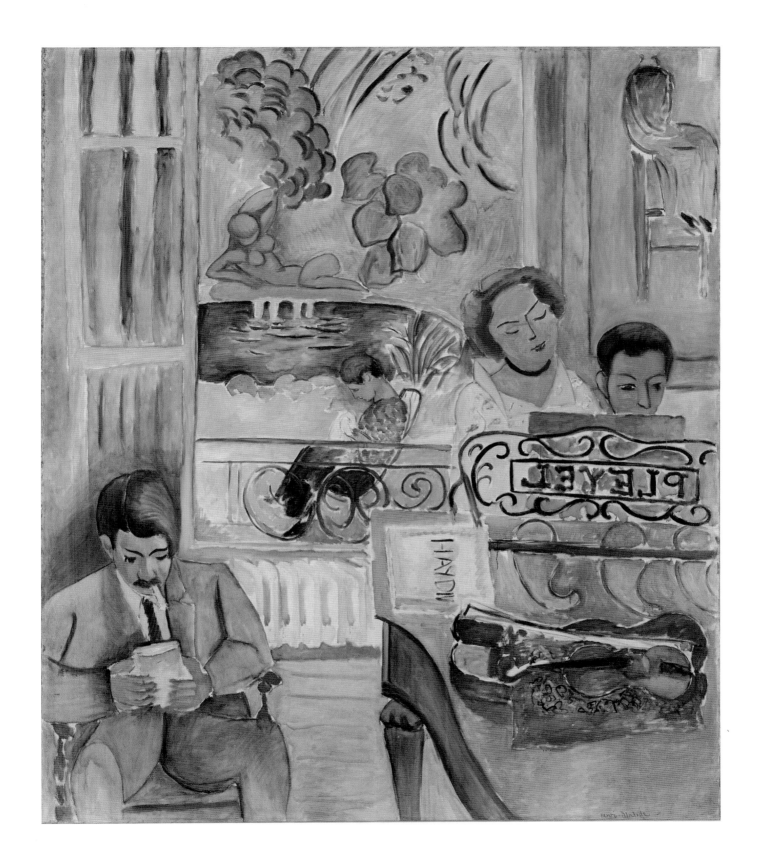

Henri Matisse
Three Sisters (Les Trois soeurs), 1917
PAGE 291

Henri Matisse
*Studio with Goldfish (L'Atelier
aux poissons rouges),*
May–September 1912
PAGE 292

Pablo Picasso
Acrobat and Young Harlequin
(Acrobate et jeune Arlequin), 1905
PAGE 292

Henri Matisse
Moorish Woman (The Raised Knee)
(Femme mauresque [Le Genou levé]),
August 1922–February 1923
PAGE 293

French
Andirons, early 16th century
PAGE 294

Giorgio de Chirico
*The Arrival (La meditazione
del pomeriggio)*, fall–winter 1912
PAGE 294

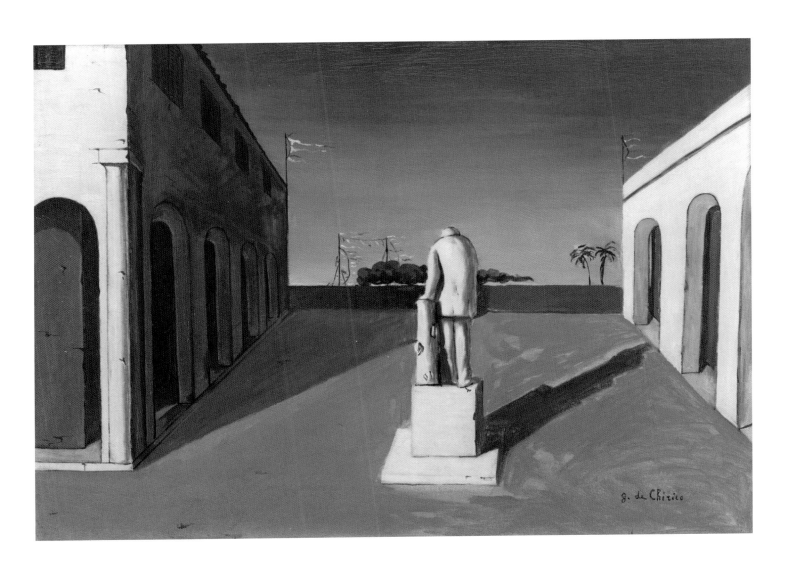

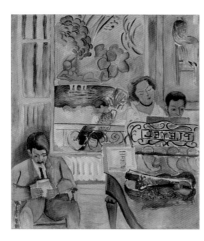

Henri Matisse (French, 1869–1954)
The Music Lesson, summer 1917
Oil on canvas. 96 ½ x 83 (245.1 x 210.8). BF717

Henri Matisse's *The Music Lesson*, like Pierre-Auguste Renoir's *The Artist's Family* (p. 61), is a monumental family portrait, but Matisse invested his scene with a disquieting sense of disconnection rather than with the intimacy and shared affection so evident in his revered predecessor's painting, in which the figures entwine their arms and exchange warm looks. In the living room of their home at Issy-les-Moulineaux, Matisse's children are absorbed in their respective activities; the artist's eldest son, Jean, smokes and reads while daughter Marguerite and youngest son Pierre sit at the piano. Visible through the large window, a seemingly diminutive Madame Matisse bends over her needlework in the lushly verdant garden. Matisse inserts himself into the scene with a violin, an instrument he played, and includes works from his oeuvre — *Woman on a High Stool*, early 1914 (The Museum of Modern Art, New York), and a monumental version of *Reclining Nude I (Aurora)* — in the garden.[1] Master of painting, sculpture, and music, as well as patriarch of the family, Matisse has a generative presence that permeates the scene despite the absence of his image. While frustrating associations of familial harmony, Matisse also flouted a convention of portraiture — likeness — by posing his figures with

heads downturned, eyes closed, and faces obscured. Only the faceless, flesh-toned sculpture lifting her arm at the end of the garden offers a sense of vitality or dynamism.

Matisse returned to a theme he had treated in 1916 with his *Piano Lesson* (fig. 1), a work marked by the austere palette, flattened space, and severe abstraction of cubism, with which he was experimenting (p. 319). Retaining the vivid green and pink planes of color from the earlier work, in which Pierre appears alone at the instrument, the painter expanded the subject. He included the other members of his family and renewed his engagement with naturalism, a reversal of his normal practice, which called for simplification through the reduction of detail.[2] Matisse's decision to take up the subject once more may have been prompted by Jean being drafted for military service during World War I.[3] While the artist fictively reunites his family in this work, his composition emphasizes their spatial and psychic distance from one another. Framed by windows, doors, and gilded surrounds, as well as obstructed by cast-iron grilles, each figure occupies his or her own sphere — even Marguerite and Pierre, seated together, are divided by the golden wedge of a picture frame.[4] JFD

1 Jack Flam, "The Music Lesson (La leçon de musique)," in *Great French Paintings* 2008, 258.

2 Ibid.

3 Ibid.; Karen K. Butler, "The Music Lesson," in *Matisse in the Barnes Foundation* forthcoming.

4 Ibid.

FIG. 1 **Henri Matisse**
The Piano Lesson, late summer 1916

Oil on canvas, The Museum of Modern Art, New York, Mrs. Simon Guggenheim Fund

Henri Matisse (French, 1869–1954)
Three Sisters (Les Trois soeurs), 1917
Oil on canvas. Left 77 1/8 x 38 1/4 (195.9 x 97.2);
center 77 x 38 (195.6 x 96.5); right 76 1/2 x 37 7/8
(194.3 x 96.2). BF363, BF888, BF25

Around 1916 Henri Matisse began experiment-
ing with double and triple portraits, the
most complex of which is this monumental
triptych called *Three Sisters*. Despite its title,
the work seems to feature four different models,
and their relationship to one another is not
clear. The figure with the turban is an Italian
model named Laurette, whom Matisse painted
obsessively around this time; in the right
panel she is the figure seated in the chair. A
second model, who wears green in all three
canvases, is unidentified. The young girl in the
left and middle panels, also unidentified, is
replaced in the right panel by an older woman.

Each canvas reveals a slightly different
setting and mood. While in the center panel the
women appear in conventional portrait poses
against a blank gray background, the left panel
is more a genre scene. Laurette relaxes and
reads a book, her head perched nonchalantly
in her hand, while another model turns her
back to the viewer entirely. Around them extends
a bourgeois interior decorated with objects
both exotic and mundane—a Sudanese sculpture
sits on the mantelpiece, and a Moroccan table
is strewn with a glass, a lemon, and a spoon. The
right panel is somewhere in between; figures
gaze out at the viewer, but they are casual and
their posing seems incidental.

Matisse's love of costume—its color, its
playful changeability—is evident in *Three Sisters*.
While the left and center panels feature

bright Moroccan garb, at right the figures wear
contemporary French fashions and short, stylish
haircuts. It is no coincidence that they pose
with a modern French painting—Matisse's *The
Rose Marble Table* (fig. 1)—the presence of which
is reiterated by the chair turned backward,
evoking a blank canvas. In the left panel, too,
Matisse painted a background that is appro-
priate to the clothing; the Moroccan costumes
are surrounded by signs of the exotic. It is an
exoticism that can be put on, or purchased, by
Europeans—and just as easily thrown off.

Colors, patterns, and repeating forms
connect the three works into a complete whole.
Black, green, orange, and purple are dominant,
and certain patterns recur as well. Small
circles decorate the Moroccan table, Laurette's
robe at center, and the magenta blouse at
right. There are more subtle connections, too,
such as the hand-to-face gesture featured in
all three panels. Forms also repeat within each
individual canvas, for example the black stock-
ings that echo the long black sweeps of hair.

While the pictures were conceived as a
triptych, Matisse allowed the three canvases to
be divided between different owners. It was
Albert Barnes who reunited them, buying the
right panel in 1922 and the left one in 1925,
though apparently he did not always display
them together. When Matisse visited the
Barnes Foundation in 1930, he urged Barnes to
buy the middle canvas, which was for sale in
New York; he even drew a diagram for how the
works should hang as a trio. "I will be so happy
if you are able to reunite these three things
which work badly when separated," Matisse
wrote in a letter. "I am almost reluctant to say
how well suited to your ensemble they are." ML

FIG. 1 **Henri Matisse**
The Rose Marble Table,
spring–summer 1917
Oil on canvas, The Museum
of Modern Art, New York,
Mrs. Simon Guggenheim Fund

Henri Matisse (French, 1869–1954)
Studio with Goldfish (L'Atelier aux poissons rouges), May–September 1912
Oil on canvas. 46 ⁷/₁₆ x 39 ¹⁵/₁₆ (118 x 101.5). BF569

This work depicts the interior of Henri Matisse's studio at Issy-les-Moulineaux. Painted just after the artist's return from Morocco in 1912, the canvas is a study in contrasts: hot tones are set against cool ones (especially in the goldfish bowl), bright light shifts suddenly to darkness, and there is a distinct play with the relationship between two and three dimensions. The sum of all this play, however, is not just formal innovation; the painting is also a clever meditation on the relationship between nature and artifice.

Though Matisse's studio was set in a garden, the work gives little sense of the outside world or of the light that undoubtedly cascaded through the large window at the back. Much of the room is dark, of a deep bluish-black. As in the famous *Red Studio*, 1911 (The Museum of Modern Art, New York), only the objects pertaining to art making glow with color. These include an easel, a green model's robe draped over a screen, paintings on the wall, and a table set with several still-life objects. Confounding this system is the rectangle of color coming through the open door. Of exactly the same width as the painting hanging above it, this view outside could just as easily be taken for a long rectangular canvas. Matisse deliberately dissolved the boundaries between art and reality.

The table in the foreground, bearing three concrete objects, is the only counterpoint to the flat space surrounding it. Each of the objects refers to the natural world but recasts that world in an artificial context. Goldfish float in a bowl; flowers now live in a vase. The reclining nude body is really a bronze sculpture Matisse produced in 1907, composed here, along with its base, in flesh tones. While the artist no doubt selected these objects for their shapes and colors, the particular mixture he created is intriguing. What Matisse assembled on the tabletop are essentially all the elements of the traditional "nude in a landscape" subject—flesh, water, and foliage. By arranging these objects as a still life—by manipulating the natural—he exposed the artifice in artistic practice. ML

Pablo Picasso (Spanish, 1881–1973)
Acrobat and Young Harlequin (Acrobate et jeune Arlequin), 1905
Oil on canvas. 75 ¹/₄ x 42 ³/₄ (191.1 x 108.6). BF382

Painted in 1905, *Acrobat and Young Harlequin* straddles Pablo Picasso's Blue Period, characterized by melancholic subjects and a predominantly blue palette, and his Rose Period, when pink and rose hues began to emerge. Two young performers stand together in a shallow space with a theater backdrop of a landscape hanging behind them. The taller boy, in a brilliant red costume and pointy hat, is dressed as an acrobat; the smaller boy wears the traditional diamond-patterned costume of Harlequin, a well-known figure from the Italian commedia dell'arte. Rather than capturing the actors in the middle of a dramatic scene, Picasso presents a moment of stillness. The pair has probably just finished performing—the figures look in different directions, as if receiving applause. The younger boy has his hand on his hip, betraying a hint of confidence, while the older one rests his hand on the other's shoulder, almost protectively.

Saltimbanques, or traveling circus performers, were a favorite theme of Picasso's. Such entertainers were a common spectacle in Paris at the time, performing especially in the public squares of neighborhoods such as Montmartre, where Picasso lived from 1904 to 1909. On the one hand, then, *Acrobat and Young Harlequin*

is simply a depiction of everyday life—a scene Picasso would have encountered in his own neighborhood. On the other hand, it may also function on a metaphoric level. Because saltimbanques lived at the edges of conventional society, they came to stand for the position of the artist in general as estranged bohemian outcast; indeed, the harlequin figure became an alter ego for Picasso in later works. This picture strikes a note of melancholy, as the vagabond figures display sad expressions, with drooping shoulders and downturned mouths that are strikingly at odds with the frivolity of their costumes. The artificial backdrop creates a sense of dislocation in space, as the landscape is only an illusion. ML

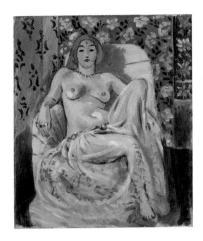

Henri Matisse (French, 1869–1954)
Moorish Woman (The Raised Knee)
(Femme mauresque [Le Genou levé]),
August 1922–February 1923
Oil on canvas. 18 3/8 x 15 1/8 (46.7 x 38.4). BF890

Recalling the languorous poses and riotous patterns of his Orientalist interior scenes painted in Nice in the 1920s, Henri Matisse retrospectively explained in 1952: "I had to catch my breath, to relax and forget my worries, far from Paris. The *Odalisques* were the bounty of a happy nostalgia, a lovely vivid dream, and the almost ecstatic, enchanted days and nights of the Moroccan climate. I felt an irresistible need to express that ecstasy, that divine unconcern, in corresponding colored rhythms, rhythms of sunny and lavish figures and colors."[1] Invoking the exoticism of the Orient, Matisse joined the ranks of celebrated eighteenth- and nineteenth-century French predecessors such as François Boucher, Jean-Auguste-Dominique Ingres, and Eugène Delacroix, who painted erotically suggestive scenes of the scantily clad denizens of the harem in vibrantly patterned decors. While Matisse's characterization of his own works seems to suggest an offering of sensual pleasures for undemanding delectation, some of these scenes challenge traditional associations of the pliant submission of the harem.

Seated in an armchair close to the picture plane, Henriette Darricarrère, Matisse's model and muse of the early years in Nice, commands the canvas, directly engaging the viewer with her strangely piercing but vacant black eyes and unnervingly flat affect. Matisse underscored the forbidding, masklike quality of her visage with the exotic marking on her forehead and the bright green headscarf, which hides her hair and accentuates the oval shape of her face. Despite Darricarrère's stonily defiant gaze and the lethargic slouch of her torso, her lower body actively twists as she raises her left knee. While Matisse suggestively obscured his model's lower body with this turn and with her lightly brushed gossamer costume, he carefully modeled her soft abdomen and the rounded contours and uneven fall of her bare breasts.

In the background, the wallpaper of Matisse's rented apartment on the rue Charles-Félix and the exuberant, printed textiles hung from frames jostle against each other in planes of color that simultaneously energize and flatten the space.[2] JFD

1 Flam 1988, 230.
2 For more extensive discussion that informs this notice, see Karen K. Butler, "Moorish Woman (The Raised Knee) (Femme mauresque [Le Genou levé])," in *Matisse in the Barnes Foundation* forthcoming.

Andirons, early 16th century
France
Cast iron. 29 ¹⁄₈ x 11 ³⁄₄ x 22 ³⁄₈ (74 x 29.8 x 56.8).
01.19.74ab

These muscular yet ornate cast-iron and-
irons—probably used to support logs in
a similarly robust fireplace—were produced
by pouring molten metal into molds. This
process created sturdy implements that could
withstand the sustained high temperatures
needed for cooking and warming fires. The
ornamentation of the uprights includes a
sinuously knotted, tassel-ended cord against a
diamond-patterned backdrop, a complement
of curved and straight lines. The heraldic
shield suggests that these andirons were made
for an aristocratic household, or perhaps
for a municipality. The human heads that cap
the uprights can be traced to fourteenth-
century European precedents.[1] JFD

1 Fennimore 2004, 27, 29–31.

Giorgio de Chirico (Italian, 1888–1978)
The Arrival (La meditazione del pomeriggio),
fall–winter 1912

Oil on canvas. 24 x 33 ¹⁄₂ (61 x 85.1). BF377

With his dreamlike yet crystalline scenes
of Italian piazzas, Giorgio de Chirico present-
ed mysterious and unsettling collisions of
antiquity and modernity. As many have noted,
De Chirico derived his themes from influences
as diverse as the fantastical paintings of Arnold
Böcklin, the exploration of the riddle in the
philosophy of Friedrich Nietzsche, and the
ancient monuments of his own Mediterranean
heritage. Born in Greece to Italian parents,
the artist evoked this latter legacy in cityscapes
lined with evocatively familiar but nonspecific,
arcaded buildings and dotted with palm trees.
Here, one of these impressive edifices—frilled
at the edges with its terracotta roof tiles and
pitted with age—dominates the left side of the
canvas, casting a long shadow over the eerily
deserted square. A seemingly newer structure,
with its pristine white surface, stands opposite,
gleaming in the bright sunshine. With their
evenly spaced arches, both buildings establish
a deep, rhythmic recession in space that is

evocative of Renaissance explorations of
perspective. A monumental sculpture of a
figure in modern dress, its back turned
to the picture plane, presides over the vacant
space. While the foreground remains still,
the obscured space beyond the low horizontal
wall in the distance suggests a zone of ener-
getic activity with a churning train—visible only
through a trail of dark billowing smoke—and
colorful pennants flapping in a strong wind.

De Chirico's metaphysical paintings
appealed to prominent avant-garde French
critics such as Guillaume Apollinaire, and
they later proved influential to the surrealists
who emerged in the 1920s. Albert Barnes
became an early and important American
supporter, acquiring thirteen works that
remain in the collection, including his own
portrait (p. 8). Barnes also penned intro-
ductions to the catalogues that accompanied
the artist's exhibitions at the Galerie Paul
Guillaume in Paris in 1926 and the Julien Levy
Gallery in New York in 1936. JFD

Amedeo Modigliani (Italian, 1884–1920)
Béatrice (Portrait of Beatrice Hastings), 1916
Oil on canvas and newsprint. 21 5/8 × 15 3/16
(55 × 38.5). BF361

Lured by the artistic legacy of Paris, the Italian painter and sculptor Amedeo Modigliani moved there in 1906, ultimately settling in Montparnasse. In this Left Bank quarter he found a vibrant international community of artists and writers who gathered frequently at certain cafés, including La Rotonde, Le Dôme, and La Closerie de Lilas. Among this sophisticated crowd, Modigliani met the South African–born British writer Beatrice Hastings (née Emily Alice Haigh), with whom he began a stormy two-year relationship. Boasting a slew of pen names and a storied marriage to a prizefighter — the purported source of her surname — Hastings remains a figure of some mystery. A poet, novelist, and journalist, she wrote her "Impressions de Paris" under the pseudonym Alice Morning for the British weekly the *New Age*, which included a roster of modernist contributors such as Ezra Pound, Walter Sickert, and Katherine Mansfield. Soon after meeting Modigliani, Hastings described the dissolute artist as "the spoiled child of the quarter, enfant-sometimes-terrible but always forgiven."[1] In addition to mentions in her column, Modigliani appears as a character called Pâtredor (aka Pinarius) in Hastings's unpublished surrealist novella "Minnie Pinnikin."

In this painting — one of several of Hastings — Modigliani presented Beatrice in three-quarter view, emphasizing her square, firm jaw, upturned nose, rosy cheek, and blank eyes. He sheathed her long neck in an elegant high-collared jacket and topped her head with a headdress complete with a feathered flourish. As he often did, Modigliani inscribed his sitter's name across the upper right of his canvas — a device that evokes Renaissance portraits of aristocrats and that paradoxically flattens the depth defined by the turn of Hastings's shoulders. Somewhat mysteriously, this canvas also includes a portion of newsprint just below the "R" of the inscription — perhaps a reference to Hastings's profession as a journalist. JFD

1 Morning 1914, 236.

Henri Rousseau (French, 1844–1910)
The Past and the Present, or Philosophical Thought (Le Passé et le présent, ou Pensée philosophique), 1899
Oil on canvas. 33 1/4 × 18 1/4 (84.5 × 47). BF582

Henri Rousseau painted portraits throughout his career, often posing his subjects outdoors surrounded by plants and flowers of species both real and imagined. Among these "portrait-landscapes," this picture is one of the few to contain two figures. Painted soon after Rousseau's marriage to Josephine Noury, the portrait represents the couple standing, with their right hands joined around a blue flower. They are dressed formally, wearing black clothing and white gloves.

The union of Henri and Josephine here symbolizes the "present" to which the painting's title refers; the "past" appears in the clouds above them, as two floating heads. These are the specters of their former spouses — Henri's first wife, Clémence Boitard, who died in 1888, and Josephine's first husband. The inclusion of images from the past — a visualization of memory — may reflect the belief shared by many artists at the time in the mystical link between the visual and the spiritual worlds. It might also reflect the nineteenth-century fascination with "spirit photography," in which specters of the dead were thought to be visible in photographs, often alongside images of the living.

The format — two figures posed side by side in front of a tree, with shorter plants in the foreground — reappeared a decade later in Rousseau's double portrait of Guillaume Apollinaire and Marie Laurencin, called *Muse Inspiring the Poet*, 1909 (Kunstmuseum Basel). In that portrait, Apollinaire holds a quill and scroll alluding to his literary role; here, too, the figures hold a symbolic object, the cut flower perhaps representing the new, present moment. The painting was exhibited at the 1907 Salon des Indépendants with the title *Pensée philosophique*. ML

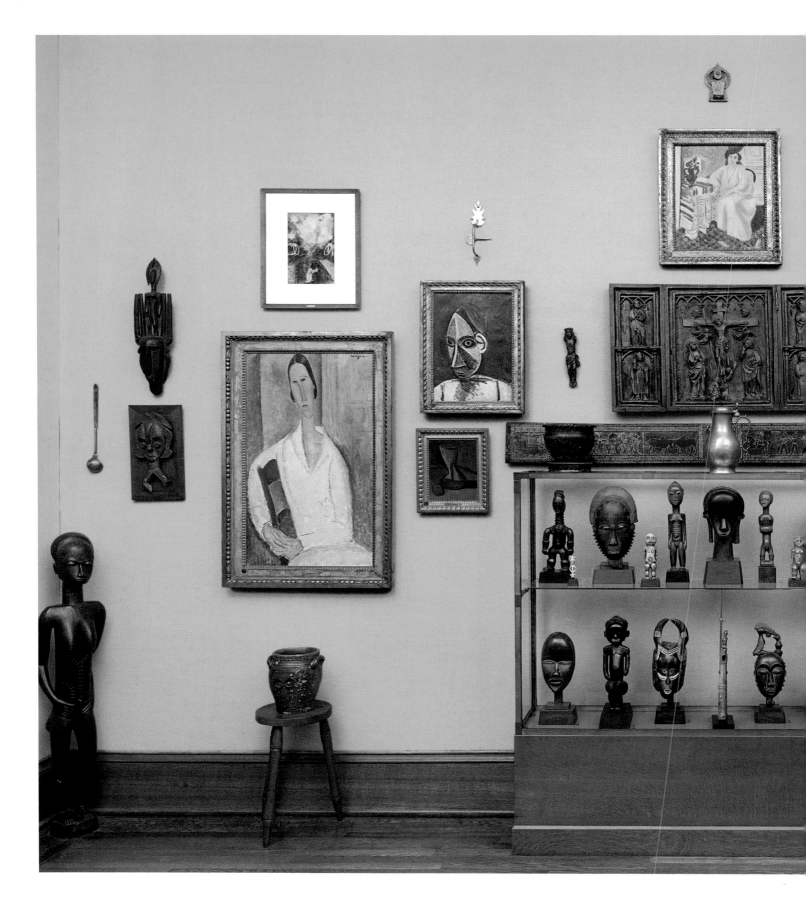

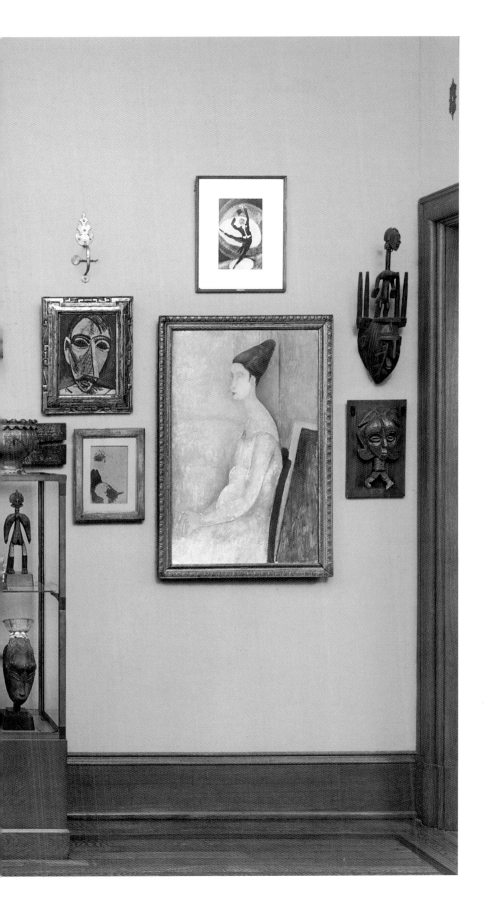

ROOM 22

SOUTH WALL

Albert Barnes installed most of his African holdings in cases in three rooms, alongside European and American drawings and modern and old master paintings as well as furniture and decorative arts. Here, the case demonstrates the same rigorous symmetry that characterizes the arrangements of the paintings. Masks and figures by Bamana, Baule, Dan, Fang, Guro, Lagoons, Lega, Pende, Punu, and Senufo peoples, carved in wood, bone, and ivory, alternate in height, volume, tonality, and patina. The Dutch flagon on the top of the case echoes the luster and the rounded contours of the Fang reliquary guardian's forehead just below.

Above this case, carved African and European reliefs, as well as figures of the crucified Christ, unite sculptural traditions from diverse cultures and many centuries. The African materials that Barnes and Paul Guillaume believed to be ancient are now known to date from the late nineteenth and early twentieth centuries. Formal affinities exist between the armless Christ figures and the African sculptures with arms held closely to the body. Portraits by Amedeo Modigliani and Pablo Picasso demonstrate stylized features—almond-shaped eyes, long necks, elaborate coiffures—owed to the example of the arts of Africa, Asia, ancient Egypt, and prehistoric Europe, which could be seen in Paris in the first decades of the twentieth century. Watercolors by Charles Demuth of acrobats and performers and an interior scene by Henri Matisse add color to a wall otherwise dominated by varying tones of brown. While the graceful handstand of Demuth's acrobat underscores the attenuated verticality of the raven-haired Hanka Zborowski's portrait at left, the legs of the high-kicking dancer repeat the angles of Jeanne Hébuterne's conical coiffure at right. JFD

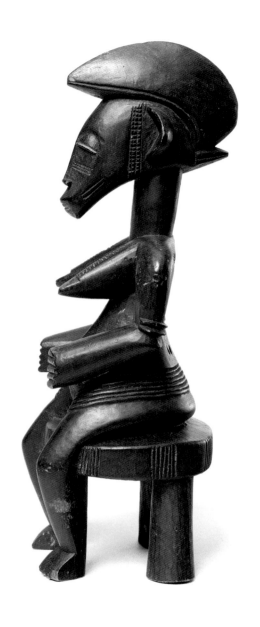
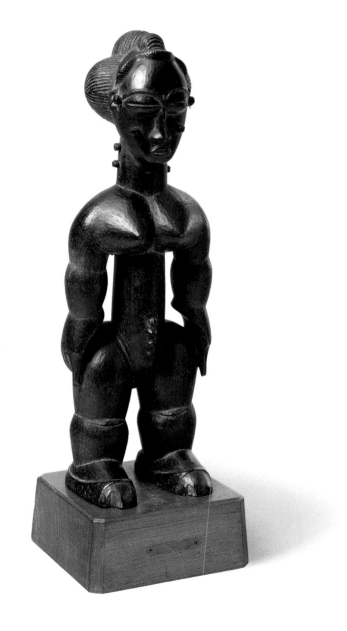

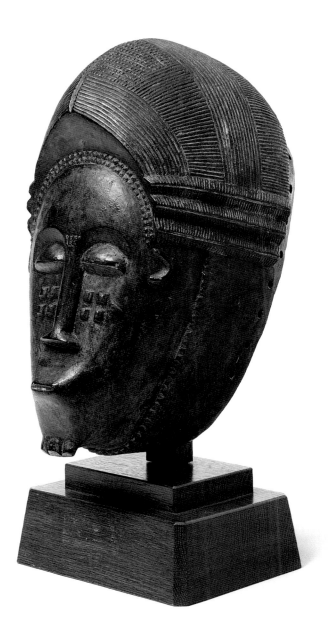

Senufo peoples
Seated Female Figure,
late 19th–early 20th century
PAGE 310

Lagoons (Ebrié) peoples
Female Figure (Nkpasopi),
late 19th–early 20th century
PAGE 310

Baule peoples
Portrait Mask (Mblo),
late 19th–early 20th century
PAGE 311

Baule peoples
Portrait Mask (Mblo),
late 19th–early 20th century
PAGE 311

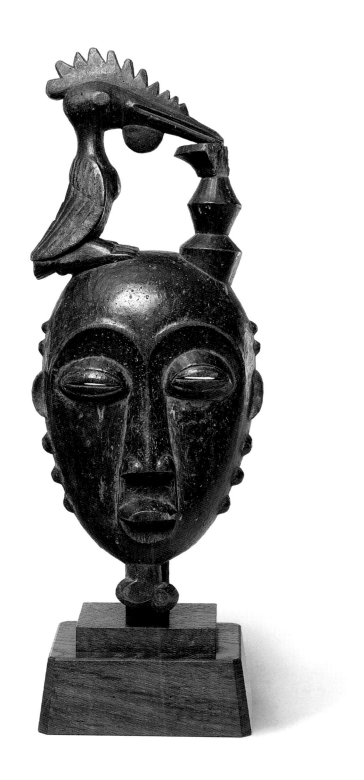

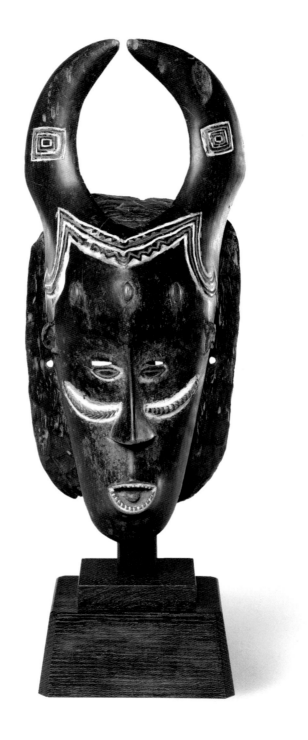

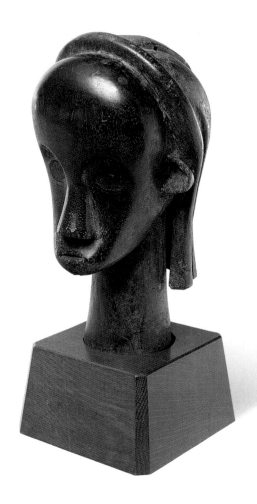

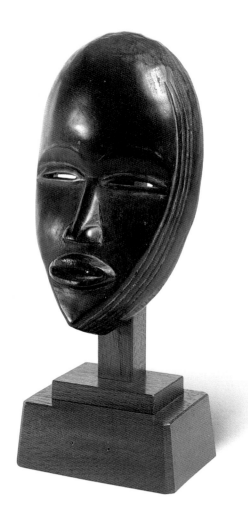

Guro peoples
Face Mask,
late 19th–early 20th century
PAGE 311

Fang peoples
*Reliquary Guardian Head
(Eyema Bieri)*,
late 19th–early 20th century
PAGE 312

Dan peoples
Face Mask,
late 19th–early 20th century
PAGE 312

Pablo Picasso
*Head of a Woman
(Tête de femme)*, 1907
PAGE 312

Dogon peoples
Seated Couple, late
19th – early 20th century
PAGE 313

French
Steeple Cock (Coq du clocher),
17th century or later
PAGE 314

Henri de Toulouse-Lautrec
"À Montrouge"—Rosa La Rouge,
1886–1887
PAGE 314

Charles Demuth
*In Vaudeville: Acrobatic Male
Dancer with Top Hat*, 1920
PAGE 315

Amedeo Modigliani
*Portrait of Jeanne Hébuterne
(Portrait de Jeanne Hébuterne)*,
1918
PAGE 315

ALTERNATE VIEW

Senufo peoples
Seated Female Figure, late 19th–early
20th century
Côte d'Ivoire
Wood. 17 ¼ x 5 ⅝ x 6 ⅛ (43.8 x 14.3 x 15.6). A196

In the matrilineal African Senufo culture, the figure of Ancient Mother presides over Poro, the education of young men as they transition to adulthood and take their places as leaders of their societies. Separated from their families, they begin an initiation carried out in phases but lasting several years. Novices retreat to a sacred grove (*sinzanga*) where the sculpture of Ancient Mother resides and serves as guardian throughout the process. At the conclusion of this demanding rite of passage, the Ancient Mother symbolically gives birth to the new members of the community.[1]

As seen in this sculpture, Ancient Mother's stylized physiognomy—specifically, her large breasts, full belly, and broad hips—suggests fertility, evocative of the importance of agriculture to Senufo peoples. In contrast to the activity of the men, the Ancient Mother figure typically sits serenely on a stool, often with a child held in her lap or at her breast.[2] Although this work does not include an infant, the positioning of her arms and hands suggests that the sculpture may once have held one. While the coiffure, head, and breasts are formed of pointed, conical shapes, the scarifications on the hips and stomach underscore the rounded contours of her form.

In the early 1920 Albert Barnes built the Foundation's facilities in Merion and also acquired African sculpture from the French dealer Paul Guillaume. Barnes decided to incorporate this core holding into the building's design and commissioned the artisans at the Enfield Pottery and Tile Works (Enfield, Pennsylvania) to create reliefs copying specific objects from his African collection to adorn the entrance vestibule. Viewed in profile, this Senufo figure flanks both sides of a plaque crowning the door. Matching the Doric columns with African forms at the threshold of the Foundation, Barnes underscored the universalism of human expression. JFD

1 Visonà et al. 2001, 145–147.
2 Ibid., 145.

Lagoons (Ebrié) peoples
Female Figure (Nkpasopi), late 19th–early
20th century
Côte d'Ivoire
Wood, thread. 11 ⅝ x 3 ¹⁵/₁₆ x 3 (29.5 x 10 x 7.6). A127

Among the Lagoons societies of south-eastern Côte d'Ivoire, diviners and healers employ carved wooden figures that display ideals of mature feminine beauty to channel and communicate with forest spirits or otherworld mates. As "guardians of the dance" in secular contexts, these sculptures are awarded to gifted dancers at performances. The straight, narrow forms of the neck and torso of this figure contrast with the contours of her full, conical breasts and ample buttocks, emphasizing her fecundity. Her broad stance on rounded thighs and calves provides a sturdy base for ease of placement. Her arms, which echo the treatment of the legs in proportion and volume, are held tightly against her body, and her hands are cupped around her broad hips. The geometric rhythms of the body are repeated in the large head—the rectilinear nose, eye slits, and rows of hair complement and underscore the oval face, lobed coiffure, arched brows, and convex eyes. Cylindrical pegs that contain medicines double as scarifications to the face and body.[1] JFD

1 Visonà et al. 2001, 215.

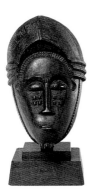

ALTERNATE VIEW

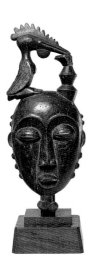

Baule peoples
Portrait Mask (Mblo), late 19th–early
20th century
Côte d'Ivoire
Wood. 12 1/8 x 7 1/4 x 5 7/8 (30.8 x 18.4 x 14.9). A189

Baule peoples
Portrait Mask (Mblo), late 19th–early
20th century
Côte d'Ivoire
Wood, pigment. 12 7/8 x 5 1/2 x 3 1/8 (32.7 x 14 x 7.9). A160

For the Baule peoples of Côte d'Ivoire, West
Africa, the portrait mask occupies a preeminent
place in the sculptural tradition. The form
may have originated with the Mamla, a Baule
subgroup that, according to legend, "emerged
from the earth" or "descended from the sky."[1]
Paired with costumes, these masks were used
in entertaining performances to commemorate
a momentous occasion—often a funeral—and
to provide emotional relief for the commu-
nity.[2] *Mblo* masks represent specific individu-
als who are identified by their distinctive
coiffures, beards, and scarifications. The masks
also incorporate universal characteristics
into these serenely contemplative faces, includ-
ing high foreheads, arched brows, downcast
eyes, and gleaming skin—a sign of good health.
When not worn in performances, these masks
remained hidden from view in the sleeping
quarters of the dancer.[3] As a namesake or double
for the portrayed, a mask was used exclusively
by the owner or by a relative of the same sex.[4]

With their bearded chins, these portraits
represent male members of the community.
A common motif but without iconographic
significance, a bird crowns the mask on page
301. The mask on page 299 reveals intricately
refined carving for the elaborate coiffure and
facial scarification. JFD

1 Vogel 1997, 141.
2 William C. Siegmann, "Mblo Portrait Mask," in
 Siegmann 2009, 98.
3 Vogel 1997, 137.
4 Ibid., 157.

Guro peoples
Face Mask, late 19th–early 20th century
Côte d'Ivoire
Wood, pigment, plant fiber. 12 3/8 x 5 1/4 x 3 3/8
(31.4 x 13.3 x 8.6). A192

The spirits Zamble, Gu, and Zauli perform at
funerals and feasts for the West African Guro
peoples, who consider these masks sacred.[1]
Captured in the forest by hunters and brought
to Guro villages, this triad receives offerings
at altars and remains sequestered from view
until an important occasion merits its
performance by skilled male dancers. First, the
graceful Zamble with his antelope horns and
leopard mouth performs to the accompaniment
of a drum beat and the chime of the bells
he wears. When Zamble's wife, Gu, takes her
turn, the drums cease and she performs her
fluid steps to flute and vocal music. Zamble's
crude brother Zauli, whose coarser features
include longer horns and a large, open jaw,
gambols, often flirting with and teasing the
women in the audience.[2]

Possibly a variant of Gu, this mask combines
highly refined female features—oval face,
long nose, small mouth and eyes—with the
curving horns and small, high-set ears of
an animal.[3] Described as *yera dro*, or smooth,
some Gu masks have lustrous dark surfaces
punctuated by incised and pigmented
decoration and raised scarifications on the
forehead and cheeks, making for a rich
array of textures.[4] JFD

1 Fischer and Homberger 1986, 16.
2 Ibid., 20.
3 Clarke 1996, 16.
4 Fischer and Homberger 1986, 10.

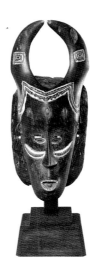

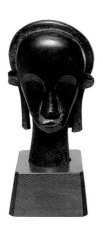

ALTERNATE VIEW

Fang peoples
Reliquary Guardian Head (Eyema Bieri),
late 19th–early 20th century
Gabon

Wood. 6 ³/₄ x 6 ⁵/₈ (17.1 x 16.8). A124

In the Fang culture, figurative sculptures such as this guardian head were created to honor revered ancestors and to protect their spirits from harm. The hope was to encourage the goodwill of these ancestors—especially those who had been important societal or spiritual leaders—who could be called upon for help in the daily life of the village. These carved objects, sometimes representing heads and sometimes full figures, were affixed to reliquary bark chests containing the ancestors' bones.

The Fang peoples are dispersed through several regions of West Africa, including Cameroon, Guinea, and northern Gabon. This piece has the swelling forehead typical of the Gabon regional style and was carved probably in the late nineteenth or early twentieth century. The eyes recede deeply into the head, and the eyebrows curve around them in a distinct contour that continues along the shape of the nose. This sculpture is not meant to be a portrait of a particular individual but represents an ideal type. ML

Dan peoples
Face Mask, late 19th–early 20th century
Côte d'Ivoire

Wood. 9 ⁵/₈ x 5 ¹/₈ x 2 ⁵/₈ (24.4 x 13 x 6.7). A110

With narrow eyes, a thin nose, and a full mouth, this mask represents the ideal female features of the Dan peoples from the Côte d'Ivoire. The face is abstracted into a highly symmetrical oval that comes to a sharp point at the chin. Four incised lines run along the sides, starting a few inches above the temples and meeting at the chin, forming a frame for the features. The surface is smooth and dark, with a beautiful luster that catches the light, reflecting the Dan ideal of smooth skin. While Dan masks occasionally announce their purpose through their forms—round eyes, for example, may signal that a champion male runner would have worn it—the specific use of this mask is not known. It may have been a sacred object that offered spiritual protection.

Albert Barnes surely chose this object for its abstracted forms, its pronounced symmetry, and its general restructuring of the human body in the interest of design. Like the majority of Barnes's African objects, the mask is displayed on a modernist mount made by the Parisian craftsman Kichizo Inagaki. This one features a long, rectangular form that serves as a neck for the sculpted face, so that the mount actually becomes an active formal element, adding to the body rather than merely supporting it. It is an intriguing intervention on Barnes's part—a carefully designed meeting of African and modernist sensibilities. ML

Pablo Picasso (Spanish, 1881–1973)
Head of a Woman (Tête de femme), 1907
Oil on canvas. 18 ¹/₈ x 13 (46 x 33). BF421

This small head is related to one of the most important paintings of Pablo Picasso's career: the monumental *Les Demoiselles d'Avignon* (fig. 1), which occupied him for much of 1907 and ultimately proposed a shocking new conception of the human body in space. Picasso produced hundreds of studies for *Demoiselles,*

and although a direct correspondence is difficult to ascertain, *Head of a Woman* probably belongs to a series of sketches made for the painting's central figures: the two nudes with their arms raised over their heads. As in this painting, those figures have almond-shaped eyes, triangular noses, and oval faces that come to a sharp point where the hair parts.

The radical forms of *Head of a Woman* have their origins in ancient art. Examples of pre-Roman Iberian sculpture had been recently excavated, while others were exhibited at the Musée du Louvre in Paris in 1906. Picasso was struck by their formal vocabulary, and *Head of a Woman* shows the absorption of the Iberian idiom into his work. The human face is translated into simplified, repeating geometric forms, as a triangular shadow mimics the shape of the nose, and the almond-shaped eyes repeat the shape of the face itself. The black curlicue line of the ear is borrowed directly from small Iberian stone heads Picasso had in his collection. While striations on the face may reveal the influence of African sculpture, they may also refer to the Western tradition of chiaroscuro. If that is the case, they are certainly meant as a cheeky dismissal of that tradition. ML

FIG. 1 **Pablo Picasso**
Les Demoiselles d'Avignon, June–July 1907

Oil on canvas, The Museum of Modern Art, New York, Acquired through the Lillie P. Bliss Bequest

Dogon peoples
Seated Couple, late 19th–early 20th century
Mali

Wood. 27 ³/₈ x 11 x 10 ¹/₂ (69.5 x 27.9 x 26.7). A197

Seated Couple is one of the finest pieces of African sculpture in the collection of the Barnes Foundation. A closely related work at the Metropolitan Museum of Art, New York, was likely carved by the same hand or workshop. In the Dogon culture of Mali, sculptures of couples did not represent specific individuals but rather the more abstract concept of male and female as an ideal social unit. Here, the two figures sit side by side, the male draping his arm around his female counterpart in what is perhaps a gesture of protection, even possession. More importantly, the gesture symbolizes their partnership and integrates the two figures into a single design unit of interlocking horizontals and verticals.

The sculpture's very design reinforces the idea of unity; the couple's postures mirror each other, and the individual forms of their bodies do as well, from the protruding belly-buttons and buttocks to the conical torsos and the matching scarification patterns. Yet if the figures are reflections of each other, they also have distinct roles within their unit. This is announced on their backs, where the woman, the nurturer, carries a tiny baby, and the man bears a quiver, signifying his identity as provider and protector. Their stools are supported by small male and female figures that possibly represent the primordial couple, or *nommo*, from the Dogon creation myth. ML

Steeple Cock (Coq du clocher),
17th century or later
France

Iron with inlaid copper eyes. With mount
17 ¹³/₁₆ x 5 ¼ x 21 (45.2 x 13.3 x 53.3). 01.22.43

A fixture on church steeples, weathercocks weave together ancient mythological and religious symbolisms. For the Romans, the rooster's boisterous announcement of a new day prompted associations with a variety of Roman deities, including Apollo, the sun god, and Mercury, the messenger god. In the Gospels, the apostle Peter betrays Jesus Christ, denying his association with him three times before the cock crows. Capping a church tower, the weathercock evoked this narrative, serving also as a call to faith and reminder of the Resurrection. In a political context, the Romans associated the Latin word for rooster—*gallus*—with Gaul (modern France), where they pursued territorial expansion. Although later enemies of France deployed the rooster in propagandistic texts and images to mock the nation's seemingly prideful and belligerent kings, the emblem was ultimately adopted by the French and endures as a symbol of vigilance and defiance.[1]

This blacksmith forged the rooster from several iron pieces, embellishing his work with a pair of copper eyes and a jauntily spiky cockscomb. The broad arcs of the rooster's tail feathers would have been an effective surface for the wind to catch and turn the weathercock. JFD

1 Pastoureau 1996, 405–430.

Henri de Toulouse-Lautrec (French, 1864–1901)
"À Montrouge"—Rosa La Rouge, 1886–1887
Oil on canvas. 28 ³/₈ x 19 ⅛ (72.1 x 48.6). BF263

Although born into an aristocratic family, Henri de Toulouse-Lautrec left behind his rarefied, privileged realm and embraced the colorful, creative, and often dissolute world of the artists, models, performers, and prostitutes of Montmartre. Deformed by injuries and stunted in his growth, Lautrec found camaraderie among the marginalized denizens of the neighborhood. By turns acerbic and empathetic, the painter and poster designer chronicled the garishly glittering world of the *café-concert*, the resigned lassitude of the brothel salon, and the grinding labor of the laundry. Lautrec displayed these incisive works at Le Mirliton, Aristide Bruant's cabaret in the quarter; some took their titles from the impresario's songs about Parisian working-class areas such as Montrouge.[1]

Carmen Gauzi—Lautrec's preferred model in the mid-1880s—stands as Rosa, the red-haired prostitute in the song "À Montrouge," with her body facing frontally and her face turned in profile to her left. Long, flame-colored forelocks cover most of her face and eyes. The *contre-jour*, or silhouette effect, of the sickly light through the grimy window further obscures her features. Despite her veiled expression, Lautrec conveys a pugnacious defiance in her slightly raised left shoulder, her clenched, square jaw, and her rouged mouth—indeed, the "dog's head" ascribed to Rosa's physiognomy in the Bruant song.[2] With her wraithlike arms and wrists protruding from the turned-up sleeves of her plain, boxy shirt, and the dingy appearance of the interior, Lautrec captured the hardscrabble existence of the prostitute. JFD

1 *Toulouse-Lautrec* 1991, 192.
2 For a translation of Aristide Bruant's lyrics to "À Montrouge," see Anne Roquebert in *Great French Paintings* 2008, 178–179.

Charles Demuth (American, 1883–1935)
*In Vaudeville: Acrobatic Male Dancer
with Top Hat*, 1920
Watercolor, graphite, and charcoal on wove paper.
13 x 8 (33 x 20.3). BF1199

Performers were a favorite subject for Charles
Demuth. Musicians, acrobats, trapeze artists,
and cabaret entertainers, often engaged in
impressively athletic feats, fill his watercolors
from around 1915 to 1920. Here, a silhouetted
vaudeville performer kicks one leg to the side,
his rippling contours cutting a sharp image
against the bright lights behind him. The figure's
movements are graceful, balletic, as he
balances skillfully on one toe. Possibly Demuth
is remembering his 1912 visits to the Ballets
Russes in Paris.

Though small, the watercolor is bursting
with energy. Movement is upward and outward,
as the top hat hovers in midair, and arms
and legs, almost elastic in their pliancy, are
extended as far as they can go. Stage lights
are represented by concentric rings of red and
yellow—thin washes of color through which
parallel pencil lines appear that reiterate the
sense of outward movement. The light also
seems to represent the energy emanating from
the performer himself. These watercolors
of performers clearly show the influence of
works by William Blake, whom Demuth
admired. Not only the extended pose of the
figure but also the radiating bursts of color
seem to be a direct quote from the poet's illus-
tration *Albion Rose*.

Demuth and Albert Barnes were close
friends. Long before Barnes established the
Foundation, Demuth, who lived for a time
in Philadelphia, would visit the collector at
his home, where they discussed modern
art. Barnes greatly respected the opinion of
his friend "Deem" and bought many water-
colors directly from the artist. ML

Amedeo Modigliani (Italian, 1884–1920)
*Portrait of Jeanne Hébuterne
(Portrait de Jeanne Hébuterne)*, 1918
Oil on canvas. 39 ¼ x 25 ½ (99.7 x 64.8). BF422

Precisely framed by the blue-gray of the studio
wall and enveloped in clothing of a similar
hue, Jeanne Hébuterne exudes tranquillity,
with her hands neatly folded in her lap and
the dreamy, unfocused gaze of her blank eyes,
the latter a hallmark of Amedeo Modigliani's
mature idiom. The pink and russet tones of
her skin, mouth, and hair, as well as the back
of her wood chair, provide a warm contrast
to the cool tones of the painting. The artist also
matches the angles of the corner of the room
and the picture frame leaning against the wall
at right with the succession of curves that
define his model's fleshy torso and back, her
long and sinuously elegant neck, slight double
chin, and rounded forehead. Hébuterne's
conical coiffure—also a synthesis of straight-
edged and convex—and her profile pose may
be derived from the ancient Egyptian reliefs
at the Musée du Louvre, Paris, in which kings
and deities wear pointed crowns.[1] JFD

1 Jeffrey S. Weiss, "Portrait of Jeanne Hébuterne Seated in
Profile," in *Great French Paintings* 2008, 220.

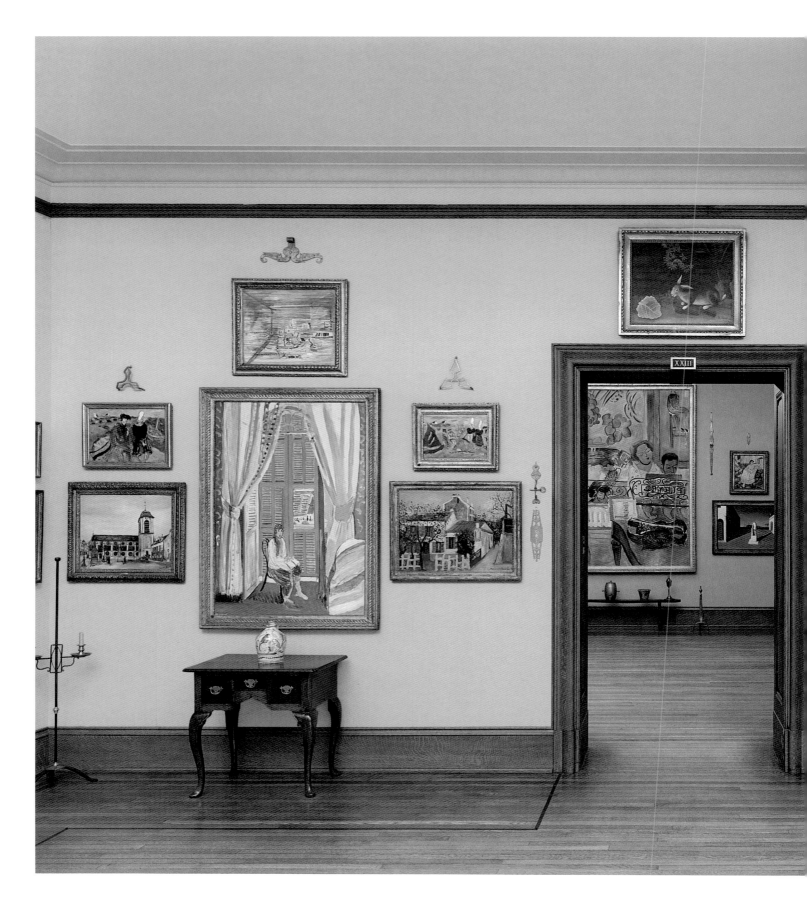

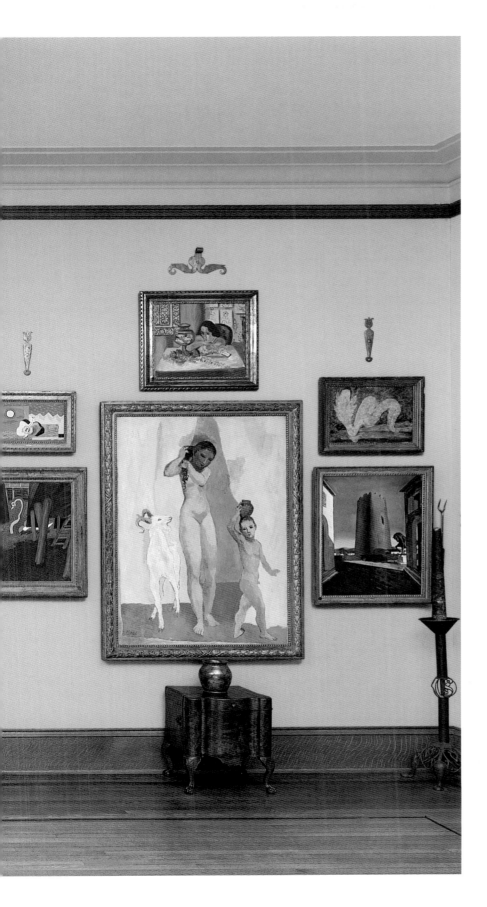

ROOM 23

NORTH WALL

Here the works are arranged in two distinct yet
interconnected groups. On the right, Pablo Picasso's
Girl with a Goat is the nucleus around which
several smaller objects (paintings, metalworks,
and furniture) form a near-perfect circle. Henri
Matisse's *The Venetian Blinds* plays the same central
role in the identically configured grouping on the
left. The two large centerpiece paintings are clearly
in dialogue with each other. Each presents its
subject in a shallow foreground space, with curtains
parting around an opening behind the figure(s).
The threshold theme depicted in the paintings
cleverly echoes the actual gallery door they flank.

Although the two ensembles mirror each other
structurally, each also has its own internal logic.
Repeating shapes unify the grouping at right: the urn
held aloft by Picasso's boy, for example, mimics
the shape of the goldfish bowl in Matisse's *Young
Woman before an Aquarium* and also the redware
pot displayed below. Color is also an organizing
principle, as the rose tones of the Picasso painting
recur in the neighboring canvases by Giorgio de
Chirico, while acting as background for a still life by
Jean Lurçat. Cooler blue tones dominate the left
grouping, as seen in the large work by Matisse and
two naturalistic Paris cityscapes by Maurice Utrillo.
This pair forms an intriguing contrast with the
dreamlike visions by De Chirico across the wall. ML

Henri Matisse
Still Life with Gourds (Nature morte aux coloquintes), July 1916
PAGE 328

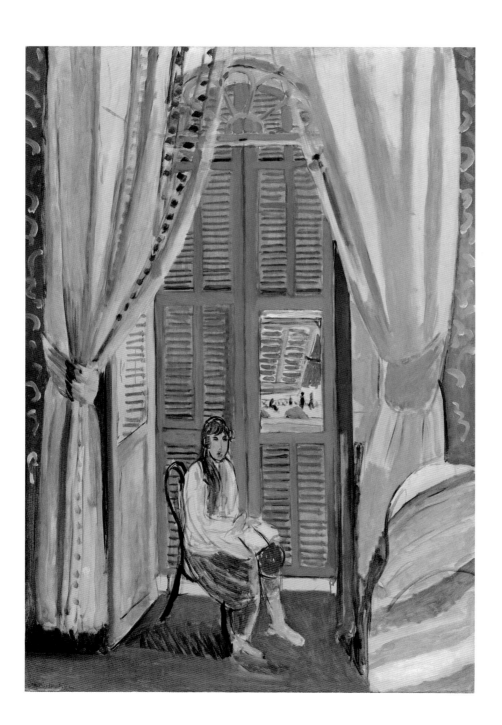

Henri Matisse
The Venetian Blinds
(Les Persiennes), spring 1919
PAGE 328

Pablo Picasso
Girl with a Goat (La Jeune
fille à la chèvre), 1906
PAGE 329

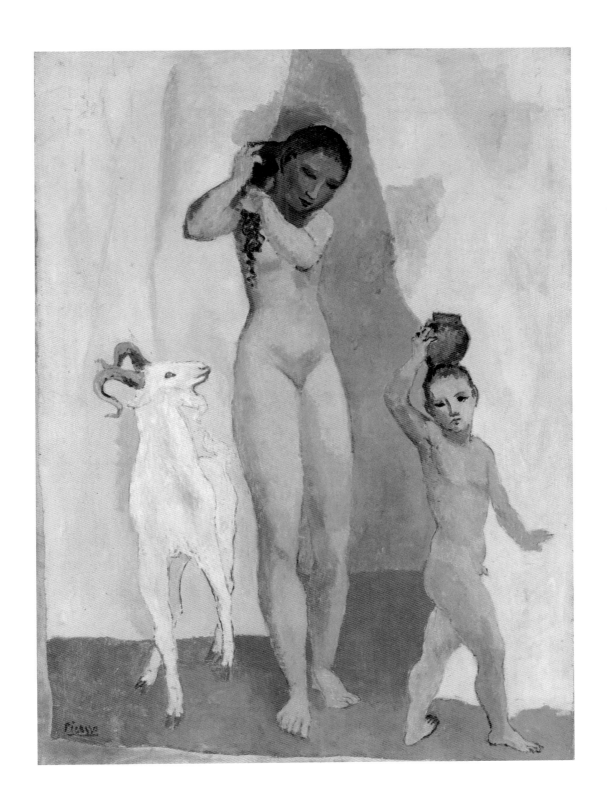

Henri Matisse
Dishes and Melon (Assiettes et melon), 1906–1907
PAGE 330

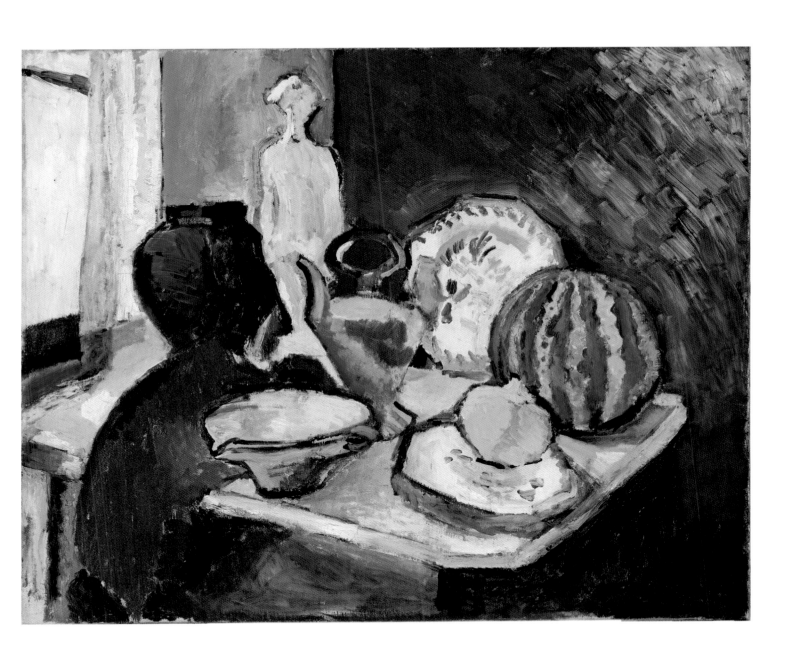

Henri Rousseau
Unpleasant Surprise
(Mauvaise surprise), 1901
PAGE 330

Henri Rousseau
The Rabbit's Meal
(Le Repas du lapin), 1908
PAGE 331

Pierre-Auguste Renoir
Leaving the Conservatory
(La Sortie du conservatoire),
1876–1877
PAGE 331

Henri Matisse (French, 1869–1954)
Still Life with Gourds (Nature morte aux coloquintes), July 1916
Oil on canvas. 39 3/8 x 32 (100 x 81.3). BF313

Although Henri Matisse had not joined Pablo Picasso and Georges Braque in their pioneering explorations of analytic cubism nearly a decade earlier, this work demonstrates his experimentation with some of the idiom's hallmarks, including a reduced palette of grays and blacks, shifting planes, varying perspectives, and flattened space. Yet Matisse made his engagement with cubism distinctly his own, retaining the hot hues—pink, yellow, red, green—so closely associated with his most innovative and celebrated work and, indeed, referring to his own practice and oeuvre in this scene of his studio, as he did in *Studio with Goldfish* (p. 283) and *The Music Lesson* (p. 279).

The artist's latest and final iteration of his sculpture *Jeanette (V)* regally presides over a voluminous cloud of flowers in a cylindrical vase, a woven basket, and a plate of gourds. While Matisse paints his plaster in strict profile, capturing its long, straight nose and bulbous masses—a familiar pairing of rectilinear and rounded—he offers tilted views of the three-legged sculpture stand and its contents, as well as the block-bottomed table beyond. The golden corner of a frame and the stacked positions of the tabletops suggest a spatial recession from foreground to background, yet

Matisse unifies and flattens his composition with an austere, unmodulated dark gray that runs the length and breadth of the canvas without differentiating wall from floor. Bright green rectangles hint at foliage-filled windows but do not provide further spatial depth and may instead stand for the flat surfaces of painted canvases, as some have suggested. Long drips of gray paint, traces of the artist's painting process, also emphasize the flatness of the support.

Light gray and pink planes of color—the top and side of the stand's tabletop—slide to the left, beyond the thick black lines meant to mark their contours. Similarly, the arced black line on an unidentified object at lower left does not align with its white echo just below. In this painting of carefully orchestrated forms and rhythms, much as in *Jeanette (V)*, Matisse balances square forms—tabletops, windows, and picture frame—with rounded ones—gourds, plate, basket, and bust.[1] JFD

1 Jack Flam, "Still Life with a Plaster Bust (Nature morte aux coloquintes)," in *Great French Paintings* 2008, 250.

Henri Matisse (French, 1869–1954)
The Venetian Blinds (Les Persiennes), spring 1919
Oil on canvas. 51 1/4 x 35 (130.2 x 88.9). BF897

"Everything was fake, absurd, amazing, delicious," wrote Henri Matisse of the elaborate decor at the Hôtel de la Méditerranée et de la Côte d'Azur in Nice, where he made his home and kept his studio during his fall and winter painting campaigns from 1918 to 1921. Covered in ornately patterned wallpaper, Matisse's quarters at the hotel opened onto views of a palm tree-lined promenade and the sparkling waters beyond. At nearly fifty years of age and having spent most of his life in the north of France, Matisse reveled in the light of Nice, noting that it even appeared to come "from below like theater footlights."[1]

Matisse cleverly exploited the theatrical elements of his high-ceilinged room. As Albert Barnes and several others have subsequently noted, Matisse focused on the towering windows framed by voluminous, tuft-edged curtains and the light that pierces through the bright

blue venetian blinds.[2] Dwarfed by the soaring windows and draperies, an exotically garbed female model sits slack-jawed, with her hands quietly folded on a book in her lap, while the southern sunshine pours through the shutters and activates the space. An open section of the shutter reveals a glimpse of the strollers on the promenade, and light enters through other apertures, stealthily creeping under the panels in a bright horizontal band, trickling through the spaces between the closed slats, bouncing off the window glass in a striped reflection, and dissolving the voluminous pale blue curtains and the sleeves of the sitter.[3] JFD

1 Francis Carco, *L'Ami des peintres* (Paris, 1953), 262–263, quoted in Fourcade 1972, 123, cited in Cowart and Fourcade 1986, 24.
2 Barnes and De Mazia 1933, 412–415.
3 Claudine Grammont, "The Venetian Blinds (Les Persiennes)" in *Matisse in the Barnes Foundation* forthcoming.

Pablo Picasso (Spanish, 1881–1973)
Girl with a Goat (La Jeune fille à la chèvre), 1906
Oil on canvas. 54 7/8 x 40 1/4 (139.4 x 102.2). BF250

Shortly before he left Paris in May 1906 for an extended sojourn in Spain, Pablo Picasso began to explore a spare neoclassicism, characterized by nude figures drawn in fluid contours and a muted palette—a departure from the colorful yet melancholy acrobats of the Rose Period. Always able to masterfully synthesize and layer visual sources, the artist called on a wealth of refined classical Greek and Roman precedents at the Musée du Louvre in Paris as he made his first forays in this mode. In his adoption of arcadian subject matter, Picasso paralleled his great contemporary foil Henri Matisse, who had issued a daring aesthetic manifesto with *Le Bonheur de vivre* (p. 272), his electric-hued idyll, at the Salon des Indépendants in March 1906.

Spending the summer in Gósol, a remote Pyrenean village untouched by modernity, Picasso matched his newfound interest in a refined classicism with austere primitivism. Against a pink and white backdrop reminiscent of Gósol's red earth and white townscape—perhaps a parted curtain—the nude female and

male figures in this work unselfconsciously display their bodies as they conduct routine activities, hair dressing and bearing water, with graceful gestures. While the nearly androgynous contours of the supple young woman echo those of flying Eros figures at the Louvre[1]—as well as those collected by Albert Barnes at the time he acquired this painting—the young boy cites both the canephorus, or basket-bearing female figure of antique statuary,[2] and the contemporary women of Gósol who carried bread and water on their heads, whom Picasso depicted in *Woman with Loaves*, 1906 (Philadelphia Museum of Art). Evoking the distinctive almond-eyed forms of the archaic Iberian sculpture that was newly available for viewing in Paris, as well as similarly stylized features in the twelfth-century *Gósol Madonna* (Museu d'Art de Catalunya, Barcelona),[3] Picasso endowed both figures with a mask-like serenity and a common heritage that he cherished and shared. In a clever nod to the herding tradition of Gósol, the goat with his leer prompts a slight turn of the girl's head, suggesting a burgeoning sexual consciousness. JFD

1 Richardson 2007, 447.
2 Hélène Seckel, "The Girl with a Goat (La Jeune fille à la chèvre)," in *Great French Paintings* 2008, 198.
3 Richardson 2007, 452.

Henri Matisse (French, 1869–1954)
Dishes and Melon (Assiettes et melon),
1906–1907
Oil on canvas. 25 9/16 x 31 7/8 (65 x 81). BF64

Unlike Henri Matisse's later still lifes, which are so frequently dominated by bold patterns — for example, *Chinese Casket* of 1922 (p. 177) — ornamentation here is kept to a minimum. The objects are plain: among them are two painted dishes, a watermelon, a shawl of solid red, and a plaster sculpture (now destroyed) called *Standing Nude* that Matisse produced in 1906. The artist often included sculptural objects in his paintings, as in *Studio with Goldfish* (p. 283) and *The Music Lesson* (p. 279).

As in all of Matisse's works, it is color that articulates the spatial relationships between the objects and that creates dimensionality. Touches of green add depth to the lemon, for example, and black establishes the contours of several items around the table's perimeter, each of which casts a shadow and occupies its own distinct space. The boundaries of other objects are less clear, however, particularly where the plaster sculpture meets with neighboring items. While color is meant to distinguish these objects from one another — white belongs to the sculpture — it also creates a certain illegibility, as the white paint pushes forward and laps up onto the dark blue vase, and the green from the central pitcher is carried into the sculpture.

Dishes and Melon once belonged to Gertrude and Leo Stein. Their famous collection of modern paintings was the most adventurous of its time, drawing artists, collectors, and writers from all over the world to their Paris apartment. Albert Barnes visited the Steins in December of 1912 and bought two paintings by Matisse from Leo, one of which was *Dishes and Melon*. They were the first works by the artist to enter the collection. ML

Henri Rousseau (French, 1844–1910)
Unpleasant Surprise (Mauvaise surprise), 1901
Oil on canvas. 76 5/8 x 51 1/8 (194.6 x 129.9). BF281

As in many of Henri Rousseau's paintings, *Unpleasant Surprise* takes up the theme of struggle between man and nature. The canvas represents the dramatic moment in which a hunter fires at a bear, thereby apparently rescuing a nude bather from the animal's attack. Despite the seemingly straightforward narrative, however, the picture remains stubbornly enigmatic. The bather stands frozen, her long hair framing her body, which is exaggerated in its curviness. She lifts her hands in a gesture of surrender, revealing dirty palms, while gazing upward. Yet if the hunter is saving her, why is her expression one of surrender? Why are the man's eyes directed at the woman rather than at the animal he is targeting? Also, the woman does not recoil from the bear, which does not even look particularly threatening. The bear's sharp claws are prominent, but the animal lacks the wild eyes of the violent beast in *Scouts Attacked by a Tiger* (p. 237).

Perhaps the bear is not attacking at all. Perhaps the painting is meant, instead, as an allegory of modern technology and its consequences, a common theme in the art of the Parisian avant-garde. In this interpretation, the woman and bear are not in conflict but rather represent an original natural state; the real threat emerges when modern man disrupts the harmonious scene. The gun-toting hunter, not the bear, is the "unpleasant surprise." Of course it is also possible that the painting is deliberately ambiguous and that no specific meaning was intended.

Whatever the interpretation, *Unpleasant Surprise* does seem to evoke an origins story.

When Pierre-Auguste Renoir saw the canvas, perhaps at the 1911 Salon des Indépendants, he marveled at this "scene from prehistoric times." The painting also may refer indirectly to biblical origins, as it seems to borrow directly from Paul Gauguin's woodcut *Nave Nave Fenua*, 1894/1895, in which Eve is cast as a naked girl in a tropical landscape. ML

Henri Rousseau (French, 1844–1910)
The Rabbit's Meal (Le Repas du lapin), 1908
Oil on canvas. 19 5/8 x 24 1/8 (49.8 x 61.3). BF578

Henri Rousseau is known for his exotic scenes of jungles in which lions, tigers, and gorillas engage in ferocious combat. But he also painted more mundane subjects, scaled down both in size and in terms of dramatic effect, as in this tender picture of a rabbit before a meal of vegetables. While the meal—two carrots and a piece of lettuce lying on the ground—is fairly unremarkable, its components are arranged with an unusual sense of importance. The lettuce leaf, for example, is turned toward the picture plane so that each of its veins, highlighted in white, is perfectly legible. Casting a slight shadow along its lower edge, the leaf almost seems to hover above the ground. Rousseau imbues his subject with a vaguely enigmatic quality so that the ordinary becomes slightly strange.

In the early decades of the twentieth century, the self-taught Rousseau became the unlikely hero of the Parisian avant-garde, drawing the admiration of artists such as Pablo Picasso. Rousseau had not developed some adventurous new technique; on the contrary, his handling of paint was conservative, almost academic, with precise contours and blended brushstrokes. What the artistic vanguard prized was Rousseau's so-called naive style, which they took to signal a deeper artistic purity. It is seen here, for example, in the awkward rendering of the rabbit's feet, which seem to float above the carrots they mean to be stepping on, and in the rendering of the carrots themselves, which lie parallel to the picture plane rather than being shown in perspective. ML

Pierre-Auguste Renoir (French, 1841–1919)
Leaving the Conservatory (La Sortie du conservatoire), 1876–1877
Oil on canvas. 73 1/2 x 46 1/4 (186.7 x 117.5). BF862

An early auction catalogue states that this scene represents students gathered outside a conservatory. The institution is perhaps the Conservatoire de musique et de déclamation in Paris, which offered lessons in music, voice, and dramatic rhetoric—though Pierre-Auguste Renoir likely did not intend to relate such specificity here. The painting gives little information about the setting, with its blank gray background free of architectural detail. The focus is instead on the figures and their interactions.

The crowd is dense—top hats stretch into the distance, bodies and faces overlap—yet the focus is on the four figures standing in the foreground. In capturing their conversation, Renoir pays careful attention to gesture, which subtly conveys relationships and social dynamics. The man nearest the viewer, for example, has a confident stance, with one leg moving into the space of the women. A hand behind his back reveals a slight reluctance, however, earning him a supportive pat on the shoulder from his friend. The women lean forward, arm in arm, clearly engaged. One holds a scroll of paper, perhaps sheet music or a script.

With its palette of grays and bluish-black, this work is much darker than Renoir's other impressionist canvases of the time, for example *Moulin de la Galette*, 1876 (Musée d'Orsay, Paris), and its large scale suggests that he may have intended it for the Salon. Renoir never exhibited the picture, however. As in *Moulin de la Galette*, he used members of his bohemian circle as models: his friend Georges Rivière posed for the man in the foreground, while Nini Lopez, another Montmartre habitué, is the female figure closest to the viewer. Made to look like a spontaneously observed moment from contemporary life, *Leaving the Conservatory* is really a highly choreographed invention. ML

SELECTED
MASTERWORKS

We see only by utilizing the vision of others, and this vision is embodied
in the traditions of art. Each of these…represents a systematic way of
envisioning the world; taken together, they record the perceptions of the most
gifted observers of all generations, and form a continuous and cumulative
growth which is one of the most important parts of the heritage of civilization.

ALBERT C. BARNES, *The Art in Painting* (1937)

Some arrangements in the collection, for example that on the Balcony above
the Main Room, are difficult to capture, and a few objects are shown in the
round. In this section, major works that define the breadth and complexity of
the collection are presented independent of their settings.

Amedeo Modigliani (Italian, 1884–1920)
Head, 1911–1912
Limestone. 25 1/2 x 7 1/2 x 9 (64.8 x 19.1 x 22.9). A249

Between 1909 and 1914, Amedeo Modigliani explored the artistic processes he observed in the work of the Romanian-born sculptor Constantin Brancusi, who had also settled in Paris. Eschewing the production of preliminary wax or clay models in preparation for carving, Modigliani worked directly with the stone blocks he found or misappropriated to create a series of approximately twenty-five heads, until his declining health forced him to end this physically demanding labor. While Brancusi served as one important influence for the technique and forms of Modigliani's *Head*, the Italian artist likely drew on archaic Greek, Asian, ancient Egyptian, and African precedents for his distinctively stylized physiognomies—elongated heads and noses, high brows, puckered lips, and almond-shaped eyes.

Modigliani left traces of his chisel on the stone and exploited the rough, uneven surface of the material for the figure's hair, typical of his direct carving method. Fellow sculptor Jacob Epstein noted that Modigliani placed candles on these carved heads at night—flickering illumination that would have heightened the materiality of the carved but unpolished stone. Moreover, Epstein recalled the mystical nature of the candlelight, noting, "the effect was that of a primitive temple."[1] JFD

1 Wayne 2002, 36.

Jacques Lipchitz (French, active United States, 1891–1973)
Bather, 1917
Limestone. 36 ½ x 14 ½ x 12 (92.7 x 36.8 x 30.5). A201

In this cubist sculpture of 1917, Jacques Lipchitz breaks up the human form while exploring its relationship to space. The figure, a bather, stands with one leg crossed in front of the other; she is in motion, it seems, twisting around a central axis. Her body is a composite of heavy, abstracted volumes, their smooth surfaces projecting at different angles so that the sculpture reads as a series of intersecting planes. Designed to catch the light, the planes convey a sense of dynamism that recalls Marcel Duchamp's painting *Nude Descending a Staircase*, 1912 (Philadelphia Museum of Art). With graceful, overlapping volumes activating all sides, the sculpture demands to be viewed from several angles at once.

Lipchitz drew here from the cubist vocabularies developed by Pablo Picasso and Georges Braque (and also by artists such as Juan Gris, whom Lipchitz knew well), which placed special value on spatial and perceptual ambiguity. Like its pictorial ancestors, *Bather* disrupts the possibility of a coherent subject, breaking it into a series of abstracted forms that are difficult to apprehend. Are we seeing the bather from the side or the front? Is the volume below the neck a shoulder or a breast? A small circle represents the figure's eye; this same shape is also used to indicate the belly button (or perhaps a nipple), furthering the perceptual confusion.

Albert Barnes was Lipchitz's most enthusiastic American patron in the decades before World War II. He purchased *Bather* in 1923, around the same time that he commissioned Lipchitz, whom he met in Paris through the dealer Paul Guillaume, to design the bas-relief panels on the façade of the Merion building. ML

Amedeo Modigliani (Italian, 1884–1920)
*Reclining Nude from the Back
(Nu couché de dos)*, 1917
Oil on canvas. 25 ½ x 39 ¼ (64.8 x 99.7). BF576

In 1917 Leopold Zborowski, a Polish-born poet-turned-art dealer, provided the impoverished Amedeo Modigliani with a space in his apartment in which to work, as well as art supplies, models, and a daily stipend. While ensconced in Zborowski's home and at his request, Modigliani embarked on an ambitious series of just over two dozen female nudes. These works combined the artist's distinctively stylized masklike treatment of the face—derived from a wealth of archaic Greek, Asian, ancient Egyptian, and African sources—with poses that recognizably cited works by his predecessors, including not only revered old masters such as Titian, Giorgione, and Diego Velázquez, but also avant-garde provocateurs such as Édouard Manet. However, Modigliani avoided any hint of anecdote, presenting his viewers with the frank carnality of his models. Some of these works caused a scandal when they debuted at Berthe Weill's gallery in December 1917, and police removed one nude from the gallery window for its perceived impropriety.[1]

Stretching beyond the edges of the canvas at left and barely contained within its edges at right, this model—cropped at the knee—occupies a shallow, claustrophobic space. Most likely looking to *The Odalisque*, 1745, by François Boucher as a reference (fig. 1),[2] Modigliani's nude lies on her stomach on the standard prop for the series—a dark crimson cushion that luridly sets off the warm flesh tones of the figure. The rounded contours of the pillow heighten the sinuous effect of the successive curves of the model, particularly along her back, buttocks, and thighs. While her body suggests litheness, her face remains stony, showing the hollowed eyes of the artist's mature idiom and the inexpressive button mouth. JFD

FIG. 1 **François Boucher**
The Odalisque, 1745
Oil on canvas, Musée du Louvre, Paris. Bequest of Baron de Schlichting

1 Griselda Pollock, "Modigliani and the Bodies of Art: Carnality, Attentiveness, and the Modernist Struggle," in *Modigliani* 2004, 55–73.
2 Jeffrey S. Weiss, "Reclining Nude from the Back (Nu couché de dos)," in *Great French Paintings* 2008, 218.

337

Paul Klee (Swiss, 1879–1940)
Sicilian Landscape (Sizilianische Landschaft), 1924
Gouache on prepared paper; artist-mounted to paperboard.
15 ¾ x 18 ¾ (40 x 47.6). BF1005

Composed only of blocks of color and devoid of outlines, this jewel-like image of the Sicilian coast includes central pale, blue-washed houses surrounded by dotted olive-hued trees and sandy ground, lapped by a refulgent blue sea, under a series of green, violet, and taupe squares suggesting tree-clad hills and sky. The conflicting perspective of two small hutlike structures (in the foreground and center left) is one of the destabilizing devices used by Paul Klee to let the picture work simultaneously on several levels: as recognizable image, color fugue, and painterly exercise.

Klee's visit to Sicily and Corsica in 1924 came a decade after his first trip to the Mediterranean and North Africa. Experiencing "the south" had been transformational to the artist, making it possible for him to shift from his previous focus on drawing and etching to becoming one of the great colorists of the modern era. Klee internalized the views of his contemporary Robert Delaunay, translating them in 1913 for *Der Sturm* magazine:

> Nature is imbued with a rhythm that in its multiplicity cannot be constrained. Art should imitate it in this, in order to purify itself to the same height of sublimity, to raise itself to visions of multiple harmonies, a harmony of colors separating and coming together again in the same action. This synchronic action is the one, true subject of painting.[1]

Sicilian Landscape, which also has roots in Paul Cézanne's fractured approach to landscape, was painted while Klee taught at the Bauhaus in Weimar and was preoccupied with presenting his own ideas on form, line, color, and balance. His now celebrated *Pedagogical Sketchbook* was published the following year, an exact contemporary of Albert Barnes's first book, *The Art in Painting*. DG

1 See Düchting 1997, 24.

Marsden Hartley (American, 1877–1943)
Movement, Bermuda, 1916
Oil on beaverboard. 16 ⅛ x 11 ⅞ (41 x 30.2). BF465

In the spring of 1916, Marsden Hartley returned to New York after having spent nearly three years in Berlin. He presented his "War Motif" series at the Little Galleries of the Photo-Secession, the gallery owned by influential photographer and art dealer Alfred Stieglitz and better known as "291" for its Fifth Avenue address. Following the cool reception that these daring works received — likely because of mounting anti-German sentiment in the wake of the ongoing hostilities of World War I — Hartley continued to explore and re-fine his cubist idiom during extended sojourns in Provincetown, Massachusetts, and in Bermuda, where he worked alongside fellow painter Charles Demuth.

In *Movement, Bermuda*, one of several works with this title, Hartley explored nautical subject matter in flatly painted pale blue, white, pink, yellow, and beige, a subdued palette evocative of the calm of these seaside retreats. This was a departure from the colorful military pageantry of imperial Germany. Hartley's subject floats at the spatially undefined center of the canvas. The precisely drawn sails in various sizes unfurl in unmodulated, overlap-ping planes on either side of a mast visible only by the hint of its round ornament at the top of the canvas. Attentive to the overall balance of his composition, Hartley matched the angular forms of the wind-filled sails with the curved hull and sail markings, while the rudder and tiller at the stern of the boat unite both squared and rounded forms.[1] JFD

1 For more on similar works, see Kristina Wilson in Kornhauser 2002, 299–300; Wattenmaker 2010, 248.

Wols (German, 1913–1951)
Light Focus, 1950
Gouache and pen and ink on wove paper. 6 ¼ x 5 ½
(15.9 x 14). BF2523

Alfred Otto Wolfgang Schulze, known as Wols, was a German painter, draftsman, and photographer. In 1932 he moved to Paris, where he worked for a time taking close-up photographs of objects and body parts, often to disturbing effect, that were clearly influenced by the burgeoning surrealist movement. After fourteen months of imprisonment during World War II (for his German citizenship) and several years of financial struggle, in the late 1940s Wols turned his focus to oils and watercolors, producing hauntingly expressive works such as this one.

In *Light Focus*, a tiny gouache (or opaque watercolor) measuring only five inches across, a glowing circular form floats in a field of deep red as if struggling to emerge. Tiny marks swirl within the white circle: anxious squiggles in ink and graphite, scratches made with the end of the brush, and fingerprints of red paint. Areas of paper are left unpainted in the circle's middle and especially at its edges. The effect is a form that appears on the verge of coming apart, unable to maintain its boundaries—making this work a good example of the *art informel* style that emerged in France after the war.

Light Focus was one of the last pictures Albert Barnes purchased. He bought it in 1950, the same year it was painted, revealing his continued interest in the most recent tendencies in art. It is one of only a few fully abstract works in the collection—Barnes greatly preferred representational painting—raising the question of the direction in which his tastes would have taken him had he not died suddenly in 1951. ML

Storage Jar, c. 1900
Attributed to Acoma Mary (Mary Histia)
(Native American, 1881–1973)
United States, New Mexico
Acoma Pueblo. Polychrome earthenware. 15 ³/₄ x 17 ³/₄
(40 x 45.1). A383

Santa Ana Pueblo
Water Jar, c. 1830–1840
United States, New Mexico
Polychrome earthenware. 11 ³/₄ x 12 ¹/₂ (29.8 x 31.8). A388

Zuni Pueblo
Water Jar, c. 1800–1820
United States, New Mexico
Polychrome earthenware. 11 ¹/₂ x 11 ¹/₄ (29.2 x 28.6). A359

These ceramic pots, all of exceptional quality,
originate from three different Native American
pueblos in the Southwest. All three were created
for daily use, either as containers for water or as
storage vessels for materials such as grains. Each is
handmade and hand-painted, and each reflects the
designs and general aesthetic of its particular tribe.

The Zuni design (below right) is the most geo-
metric of the three, with triangles, a checkerboard
pattern, and interlocking gridlike elements
contained in a horizontal band. The Acoma vessel
(opposite), made by a master potter called Acoma
Mary (Mary Histia), is the least regimented in
terms of design; dispensing with the horizontal
band, its polychrome pattern spreads fluidly
over the vessel, emphasizing its roundness. Like
the Acoma pot, the Santa Ana piece (above right)
includes a representational element, with animals
filling out the composition. Very few Santa Ana
vessels from this period exist, making this last
piece a historical rarity.

In collecting Native American ceramics, Albert
Barnes was less interested in contemporary
pueblo pottery than in older objects from the
nineteenth century, which he regarded as
more authentic. He preferred pottery with com-
plex painted designs, such as the three examples
pictured here, to plainware vessels. Between
1930 and 1932, Barnes collected forty-eight pieces
of pueblo ceramics, selecting them strictly
for their artistic excellence rather than for their
ethnographic interest, which was standard
practice at the time. ML

Chaim Soutine (Russian, active in France,
1893–1943)
The Pastry Chef (Baker Boy) (Le Pâtissier), c. 1919
Oil on canvas. 26 x 20 (66 x 50.8). BF442

Albert Barnes first encountered the work of
Chaim Soutine during a trip to Paris in
1922, when the artist was known only in the
city's bohemian circles. He was struggling
to survive, desperately, by some accounts.
When Barnes saw *The Pastry Chef* hanging
in Paul Guillaume's gallery, he had an imme-
diate response to the painting, sparking him
to buy more than fifty of Soutine's canvases in
the course of a few weeks. "Dr. Barnes Makes
Soutine Hero of Paris Art World," one news-
paper headline announced.

The Pastry Chef shows an adolescent boy
staring plainly out at the viewer, one bright
red ear extending wildly to the side, a distortion
echoed by the armrest. The painting is an
explosion of color and gestural brushstrokes.

As the cook's coat slumps around his elbows,
swirls of thick paint move in all different di-
rections—a slash of blue here, a long zigzag
of yellow and purple there, so that the entire
surface seems to undulate. Yet what Barnes
admired about Soutine was that his colors were
not arbitrary or applied haphazardly as a
means of being superficially expressive; rather,
Soutine's use of color was highly designed
and crucial to establishing the pictorial space.
The strange distortions, here and in all of
Soutine's paintings, were key to the works' sense
of drama. Barnes later sold a good portion of
the original batch of paintings, but Soutine still
occupies an important place in the Foundation's
modernist pantheon, with twenty-one canvases
filling out the collection. ML

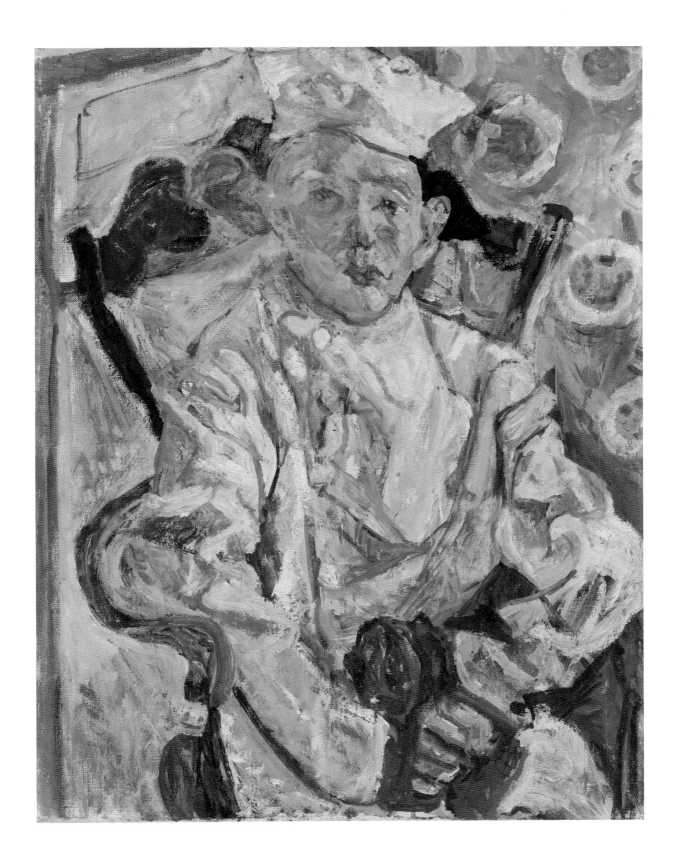

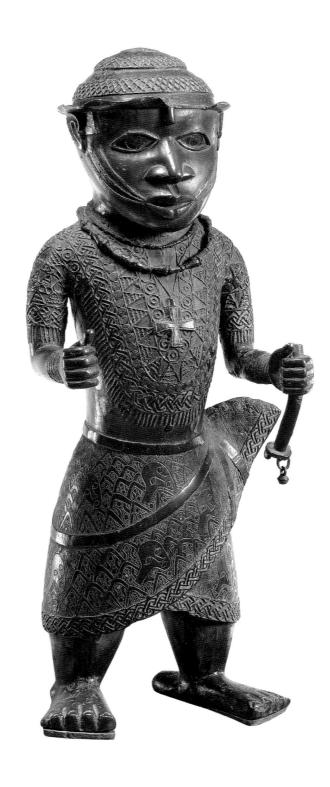

Bini (or Edo) peoples
Standing Male Figure, 16th century
Nigeria
Copper alloy. 22 ¼ x 9 ¼ x 8 ¾ (56.5 x 23.5 x 22.2). A230

In the kingdom of Benin, which flourished from the fourteenth to the nineteenth century in southern Nigeria, richly patterned figures, cast in copper alloy (bronze) in the lost-wax technique, were commissioned by the *Oba*—a ruler endowed with sacred as well as political power—for altars dedicated to ancestor kings. While costume and accessories helped identify a person's status in Benin society, this figure's pendant in the form of a cross suggests the possibility of a variety of roles in the court's complex administration and rituals: the figure could be a messenger from the ancient kingdom of Ife (modern Nigeria), sent by a more powerful monarch to confirm the Oba's ascension; a priest of the creator god Osanobua; or an Ewua dignitary, who awakened the king each morning.[1] With an accessory missing from his left hand and a damaged one in his right, a more specific identification of the figure's role cannot be made.

The figure wears a fringed vest or tunic that fastens behind his neck. The sides of his torso, his navel, and his back are exposed, juxtaposing the raised relief of the richly ornamented costume with his smooth skin.

Some traditions suggest that techniques of bronze casting came to Benin from Ife in the thirteenth century, while others indicate that the casting technique began independently in Benin during the thirteenth century.[2] This is one of the oldest African objects in the collection of the Barnes Foundation—and one of the most prized for its rarity and virtuosity. Yet Paul Guillaume and Thomas Munro described these bronzes as a hybrid of African and European elements in *Primitive Negro Sculpture*, published in 1926. By contrast, Guillaume believed that the remainder of the African holdings in Albert Barnes's collection represented ancient cultures, untarnished by the incursions of conquering forces. JFD

1 Plankensteiner 2007, 28; Barbara Blackmun, "Ewua Official," in *Benin Kings and Rituals* 2007, 333–334.
2 Daniel Inneh, "The Guilds Working for the Palace," in *Benin Kings and Rituals* 2007, 103, 105.

Luba peoples

Caryatid Stool, late 19th–early 20th century
Democratic Republic of Congo

Wood. 23 ¼ x 14 ¼ x 12 (59.1 x 36.2 x 30.5). A185

Wooden stools such as this one were made for exclusive use by Luba chiefs, kings, and heads of clans. While they served a functional purpose, these royal stools also carried a great deal of symbolic importance; they were an integral part of the induction ceremony that established the chief's right to rule and possibly served as a receptacle for the soul. Central to the stool's symbolic resonance is the squatting caryatid figure forming its base. She represents a venerated female ancestor, the scarification marks on her thighs and stomach indicating her high status in Luba society. The female figure's own authority provided symbolic support for that of the ruler occupying the seat.

Carved from a single block of wood, the stool is highly sophisticated in technique. The scarification areas are intricately cut in diamond-shaped patterns that would have been especially difficult to carry out on the figure's hard-to-reach areas beneath the stomach. The elaborate hair, which also indicates the figure's rank, is an expanse of raised, beadlike forms. The body is abstracted into stylized geometric forms that echo each other—the conical shape of the breasts, for example, is repeated in the chin. The body is also perfectly symmetrical in its arrangement, as the elevated arms form a square frame around the head while the fingers delicately meet the edges of the seat. The seat itself is mirrored in the rounded form on which the figure rests. ML

Punu peoples

Face Mask (Mukudj), late 19th–early 20th century
Gabon

Wood, pigment. 12 ½ x 6 ½ x 7 ¼ (31.8 x 16.5 x 18.4). A282

In southern Gabon, members of the Okuyi society of the Punu peoples perform strenuous acrobatic dances on tall stilts at momentous occasions: the birth of twins, the initiation of young men, and the end of mourning periods for prominent people.[1] For these performances, male dancers don *mukudj* masks displaying highly stylized and idealized female features, including the lobed coiffure, heart-shaped face, full lips, arched brows, and eye slits.[2] The artist coats the mask in kaolin, a white clay harvested from riverbeds and associated with ancestral spirits, merging the image of the living with a transcendent force. Typically, diamond and square patterns of scars in groups of nine appear between the brow and on the temples, respectively, although the mask seen here includes arrangements of only four.

After he moved to Paris in 1921, Man Ray, an avant-garde art and commercial photographer, captured the holdings of several important collectors and dealers. Among them was Paul Guillaume, from whom Albert Barnes bought the entirety of the Foundation's African objects. For Man Ray, photographing African sculpture provided a means for formal exploration in this medium, and his images helped dealers such as Guillaume disseminate their holdings.[3] A print of Man Ray's photograph of this Punu mask, which Barnes bought from Guillaume in 1922, was affectionately inscribed by the dealer to Laura Barnes: "To Mrs. Barnes who in an anterior life was perhaps queen somewhere in Africa—but who prefers to reign in the heart of Dr. Barnes!!! With my respects. Paul Guillaume."[4] JFD

1 Kevin D. Dumouchelle, "Mask for the Okuyi Society (Mukudj)," in Siegmann 2009, 178.
2 Visonà et al. 2001, 364.
3 For more on Man Ray's engagement with African art, see Grossman 2009.
4 Man Ray, photograph of *Face Mask (Mukudj)* (A282), c. 1921. BFA.

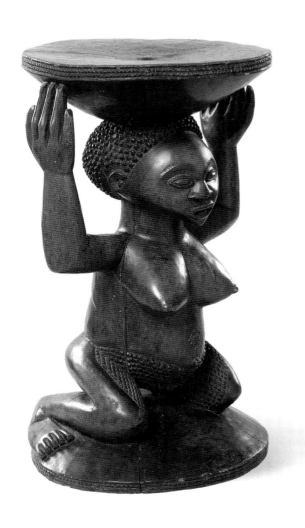

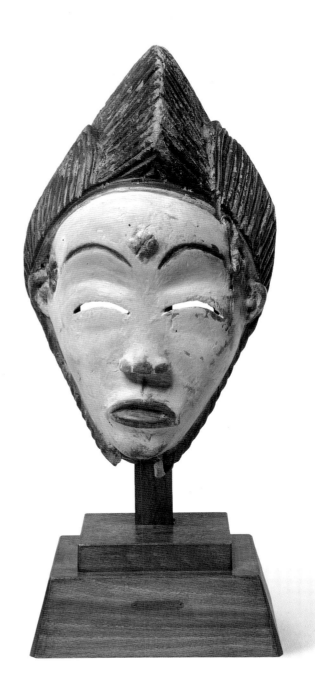

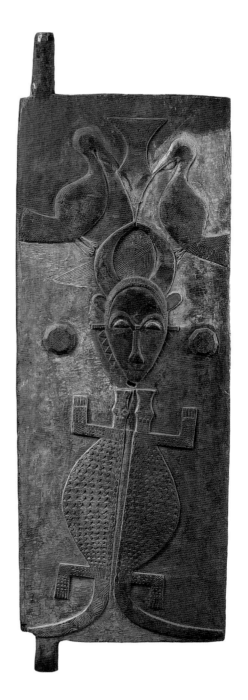

Baule peoples
Door (Anuan), 19th–early 20th century
Côte d'Ivoire
Wood. 61 ½ x 20 x 2 (156.2 x 50.8 x 5.1). A238

Albert Barnes assembled his substantial collection of African art in 1922 and 1923 with the help of the French dealer Paul Guillaume. While Barnes was not the only collector of his generation to pursue African sculpture, he was one of the first to consider it solely for its aesthetic value; the tendency had been to regard African objects as mere ethnographic curiosities. For Barnes, African art exemplified the universal human impulse toward expressivity. He admired the symmetry seen in many of the regional styles and the way in which the human body was frequently depicted as an amalgam of simplified geometric parts. This last point in particular had enormous consequences for modernist European painters, who found inspiration in these abstracted forms.

This door from the Baule peoples of the Côte d'Ivoire is one of the most important pieces in the collection. Doors of this type, very few of which still exist today, often stood at the entrances to courtyards and rest houses in Baule villages. The front (right) bears two birds, two crocodiles, and a mask carved in low relief, and the back (left) has a checkerboard pattern. Whether these motifs are merely decorative or have symbolic significance is uncertain. The carving is intricate, particularly in the legs and backs of the crocodiles, which reveal a diamond pattern and V-shaped grooves; the birds are decorated with incised lines contained in overlapping triangle shapes. The overall design is symmetrical yet not stringently so. While the motifs surrounding the central mask mirror each other—the crocodiles, for example, are similarly arranged—they are presented slightly askew, disrupting the vertical axis created by the mask. ML

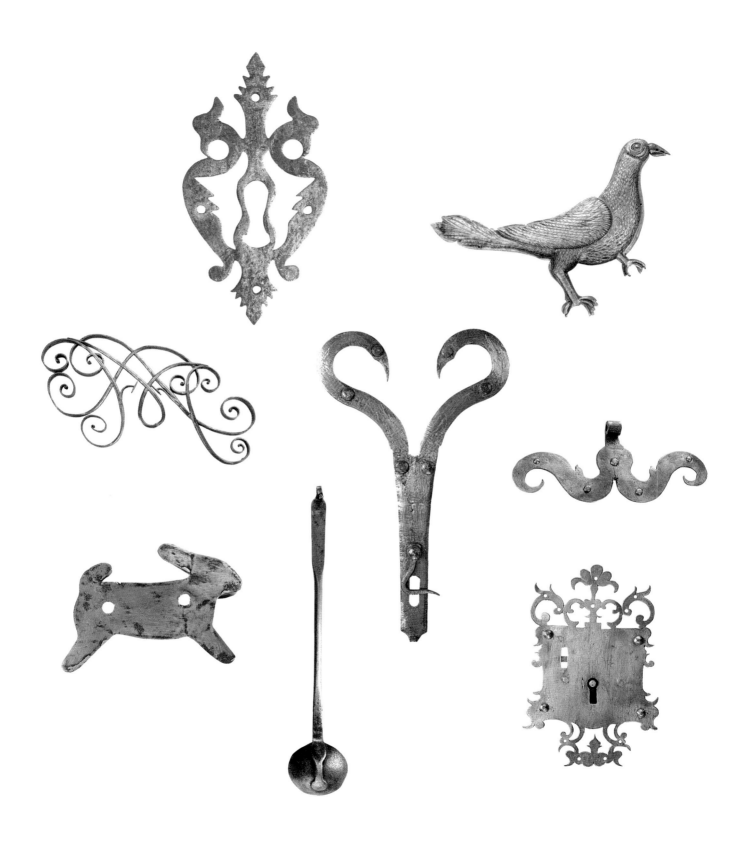

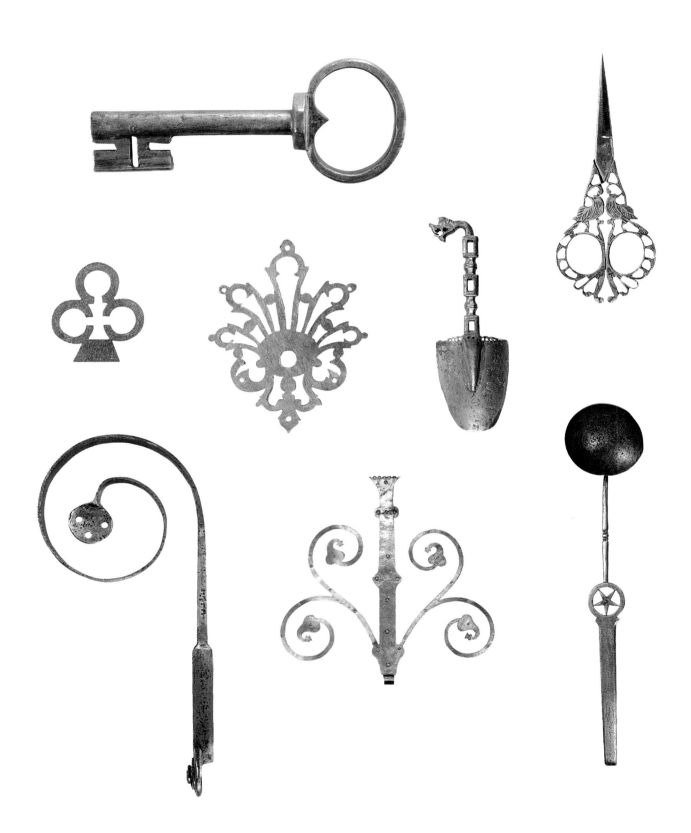

BIBLIOGRAPHY

This catalogue reflects the research gathered in the Curatorial White Papers (2002–2004) of the Barnes Foundation's Collections Assessment Project, funded by the Andrew W. Mellon Foundation and keenly supported by Angelica Zander Rudenstine. This important project was initiated by Kimberly Camp and skillfully supervised by the following members of the Curatorial Advisory Committee: Murtha Baca, Jeff R. Donaldson, Beatrice W. B. Garvan, George E. Hein, Joseph J. Rishel, Robert Rosenblum, Jeremy Sabloff, Edwin L. Wade, Richard J. Wattenmaker, William D. Wixom, and Bernard Young. Emily Croll and Susan Shifrin masterfully shepherded the research, and Sarah Noreika and Kristin Swan ably assisted. The entries are also informed by the work of scholars who researched individual objects in the collection as part of this project. Other scholars who contributed their expertise include Milo Beach, Bruce Bernstein, Jonathan M. Brown, Joseph Chang, Christa Clarke, Gordon S. Converse, Lane Coulter, Lloyd DeWitt, Elizabeth W. Easton, Linda Eaton, Jonathan L. Fairbanks, Donald M. Herr, Kathryn B. Hiesinger, John Ittman, Laurence Kanter, Adria Katz, Thomas Lawton, Katherine Luber, John Oakley, Nicholas Penny, Marilyn Rhie, Joseph J. Rishel, Irene Bald Romano, Pierre Rosenberg, Larry Silver, David Silverman, Carl B. Strehlke, Gay LeCleire Taylor, Michael Taylor, Edwin L. Wade, Richard J. Wattenmaker, Jennifer Wegner, Juliet Wilson-Bareau, William D. Wixom, Hiram Woodward, Don Yoder, Anne Yonemura, and John Zarobell.

Barkin et al. 2002
Barkin, Kenneth, et al. *From Tavern to Tabernacle: Decorated British and European Pewter, 1600–1800.* Exh. pamphlet, Long Beach Museum of Art. Long Beach, CA, 2002.

Barnes 1915
Barnes, Albert C. "How to Judge a Painting." *Arts and Decoration* 5, no. 6 (April 1915).

Barnes 1916
Barnes, Albert C. "Cubism: Requiescat in Pace." *Arts and Decoration* 6, no. 3 (January 1916).

Barnes 1923
Barnes, Albert C. "The Barnes Foundation." *New Republic*, March 14, 1923.

Barnes 1925
Barnes, Albert C. *The Art in Painting.* New York, 1925.

Barnes 1937
Barnes, Albert C. *The Art in Painting.* 3rd ed. New York, 1937.

Barnes and De Mazia 1933
Barnes, Albert C., and Violette de Mazia. *The Art of Henri-Matisse.* Merion, PA, 1933.

Barnes and De Mazia 1935
Barnes, Albert C., and Violette de Mazia. *The Art of Renoir.* New York, 1935.

Baxter and Bird-Romero 2000
Baxter, Paula A., and Allison Bird-Romero. *Encyclopedia of Native American Jewelry.* Phoenix, 2000.

Bedinger 1973
Bedinger, Margery. *Indian Silver: Navajo and Pueblo Jewelers.* Albuquerque, 1973.

Benin Kings and Rituals 2007
Benin Kings and Rituals: Court Arts from Nigeria. Kunsthistorisches Museum, Vienna. Ghent, 2007.

Benjamin 2003
Benjamin, Roger. *Orientalist Aesthetics: Art, Colonialism, and French North Africa, 1880–1930.* Berkeley, 2003.

Berzock and Clarke 2011
Berzock, Kathleen Bickford, and Christa Clarke, eds. *Representing Africa in American Art Museums: A Century of Collecting and Display.* Seattle, 2011.

Brown 2006
Brown, Jonathan. *Goya's Last Works.* The Frick Collection, New York. New Haven, 2006.

Cachin et al. 1996
Cachin, Françoise, et al. *Cézanne.* Philadelphia Museum of Art. New York, 1996.

Cash 1999
Cash, Marie Romero. *Santos: Enduring Images of Northern New Mexican Village Churches.* Niwot, CO, 1999.

Catalogue of an Exhibition 1923
Catalogue of an Exhibition of Contemporary European Paintings and Sculpture, April 11, 1923–May 9, 1923. Pennsylvania Academy of the Fine Arts, Philadelphia. Philadelphia, 1923.

Clarke, Mathews, and Owens 1990
Clarke, Carol, Nancy Mowll Mathews, and Gwendolyn Owens, eds. *Maurice Brazil Prendergast, Charles Prendergast: A Catalogue Raisonné.* Williams College Museum of Art, Williamstown, MA. Munich, 1990.

Clarke 1996
Clarke, Christa. *Collecting African Art, 1890s–1950s.* Hurst Gallery, Cambridge, MA. Cambridge, MA, 1996.

Conisbee and Coutagne 2006
Conisbee, Philip, and Denis Coutagne. *Cézanne in Provence.* National Gallery of Art, Washington. New Haven, 2006.

Cooper and Minardi 2011
Cooper, Wendy A., and Lisa Minardi. *Paint, Pattern and People: Furniture of Southeastern Pennsylvania, 1725–1850.* Henry Francis du Pont Winterthur Museum, Winterthur, DE. Philadelphia, 2011.

Cowart and Fourcade 1987
Cowart, Jack, and Dominique Fourcade. *Henri Matisse: The Early Years in Nice, 1916–1930.* National Gallery of Art, Washington. New York, 1987.

Cowart et al. 1990
Cowart, Jack, et al. *Matisse in Morocco.* National Gallery of Art, Washington. New York, 1990.

Cowling 2002
Cowling, Elizabeth. *Picasso: Style and Meaning.* London, 2002.

Cret 1923
Cret, Paul. "The Building for The Barnes Foundation." *Arts* 3, no. 1 (January 1923).

Düchting 1997
Düchting, Hajo. *Paul Klee: Painting and Music.* Munich, 1997.

Einecke and Patry 2010
Einecke, Claudia, and Sylvie Patry. *Renoir in the 20th Century.* Musée d'Orsay, Paris. Ostfildern, 2010.

Fabian 2004
Fabian, Monroe H. *The Pennsylvania-German Decorated Chest.* Atglen, PA, 2004.

Faunce and Nochlin 1988
Faunce, Sarah, and Linda Nochlin. *Courbet Reconsidered.* Brooklyn Museum. New Haven, 1988.

Fennimore 2004
Fennimore, Donald L. *Iron at Winterthur.* Henry Francis du Pont Winterthur Museum, Winterthur, DE. Winterthur, DE, 2004.

Fischer and Homberger 1986
Fischer, Eberhard, and Lorenz Homberger. *Masks in Guro Culture, Ivory Coast.* Center for African Art, New York. New York, 1986.

Flam 1988
Flam, Jack, ed. *Matisse: A Retrospective.* New York, 1988.

Flam 1993
Flam, Jack. *Matisse: The Dance.* National Gallery of Art, Washington. Washington, 1993.

Flam 1995
Flam, Jack. *Matisse on Art.* Rev. ed. Berkeley, 1995.

Frank 1992
Frank, Larry. *New Kingdom of the Saints: Religious Art of New Mexico, 1780–1907.* Santa Fe, 1992.

Gedo 1995
Gedo, Mary Mathews. "Retreat from an Artistic Breakthrough: Gauguin's 'Nude Study (Suzanne Sewing).'" *Zeitschrift für Kunstgeschichte* 58, no. 3 (1995): 407–416.

Great French Paintings 2008
Great French Paintings from the Barnes Foundation: Impressionist, Post-Impressionist, and Early Modern. New York [1993], 2008.

Grossman 2009
Grossman, Wendy A. *Man Ray, African Art, and the Modernist Lens.* International Arts and Artists. Washington, 2009.

Guillaume 1923
Guillaume, Paul. "Le Docteur Barnes." *Les Arts à Paris* (January 1923).

Herbert et al. 1991
Herbert, Robert L., et al. *Georges Seurat, 1859–1891.* The Metropolitan Museum of Art, New York. New York, 1991.

Ilchman et al. 2009
Ilchman, Frederick, et al. *Titian, Tintoretto, Veronese: Rivals in Renaissance Venice.* Museum of Fine Arts, Boston. New York, 2009.

Keller 1991
Keller, Patricia J. "Black-Unicorn Chests of Berks County, Pennsylvania." *Antiques* 140 (October 1991): 592–605.

Kornhauser 2002
Kornhauser, Elizabeth Mankin, ed. *Marsden Hartley.* Wadsworth Atheneum Museum of Art, Hartford, CT. New Haven, 2002.

Lucy and House 2012
Lucy, Martha, and John House. *Renoir in the Barnes Foundation.* The Barnes Foundation, Philadelphia. New Haven, 2012.

Mallarmé 1876
Mallarmé, Stéphane. "The Impressionists and Edouard Manet, 1876." *Art Monthly Review,* September, 1876; reprinted in *The New Painting: Impressionism 1874–1886.* National Gallery of Art, Washington, and Fine Arts Museums of San Francisco. Geneva, 1986.

Matisse in the Barnes Foundation forthcoming
Bois, Yve-Alain, ed. *Matisse in the Barnes Foundation.* The Barnes Foundation, Philadelphia. Forthcoming.

Meyers 2004
Meyers, Mary-Ann. *Art, Education and African American Culture.* New Brunswick, NJ, 2004.

Modigliani 2004
Modigliani: Beyond the Myth. The Jewish Museum, New York. New Haven, 2004.

Morris and Green 2006
Morris, Frances, and Christopher Green, eds. *Henri Rousseau: Jungles in Paris.* New York, 2006.

Morning 1914
Morning, Alice [Beatrice Hastings]. "Impressions de Paris." *New Age,* July 9, 1914, 236.

Mullen 1923
Mullen, Mary. *An Approach to Art.* Merion, PA, 1923.

Pastoureau 1996
Pastoureau, Michel. "The Gallic Cock." In *Realms of Memory: Rethinking the French Past,* edited by Pierre Nora, translated by Arthur Goldhammer. Vol. 3. New York, 1996.

Pennsylvania German Art 1984
Pennsylvania German Art, 1683–1850. Philadelphia Museum of Art and the Henry Francis du Pont Winterthur Museum, Winterthur, DE. Chicago, 1984.

Plankensteiner 2007
Plankensteiner, Barbara. "Introduction." *In Benin Kings and Rituals: Court Arts from Nigeria.* Kunsthistorisches Museum, Vienna. Ghent, 2007.

R.E.D. 1913
R.E.D. [Robert E. Dell]. "Art in France." *Burlington Magazine* 22, no. 118 (January 1913): 240.

Reed 1987
Reed, Henry M. *Decorated Furniture of the Mahantongo Valley.* Lewisburg, PA, 1987.

Richardson 2007
Richardson, John. *A Life of Picasso.* 2 vols. New York, 2007.

Rishel and Sachs 2009
Rishel, Joseph J., and Katherine Sachs, eds. *Cézanne and Beyond.* Philadelphia Museum of Art. New Haven, 2009.

Rosand 1988
Rosand, David. "Giorgione, Venice, and the Pastoral Vision." *In Places of Delight: The Pastoral Landscape,* Robert C. Cafritz, Lawrence Gowing, and David Rosand. The Phillips Collection in association with the National Gallery of Art, Washington. New York, 1988.

Shackelford et al. 2011
Shackelford, George T. M., and Xavier Rey, et al. *Degas and the Nude*. Museum of Fine Arts, Boston. Boston, 2011.

Shaner 2006
Shaner, Richard H. "Bieber Family of Furniture Makers in Oley Valley." *Historical Review of Bucks County* 71, no. 3 (Summer 2006): 123–126.

Shattuck 1985
Shattuck, Roger, et al. *Henri Rousseau*. The Museum of Modern Art, New York. New York, 1985.

Sidlauskas 2009
Sidlauskas, Susan. *Cézanne's Other: The Portraits of Hortense*. Berkeley, 2009.

Siegmann 2009
Siegmann, William C. *African Art: A Century at the Brooklyn Museum*. Brooklyn Museum. Munich, 2009.

Slive 1970–1974
Slive, Seymour. *Frans Hals*. 3 vols. London, 1970–1974.

Taylor 2004
Taylor, Michael. *Jacques Lipchitz and Philadelphia*. Philadelphia Museum of Art. Philadelphia, 2004.

Thomson 1985
Thomson, Richard. *Seurat*. Salem, NH, 1985.

Tinterow and Stein 2010
Tinterow, Gary, and Susan Alyson Stein, eds. *Picasso in The Metropolitan Museum of Art*. The Metropolitan Museum of Art, New York. New Haven, 2010.

Toulouse-Lautrec 1991
Toulouse-Lautrec. Réunion des musées nationaux. Paris, 1991.

Visonà et al. 2001
Visonà, Monica Blackmun, et al. *A History of Art in Africa*. New York, 2001.

Vogel 1997
Vogel, Susan Mullin. *Baule: African Art, Western Eyes*. Yale University Art Gallery, New Haven. New Haven, 1997.

Wayne 2002
Wayne, Kenneth. *Modigliani and the Artists of Montparnasse*. Albright-Knox Art Gallery, Buffalo. New York, 2002.

Wattenmaker 1994
Wattenmaker, Richard J. *Maurice Prendergast*. New York, 1994.

Wattenmaker 2010
Wattenmaker, Richard J. *American Paintings and Works on Paper in The Barnes Foundation*. The Barnes Foundation, Merion, PA. New Haven, 2010.

Weiser and Sullivan 1973
Weiser, Frederick S., and Mary Hammond Sullivan. "Decorated Furniture of the Mahantango Valley." *Magazine Antiques* 103, no. 5 (May 1973): 932–939.

Wilson-Bareau 2005
Wilson-Bareau, Juliet. Unpublished correspondence in curatorial file regarding Manet's *Le Linge* (BF957), October 2005.

Wilson-Bareau and Degener 2003
Wilson-Bareau, Juliet, and David Degener. *Manet and the Sea*. Philadelphia Museum of Art. Philadelphia, 2003.

Wright 1915
Wright, Willard Huntington. *Modern Painting. Its Tendency and Meaning*. New York, 1915.

Wroth 1982
Wroth, William H. *Christian Images in Hispanic New Mexico: The Taylor Museum Collection of Santos*. Taylor Museum of the Colorado Springs Fine Arts Center. Colorado Springs, 1982.

Wye 2004
Wye, Deborah. *Artists and Prints: Masterworks from The Museum of Modern Art*. The Museum of Modern Art, New York. New York, 2004.

Yount and Johns 1996
Yount, Sylvia, and Elizabeth Johns. *To Be Modern: American Encounters with Cézanne and Company*. Museum of American Art at the Pennsylvania Academy of the Fine Arts, Philadelphia. Philadelphia, 1996.

INDEX

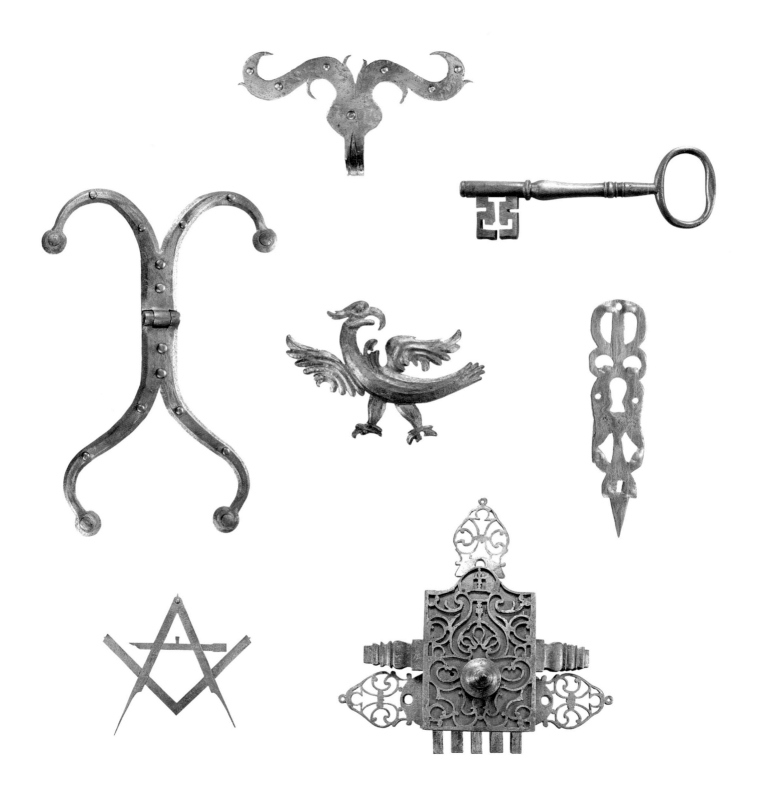

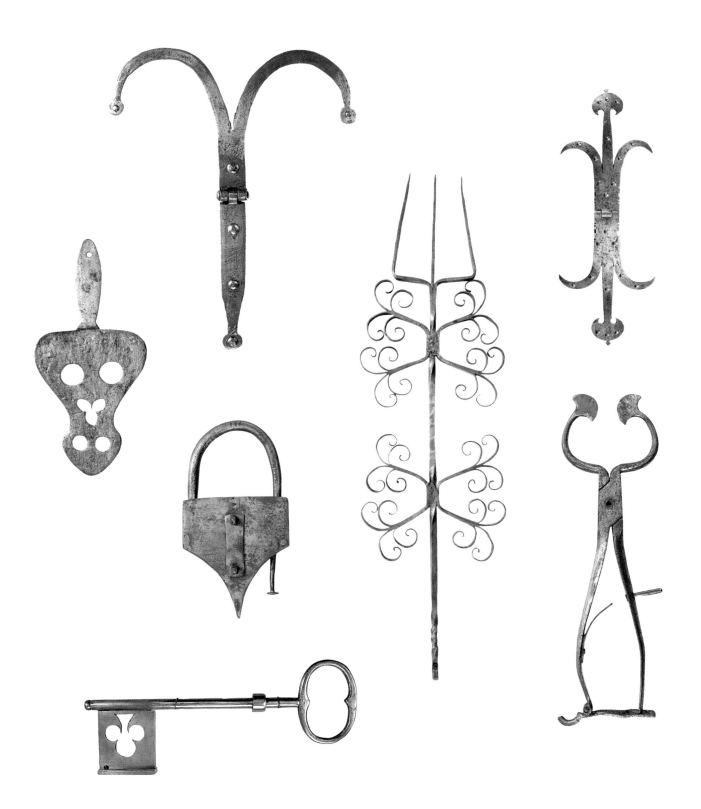

METALWORK
CAPTIONS

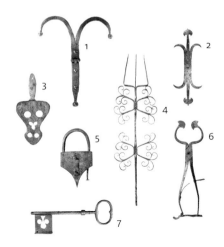

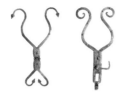

PAGES 6–7

Hinge
Iron. 01.02.03

Hasp, late 18th–early 19th century
United States
Iron. 01.08.54

PAGES 360–361

Escutcheon for a Furniture Pull, 18th–19th century. Possibly Spain
Iron. 01.01.30

Door Knob or Pull Escutcheon, 17th century
France
Iron. 01.05.25

PAGES 366–367

H-L Hinge, 18th century
Probably Europe
Iron. 01.14.49 A&B

Hinge, 18th–19th century
France
Iron. 01.11.32

PAGES 356–357

Keyhole Escutcheon, 18th century
France
Iron. 01.09.58

Brace, 18th century
United States, Pennsylvania
Iron. 01.05.24

PAGES 362–363

Ladle, 19th century
United States
Iron. 01.15.38

Ladle, 1839
United States, probably Pennsylvania
Iron, brass, and copper. 01.06.55

PAGES 358–359

Plate for a Door Pull, 18th–19th century
France
Iron. 01.01.27

Door Hinge, 18th–19th century
Europe or United States
Iron. 01.01.28

Hinge
Iron. 01.13.67

PAGES 364–365

Key
Iron. 01.13.35

Hinge
Iron. 01.02.19

The publication of this book was made possible by a contribution from Wilmington Trust, an affiliate of M&T Bank. Additional support was provided through a generous grant from the John S. and James L. Knight Foundation.

[Knight Foundation

2012 2013 2014 2015 / 10 9 8 7 6 5 4 3 2 1

First published in the United States of America in 2012 by

Skira Rizzoli Publications, Inc.
300 Park Avenue South
New York, NY 10010
www.rizzoliusa.com

in association with
The Barnes Foundation
2025 Benjamin Franklin Parkway
Philadelphia, PA 19130
www.barnesfoundation.org

FRONT COVER

TOP **Henri Matisse**, *Reclining Nude with Blue Eyes (Nu couché aux yeux bleus)*, January 1936 (PAGE 182)

LEFT *Sign for a Locksmith*, 18th century, France (PAGE 371)

RIGHT **Senufo peoples**, *Seated Female Figure*, late 19th–early 20th century (PAGE 310)

BACK COVER

Room 2, ensemble view, north wall, detail (PAGES 81–82)

Library of Congress Cataloging-in-Publication Data

Barnes Foundation.
The Barnes Foundation: masterworks / Judith F. Dolkart and Martha Lucy; with contributions by Derek Gillman.
 pages cm
 Summary: "This volume represents the first overview of works from the art collection of the Barnes Foundation, Merion, PA, highlighting the diversity of cultural forms assembled by Dr. Albert C. Barnes"—Provided by publisher.
 Includes bibliographical references and index.
 ISBN 978-0-8478-3806-6 (hardback)
 1. Art—Private collections—Pennsylvania—Merion—Catalogs. 2. Barnes Foundation—Catalogs. 3. Barnes, Albert C. (Albert Coombs), 1872–1951—Art collections—Catalogs. I. Dolkart, Judith F. II. Lucy, Martha. III. Title.
 N5220.B28B37 2012
 708.148'14—dc23 2011050387

ISBN 978-0-8478-3806-6
(Skira Rizzoli trade hardcover edition)

ISBN 978-0-9848578-0-7
(Barnes Foundation deluxe edition)

Photography credits and copyrights appear on page 373.

For the Barnes Foundation
Johanna Halford-MacLeod, Publications Manager
Ulrike Mills, Editor

For Skira Rizzoli Publications, Inc.
Margaret Rennolds Chace, Associate Publisher
Elisa Urbanelli, Editor

Design
Abbott Miller and Kimberly Walker, Pentagram

Printed and bound in China